The eighteenth and nineteenth centuries witnessed a change in the perception of the arts and of philosophy. In the arts this transition occurred around 1800, with, for instance, the breakdown of Vitruvianism in architecture; in philosophy the foundationalism of which Descartes and Spinoza were paradigmatic representatives, which presumed that philosophy and the sciences possessed a method of ensuring the demonstration of truths, was undermined by the idea asserted by Nietzsche and Wittgenstein that there exist alternative styles of enquiry among which a choice is open. The essays in this book examine the circumstances, features, and consequences of this historical transition, exploring in particular new aspects and instances of the interrelatedness of content and its formal representation in both the arts and philosophy.

CAMBRIDGE STUDIES IN PHILOSOPHY AND THE ARTS

Series editors
SALIM KEMAL *and* IVAN GASKELL

The question of style in philosophy and the arts

CAMBRIDGE STUDIES IN PHILOSOPHY AND THE ARTS

Series editors

SALIM KEMAL *and* IVAN GASKELL

Advisory board

Stanley Cavell, R. K. Elliott, Stanley E. Fish, David Freedberg, Hans-Georg Gadamer, John Gage, Carl Hausman, Ronald Hepburn, Mary Hesse, Hans-Robert Jauss, Martin Kemp, Jean Michel Massing, Michael Podro, Edward S. Said, Michael Tanner.

Cambridge Studies in Philosophy and the Arts is a forum for examining issues common to philosophy and critical disciplines that deal with the history of art, literature, film, music, and drama. In order to inform and advance both critical practice and philosophical approaches, the series analyses the aims, procedures, language, and results of inquiry in the critical fields, and examines philosophical theories by reference to the needs of arts disciplines. This interaction of ideas and findings, and the ensuing discussion, brings into focus new perspectives and expands the terms in which the debate is conducted.

Already published

The language of art history

Landscape, natural beauty, and the arts

Explanation and value in the arts

The question of style in philosophy and the arts

Forthcoming titles include

Authenticity and the performing arts

Politics, aesthetics, and the arts

Schopenhauer, philosophy and the arts

The question of style
in philosophy and the arts

Edited by
CAROLINE VAN ECK
University of Amsterdam
JAMES MCALLISTER
University of Leiden
RENÉE VAN DE VALL
University of Limburg

CAMBRIDGE
UNIVERSITY PRESS

Published by the Press Syndicate of the University of Cambridge
The Pitt Building, Trumpington Street, Cambridge CB2 1RP
40 West 20th Street, New York, NY 10011–4211, USA
10 Stamford Road, Oakleigh, Melbourne 3166, Australia

© Cambridge University Press 1995

First published 1995

Printed in Great Britain at the University Press, Cambridge

Library of Congress cataloguing in publication data
The question of style in philosophy and the arts / edited by Caroline
van Eck, James McAllister, Renée van de Vall.
p. cm. – (Cambridge studies in philosophy and the arts)
Includes index.
ISBN 0 521 47341 1 hardback
1. Style (Philosophy) 2. Arts – Philosophy. 3. Aesthetics.
I. Eck, Caroline van. II. McAllister, James. III. Vall, Renée van
de, 1956–. IV. Series.
B105.S7Q47 1995
111′.85–dc20 94–15671 CIP

ISBN 0 521 47341 1 hardback

Contents

B
105
.S7047
1995

Illustrations

Illustrations

Contributors

CHARLES ALTIERI
University of California

FRANK ANKERSMIT
University of Groningen

NICHOLAS DAVEY
Cardiff Institute of Higher Education

CAROLINE A. VAN ECK
University of Amsterdam

DOROTHEA FRANCK
University of Amsterdam

SALIM KEMAL
Pennsylvania State University

BEREL LANG
State University of New York at Albany

MARY KLINGER LINDBERG

JAMES W. MCALLISTER
University of Leiden

J. MORDAUNT CROOK
University of London

LAMBERT WIESING
University of Chemnitz-Zwickau

RICHARD WOLLHEIM
University of California, Berkeley

Introduction

CAROLINE A. VAN ECK, JAMES W. MCALLISTER *and*
RENÉE VAN DE VALL

THE NEED FOR STYLE

Why do philosophers concern themselves with questions of style? Moreover, why should they bring together a volume of essays dealing with matters as seemingly diverse as Heinrich von Kleist's *Marionettentheater*, Hogarth's graphical work, the writings of Tocqueville, the use of ellipses in Kepler's astronomical theories, and eclecticism in eighteenth-century English architecture? The answer is a short one: to get clarity about their daily work.

Philosophers can no longer consider the question of style a mere artistic or literary question. Style has transgressed the boundaries of art and aesthetics, and has invaded philosophical fields such as metaphysics, the philosophy of science, political philosophy, and ethics. One of the consequences of what could be called postmodern pluralism in philosophy is that philosophy as a whole – whether it accepts a postmodern stance or opposes it – has grown more conscious of the importance of its medium, which is generally the written text, and as a consequence of its own hidden aesthetics.

This awareness is most often prompted by philosophers who, like Nietzsche and Wittgenstein, write in a distinctive, more or less literary style, and who, moreover, attach a particular importance to style in philosophical thinking, knowledge, or life in general. But even those philosophies that deny having a dependence on style, seeing themselves as conducting a methodical search for truth, cannot be exempted from stylistic analysis. In the first essay of this volume, Berel Lang makes clear why the question of style is inescapable, even for those philosophical writings that profess to be style-less. In fact, Lang writes, philosophy's silence about the literary character of its writings is part of a more general effort to repress its

1

own historicity. Method aims at excluding what style embodies: method is supposed to lead anyone who follows its rules to the same results, whereas style is essentially personal and historically rooted. Nevertheless, even such methodically rigorous writings as Descartes' and Kant's exhibit style-related features, of which the contrast between style and method itself is not the least important. The contrast between method and style, Lang writes, has become part of the representation of philosophy, and thereby of its meaning; philosophy's disregard of its own expressive features and its emphasis on methodological rigour has itself become an expressive feature of philosophy. As Lang says, 'In this sense, style gives method a voice that method by itself would not have or even allow for'.

It is therefore not surprising that many philosophers are suspicious of the recent concern for philosophy's styles: what is at stake is the self-image of their discipline. They fear a trivialisation of philosophy, in which the rigorous reflection on time-honoured questions about the true, the good, and the beautiful is reduced to the rhetoric efficacy of advertising strategies. Indeed, the growing awareness of the stylistics of philosophy could lead to cynicism: for instance, when the hidden rhetorical strategies of a text are shown to be in opposition to the overtly proclaimed argumentation, as when Plato, in the *Gorgias*, sets out to demonstrate the futility of rhetoric, but, in doing so, does not shrink from employing all the rhetorical devices he professes to despise.

But there is more to style than that. The philosophy of style could tell us that the emperor we so earnestly believed in has in fact always been naked. But it could also show the other side of that story: the capacity we have to visualise those non-existent clothes. Even if we saw through philosophy's tricks, and discovered how it tries to convince us of imperial robes that actually consist of thin air, we could marvel at its capacity to stimulate our imagination and to give form to a hitherto unthought aspect of the world. Even if a philosophical text fails to give us certainty about the world, it can give us new and fruitful ways to think about it. Not only by what it sets forth through its explicit argumentation, but also by what it shows: by what it makes us see through its imagery, by what it makes us feel through its tone, by the way the text constructs its world for us through the selection and arrangement of its material. Call it the *je ne sais quoi* of good philosophy, that makes the difference between a book we merely use in our research, and a book

we continue to cherish after our theses are written. That is, in short, what good philosophy makes us discover through its style.

The question of style presents itself not only when we read other philosophers, but also – most forcefully – when we ask ourselves how we should write. There is the problem of the method, or approach, or tradition, and the concomitant style we choose to work in – style here in the sense of 'general style'. Do we choose an analytical, a dialectical, or a phenomenological approach? Do we opt for herme-neutics, semiotics, or deconstruction? Or do we combine several of these, and if so, how do we do that? We seem to have too many options. And it is difficult to compare them in a neutral, rational way. What one considers relevant depends on the approach one has chosen; and the particular approach one chooses, depends on what one finds relevant. Our choice, therefore, is not wholly justifiable from a neutral, third-person stance. It will have something to do with who we are or want to be: with our style in the sense of 'personal style'.

And our choice will also have to do with our sense of our subject-matter. How do we want to present it, so that we not only define it, analyse it, compare it, but also bring it alive? What happens to our subject matter after we have dealt with it? Do we still recognise it, or have we irrevocably changed its appearance? Are we still able to tell our readers, not only what its component parts are, which muscles and bones and nerves we find under its skin, but also why it fascinated us in the first place? What we communicate about our subject depends on the form of our writing: 'form' not as an external and arbitrary mould we use for a given content, but as the way we discover and construct that content for ourselves and our readers. This is also very much a question of style. Style might be the place where our sense of our subject-matter and our sense of ourselves as philosophers meet.

With respect to the analytical power of the notion of style, philosophers can learn from musicians, painters, architects, and writers, and from the theorists and historians of their practices. We can learn how styles work, how they are formed and transformed, from those fields where style has been a major issue long before philosophy discovered its significance. Richard Wollheim's essay, for instance, offers many categories, distinctions and insights on pictorial style that with some modification might be valid for philosophical style as well. Wollheim makes a persuasive case that while an individual pictorial style (such as the style of Rembrandt) has psychological reality, and reference to it may therefore have

explanatory value, there is no 'fact of the matter' to universal style (such as the style of the northern baroque). Therefore reference to the latter may have taxonomical value, but can have no explanatory power. We might ask whether the distinction between general and individual philosophical style runs along the same lines as that between general and individual pictorial style, or differs in that general style has a more substantive reality in the case of philosophy, a reality being rooted in method. In this way, comparison with the arts can help us to develop stylistic categories that are specific to philosophy, as Lang's essay proposes.

STYLE AND PROPRIETY

The first requirement is a philosophical analysis of styles and their choice that attributes no privilege to any particular style (not even to 'scientific', 'objective', or 'representational' styles), but rather sets on an equal footing all styles that may be adopted in a practice. A possible tool is the interpretation of a style as the codification of a notion of propriety.

A feature of many human practices (perhaps of all, save the conceptually most elementary ones) is that their practitioners construct for themselves a notion of propriety. (The term 'aptness' might serve almost equally well.) The notion of propriety that a practice has stipulates, in some sense, which potential contributions to the practice should be regarded as proper or apt. It serves to validate certain contributions to the practice, and to disqualify certain other ones. A notion of propriety is particular to a certain practice, and it alters with time; moreover, especially in periods of crisis, different members of a practice may advocate competing notions of propriety. Physical science in eighteenth-century France, government in nineteenth-century Britain, painting in the Soviet Union, had each one or more distinctive notions of propriety.

In different practices, the notion of propriety assumes different forms. Depending on the nature of the practice, propriety might be identified in a methodological, epistemological, aesthetic, moral, or communicative value. 'Objectivity', which has entered into definitions of propriety in many practices, including the sciences and prose genres in literature, is a primarily epistemological notion; 'authenticity', which has entered into definitions of propriety in music and architecture, is largely an aesthetic notion; 'justice',

which has entered into definitions of propriety in political practice, is chiefly a moral notion.

Now, where is a practice's notion of propriety codified? We suggest that it should be seen as codified in a style. This suggestion coheres well with many well-entrenched turns of phrase which we use about style. In virtue of coming under the influence of a style, a practitioner becomes acquainted with the notion of propriety currently prevailing in his or her practice. In creating and proposing an unprecedented style, a practitioner offers to the community a fresh notion of propriety. A work created outside the prevailing style is seen as improper, as lacking propriety. Clearly, styles in this sense are not the styles projected as interpretative or classificatory concepts by historians into the arts of the past. Rather, they are, while probably never explicitly voiced in an art, what guides the practitioner in his or her contributions.

This explains how it is that we can usefully identify something like a style in many different practices, while they seem so unlike one another. Styles in all practices resemble one another in being codifications of notions of propriety, and they can be identified on this criterion; but the notions of propriety constructed within different practices are very different, and therefore so are styles, their codifications.

On this view of styles, it is not the case that there is for each practice a 'non-stylistic' specification of what counts as a proper contribution, and styles merely suggest different ways in which such a contribution may be made. Rather, styles stipulate what a proper contribution to the practice is. For instance, it is not the case that, in painting, there is a style-independent notion of 'representation', and that different painterly styles compete to offer such a representation; rather, these styles issue their own norms governing what 'representation' itself should be understood as.

This view lends itself to, but probably does not require, a strongly constructivist interpretation of many epistemological and other notions. According to this interpretation, the notions of the rational, the objective, the rigorous, and so on, are defined afresh in each new style which refers to them, and have no content outside particular styles.

By relating styles in this way to notions of propriety, we can identify certain questions as being worthy of consideration when analysing a given style. Which notion of propriety is codified in this style? Why did some practitioners find it necessary to originate this

notion of propriety? What is its relation with notions of propriety prevalent in other practices at the same time, or in the same practice at other times?

A phenomenon of especial interest for our concerns is the development within certain practices of notions of propriety referring to 'objectivity'. Clearly, a very effective way of commanding assent for a certain manner of doing things is to portray that manner as the 'sole possible', the 'sole true', or the 'natural' manner. Portrayed in such light, this manner ceases to be one contender among many approximately equally worthy manners, and comes to constitute the benchmark against which other manners are to be judged for their lesser degrees of 'naturalness'. So it is for the manners which constitute styles.

Portraying a style as 'objective' generally involves establishing that reality is uniquely or unusually amenable to treatment by a particular manner of representation or expression. This is an interesting rhetorical manoeuvre, since it amounts to promoting and validating a particular choice by portraying it as lying wholly beyond discretion. Reality is, so to speak, depicted as being not the sort of thing that can be depicted in a choice of ways. None the less, it is a stylistic choice. As Martha Nussbaum has written about philosophy,

> The telling, if the story is a good one, is not accidentally connected with the content of the told. And this ought to be so whether the teller is a literary artist, whom we suppose always to be conscious of the nature of stylistic choices, or a philosopher, whom we often think of as avoiding or eschewing style altogether. No stylistic choice can be presumed to be neutral – not even the choice to write in a flat or neutral style.[1]

The next step in entrenching a style as natural is, of course, to deny that its adoption poses any stylistic question at all. A particular mode of representation or expression, one hears, is not subject to styles; only the modes alternative to ours are styles; to introduce questions of style here would be to relinquish objectivity. In this line of reasoning, 'style' invariably acquires a pejorative connotation, as if it were a perturbing influence on the otherwise natural administration of business.

Therefore the greatest victories of particular styles are signalled by the widest and most enthusiastic proclamation that a practice has resisted the lure of a style. Traditionally, the practitioners of logic, mathematics, and the natural sciences have prided themselves on the avoidance of styles. These are also the disciplines in which the

rhetoric of objectivity is strongest. Clearly, these disciplines have, for a large part of their existence, been under the complete domination of a particular notion of propriety, a particular style.[2]

Members of other practices, which are more obviously subject to styles, sometimes strive to establish a notion of objectivity in reaction to the styles which they find on offer. These attempts are generally expressed as calls for the return to the primitive or unvarnished manner of doing things: the idea of styles as unnatural perturbations is reinforced by the implicit suggestion that they have grown on us in recent times. The concern for objectivity which is advocated by these reformers is, of course, just one style among many; but it is presented as the repudiation of styles.

Our analysis suggests that all styles, being a working out of a particular notion of propriety, are to be treated on an equal footing from the systematic point of view. However, of course, from the historical point of view, the realisation that one style could be an alternative to another, rather than the natural way of telling the truth, arose only from an appreciation that there were different ways of telling the truth, or even different truths. Many practices spent a period of their development during which it was thought that they were immune to styles, and had only to identify the representational mode which was appropriate for that practice. This transition occurred, at different times, in the visual arts and in philosophy. Both to understand historically the development of self-aware styles, and to appreciate the current debate on styles in philosophy, it is necessary to retrace this transition.

STYLE AND MEANING IN THE ARTS

The term 'style' was mainly used until the end of the eighteenth century by artists and art critics, as opposed to art historians in the present day, to indicate the place of a work of art in the hierarchy of the arts. Historical paintings, for instance, used the 'grand style', corresponding to the style of epic poetry, which was considered to be the summit of literature. It was also used in contrast with the terms 'manner' and 'maniera' to describe the general characteristics of a genre or school of painters, as opposed to the personal idiosyncracies of an individual artist. It had not yet acquired the importance it was going to have after 1800, when, as this volume demonstrates, style became an integral part of the content or meaning of a work of art.

When we inquire into the causes that led to the rise of style as a major artistic factor, it is illuminating to contrast the writings of two eminent artists, one writing before and the other after 1800, on artistic standards and style. Reynolds and Schinkel serve here as examples, but there are many other possible instances. Reynolds repeatedly declares in his *Discourses* that the assiduous imitation of nature and tradition, guided by reason, is the only way of reaching perfect truth and beauty in painting:

Nature is, and must be the fountain which alone is inexhaustible, and from which all excellencies must originally flow ... All the inventions and thoughts of the Antients ... are to be sought after and carefully studied; the genius that hovers over these venerable relicks, may be called the father of modern art.[3]

Whereas Schinkel, writing sixty years later, looking back on his own lifelong preoccupation with style, is not so sure:

I observed a great vast store of forms that had already come into being, deposited in the world over many millennia of development among very different peoples. But at the same time I saw that our use of this accumulated store of often very heterogeneous objects was arbitrary ... It became particularly clear to me that the lack of character and style from which so many new buildings seem to suffer is to be found in such arbitrariness in the use [of past forms]. It became a lifetime's task for me to gain clarity on this issue. But the more deeply I penetrated into the matter, the greater the difficulties that stood in the way of my efforts. Very soon I fell into the error of pure arbitrary abstraction, and developed the entire conception of a particular work from its most immediate trivial function and from its construction. This gave rise to something dry and rigid, and lacking in freedom, that entirely excluded two essential elements: the historical and the poetical.

 I pursued my researches further, but very soon found myself trapped in a great labyrinth.[4]

Nature, the classical heritage, and reason lost their status of reliable and unquestionable guides and standards for the artist. Instead, the artist was confronted with an overwhelming repertoire of forms left from the past, and at a loss to find a reliable and justifiable criterion for selecting from these. Thus bereft, art becomes style-less and therefore meaningless: because it can no longer evoke the tradition to which it should belong, it lacks the power to speak to the beholder. Although Schinkel's use of the term 'style' still echoes Reynolds' definition – 'Style in painting is the same as in writing the power over materials, whether words or colours, by which concep-tions or sentiments are conveyed'[5] – in his stress on the instrumental role of style in conveying the meaning of a work of art, he does not

share Reynolds' serene confidence in nature and the past. Instead, he tries to find new foundations. Prefiguring the splendours and misery of Modernist architecture, he tries to find a guide for design in the function and construction of a building, but without success: the result was not architecture, we might say, but mere building, without freedom or meaning. In other words, concentrating on structure and content is not sufficient to create meaningful architecture, when the traditional standards for its design and interpretation are no longer there. Something else is needed, which Schinkel, and many others with him, call 'style'.

Style thereby takes over the role of nature, the past, or reason as the provider of meaning. That is, an aspect of writing, painting, or building traditionally associated with ornament or presentation, that could be varied without changing the content, gradually becomes the principal bearer of meaning of the work of art. This can perhaps be demonstrated most clearly in architecture, where the selection of a historical style, unrelated to structural or functional matters, becomes the vehicle for the meaning of the building. One example is steel and glass architecture, which, because of its rejection of the use of historical styles, was called meaningless and therefore denied the status of architecture.[6]

The growth of the importance and scope of style in the arts is traced in the contributions of Mary Lindberg, Joe Mordaunt Crook, and Caroline van Eck. Lindberg shows how style is invested with a new role in Hogarth's satirical work: from being a technique for the selection of the appropriate idiom, it becomes a *strategy*, that is, a purposive method for conveying meaning and persuading the spectators of his work, by making use of the associations connected with several theatrical and operatic genres and their formal devices. Lindberg examines in detail in what way Hogarth borrowed devices from the theatre and from satirical fiction, such as conventions for stage-setting, acting or story-telling, and incorporated them into his own prints. She thus brings fresh insights to the study of the interrelatedness of the arts based on the doctrine of *ut pictura poesis*, which in the case of the links between theatre and painting has until now received very little critical attention.

The essays of Mordaunt Crook and van Eck throw light on the evolution from stylistic device to style from a different angle. Van Eck shows the rhetorical origins of the concept of style when it was introduced in French architectural theory around 1750. There it performed the role of a unifying concept, regulating the choice and

use of ornament in order to enhance the emotional effect of the building on the spectator. By taking into account the rhetorical background of the notion of style, new light is thrown on the breakdown of Vitruvianism at the end of the eighteenth century. She then discusses the way style acquired a wider meaning in the writings of Quatremère de Quincy, where it became the expression of the age, country or material of a given period, thereby prefiguring nineteenth-century notions of style. Her essay thus illuminates the development of the meaning of the concept of style in architectural theory in a new way, by taking into account the hitherto neglected role of rhetoric, and shows why the nineteenth-century quest for a style of its own was bound to fail because of its inherent contradictions.

Mordaunt Crook shows the historical origins of what he terms the 'dilemma of style': the rise, as the consequence of the disintegration of the classical tradition in the second half of the eighteenth century, of a situation in which architects were faced with a choice between several styles. This dilemma was the result of the combination of the Renaissance notion of an individual style and of Romantic Picturesque aesthetics, which gave birth to the notion of a multiplicity of styles. Thereby style was transformed from the expression of structure into a pictorial allusion which would act on the memory and imagination of the spectator. This development resulted in the theory of architectural association, which stressed the individual nature of beauty, and rejected objective standards. Thus Associationalist aesthetics contributed to the displacement of Classicism as the universal style. Mordaunt Crook then traces the development resulting from the Picturesque choice of styles on Associationalist grounds to the conflict in the early nineteenth century between the Neo-Gothic and Neo-Classicism, which he presents as the triumph of the Picturesque. It led to a stylistic jungle later on in the nineteenth century, to which Modernism momentarily put an end. But with the rise of Postmodernism, the dilemma, based on our desire for ornament, semiotic codes, or images of structural processes, has returned.

As we have sketched above, style becomes the focal point for the artist's search for meaning, after the loss of belief in the absolute standards of reason, nature, and antiquity which occurred around 1800. Before 1800, there was hardly a question of there being a possible choice among styles: contributions to a practice were regarded not as belonging to one style or another, but rather as

falling within or being alien to the practice. For instance, in architecture, buildings that did not conform to the Classical style (as we would say), such as Gothic buildings, were regarded as falling outside the scope of architecture.[7] Rather than a distinction between different architectural styles, there was merely a distinction between architecture and non-architecture.

In our view, the development from stylistic monism to stylistic pluralism in artistic theory and the arts can be seen as foreshadowing the present concern of philosophy with style.

STYLE IN PHILOSOPHY

The deepening erosion of objective standards in the arts, as exemplified in architecture, and the arts' growing self-awareness as style-bound, invested philosophy too, with a time-lag of about a century. From the late sixteenth century onwards, western philosophical writing incorporated standards of propriety and efficacy about which there was no debate. These standards were based in part on mathematical and geometrical forms of reasoning, that were credited with the power of leading infallibly to truth. Philosophical method, as exemplified in Descartes' *Discours de la méthode*, in Spinoza's *Ethics*, or in Kant's *Prolegomena*, took the analytical rigour, conceptual clarity, and absolute standards of truth of mathematics as its model. Writings which did not embody this model, while apparently philosophical to present-day eyes, such as Pascal's *Pensées* or the fragment of Kleist's that Dorothea Franck reproduces, were in their time considered as literature rather than philosophy or science.

In the twentieth century, we have relaxed both the criteria for what counts as effective manners of reasoning in philosophy and correspondingly the range of works that we are prepared to see as philosophical. In place of a distinction between philosophy and non-philosophy, there is now a portfolio of philosophical styles. Both Nietzsche and Wittgenstein contributed to the erosion of this monolithicity by their critique of the absolutist pretensions of traditional metaphysics and of the supposed transparency of method. Simultaneously, their writings exemplify the stylistic diversity of what became acceptable in philosophy. In their work, the notion of style, which originated in rhetoric, with its focus on persuasion rather than proof, probability rather than truth, ornament rather than content, and more generally on the process of writing

11

rather than on the body of truth revealed in the philosopher's writing, becomes the point on which the concern for meaning and truth focuses.

The approach of philosophers such as these is examined in this volume by Lambert Wiesing and Salim Kemal. Wiesing sees in their work a '*Stil statt Wahrheit* programme': they tend to substitute style for truth.

Wiesing explores the parallels between the stance of Ludwig Wittgenstein in philosophy and of Kurt Schwitters in art. Each was trained in a discipline in which the traditional goal was truth, but in which confidence that truth could be attained had in the early part of the twentieth century been shaken. Each reacted to this state by setting out a view of his discipline in which truth was replaced as a goal by style. Schwitters, whose reflections originated in artistic practice, found in style the sole admissible principle of orientation for artistic work. For him, works of art had no meaning but only style. For instance, he regarded his poetry as 'sound painting', in which words are used as expressive but meaningless material of composition. Schwitters thus rejected two of the images of art that were most influential during his lifetime. On the one hand, he regarded as an illusion the conventional view of artworks as bearers of meaning and portrayers of the truth; on the other, he resisted the dadaists' anguish at the apparent lack of any principle of orientation in the arts. The intermediate line that Schwitters traced posited that, while this principle of orientation could not be truth, it could and had to be style.

Wiesing sees in Wittgenstein a similar response to his age. Wittgenstein writes that the behaviour of persons is determined not so much by the content of dogmas as by images, especially images of themselves. Moreover, the effect of such images is more subtle than any effect that dogmas could ever have: pictures do not issue injunctions, but rather offer to the agent forms of expression. In his more radical writings, Wittgenstein interprets even the question of the validity of propositions as a matter of style. So Schwitters and Wittgenstein saw style discharging the roles that had formerly been attributed in art and philosophy to the ideal of truth.

Kemal argues that Nietzsche's concept of will, understood as the stylistically guided creation of values, can be reconciled with a progressive idea of community. He does so by showing that Nietzschean genealogy does not necessarily lead to nihilistic consequences. Though genealogy considers values to be interpreta-

tions, issuing from particular standpoints, the threat of solipsism can be surmounted if one stresses the space it allows for the creation of new values. Those styles are marked as healthy, strong or full that make possible the generation of new interpretations and the creative interaction between the producers of values. Therefore the pursuit of style can engender a viable and progressive community of creators.

Now that we have been alerted to the existence of this diversity of philosophical styles, we can turn a fresh gaze onto the history of pre-nineteenth-century philosophy, and reinterpret even those philosophers who prided themselves on the objectivity of their method in stylistic terms. We can now detect stylistic devices in all philosophical writing, however remote in time, however apparently straightforward. Some stylistic devices are evidently chosen with a persuasive effect in mind, such as the dialogue form.[8] As Lang's essay shows, Plato's dialogue form implies an individual role for the reader and – like a poem or play – does not allow for generalising conclusions without obscuring other, more central features of the text. But even the apparently more neutral treatise styles must be the fruit of stylistic choice. Descartes and Kant, writers who are usually considered to address their readers in a straightforward manner, use different stylistic devices. Descartes' implied readers have to do something beyond their reading: they have themselves to practise the method described by Descartes and to come to its conclusions individually. With Kant however, reading the description of the method is itself its application.

The conscious introduction of stylistic devices as an argumentative strategy into philosophical discourse is exemplified by the writings of Tocqueville on democracy, which are discussed in the essay by Frank Ankersmit. In Tocqueville's analysis, democracy is a subject-matter that lends itself to being treated in only certain ways by historians and political theorists. Unlike the despotic political systems that preceded it, democracy is not an entity about which one could lay out an objective and detached theory using familiar scholarly language. In Tocqueville's time, historiographic language was heavily metaphorical. Metaphors order reality by identifying essences and creating centres. But Tocqueville saw democracy as lacking essences and centres. The language most suitable to depict the network of interrelations between people and their democratic rulers was, in Tocqueville's view, not metaphorical, but paradoxical. As Ankersmit shows, verbal paradoxes cause us to mistrust utterances and direct our attention back to the object of discussion.

When the object of discussion is unsusceptible to well-worn utterances, as was democracy, this stylistic strategy alone enables us to grasp its nature.

Even the practice of the natural sciences, which up to the Renaissance were classed as branches of philosophy, shows stylistic aspects. Branches of science traverse periods in which theorising is dominated by a particular style. The task for historians and philosophers of science is to proceed beyond recognising styles of theorising in the historical record, and provide some account of how these styles become entrenched in scientific practice. James McAllister's essay defends the suggestion that scientists attribute weight to stylistic features of theories in recognition of the empirical performance of past theories that have embodied those features. Lest this utilitarian connection be regarded as foreign to the notion of style, McAllister portrays well-known episodes in the formation of styles in the applied arts as exhibiting similar aspects. For instance, in architecture, the design possibilities offered by new materials of construction have won favour within stylistic canons only once the utilitarian advantages of the new materials have become apparent. The parallels between the manner in which styles become entrenched in the sciences and in the applied arts hint at a unity underlying phenomena of style in different practices.

USES AND LIMITS OF STYLE

Looking backwards, we cannot but acknowledge that philosophical propriety might be encoded in more than one way. But what does this recognition of philosophical pluralism entail for the philosophy-to-be? The task of the stylistically informed philosopher is a precarious one. To use the potential of style to its greatest philosophical advantage, one has on the one hand to do without the certainties of style-less and objective truth, and on the other to avoid the nihilism that pluralism might lead into. This task in many ways resembles that of the artist, who, in the midst of a proliferation of styles, has to find his or her own way of working.

Some of the possibilities and the dangers of a philosophy that is aware of its style are traced in the three essays that conclude this volume. Nicholas Davey's essay focuses on a question that was also commented upon by Kemal's essay: how to save philosophy, now that it is aware of its inherent stylistic character, from collapsing into indifference. He attacks the presuppositions of the deconstructive

strategy that aims at reducing meaning to 'mere' stylistics. Decon-struction may be right in challenging metaphysical notions of meaning-in-itself, but what it cannot challenge is a dimension of philosophical awareness that cannot be put into words and that prevents philosophy's reduction to the rhetorical. This dimension lies in the revelatory experience of meaningfulness that happens for instance in the sudden understanding of what somebody is 'getting at'. Only if we re-learn to trust this experience of meaningfulness whenever this occurs, Davey writes, will we be able to 'climb over the stile of being merely mannered' and find our own individual styles.

Davey tries to find a middle ground, in between traditional philosophical claims on certainty of meaning and deconstructivist denials of its possibility. The construction of this 'in between' is also a central concern in Charles Altieri's search for a dynamic concep-tion of intentionality, in which both the quest for individual fulfilment and the ethical responsibility towards others are con-ceived in terms of a personal style. He tries to shed light on those aspects of subjective agency that are 'too fluid and too resistant to concepts to be easily handled by traditional models of desire and judgment, or to be easily demystified into the equation of subjec-tivity with subjection now dominating literary criticism'. He especially focuses on the notion of responsibility, which can be understood neither in terms of how we respond, nor be deduced from third-person understandings about categorical imperatives. Responsibility depends on 'how we represent actions so as to involve consequences in our relations to future selves and to other persons'. Our personal style might be conceived of as the making visible of the boundary conditions allowing our engaging in those relations: 'Style maps a will onto a world'.

Davey's and Altieri's essays focus on a dimension of reflective awareness that hovers between determinacy and indeterminacy. The fragility of this awareness and its articulation is brought out with poetical lucidity in Franck's essay. Franck attempts to illuminate the elusive notion of style from a new angle: from its aspects of innocence (lost or regained), self-consciousness and gracefulness. She takes as a starting-point Heinrich von Kleist's essay on the theatre of marionettes, which is printed here as an appendix to her essay. Her paper charts the risks and difficulties of tracing the way style can be understood by calling in such concepts as grace and innocence without losing the sense of the topic or without letting

slip the separation between what we say and the act of saying it. As Franck points out, 'when we state that a strict borderline between art and the discourse *about* art can no longer be drawn, our own discourse might become infected by this confusion, without, however, automatically becoming art'. By using Schleiermacher's notion of divination (instead of interpretation) as the appropriate mode of understanding style, and Wittgenstein's ethical criterion of truthfulness rather than truth, she illuminates the change in the role and meaning of style in contemporary philosophy.

As this volume shows, style has always been with us, though not always acknowledged. By bringing together essays on style in the arts and in philosophy in one volume, we show that the relation between philosophy and the arts is not only one of the arts being influenced by philosophy. On the contrary, these essays show that developments in recent philosophy that are intimately related to style can be made intelligible by looking at the way the concept of style functioned and developed in the arts. In both fields, we can observe that when a crisis occurs, and practitioners start to look around for new foundations and certainties, the scientific or philosophical criteria of truth and the rigour of method are abandoned in favour of an approach that is closer to the rhetorical attention to strategies for formulating insights. Then the philosopher or artist has the task of selecting the stylistic devices apt to captivate and move the audience, rather than searching for the inescapable objective representation. This represents not a loss, but an opportunity.

NOTES

1 M. Nussbaum, 'Fictions of the Soul', *Philosophy and Literature* 7 (1983), pp. 145–6.
2 Among the studies of science as a rhetorical practice, see J. A. Schuster and R. Yeo eds., *The Politics and Rhetoric of Scientific Method: Historical Studies* (Dordrecht: Reidel, 1986); A. G. Gross, *The Rhetoric of Science* (Cambridge, Mass.: Harvard University Press, 1990); P. Dear ed., *The Literary Structure of Scientific Argument: Historical Studies* (Philadelphia: University of Pennsylvania Press, 1991); and M. Pera and W. R. Shea eds., *Persuading Science: The Art of Scientific Rhetoric* (Canton, Mass.: Science History Publications, 1991).
3 Sir Joshua Reynolds, *Discourses*. Edited with an introduction and notes

by P. Rogers (Harmondsworth: Penguin Books, 1992), *Discourse VI* (1776), pp. 160 and 166.

4 C. F. Schinkel, *Architektonisches Lehrbuch*, ed. K. Peschken (Berlin: Akademie Verlag, 1979), p. 150, quoted and translated by A. Potts, 'Schinkel's Architectural Theory', pp. 48–9, in M. Snodin, ed., *Karl Friedrich Schinkel: A Universal Man* (New Haven and London: Yale University Press, 1991).

5 Reynolds, *Discourse II*, p. 96.

6 See for example *The Ecclesiologist* 12 (1851), p. 269.

7 See also E. S. De Beer, 'Gothic: Origin and Diffusion of the Term', *Journal of the Warburg and Courtauld Institutes* 11 (1948), pp. 143–62; see p. 156.

8 On the dialogue form in science and philosophy, see G. Myers, 'Fictions for Facts: The Form and Authority of the Scientific Dialogue', *History of Science* 30 (1992), pp. 221–47.

The style of method: repression and representation in the genealogy of philosophy

BEREL LANG

> Every philosophy also
> *conceals* a philosophy.
>
> Nietzsche

The issue that I try to unravel here takes its cue from two misquotations of my own making. In *Hamlet*, Polonius – artless plotter, doting and dolting father – finds himself perplexed by a conversation with the prince whose meandering wit he understands only to the extent of guessing that it does make a kind of sense: 'Though this be madness', Polonius mutters to their common audience beyond the stage, 'Yet there is method in't', an acknowledgement that has since been canonised in one of the many clichés for which Shakespeare bears a certain responsibility – 'There's method in his/her madness'. And then, a century and a half after Polonius spoke for the first time, the French naturalist Buffon, turning from his study of animal-species to human character, reaches a conclusion that also seems to follow naturally: 'Le style', he surmises, 'c'est l'homme même' – or, as the English version compresses it, 'Style is the man.'

I want to consider first what happens with a small exchange between these formulas. Polonius now takes a slightly different direction in his view of Hamlet's wandering: 'Though this be madness', he says in this new version, 'yet there is style in't', And then Buffon, as though to balance the number of times any one term appears in world-history, chimes back: 'La méthode', he pronounces, 'c'est l'homme même' – 'Method is the man.'

Obviously, the revised statements reach us as a jangle, to the mind no less than to the ear. If anyone had supposed that style and

method are interchangeable, a prima facie disproof is evident here – together with the beginning of a more exact account of the relation between the two. In what follows, I focus on the role of this relation specifically for philosophical discourse, considering also the question of why acknowledgement of the relation in that context has been, as I shall argue, consistently repressed. This discussion can hardly avoid referring to style and method in their more general appearances, and from those we will understand why Shakespeare and Buffon wrote as they did rather than as the misquotations cited would have them. Such confirmation does not mean that possible allusions to a 'style of madness' or to 'method making the man' would be pointless or unintelligible. But the metaphoric conceit in the former conception and the latter's flat-footedness argue against them; certainly there is little worth remembering in either.

What separates the original statements from their revisions does, however, shed light on each of them. Polonius' juxtaposition of madness and method assumes a contrast: if madness were deliberate, shaped by reason, it would not be madness. What does madness amount to *with* such features? Well, feigned madness at most, calculating reason – or method – at least. And so, too, the beginning of a definition of method as deliberate and, still more narrowly, intentional. What does 'method' in this sense entail for Polonius that 'style' would not? Not *simply* a place for intention, since style, too, is neither accidental nor involuntary (the two contraries of intentional). In method but not in style, however, the end intended exists beforehand and independently: it, too, is intended, with the consequence that the intention itself may also occur beforehand and independently. In method but not in style, furthermore, the requirement of reiterability, of exact reapplication, is a constant feature. Method so emphasises the regularity of its process, in fact, that the means it prescribes are held to be independent of both agent and object;[1] it can be applied by anyone who 'learns' the method, and equally well to any of an indefinite class of situations or objects – both of these, as we shall see, absent from the conditions of style.

The assertion, 'Method is the man', does not produce the same jangle that the first misquotation does, but method is none the less clearly not what Buffon meant. Method could not *be* the man because, unlike style, it is fully contrived *by* the man; and Buffon need not have shared the suspicions of human nature held by La Rochefoucault or La Bruyère to know that other contrivances –

hypocrisy or even forthright lying – may at times be as fundamental as method itself. To know a person fully requires that we observe him as he himself cannot, since he otherwise could make himself seem to be what he isn't. No matter now circumspect method is, then, style remains one step ahead of it, more exactly, *beyond* it. And so, Buffon's verdict in its favour.

It might be objected that this is an unlikely pair of examples on which to base so large a distinction – but other, more standard examples move in the same direction. Notwithstanding the vague boundary by which we circumscribe the 'baroque' style, for instance, we do not associate that style with a similarly baroque 'method'. Not because there is no method in the style (for example, in Bernini's *St Theresa*), but because for that sculpture, it is the style not the method that matters – the style, we might say, that is the woman. Or again: we ascribe to science the 'hypothetico-deductive' method which, for theorists if not for scientists themselves, has a standard form: first, hypothesis, then inference, then confirmation or discon-firmation. What then, in counterpoint to the baroque, of a hypothe-tico-deductive 'style'? Well, it is not that physicists or biologists may not *also* have styles, but that it is method and not style that they profess. Only by following a common – single – method are experiments duplicatable – that is, verifiable. (By contrast, a painting that duplicates an earlier one provides nothing in the way of confirmation; its maker would in fact be likelier to face charges of forgery.) The virtue of impersonality in method is thus a vice from the viewpoint of style. We know well enough the one style that method – any method – would choose for itself if it indeed had the choice. Attempts at a 'style-less' style recur, after all, in the history of style – from realism in painting to naturalism in the novel to the claims for an ideal and transparent language in philosophy.

REPRESSION

The misquotations and category-mistakes thus cited point to characteristic differences between method and style. Before elabor-ating on these, however, I would call attention to a *connection* between the two that is no less fundamental. I do not refer here to the most obvious features that style and method share – the presence in them, as I have suggested, of aspects of intention, or their common reliance (in different versions) on repetition. (As a measure only of *these* features, Meyer Schapiro's definition of style as 'constant form'

would be broad enough to include method as well.)[2] Rather I allude to an involuntary relation between them – method (despite itself) anticipating style; style, also despite itself, presupposing method.

I shall mainly be considering here the former of these, that is, the 'style of method' – more narrowly, the style of philosophical method. But even with this emphasis, the general connection between style and method is evident in the inverse relation between them. Where the focus of interest in a particular process or object is on method (as in scientific or technological discourse), the role of style is shunted to one side; where style is primary (as in artistic representation), the allusion to method is subordinate, if not absent altogether. Admittedly, this inverse proportion might simply mean that the two phenomena of method and style have nothing to do with one other. But the inverse ratio is too persistent to support such a benign explanation, especially when a conspiracy theory is available that has the additional advantage of giving a fuller account of the evidence. I shall be arguing rather that it is intentional concealment – that is, repression – that has governed the relation between method and style in philosophical discourse (and else-where as well – but that is another story). In these terms, the focus on method in philosophical writing and the silence there about its literary character are symptomatic not of the irrelevance of stylistic issues, but of an effort – presumably for philosophy's own reasons – to repress them, to deny a role for style or (what amounts to the same thing) to 'allow it only in ornamental doses', as Stanley Cavell criticises that alternative.[3] So, at least, the argument presented here will go – itself part of a broader claim for the substantive and not merely 'ornamental' role of style in philosophical discourse.

The starting point of this diagnosis of repression is prosaic enough – a matter of counting. Philosophers and their historians have expounded conceptions of method (their own and others') with a much stronger emphasis than in their relatively few and unsyste-matic references to the stylistic means by which method is articulated. So we hear familiarly about Descartes' method of doubt, Spinoza's geometric method, Kant's transcendental method, James' pragmatic method, Husserl's phenomenological method – all expli-citly affirmed at their sources, but with only brief glances (if any) at the medium in which they are inscribed, and still less at what the methods themselves, viewed through style, represent or express.

Admittedly, the presence of method is not always announced by its author. But the fact that Socrates did not himself name the

'Socratic method', for example, hardly stands in the way of the procedure. On certain views, moreover – Pyrrho's radical scepticism, or in the anti-sceptical but also anti-methodic claims of Kierkegaard or Nietzsche – philosophical method in itself is under attack; the attack, then, not on one or another method, but on method as such. And lastly, of course, it is undeniable that philosophers as central and otherwise diverse as Plato and Locke, Descartes and Wittgenstein, Spinoza and Kierkegaard, albeit often tacitly and always unsystematically, *do* implicate aspects of style and literary structure as substantive factors in their work.

Even with these disclaimers, however, the disparity in philosophical writing between its references to method, on the one hand, and to style, on the other, is notable. One can imagine a ready if rough history of philosophy based on what philosophers have said about method (their own and others') – but not even an approximate history from their statements on the *writing* of philosophy. And although this disproportion has *something* to do with style's self-effacing character (if it did talk about its own stylistic features, that talk, too, would only become another such feature), it also reflects an ideological view that philosophy, corporately, has exhibited of itself. Again, this disproportion *might* be a chance occurrence; or it might follow from the more basic claim that nothing in philosophical style matters *philosophically*. My thesis here, however, is that the neglect has been due to neither of these, at least not primarily: that it is rather a tactic of avoidance, related to a specifically tendentious – and ideological – self-image projected by philosophy; and that the combination of those reasons and of the role of style seen more generally disclose style as at once a source and analogue – even more deeply rooted in the text – for philosophical method. Both of them, in any event, are integral to the writing and then the reading of philosophy – although only one of them, method, is explicitly professed.

The evidence for this claim of repression is circumstantial, but those circumstances demonstrate that method's usual (if problematic) priority in philosophical discourse *would* lead to silence about its stylistic features. One central factor here is that, in contrast to method, style is a 'retrospective' concept – ascribed from an external view or 'after the fact' (when the stylistic work is complete), and as the one work cited is, in time, invariably juxtaposed with others. This retrospective feature affects not only the analysis but the *occurrence* of style as well: no author or artist chooses a style

beforehand as, for example, one selects clothes from a rack – for the good reason that style does not in this sense exist beforehand. Intentional as stylistic choices surely are, they do not aim at ends that exist prior to the choices themselves; it follows, then, that the categories of style could not be known beforehand either.

To be sure, acolytes, imitators, and even forgers will have their day wherever style occurs, the most successful of them passing forever undetected. But there is no reason to believe that forgers or even more open imitators have been much of a presence in the history of philosophy – in part because the ratio of profit to effort would be small, but also because the element of philosophical discourse most easily mimicked – method – would not take a forger very far philosophically. Group style serves everywhere and readily as a model – as, for example, in Mannerist or Impressionist painting. But unlike 'group method', group style can be rehearsed only in very broad outline – too broad to confine or, more certainly, to assure success for the individual who adopts it. Thus even for the Neo-Thomists and Neo-Kantians who would deliberately follow Thomas and Kant, the swerve of style takes them, despite themselves, outside their sources. Like the 'Neo' in 'Neo-Classicism', the designation is for them neither redundant nor only an historical point of reference.

The invisibility to a writer of his own style does not explain why philosophers have been silent about the role of style in *other* philosophers. But to call attention to its occurrence elsewhere would, after all, call attention to it in themselves as well; juxtaposed to the inversely related features of method and style, the reasons for avoiding *all* reference to the latter thus emerge as ideological, tied to a specific and tendentious conception of philosophy. On the ideal of method as yielding the same results for anyone who follows its rules, method appears as at once impersonal and ahistorical. As impersonal, *anyone* can do or use it; the requirement of duplicatibility – that 're-application' of the method should yield the same results – presupposes this condition. Method is ahistorical in the sense that the same rules hold whenever and wherever the method is invoked. (Particular circumstances may hinder a method's application (as carbon-dating is impossible in the absence of carbon) but this is not a limitation of the *method*.)

Style differs from method in both these respects. It is inseparable from the agent whose style it is and whose name often remains to designate it (as 'Rubens' or 'Dickens' are used as metonymies for their writings). In this sense, style is both personal and expressive of

that fact. (This holds, in my view, for 'general' style in a school or group as well as for individual style – inasmuch as the former conceptually presupposes the latter.)[4] It is historically rooted beyond this personal ground, furthermore, as it presupposes the completion of the individual work and a comparison between it and others. (This is reflected, again, in its 'retrospective' character.) Styles are virtually never named or recognised on the basis of one work alone, still less on the basis of a single part of one work; even the connoisseur's attribution of a painting on the evidence of a brushstroke or the shape of an ear – if indeed these qualify as stylistic analysis any more than does fingerprint identification – *presupposes* a more extensive basis. A corollary of this feature is that style *requires* multiplicity: no one style without two. (So we better understand Spinoza's odd pronouncement in the *Tractatus* that 'God has no particular style in speaking.')

These general differences between method and style disclose the repression of style in philosophical discourse as part of a more inclusive repression – the tendency of philosophers to decontextualise or dehistoricise their own discourse. Characteristically, philosophers profess to write not within or for a particular context but against it (and any), admitting no external – historical, causal – factors as motivating their work. 'What does history matter to me?' Wittgenstein asks rhetorically, 'My world is the first and only one'[5] – and although this is an extreme formulation, the view it expresses has a broader resonance. This is not a matter of philosophers acknowledging that future evidence may compel revision in present conclusions (as the present has done for the past), but a denial that history (the particularity of the particular) matters for either the writing or the judgement of their philosophical claims. They purport to speak out-of-time even when, as often happens, they take time seriously as a subject for philosophical analysis.

One might expect this anti-historicism to founder in the launching, since the words and texts of any discourse are evidently set in particular historical contexts. But the question is how philosophers conceive of their discourse, not what it is in fact – and the difference here is evident. I have alluded to the scarcity of references by philosophers to the character of their own writing – to the body accompanying philosophy's mind. Even authors who admit this relation in principle have reported it impressionistically and unsystematically; more often, they simply avoid such references, preferring then as before to detach themselves from history in

general and from their own origins in particular. The assumption
underlying this avoidance is that the medium of philosophical
writing has nothing to do with what gets written, that the texts of
philosophy are simple transparencies – which then, from the
viewpoint of the reader, 'interpret themselves' (to extend Luther's
phrase about the Bible). On this view, the material and so the
historical status of the acts of writing and reading are quite
incidental to the work of philosophy – a contention that *may* be true,
but that would even so require more by way of evidence than is
usually provided.[6] And of course, it would also have to defend itself
against the thesis – asserted here – that it is not true at all.

There is, furthermore, more positive evidence of this self-denial –
for one thing, in the stance of philosophers toward their predeces-
sors that makes into a principle what might otherwise be only
another skirmish in the war between generations. Certainly *some-
thing* of the generational strife that Harold Bloom finds in the
historical relations of 'strong poets' figures also in the history of
philosophy as well.[7] Indeed, philosophy may provide more sus-
tained evidence of this than poetry does, since in it examples of such
conflict are not confined, as Bloom's are, to the 'romantic' tradition. I
would argue, however, that this aspect of the history of philosophy
is better understood as related to the character of philosophy than to
the psychological make-up of philosophers; there are, in other
words, more substantial institutional than personal grounds for the
repression.

Whatever the explanation, it is clear that their 'predecessors' have
posed for philosophers an unusual provocation – philosophers in
the present acting to ensure the *death* and not only the revision of
their predecessors. Significantly, such efforts commonly appear in
the prefaces or introductions of philosophical works, that is, just
before philosophy truly comes to life: so, for example, in Descartes'
dedication to the *Meditations*, in Locke's introduction to the *Essay*,
or in Kant's two prefaces to the *First Critique*. What is supposed to
follow these summary openings is to be a new and a true beginning,
one that at once overturns earlier solutions and then promises a
definitive resolution. For Heidegger or Wittgenstein, the declaration
of this (new) end to philosophy is explicit – what religious discourse
more candidly names apocalypse. But even when the claim of
resolution does not assume so explicit a philosophy of (philoso-
phical) history, it acts causally in the discourse. The present is
necessary because the past has failed; the future is already

redundant because the present – the philosopher's own text – anticipates it. This is, again not a philosophical version of scientific modesty which concedes only that the new evidence may compel the revision of earlier conclusions. Philosophers exempt themselves from the present (both past and present) because this is what adherence to a method *means* to do. Philosophical method does not provide for its own displacement – for the same reason, one supposes, that governments do not legitimise civil disobedience: the corporate body would not survive.

To be sure, philosophers usually admit (however unenthusiastically) to being part of a history, accepting for themselves a place in a vertical line of philosophical questions and answers. But they rarely acknowledge that this history is tied to a *genealogy* – where the production of philosophy involves a chain of causes and motives, expressing sources that, strictly speaking, may not be philosophical at all. The phenomenon of style is part of just this genealogy, as it has acted on and through philosophers and also as that role has been repressed in their writing. Some of this repression has been wilful – a 'noble lie' told by philosophers to themselves and others about the atemporality of a temporal discourse. Some of it has been intrinsic and unavoidable, a symptom (one among others) of the presence of style. Even those writers most acutely aware of the embedding of style in philosophical discourse – Plato, Kierkegaard – do not fully give themselves away stylistically. One reason for this is a feature of style that both distinguishes it from method and assures to method a stylistic afterlife: whatever philosophers say in writing, including what they write *about* writing as writing, itself becomes an element of style – which thus, silently, has the last word.

REPRESENTATION

The search for motives behind the repression of style in philosophical discourse would be pointless unless philosophical style did in fact bear substantively on the work of philosophy. Obviously, that thesis takes a good deal of proving, but the evidence for it, and its potential importance if proven, have been increasingly acknowledged.[8] (One notes also the turn to a role for style in other disciplines – in history, sociology, anthropology, economics, law, political theory, and even the 'hard' sciences; in literary theory, of course, stylistic categories now compete with what used to be called the primary texts.)[9] Admittedly, the repetition of a claim does not

prove its significance or even its legitimacy. But if evidence of a stylistic presence similar to that for other, less central elements of philosophical discourse can also be found in philosophical method, the substantive importance of style for philosophical writing and reading would be compelling indeed. This would not imply that style and method are equivalent; it would not imply even that they are different aspects of the same 'thing'. But it *would* indicate that a significant relation exists between the two, and thus that philosophical discourse is to be taken not only literally, at its own word (as required by the prescriptions of method), but also representationally, at more than its word – that is, as style.

Let me turn again to an improbable example – something like a 'thought-experiment'. In his classic *Principles of Art History*, Heinrich Wölfflin proposes five pairs of stylistic categories as distinguishing renaissance from baroque style. In elaborating these, Wölfflin meets a number of contentious issues in the concept of style – among them, the logic (if there is one) in the historical development of style, and the question of stylistic correlation among individual arts (and between them and the culture as such). His position on these need not concern us here except for the assumption they share with his paired stylistic categories that style and its elements are expressive – modes of 'representation'. Thus, notwithstanding the formalist cast of his analysis, the features governing style are for Wölfflin not *mere* forms but speak beyond form; style betokens an 'ideal of life' – a referent thus also implied in the five stylistic pairs individually: the linear and the painterly, plane and recession, closed form and open, multiplicity and unity, clearness and unclearness.[10]

I suggested earlier that, in contrast to style, method is in its own terms prescriptive, enacting rather than representing or expressing. In its philosophical appearances, moreover, method purports to be complete, at the very least accounting for its own presuppositions axiomatically. On these terms, method excludes even the possibility of anything other than a literal understanding of its own statements. Let us imagine, however – here the thought-experiment begins – method taken not at *its* word, but as that word might itself be interpreted; for example (here), through Wölfflin's categories; that is, as viewed stylistically. I do not mean to exaggerate the possibilities here. It is clear that Wölfflin is not writing about philosophical style even when he finds a ground in philosophical terms or principles for artistic style. But consider the following three statements – the first,

a composite account from Wölfflin of the differences between linear and painterly styles; then, two composite statements of method, by Descartes and Kant respectively.

So, first, Wölfflin:

There is a style which, essentially objective in outlook, aims at perceiving things, and expressing them in their solid tangible relations, and conversely, there is a style which, more subjective in attitude, bases the representation on the *picture*, in which the visual appearance of things looks real to the eye, and which has often retained so little resemblance to our conception of the real form of things. Linear style is the style of distinctness plastically felt. The evenly firm and clear boundaries of solid objects give the spectator a feeling of security, as if he could move along them with his fingers . . . Representation and thing, so to speak, are identical The painterly style, on the other hand, has more or less emancipated itself from things as they are . . . Only the *appearance* of reality is seized, and . . . just for that reason, the signs which the painterly style uses can have no further direct relation to the real form . . . The tactile picture has become the visual picture – the most decisive revolution which art history knows.

(pp. 20–1)

Listen now to Descartes and Kant – Descartes in the *Rules for the Direction of the Mind*:

[Rule IV] In the search for the truth of things method is indispensable. [Rule V] Method consists entirely in the orderly handling of the things upon which the mind's attention has to be concentrated . . . We shall comply with it [method] exactly, if we resolve involved and obscure matters step by step into those which are simpler. [Rule VI] For the distinguishing of the simplest things from those that are complex, and in the arranging of them in order, we require to note . . . which thing is simplest, and then to note how all the others stand at greater or lesser distance from it. [Rule IX] It is also helpful to draw these as figures, and to exhibit them to the external senses, in order that thereby our thought may be more easily kept attentive.

And then, Kant, in the *Critique of Pure Reason*:

If appearances were things in themselves, and space and time forms of the existence of things in themselves the conditions would always be members of the same series as the conditions . . . [and] freedom cannot be upheld . . . If, on the other hand, appearances are not taken for more than they actually are, if they are viewed not as things in themselves but merely as representations . . . they must also have grounds which are not appearances. The effects of such an intelligible cause appear, but the intelligible cause . . . is outside the series. (B564–645)

[Transcendental method] treats only of the understanding and of reason, in a system of concepts and principles which relate to objects in general but take no account of objects that may be general but take no account of objects that

may be given . . . We take nothing more from experience than is given . . .
We take nothing more from experience than is required to give us an object
of outer or inner experience. (B873, 876)

This method . . . consists in looking for the elements of pure reason in what
admits of confirmation or refutation by experiment . . . All that one can do is
to . . . view objects from two different points of view – on the one hand, in
connection with experience . . . and on the other hand, for the isolated
reason that strives to transcend all limits of experience as objects which are
thought merely. (Bxix)

The parallels here should be evident – even if what follows from
them is less so. Wölfflin's category of linear style finds a methodic
anticipation in Descartes' statement: the clear and distinct ideas that
Descartes requires for certainty have a 'linear' counterpart in the
'distinctness plastically felt' which for Wölfflin discloses 'represen-
tation and thing' as identical – an identity also close to Descartes'
conception of truth. The Cartesian method, like linear style, is
intended to mark the boundaries among 'things', defining the
distances, relations, and order among them – the essential features
that philosophy, in Descartes' view, attempts to identify for the
understanding and that, according to Wölfflin, the linear style
employs in the plastic arts as the expressive means of *its* 'ideal of
life'.

Then, too, a sharp contrast appears in Kant: the painterly
revolution which, according to Wölfflin, produces a new world of
appearance has a parallel in the transcendental method that grounds
the limits of knowledge in the domain of appearance; more than this,
appearance itself is the basis for inferring another domain that
cannot be known but only thought. Appearance here, in Wölfflin's
words, has no 'direct relation to the real form' – but there is no doubt
either, from appearance itself, that the other domain exists – in what
Wölfflin later refers to as the 'beauty of the impalpable' (p. 72). The
painterly world of the senses defers its most fundamental distinction
to a point outside appearance (and the painting) altogether – with
this asserting a likeness to both the starting and end points of the
transcendental method which similarly moves from the apparent
distinctions among phenomena and noumena. It is not only that
method finds here a stylistic counterpart, but that this relation
discloses the possibility of viewing method itself stylistically, as
formally expressive.

Now I recognise the sharp demurrals that this reading is likely to
provoke: analogies are endlessly possible; Wölfflin's five pairs of

stylistic categories (of which I cite but one) lack rigour; it is much easier to claim that form is expressive than to say exactly what it expresses. And then, even if in reapplying Wölfflin's terms we do arrive at the odd images of a Durer-like Descartes and of a now-baroque Kant, the question is inevitable: 'So what?' 'What *philosophical* advantage could there be in this?'

Such objections cannot be avoided, but that does not mean that they cannot be cut down to size or postponed, and I hope for something of both. By cutting them down to size, I mean that prima facie, doubts about the relevance of stylistic analysis have no more force directed at philosophical discourse than they do elsewhere: the test of stylistic analysis is *always* in its disclosure of the object to which style is ascribed. More specifically: as stylistic categories applied to painting or architecture are judged functionally, by what they disclose or illuminate of the artwork or its kind, so stylistic features attributed to philosophical discourse will be assessed in terms of the understanding they provide (or fail to) of that discourse. The category of the baroque, with its checkered history, is obviously a shorthand label for much else in the artworks to which it is applied; and certainly one can question how informative the conception of a 'baroque' Kant (for example) is. But quite apart from the issue of this specific reading, what is crucial here is establishing the *possibility* of a 'style of method' – the sense that method can be articulated in stylistic terms, and that this possibility itself says something more about method and its place in philosophical discourse than method by itself would admit or disclose.

The example cited applies Wölfflin's categories to philosophical discourse even though they were initially conceived for the plastic arts. I have argued elsewhere that *all* stylistic categories have some such analogical or figurative ground[11] – but that claim, too, would grant that some categories are closer than others to their objects. A question remains, then – one ignored so far in discussions of philosophical style – of whether stylistic categories can be found that are *specifically grounded* in philosophical discourse, as Wölfflin's categories, for example, derive from the plastic arts. The goal of this search is clear – to bring the literary analysis of philosophy to a stylistic 'point-zero' in philosophy itself, or as close to that point-zero as the converging phenomena of style and philosophy permit.

A substantial literature already exists in which certain terms of literary analysis are applied to philosophical texts – through such

common categories as genre, authorial point-of-view or the implied author, reader-response, and figurative language.[12] These stylistic traits pertain to philosophical texts on the basis of their status *as* writing, and I believe the evidence is compelling that they do indeed disclose important and neglected (or as I have claimed, repressed) aspects of philosophical discourse in individual authors, for schools or groups, and even for the 'genre' of philosophy as a whole. But these categories by and large originate not in philosophical discourse but 'imaginative' literature where stylistic issues cut with rather than against the grain, attempting to emphasise rather than to conceal the mark of style. The question remains, then, of whether stylistic categories can be found that are similarly grounded in philosophical discourse. The relevance of stylistic analysis to philosophical writing does not *depend* on this possibility since that writing would (arguably) be subject to more general literary categories in any event. But obviously claims for the connection between style and the philosophical text would be strengthened if categories of this sort could be identified.

I offer two possible examples of such categories, the first of them drawn from Stephen Pepper's book, *World Hypotheses*. In that suggestive work, Pepper introduces a conception of 'root-metaphors' – four images which, inferred retrospectively, serve (he claims) as a metaphoric basis for the 'world-hypotheses' underlying philosophical systems.[13] Admittedly, metaphor is not distinctively a philosophical figure of speech; nor would I propose to defend the specific 'root-metaphors' Pepper names (likeness, the machine, the event, organism). More significant, it seems to me, is the systematic issue posed by his claim. For if philosophical discourse *has* a metaphoric ground, figurative representation would be a constant feature even of philosophy's ostensively non-figurative assertions (of which statements of method are a notable instance). And the conclusion would *then* follow that to ignore the literary or stylistic reading of philosophical texts in favour of an exclusively 'philosophical' analysis would be self-defeating and even self-refuting. Any attempt to demonstrate the latter conclusion as a general thesis will depend to some extent on our being able to demonstrate it empirically and thus piecemeal, text by text. But (as suggested above), this is the case for the phenomenon of style as such and not only for philosophical style. To prove that or how *any* term is figurative or expressive is a problem for discourse analysis generally, not peculiarly for the history or genealogy of philosophy.

A second, more specifically philosophical category of philosophical style appears in what I call 'stylistic implication'. The term 'implication' itself, of course, has a standard definition in logic ('One statement logically implies another if from the truth of the one we can infer the truth of the other by virtue solely of the logical structure of the two statements').[14] Similarly, accounts of philosophical method invoke that meaning in the relation between method and its conclusions. By contrast, stylistic implication is on my account also a form of inference – but stylistically, as viewers or readers are 'implicated' or have their roles determined by method in its representational character.

Consider again the statements quoted above of Cartesian and transcendental method. Formally, the two are similar: each specifies a progression of steps to be followed in philosophical thinking as stages on the way to truth or understanding. Viewed representationally, however, the two methods 'implicate' the philosophers-to-be whom they address – that is, their readers – in quite different ways, with what I call 'plural' and 'universal' implication respectively. Descartes' statement of method is directed to a reader who must yet, beyond his reading, practise or implement the method. The method is indeed described; in this sense it is addressed in common to all readers who presumably will then reach like conclusions. But they are required to reach those conclusions individually – not because each reads with his own eyes (which is of course true, but not only here), but because the reading involves a distinctive 'doing'. When Descartes says that 'we require to note . . . which thing is simplest . . .', he appeals neither to an authorial nor to a collective we – but to the individual employing (and required by) the method. (This point is epitomised in the *Meditations* when Descartes insists that the 'proper' reader will not read *about* meditation, but actually meditate – something that no one else can do for him.) 'Plural implication' here offers the promise of a common conclusion – but one to be arrived at only as the method is activated by the individual, and then by the 'plural', readers. In the statement on transcendental method, by contrast, the description of the method – available in common to all readers – is itself the application of the method. The method itself has the form of an argument, not simply because it states what the outcome of applying the method will be, but because that outcome – in broadest terms, the distinction between phenomenon and noumenon – is itself asserted in the method itself. The reader here, all readers together – whether they in the end agree to its terms or not –

follow the method and then its conclusions. The reader's 'implication' in the method, then, is universal, actualised in any one reading as also in the common reading and asserted also in the common conclusion then reached. The role of this universal or shared reference is not asserted by Kant in so many words; but it is none the less implied, *required*, in his discourse – a feature of method that is, moreover, learned stylistically, through the figurative or expressive structure of that discourse and the conclusions claimed by it.

For 'singular' implication – the last of what I take to be three modes of stylistic implication – Plato provides an example. In the genre (and method) of the Platonic dialogue, a number of individual persons speak – each of whom has a name and history as well as a voice and present. But the implication of the method – that is, the method viewed stylistically – is also individual, since unlike most instances of dialogue (philosophical or not), Platonic dialogues do not incorporate a universal voice. Even Socrates, the likeliest candidate, is never more than a mitigated – that is, an ironic – hero. The reader, in other words, makes his or her own way, not only because readers in general are on their own, but because the dialogue *implies* an individual role for the reader, perhaps as the latter identifies with one or another of the characters, but more often in projecting a character of the reader's own making. This 'singular' implication is entailed for Plato in the act of philosophy itself, as a means of 'doing' that is quite different from only following or understanding the lines of a text. This process intensifies the relation between method and style – on the one hand, posing a systematic method of inquiry; on the other hand, stylistically implicating the individual reader who is not and could not be literally present in the dialogue at all. Does this mean that there is no 'universal' implication in dialogues like the *Phaedo* or the *Theaetetus*? No – any more than it means that no generalisations can be drawn from an individual poem or play. It does mean, however, that such generalising in a 'singular' text comes always at the expense of obscuring other, arguably more central features – a disparity that is no less evident for philosophical texts than it is for other literary forms.

In certain of its features, the category of stylistic implication resembles the literary category of 'implied reader'. Certainly both, as instruments of style, relate formal features of the text to its meaning (the latter connection one of particular importance to philosophical texts). The differences among the three methods cited are, then, not 'merely' stylistic but implicate the 'reader' of method in specific and

different ways of carrying on the work of philosophy. *How* to read thus becomes a component of *what* is read. Stylistic implication, evoked first in the 'look' of the philosophical text, is no less essential to it than its 'internal' organs (of which method is undoubtedly one) – much as the look on a face (or the face itself) is integral to the person. In this conjunction, style and method are interdependent, although not, from what we have seen, identical, not even alternate views of the same structure.

One way of summarising the difference engaged here between method and style is in the factor of intention which, I have suggested, is presupposed in both. For method, the goal intended is fixed beforehand and then continuously motivates the process. For style, by contrast, the goal is itself always being elaborated; stylistic categories are retrospective because of this, and the status of their intention is then affected by this condition. Roland Barthes compares style to an onion in which one peels away layer after layer, hoping to find a centre but alas finding only layers until one finds nothing at all.[15] With method, by contrast, there is only a centre, no layers. Until, that is, we view it stylistically – a view that is even more pertinent to philosophy than to other disciplines because philosophy *has* no single or presumptive method. For it, method is constantly in question, almost as close as style itself to the philosopher-in-the-text. And yet, as I have also claimed, philosophical method is in its own terms posed *against* style. In philosophy, too, method is prescriptive and reiterative; style is retrospective (perhaps retroscriptive), and not reiterative but representational. Stylistic implication – like other stylistic categories – shows how this opposition becomes part of the representation and then of the *meaning* of philosophy. In this sense, style gives method a voice that method by itself does not have or even allow for.

Admittedly, it is possible to imagine the distance between style and method even further diminished. As Kant in his ethical conception of a Holy Will finds inclination and obligation wondrously reconciled, one might envision the freedom and individuality of style in philosophy unified with the strictures and objectification of method. This ideal recalls the Platonic identity of the true and the beautiful, and it is more than coincidental that philosophy comes closest to this ideal in the weave of style and method in Plato's dialogues – a genre which, notwithstanding that achievement, has since remained outside the mainstream of philosophical discourse. More commonly, method is asserted in the history

of philosophy as autonomous – intended, among other things, to repress any attempt to view it representationally or expressively or stylistically. I speak of the style of method, then, not to force a connection between them but to disclose a relation already present. As that relation was previously denied, supposedly on philosophical grounds, it is now reasserted – also on philosophical grounds. The issue between these claims thus becomes more recognisably a dispute between differing conceptions of philosophy – an acknowledgement which in its concession of pluralism already grants much of the claim made here for ascribing style to method.

NOTES

1 See the discussion of method in Justus Buchler, *The Concept of Method* (New York: Columbia University Press, 1961). Buchler's distinction (pp. 30–2) between method as 'repeatable' and method as 'predictable' (the latter of which he denies) becomes part here of the distinction between method (both repeatable and predictable) and style, which is neither. Buchler's citation of Coleridge on Hamlet (from Coleridge's *A Preliminary Treatise on Method*) has a special point here; Hamlet's fault, Coleridge, claims, is to 'methodize to excess, ever philosophizing and never descending to action'.

2 Meyer Schapiro, 'Style', in A. L. Kroeber, ed., *Anthropology Today* (University of Chicago Press, 1953), p. 287.

3 Stanley Cavell, 'Aversive Thinking: Emersonian Representations in Heidegger and Nietzsche', *New Literary History* 22 (1991), p. 133.

4 For a claim of the *difference* between general and individual style, see Richard Wollheim, *Painting as an Art* (Princeton University Press, 1987), pp. 26–7.

5 Ludwig Wittgenstein, *Notebooks 1914–1916*, trans. G. E. M. Anscombe (New York: Harper and Reed, 1961).

6 See as an example of this indifference, the review by Jenny Teichman, of Martha Nussbaum's *Love's Knowledge* (*New York Times Book Review*, 18 February 1991).

7 See Harold Bloom, *The Anxiety of Influence* (New York: Oxford University Press, 1975).

8 See, for example, Jacques Derrida, *Spurs: Nietzsche's Styles*, trans. Barbara Harlow (University of Chicago Press, 1979); Ernesto Grassi, *Rhetoric as Philosophy* (University Park, Pa.: Pennsylvania State University Press, 1980); Berel Lang, *The Anatomy of Philosophical Style* (Oxford: Basil Blackwell, 1990), and Berel Lang, ed., *Philosophical Style* (Chicago: Nelson-Hall, 1980); Christopher Norris, *The Deconstructive Turn: Essays in the Rhetoric of Philosophy* (New York: Routledge, 1984); Jonathan Ree, *Philosophical Tales* (New York: Routledge, 1987); John

J. Richetti, *Philosophical Writing: Locke, Berkeley, Hume* (Cambridge, Mass.: Harvard University Press, 1983); Richard Rorty, 'Philosophy as a Kind of Writing', *Consequences of Pragmatism* (Minneapolis: University of Minnesota Press, 1982); Martin Warner, *Philosophical Finesse* (Oxford University Press, 1990).

9 See for example, Hayden White, *Metahistory: The Historical Imagination in Nineteenth-Century Europe* (Baltimore: Johns Hopkins University Press, 1973); Peter Gay, *Style in History* (New York: W. W. Norton, 1974); David Johnston, *The Rhetoric of Leviathan* (Princeton University Press, 1986); James Boyd White, *Heracles' Bow: Essays on the Rhetoric and Poetics of the Law* (Madison: University of Wisconsin Press, 1985); Donald N. McCloskey, *The Rhetoric of Economics* (Madison: University of Wisconsin Press, 1984); Richard Brown, *A Poetic for Sociology* (New York: Cambridge University Press, 1977); David E. Leary, ed., *Metaphors in the History of Psychology* (New York: Cambridge University Press, 1990).

10 Heinrich Wölfflin, *Principles of Art History*, trans. W. D. Hottinger (New York: Dover, 1950).

11 Berel Lang, 'Style as Instrument, Style as Person', *Philosophy and the Art of Writing* (Lewisburg: Bucknell University Press, 1984).

12 For a survey of such genres, see Berel Lang, 'Plotting Philosophy: The Acts of Philosophical Genre', *The Anatomy of Philosophical Style* (Oxford: Basil Blackwell, 1990).

13 Stephen Pepper, *World Hypotheses* (Berkeley: University of California Press, 1961), ch. 5.

14 W. V. O. Quine, *Elementary Logic* (New York: Harper & Row, 1965), p. 2.

15 Roland Barthes, 'Style and its Images', in Seymour Chatman, ed., *Literary Style* (London and New York: Oxford University Press), 1971.

2

Style in painting

RICHARD WOLLHEIM

I

In this chapter I want to re-present and to reconsider a thesis about style – specifically, pictorial style – which I advanced in an essay written in 1977 entitled 'Pictorial Style: Two Views', to be found in Berel Lang's 1979 collection, *The Concept of Style*.[1] Pictorial style is a long-standing interest of mine, and I believe style to be a fundamental, indeed a foundational, element in the art of painting, and anyone interested in the very little progress that I have made with this element over the years – which may show something about *me*, but which also, I think, shows something about *it* – may compare this essay with an earlier and more complex version of the thesis which I gave in 1972 as the Power Lecture in Sydney and other Australian cities under the title 'Style Now', as well as with the more up-to-date summary of the thesis which I included in my 1984 Mellon Lectures at the Washington National Gallery of Art: now published as *Painting as an Art*.

II

One way of looking at 'Pictorial Style: Two Views' would be to see it as offering a whole catalogue of distinctions.

The essay opens with a broad distinction between *general style* and *individual style*. General style is subdivided into *universal style*, *historical* or *period style*, and *school style*: and individual style, which is the contrast to general style, and which is the real topic of the essay, and for that matter of this chapter, is in turn opposed to *signature*. To grasp what is special to individual style, the contrast between a *merely taxonomic* and a *generative conception* of style is

37

invoked, and the better to understand a generative conception of style, the notion of a *style-process* is invoked, and a style-process in turn breaks down into a *schema* or *universal*, a *rule* or *instruction*, and a *disposition*: the disposition being the internalisation of a rule operating upon what falls under a schema. To refute the taxonomic conception of style I suggested two arguments, each of which is directed against an alleged consequence of this conception: these two consequences I associated with what I called the *description thesis* and the *relativisation thesis*. At this stage it struck me that in order, not just to refute the merely taxonomic conception of style, but (a further matter) to establish the generative conception, what was required was not argument but evidence: and this evidence could only be the fruit of research that presupposed the generative conception. In 1977 I suggested that this search lay in the future. It still does. This means that, now as then, my advocacy of *one* view of style, in so far as it aims at more than *a priori* or intuitive appeal, remains promissory. Another way of putting this last point would be that, now as then, it is the intuitive, the *a priori*, appeal of the thesis I advanced in my essay – in other words, that aspect of it which rests on the distinctions I proposed – that should get the lion's share of attention, and the attention it needs is a matter of showing that these distinctions do not compose a *mere* catalogue. It has to be shown that they furnish the most natural way of ordering the material of style.

III

Perhaps I should make it clear that the view of pictorial style that I advocate cannot be expected to find favour, or even to possess intelligibility, outside a broader framework within which the art of painting may be set. This framework is essentially an interpretative framework, and it presupposes that, in trying to understand a painting, in trying to grasp its meaning, we should always see it as (what after all it is) the product of a human mind: the mind of its painter. I say its painter in the singular: though I do not see any fundamental difficulty in extending the framework to cover paintings whose authorship is plural. There should be no greater difficulty in using this framework to understand a work made by more artists than one than the artists themselves would have had in co-operating on the work: which was probably not negligible.

Such a framework might be called a psychological framework.

Arguably it might also be called an intentionalist framework, the open question being whether the project of understanding works of pictorial art as products of painters' intentions is or is not narrower than that of understanding them as products of painters' minds. Since I at any rate take a very broad view of what an intention – that is, of what a painter's intention – is, equating it with more or less any psychological factor that motivates him to paint one way rather than another, I shall assume there to be no crucial difference between the two projects.

It is in *Painting as an Art* that I put the real case, as I saw it then, as I see it now, for understanding pictorial works of art in psychological, indeed in intentionalist, terms. My argument was this: that, in the case of human artefacts, intentionalist understanding prevails except in those cases where *for a special reason* it doesn't. It is, as is said nowadays, the default mode of understanding. And those cases where intentionalist understanding does not prevail, or where it meets principled opposition, amount to three in number. In two of these cases, understanding of an artefact does not appeal in any way to the artefact's history of production. Let us look at these two cases first. One is where the artefact essentially figures as part of a rule-governed system that assigns meaning to every item, to every simple or complex, according to the position it, the item, occupies within that system as a whole. As example would be a sentence or a well-formed string of words – not a speech-act, or the utterance of that sentence – as a part of a natural language. The second case where any appeal to history of production is superfluous is where the artefact essentially has a purpose or function, and this purpose is specific enough to determine what the artefact is like to a very minute degree. An example here would be a law or an article in the constitution of a sovereign state. Now the third case where intentionalist understanding is out of place is where the history of production *is* relevant, but in each case, this history is so totally choreographed – it might, for instance, exemplify a Markov chain where each link in the chain is absolutely conditioned by the immediately preceding link – that what goes on in the head of the artificer, or in the heads of the artificers, can be completely discounted. An example here would be a ritual.

Now it is my claim that a pictorial work of art falls under none of these three headings: hence it requires psychological or intentionalist understanding. (A point about this claim. There may very well be some parts of pictures, there may even be some pictures in their

totality, that are bound by meaning-rules, or that are teleologically conditioned, or whose production is exhaustively choreographed, but these instances would do nothing to overthrow a claim about how pictures as a whole, alternatively pictures *in general*, are to be interpreted. So if you are impressed by these seeming counter-examples – *if*, I stress – then take my claim as requisitely qualified.)

I am fully aware that our age bristles with anti-intentionalist, anti-psychologistic, claims about the understanding of art. It bristles with semiotic claims and teleological claims: that is, claims that, from the point of view of explanation, art can be assumed to have the structure of a language or can be equated with the output of a social or economic system. So let me make clear that, if any of these claims were justified, my particular view of style would fall to the ground. Having made this point, I now move on to my view of style, armed with the conviction, which you may not all share, that none of the arguments for these claims have the power to detain us.

IV

The starting-point of my consideration of pictorial style calls for the deployment of two of the distinctions I have reviewed: that between individual style and general style, and that between a generative conception of style and a merely taxonomic conception of style. (The word 'merely' here is all important.)

I start thus: We can and do talk of the style of Rembrandt. At the same time we can and do talk of the style of the school of Amsterdam (or the school of Leyden): of the style of northern baroque: and, finally, of the baroque itself as a style. Here we have individual style, school style, historical or period style, and universal style. And the first point I want to make is that, when we make these distinctions, it is at least open to us to make one more distinction than the surface structure of our talk makes apparent, for it is a distinction buried in what we say: furthermore we often take advantage of this opportunity. The opportunity arises because in the world individual style differs from school style, period style, and universal style not just in that an individual is a different, or different kind of thing from a school, from a period, or from the world of art at large – that is, *the things that have the style* are different – but in that *style itself*, or *the thing had*, is a different, or different kind of, thing when had by an individual from what it is in the other three cases. We don't of course always recognise this: but,

when we *do*, though our talk continues not to, our thought does. For, in giving expression to this recognition, we employ, when we refer to individual style, the generative conception of style, as opposed to a merely taxonomic conception, which is what we use in talking of school style, period style, universal style. However, employing a generative conception of style is not simply a way of recording that there is something special about individual style. It does that, but it does more than that. It registers what *is* special about it. In other words, unpack the generative conception, and you will discover what is different about individual style. Unearth what is different about individual style, and you will have the materials for reconstructing the generative conception of style.

<div align="center">V</div>

So let us consider what it is that *is* different about individual style. What are the characteristics that single out individual style? I suggest the following:

(a) Individual style has *reality*. That is, there is a fact of the matter to a painter's having a style: having a style makes a difference to the painter.

(b) Individual style has *psychological* reality. That a painter has a style is a fact of psychological matter: the difference that having a style makes is a difference in the mind of the painter.

(c) Individual style is something that the painter *acquires*. A painter's style is not a matter of natural endowment. Nor does a painter have a style solely in virtue of being a painter. It is easy to confuse the truism that, if X, a painter, has a style, then it is X's style that he has with the further claim that, if X is a painter, then there is a style, X's style, that he has. The latter claim is not truistic, it is false. A painter may have no style: though, if he has one, it would be his and it would be named after him. In my earlier essay I made it true, stipulatively true, that every *artist* has an individual style. That impresses on us a particular way of understanding the term artist.

(d) An individual style is acquired through being *formed*. It is formed, not learnt: though an artist may learn how to form a style. He may learn it through being taught, from example, or by trial and error. Or he may just form a style without having first learnt how to do so.

(e) Before forming a style, the artist produces his *pre-stylistic work*. The style once formed accounts for the artist's *stylistic work*, so long, that is, as the style endures. However, the style may, for one reason or another, decay or disintegrate, and then, if the artist continues to work, his work will be *post-stylistic*. And finally the style may persist yet a possibility opens up which conventional art history often overlooks and which a realist understanding of style singularly equips us to recognise: that is, the artist may engage in some undertaking that his style cannot encompass, and in this case his work will be *extra-stylistic*. Extra-stylistic work presents special problems for the student of style or (as he is called) the connoisseur. He may be misled by it in one or other of two ways. If he is trying to build up a description of the artist's style, he may be misled by extra-stylistic work and build up an unduly broad description of the artist's style: however, if he has already built up a true description of the artist's style and is now trying to use this description to construct a corpus of the artist's work, he may be misled by extra-stylistic work into constructing an excessively narrow corpus.

(f) The style that the artist forms subdivides itself into two capacities or skills. The first consists in segmenting or concep-tualising the elements of a painting in a certain preferred way: this gives what I call the 'schemata' of that artist's style. The second consists in evolving rules or principles for operating with these schemata: that is to say, giving shape to them and placing them on the support in relation to one another. Two points need to be stressed about both these capacities. In the first place, they are practical, not theoretical, capacities. They are exercised by the artist in making his picture and they evince themselves in an intellectual form only if it is in the nature of the particular artist to reflect upon his way of making a picture. Secondly, both capacities resist propositional or (for that matter) imagistic formulation. This point does not merely recaptiulate the pre-vious point: it also tries to do justice to the high degree of context-dependence to which these capacities are submissive. In different contexts the same style might find outlet in two very different-looking outputs.

(g) Individual style is highly internalised: not just in that it does not require reflective consciousness, but further in that it is encapsulated in the artist's body. Individual style involves a

modification of the movements of the fingers, the hands, the arms, indeed the whole body: more specifically, it involves modification of those movements through the monitoring role of the eye. Style is a particular fine-tuning of what Merleau-Ponty called the 'hand-eye'.

(h) And finally style can be partially grasped through its consequences. Specifically style puts within reach of a painter the fulfilment of his intentions. An artist can *fulfil* his intentions: the painter who is not an artist can merely make work that is *suggestive of*, or *evidential for*, his intentions. A further point, or perhaps the same point, and I find it hard to decide which, the formation of a style permits expression.

VI

A point that cannot be too heavily or too frequently emphasised is that this view of style is not a *formalist* view of style. The schemata that are the bricks out of which individual styles are formed are not to be understood as limited to formal or formally defined elements. (The problem here, as elsewhere in arguing against formalism, is to make the target, formalism itself, a coherent view.) Formalism, if it is to merit its appellation, ought to think of schemata as narrowly configurational items which a careful scrutiny of the support will reveal inscribed on it. Schemata should be confined to such things as lines, squares, spatterings, absence of black, expanses of white or red, and film of blue over apricot. Few formalists are as consistent as this, so my strategy will be to give a capacious list of items that I believe a viable account of pictorial style *must* be ready to admit as possible schemata in an artist's style, and I am confident that, at *some point* in the course of this list, any self-styled formalist will object.

In the first place, then, room must be found in the list of schemata for *material elements* of the painting: that is, elements that depend upon the artist's materials not only for their realisation (all plausible candidates, including configurational items, must do this) but also for their identification. Examples would be: cross-hatching, contour, (in medieval panels) punch mark (in later art) impasto, patches of lapis lazuli, priming, weave of the canvas. Secondly, room must be found for *represented elements* in the painting: that is, elements whose claim to be part of the content of their paintings rests on the fact that they can be, and correctly are, seen *in* the surface of the

43

painting. Examples would be: sphere (as opposed to circle, which *is* configurational), middle ground (as opposed, say, to half way up the surface, which also is configurational), in movement or fast-moving, foreshortening. A sure sign of a represented element is when its identification requires attention not just to the two dimensions of the surface, but to a third dimension. For that third dimension is a represented dimension. Finally (and by now at any rate the formalist is left behind) there must in the list of schemata occur *figurative elements*: that is, elements that not only require for their detection seeing-in but are then identified through concepts of which geometry, even in the most extended sense, has no ken. Examples would be: body, foliage, drapery, valley, battlefield, shadow, reflection in the water, skin, eyebrow.

Incidentally the last four examples of figurative elements that might turn up as schemata within a particular artist's individual style have not been chosen at random. They are taken from interpretative views of my own about the style of two major artists: Monet and Titian. I have recently argued that shadows, particularly shadows that run at six o'clock from the represented object straight down towards the bottom edge of the painting, play a crucial role in Monet's strategy of incorporating the spectator. They account for his marked preference for back-lighting or the *contre-jour* effect. Indeed it was only when Monet fully appreciated that reflections in the water are not like shadows but *invariably* run straight towards the spectator, no matter where the source of illumination is, that he shifted from back-lighting to direct or frontal illumination. (The *Poplar* series is the turning-point.) Again, I have argued – and the argument is too detailed to recapitulate here – that in the style of Titian, the segmentation of, and emphasis upon, skin, human skin, and the eyebrow, envisaged as the arch that frames the organ of sight and shows off the delicacy, the fragility of skin, are crucial factors in the systematic fulfilment of his intentions.

In decrying a formalist understanding of pictorial style, I ally myself, as I see it, with two highly original thinkers in the field, whose contributions to the theory of style are momentous but whose work has been in several regards gravely distorted: Heinrich Wölfflin and Giovanni Morelli. Morelli's anti-formalist stance is surely attested to as strongly as one could wish by the schedules that he offered for the recognition – I should say for the stylistic recognition, the recognition via style – of the work of the great, and the less great, masters: for these schedules try to establish how the artist in

question depicted the ear, the ball of the thumb, the forefinger, the toe. What has allowed Morelli to be erroneously recruited to the formalist camp is the suggestion, made (I believe) too much of, that these depictions always preserved a constancy of configuration; that they were completely inelastic to the pressures of context. The case of Wölfflin is more complex. Addressing himself primarily to the issues of general style, he gave the impression that, when the issue of individual style came to be broached, the schemata out of which the different individual styles were made up could be identified in the same way, in the same terms, as those in which he *purported* to describe general style: that is, in overtly configurational terms, such as open versus closed forms, painterly versus linear etc. But when we examine Wölfflin's account of an individual style – say his account of Raphael's style in the Stanze, in *Classic Art* – it is represented elements, indeed figurative elements, that are invoked and do the work.

VII

Reference to Wölfflin and to Wölfflin's preoccupations might seem to provide just the right pretext for switching from individual style and the generative conception of style and the merely taxonomic conception that suffices for its characterisation. But I shall delay making the transition until I have made a methodological point about the study of individual style. It is a point that requires the introduction of a new distinction, and once the point is made, the contrast between individual and general style should be starker.

I start then with the distinction. The distinction is between a *style-description* and a *stylistic description*. A style-description, as I use the phrase, is a description of an artist's individual style: it describes the schemata and the rules, and it might, for good measure, throw in some indication of where and why it was that the artist took on tasks to which his style could not be turned so that the work he did was extra-stylistic. In contrast to a style-description, a stylistic description is a description not of an artist's style but of a painting by an artist in his style, and, in describing it, it concentrates on the picture's stylistic features: it concentrates on those features which the painting owes to the artist's style and shows how this is so.

I hope that I have said enough about individual style to put it beyond doubt that in my view the project of producing either kind of description is a fantastic idealisation of conceivable art–historical

practice. But this does not mean that to reflect upon these idealisations is without value. Quite the contrary, I should say.

The first thing that such reflection reveals is that there *is* a distinction to be drawn between the stylistic and the non-stylistic features of a painting. For not everything that manifests itself on the surface of an artist's work is the direct output of that productive system which is his style: though it might be hard to find features that were untouched by style. Secondly, what are the stylistic features of a picture in an individual style depends on the content – that is to say, the schemata and the rules – of the style that it is in, and there is no way, independent of the style itself or in advance of the style description, to predict how the features of a painting will divide themselves between the stylistic and the non-stylistic. And the third thing that reflection on the distinction between style-description and stylistic description brings to light is the ineliminable gap that divides the two. In other words, there is no delimitable body of information that will allow us to infer from any stylistic description of a work by an artist or any set of stylistic descriptions of works by the same artist to the relevant style-description. This results from amongst other things, the fact that, in any given work or in any given body of work of an artist, his style may not be employed in its entirety. Conversely, there is no delimitable body of information that will allow us to infer from the style-description for a given artist to the stylistic descriptions that paintings of his will satisfy. This results from, amongst other things, the vast complexity of ways, which is not in principle reducible, in which the different rules constitutive of the style interact with one another.

VIII

And now is the moment, as I see it, to turn from individual style to general style in all its varieties, or to turn from the generative conception of style to a merely taxonomic conception. For once we make the transition, then it will turn out to be a feature of the new terrain in which we find ourselves that here there is no gap to open up between style description and stylistic description.

Let us look at this.

In so far as it is plausible to think of a style that belongs to a school, or of a style that belongs to a period, or of a style that is in principle universally available, it is clear that we are not entitled to claim that in each case there is a productive system that could

account for the style. That being so, in what does the unity of a general style consist? And the answer must be that it consists in some conjunction, or some disjunction, or (likeliest) some conjunction of disjunctions, of features or properties that are identified by their appearance, and what makes it plausible to colligate such features is that clusters of otherwise related works of pictorial art satisfy just such colligations. We scan, say, the paintings of students of some artist and find that they share certain features to define a certain school style. Or we scan the paintings produced by various painters living in some temporal and probably spatial propinquity and find that they share certain features and then we use these features to define a certain period style. And the same kind of thing goes for universal style. And that general styles are, all of them defined in this way, by invoking solely manifest properties that are observed to be co-instantiated, reveals conclusively that general style involves a merely taxonomic conception of style.

And now we should be able to see why, in the domain of general style, there is no gap between style-description and stylistic description. The only discrepancy that could occur would be of a trivial kind. It would be when a painting in a general style does not satisfy *all* the properties definitive of that style, for then there would be an underlap of stylistic description and style-description. Not the whole of the style-description would be taken up in, or find its way into, the stylistic descriptions of work in that style. But this offers no difficulty of principle. In the case of a general style, particular stylistic descriptions stand to the appropriate style-description like different texts in the same language do to a lexicon of that language. However in the case of individual style, particular stylistic descriptions stand to the appropriate style-description more like different texts in the same language do to a grammar of that language.

What characterises general style may now be formulated. I suggest the following:

(a) General style, unlike individual style, lacks reality. There is no fact of the matter to it. From this it follows that

(b) general style, unlike individual style, has no explanatory value. It cannot explain why paintings in a given general style look as they do. On the contrary, they are in whatever general style they are in because of how they look. And another consequence to follow from the fact that general style lacks reality is that

(c) art historians may reconstruct or redefine general styles as they

find helpful. They may tamper with the identities of styles by amalgamating, subdividing, or gerrymandering them, and they may tamper with the contents of styles by altering the properties that define them. They may do so for a number of reasons, but the reason can never be that they thereby do better justice to the styles themselves. By contrast all justified rewritings of style-descriptions of individual styles will, if justified, be justified in this way.

IX

I have mentioned, as have other contributors to this volume, *signature*. Signature is not, strictly speaking, a form of style at all. It is however a sibling of style, and, in so far as we look at it in this way, it is the merely taxonomic conception of style that we employ. Signature is a set of features that we use, and are justified in using, to establish authorship. They are drawn from stylistic and non-stylistic features of the work indifferently, but, in so far as they include stylistic features these features do not have to be identified stylistically, i.e. as the outcome of certain stylistic processes. They can be identified in any way that best serves the purpose for which signature is invoked: that is, making true and secure attributions of painting to painter. Signature itself is of great importance to art history, but I do not believe that the conception of signature is of much interest to the theory of art.

X

I have talked of individual style as psychological. I wish it to be recognised that, on my understanding of the matter, it is psychological only in a minimal sense. It is psychological only in the way in which vision or language-competence is psychological. It interacts with other psychological phenomena at any rate at some level. There has been no suggestion on my part that the artist has direct access to the processes of style, or even that he is in a particularly good position to retrieve them after the fact: indeed there is no reason to think that he has any mental representation of his individual style, either in an overall way or in its detail or structure. This last fact is connected with the well-attested way in which artists never fail to resent the fact that they have a style. (Which is not to say that they wouldn't also resent the allegation that they *didn't* have one.)

However, times of crisis may arise in an artist's life when he starts to represent his style internally. And at the same time he represents to himself the style of others. If this time is a time of *deep* crisis, we have to be prepared for the possibility that these representations will be misrepresentations, and in line with what depth psychology teaches us is pervasively the case, they will be misrepresentations in *corporeal* terms. The artist's own style and those around it will be conceptualised as bits or parts or products of the body, and by this stage the scene is set for any one of the great dramas of projection, introjection, projective identification, that deep crisis precipitates. The style of another becomes an introject, and it is I think in this way, in these terms, that we should attempt to understand the otherwise puzzling phases in the lives of great artists when their individual style drifts into grave trouble. I am thinking, for instance, of the extraordinary momentary submission of Titian to the muscular style of Michelangelo or Pordenone: or the momentary submission of Renoir to the hard-edged style of Ingres: or the clamorous inner dramas of Picasso's stylistic evolution.

I mention this subject not to develop it, but just to show what must be developed if we are to stick to the maxim that I claimed in 1977 is fundamental to stylistic studies: one artist, one style. Only in cases of real breakdown should this maxim be abandoned. After all, a style can retain its identity, can be the very style it is, *and* undergo change. Indeed nothing can undergo change unless it remains what it is, or retains its identity. It is not change that contrasts to identity: what contrasts to identity is diversity. I am sorry to end this chapter on a truism, but regrettably the state of the subject makes it appropriate.

NOTE

1 Now reprinted in Richard Wollheim, *The Mind and Its Depths* (Cambridge, Mass.: Harvard University Press, 1993).

3

Stylistic strategies in William Hogarth's theatrical satires

MARY KLINGER LINDBERG

The study of rhetorical or persuasive strategies in literary works is now well established. Less known are the stylistic strategies at work in the domain of graphic art. What is the relation between stylistic strategies in these different domains? Are they specific to graphic art, or are they common to modes of expression in general? And what is meant by 'stylistic strategy'?

One approach to answering these questions is to focus on the use of theatre in the arts. It is well known, for instance, that novelists like Henry Fielding in the eighteenth century, and Charles Dickens in the nineteenth century, used theatrical conventions in their work, incorporating experiences at the theatres, critiques of actors and acting, and elaborate use of gesture and expression.

Turning to representational art, there is a similar generalised use of theatre as subtext on at least two levels, one as subject and the other as visual persuasion. One thinks of Daumier, for stage moments and portrayals of actors and audiences, for example, and Watteau, for a deeper sense of rhetorical theatricality in outdoor scenes.

Not much work has been done to explore the nature of such interconnections in art and the theatre, links which in the case of the English artist William Hogarth (1697–1764), reflect both his artistic and theoretical roots in the eighteenth-century rococo style, as well as his manipulation of conventions to postulate his own theory of beauty. Richard Wendorf, who considers Hogarth 'the century's most literary artist', coins the term 'iconicism', which covers verbal or literary motifs in visual portraits. However, his focus is on portraiture in art and literature.[1] Hogarth's stylistic strategy is to borrow extensively from accepted devices of the eighteenth-century theatre – its dynamic stage and acting commonplaces, and a

storyline of satirical fictions, for example – and incorporate them into a static, pictorial form.

To some the word strategy implies a temporal sequence of intentions and actions and therefore might not seem applicable to print or text, although this is arguable for Hogarth's work, since he created 'progresses' or series of prints to show temporal sequence. Some might consider Hogarth's setting out to convince the public of his opinions by creating a series of prints to be stylistic strategy. These are indeed all valid uses of the term with regard to Hogarth. However, what I define as stylistic strategy in this chapter is (1) a visible feature of the graphic works themselves, the choice of motives and devices Hogarth's prints display, and (2) his particular way of converting ideas into graphical forms. Moreover, I consider it 'stylistic' rather than rhetorical because of the pervasiveness of the use of the theatre in Hogarth's work and writings.

He is not simply creating a group of prints that deal with the theatre as a theme and incorporate conventions of gesture or signs shared between the arts of stage and print. Rather, Hogarth consciously makes the effort to have his scenes considered as stage works. He declares this in his autobiographical notes and in other places. For example, to proclaim his new strategy of representation, a variation of the accepted modes of history painting, Hogarth in his writings repeatedly utilises stage comparisons and posits dramatic analogies.

His stylistic strategy in the theatrical satires is to create a picture using theatrical constructs or parts thereof to express his convictions about taste in graphical form. In one case, indeed, he uses a verbal structure from the stage world to frame his picture – a playbill.

I have found a proactive reliance on stage topics, themes and devices in over 50 per cent of Hogarth's lifetime graphical output. His persistent use of theatre in pictures is supported in his commentary by pointed verbal references to London staged events. It is a primary source. When Hogarth might turn to earlier painters, sculptors or others, social or historical, in his writings, he emphasises the English theatre, closely observing and commenting on practical details of costuming, dance, and acting practice as well as Shakespearean scenes.

It could be argued that Hogarth's concerns with social customs, religion, mores and morals were, at the least, as ubiquitous in his work. However, enough specific evidence exists of theatrical themes and forms in over half his graphic works, I believe, to use the word style in this context.

It is Hogarth's unique contribution to eighteenth-century art to employ theatrical subtexts so pervasively. Other artists did not integrate the theatre in this closely woven manner; they were more interested in the use of theatrical trappings for embellishing portraiture, for instance. However, in the nineteenth century, linkages between theatre and art experienced a more aesthetic focus.

Marvin Meisel has looked at conjunctions of narrative, pictorial and theatrical arts in nineteenth-century England in his book *Realizations – Narrative, Pictorial and Theatre Arts in 19th Century England*.[2] He points to a special use of pictorial allusion onstage called 'realizations'. He takes the word from stage scripts, where actors and actresses were directed pointedly to arrange themselves in a way that would 'realize' a specific painting. 'Realizations' were aimed at spectacular not 'thematic' enrichment. Further, he observes that these 'shared structures in the representational arts', i.e. painting and acting, helped constitute 'not just a common style, but a popular style' in the nineteenth century (p. 93). They also represent a more aesthetic approach.

Looking back to the eighteenth century, Meisel observes that Hogarth's pictures on the walls in his series 'Marriage à la Mode' (1745) were not 'realizations', but rather 'visual emblems'. More than emblems, I would argue, these paintings, consciously chosen and depicted by Hogarth, amount to a literary and theatrical device analogous to the play-within-the-play (here paintings-within-a-painting), where they provide thematic point and counterpoint to the action in the rooms they decorate. Hogarth was extremely adept at integrating myriad aspects of the theatre in his art for rhetorical and persuasive purposes to a greater extent than Meisel credits him.

Indeed, I contend that the strong interplay of theatre and art in a majority of Hogarth's graphic works constitutes a stylistic strategy, one that visual artists such as Watteau and Daumier or Picasso may partake of at times, but in Hogarth's case, it is formidable enough to command special notice. His extensive writings on the London stage and theatrical world, especially in his only book, *The Analysis of Beauty* (1753), underscore the significance of this stylistic mode in his work.[3] In a major number of graphic works he uses theatre as a subject, but also weaves many signs of theatrical presentation in his scenes.[4] Rooted in the eighteenth-century theatre and its world, these techniques are particularly useful in the domain of pictorial

satire as he critiques theatrical taste and contemporary London entertainments in the early eighteenth century.[5] This chapter will explore how these strategies work in four of his satires.

THEATRICAL SATIRES

Grant Sampson has shown that shifts in Hogarth's iconography of Nature and Time over his lifetime reveal an awareness of ambiguities in the eighteenth-century tradition of satire. The vision becomes complex and even 'dark'.[6] Ambiguities in Hogarth's moral vision and satire have also been noted by Joel Blair and Ronald Paulson.[7] However, in three early prints of the 1720s and a drawing from the 1740s, Hogarth is unambiguous in attacking the 'follies' of public taste.

In these works, he argues with theatrical taste, decrying inattention to traditional English dramatic literature. I call these scenes 'theatrical satires'. The term has been defined by Samuel Macey in a literary mode as 'all plays which ridicule their own medium' from Buckingham's *Rehearsal* (1671) to Sheridan's *The Critic; or, A Tragedy Rehearsed* (1779).[8] Into this genre fit Fielding's *The Author's Farce* (1730) and *Eurydice Hissed* (1737), among others.[9] Hogarth's pictorial theatrical satires offer similar strategies of commentary, as he targets taste and judgement of authors, managers, and the public. Moreover, his four satires go beyond criticism of staged plays to attack operas, pantomimes, and masquerades – all part of the whole show from the 'First Music' to the afterpiece that theatregoing Londoners enjoyed and grew to expect in the eighteenth century.

Specifically, in *Masquerades and Operas* (1723/4) and *Masquerade Ticket* (1727), Hogarth criticises the public's attraction to evenings of disguise and entertainments emphasising purely spectacular effects; in *A Just View of the British Stage* (1724), he unsympathetically portrays theatre managers catering to the pantomime rage in the guise of staging a show himself. In *Charmers of the Age* (1740/1), he makes ludicrous the London popularity of European ballet dancers.[10] The three prints and drawing fall into a satiric mode defined by Blair as 'direct didactic statement', whereby rhetorical pressures force a rejection of the objects under attack.[11]

In these scenes, Hogarth expresses concerns similar to those of such literary and social satirists as Pope, Addison and Steele, and dramatic satirists Buckingham, Gay, and Fielding. Their targets, like Hogarth's, were attitudes of playgoers who treated theatres 'merely as

places of fashionable entertainment', as well as theatre managers and playwrights whose goal was to satisfy the taste of the town regardless of standards.[12] Hogarth is no different in his theatrical satires.

Hogarth's satiric style is also highly literary and dramatic. To clarify a point or enhance irony, he adds verbal/textual elements to his portrayals – verses, tags, subtitles, playbills, book titles. Through this satiric subtext, he extends his own medium as versifier, playwright-manager, and critic of dramas, theatre management, and continental choreography. His own newspaper advertisements are part of this subtext as well. His primary strategies in these prints consist of (1) the visual use of theatrical conventions and stage forms as fictions (2) drawing illustrative examples of his own theory of humorous effects, and (3) calling upon the shared base of cultural knowledge within his audiences. The satiric contrasts are enhanced since his patrons, i.e. spectators and consumers, shared an aware- ness of the theatrical values and conventions depicted in these graphic scenes. As Shirley Strum Kenny has shown, the lively interplay of theatre and visual arts in this period was a cultural commonplace.[13]

We will look at the prints in detail to see how these strategies operate.

MASQUERADES AND OPERAS (1723/4)

Announced as 'The Bad Taste of the Town' in periodical advertise- ments by Hogarth, *Masquerades and Operas* (see figure 1) appeared in early February 1723/4 (*HGW*, 47). In the 1760s, Hogarth described this 'first plate' as one wherein he 'lashed' the 'then reigning' follies.[14] By choosing a theatrical subject for the first engraving he published, Hogarth shows himself an enterprising artist and an alert playgoer fighting for literary and theatrical standards. He must have been confident that his print buyers would be interested too, since they shared the same entertainment experiences.

With *Masquerades and Operas* in particular, Hogarth adds his views to the many printed attacks on the pantomime craze, peaking from 1723 to 1725. As G. Winchester Stone, Jr points out, this 'rage for opera, pantomime, masquerade and raree show' gave both authors and artists opportunity to 'bewail decay in taste' and to look for a return of the 'dramatic giants of the past'.[15] All these elements appear in Hogarth's print.

He depicts crowds of Londoners as they rush or are drawn to

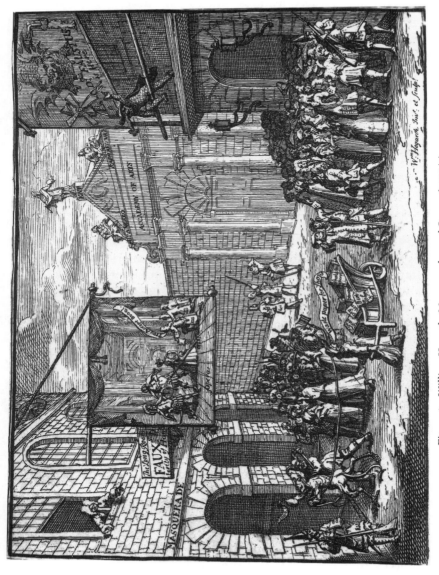

Figure 1 William Hogarth, *Masquerades and Operas* (1723/4)

operas and the midnight masquerades organised by Heidegger, who leans out of a building. This Swiss impresario was famous not only for his ugly features, but for the masquerades and late night shows he produced. In 1728 Fielding ironically dedicated his first published poem, 'The Masquerade', to him, and like Hogarth earlier, he critiques public taste, especially that of the women.[16]

The first state of Hogarth's print was accompanied by the following verses, presumably Hogarth's own, where he asks

> Could new dumb *Faustus*, to reform the Age,
> Conjure up Shakespear's or *Ben Johnson's* Ghost,
> They'd blush for shame, to see the *English Stage*
> Debauch'd by fool'ries, at so great a cost.
> What would their *Manes* say? should they behold
> *Monsters* and *Masquerades*, where usefull Plays
> Adorn'd the fruitfull *Theatre* of old,
> And Rival Wits contended for the *Bays*.

(HGW, 47)

His graphic scene expands on this commentary, illustrating a rampant enthusiasm for pantomimes and masquerades as crowds strain to see John Rich's *Harlequin Doctor Faustus* on one side of the street. On the other, a masked, costumed queue is literally (but not unwillingly) roped in by a satyr and fool. The bulging queues profile the potency of the public's addiction to Heidegger's masked balls, conjurer shows, and pantomimes.

Above the maskers hangs a showcloth. In it Hogarth lashes at the current rage for opera by depicting Francesca Cuzzoni, the famous soprano of the day, literally raking in money offered her by three noblemen *(HGW*, 47). The abandonment of 'usefull Plays' is explicit, as the works of Congreve, Dryden, Otway, Addison, and Shakespeare are carted away in a wheelbarrow with their destination: 'Waste paper for Shops'. The theme of Hogarth's satire concurs with contemporary criticism. As Emmett Avery noted, the success of pantomime entertainments was unquestionably great; they set new records and dominated legitimate plays.[17] Satirical attacks attempted to diminish the value of such shows, and Hogarth's role in this pattern is unequivocal. As M. D. George observes, the first print Hogarth published on his own account illuminates two standard themes which long prevailed: the 'neglect' of drama for spectacle, and 'resentment at large sums paid to foreigners'.[18]

MASQUERADE TICKET (1727)

He targets the sexual motivations of masquerades in *Masquerade Ticket* (see figure 2, here; *HGW*, 70–1).[19] Specifically the print marks the accession of George II, and criticises his royal endorsement of masked balls (*HGW*, 70).[20]

George II, Heidegger's patron as Prince of Wales, now as King, made him Master of Revels. Public opposition to masquerades was quite widespread in 1726, but no parliamentary legislation was passed to suppress them; only lip service was paid to their deleterious effects. Heidegger himself was indicted in 1729 as arch promoter of vice and immorality, but the masked evenings continued. The only concession to the popular outcry was to change the name to 'Ridotto'.[21] Thus James Bramston in 1733 wrote: 'if Masquerades displease the Town, / Call'em Ridottos, and they still go down'.[22] Wheatley notes that Hogarth's *Ticket* shows the 'interior of a large room which serves as a vestibule' to the chamber where the masquerade is held.[23] It may be intended as Heidegger's 'Long Room', the destination of maskers in *Masquerades and Operas*.

Like Hogarth, contemporary poets and playwrights focus on the lascivious opportunities and, particularly, adulterous assignations offered by such occasions. Indeed, one poet describes an ironically happy flirtatious meeting of a man and wife in disguise.[24] Playwrights were fond of staging a scene, as Charles Johnson does, in 'a Masquerade-Room in Imitation of that in the Hay-Market' with 'several People in Masquerade' (*The Masquerade*, 1719).[25]

Hogarth employs pictorial devices and emblems, some rather original, in his *Masquerade Ticket*. The lion and unicorn lying on their backs (on either side of a clock with the face of Heidegger on its dial) allude to George II's patronage of masquerades.[26] The large room is flanked by the signs 'Supper below' on either side, the 'pair of Lecherometers', and the altars and distorted statues of Priapus and Venus/Cupid. The emblematic furniture emphasises the mechanical nature of lechery at these affairs, which in turn discloses the dubious pleasure of the masquerade itself. For instance, the left 'Lecherometer' indicates degrees of potential 'Expectation Hope Hot desire Extreem Hot Moist Sudden Cold [*sic*]', while the one on the right indexes 'Cool Warm Dry Changable Hot moist Fixt [*sic*]'.

Stage treatments speak frankly of the enterprising sexual intrigues made possible by these events. The opening dialogue of Johnson's *The Masquerade* attributes the origin of the custom to the refined

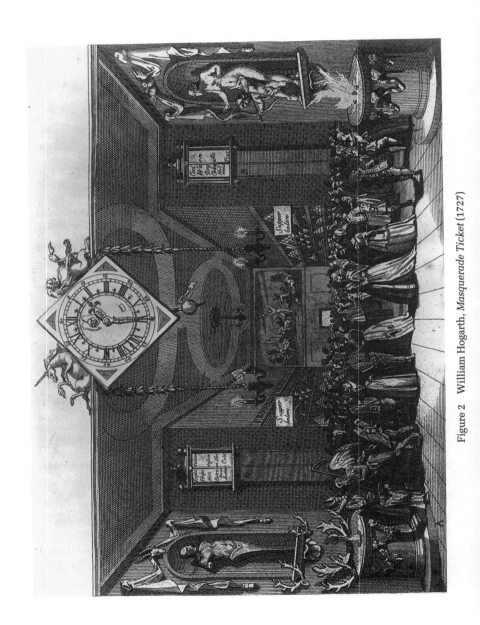

Figure 2 William Hogarth, *Masquerade Ticket* (1727)

class. In Benjamin Griffin's two-act comedy of 1717, *The Masquerade; Or, an Evening's Intrigue*, onstage in a 'large Room for the Masquerade', a 'Reveller' comments:[27]

Well, to carry on an Intrigue with an Air of Secresy, to debauch a Citizen's Wife, or steal an Heiress, what Contrivance in the World so proper as a Masquerade? We are allow'd to be satyrically rude to our Superiors, free with our Neighbours Wives, and talk lasciviously to the Sex in general, delighting their Fancies without the Expence of a Blush [*sic*].

Hogarth's satiric strategy in these prints of the 1720s uses stagelike settings, indoors in the *Ticket*, and outdoors in *Masquerades and Operas*, to expose the pernicious aspects of vizard evenings. He underscores what are to him negative aspects of such public entertainments by adding visual emblems and verbal subtexts. Not long after, he calls upon all of these strategies in his satire of theatre management, *A Just View of the British Stage*.

A JUST VIEW OF THE BRITISH STAGE
(December 1724, see figure 3)

In this print Hogarth devises an original mock playbill that advertises a rehearsal of his own 'new Farce' titled 'Scaramouch Jack Hall'. He thus adds to pantomime criticism a visual satire on theatre management. Both visual and verbal elements in the playbill itself attack the Drury Lane managers and the London populace for catering solely to pantomime extravaganzas without regard to more serious and 'usefull Plays'.

The playbill exemplifies Hogarth's strategy of using a particular theatrical form which becomes a fiction of his satire to convey criticism. In this case layers of theatrical values are embedded in the two-part form he gives to the playbill, a picture with an accompanying inscription beneath. His title, visible above the print, taps the contemporary pulse of theatre productions, stating: 'A Just View of the British Stage, or three Heads are better than one, Scene Newgate, by: M D–V–to.'[28] The 'three Heads' refer to managers Colley Cibber, Barton Booth, and John Wilks; DeVoto was a known scene painter; and the Newgate prison 'Scene' refers to a contemporary Drury Lane pantomime production.

Most spectators would recall John Thurmond's *Harlequin Sheppard* (performed 28 November 1724), when Cibber and his colleagues created a harlequin story based on a criminal executed that

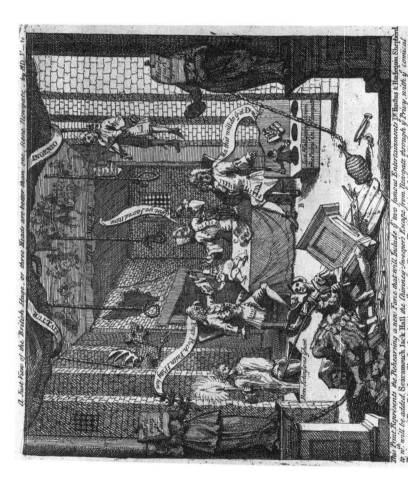

Figure 3 William Hogarth, *A Just View of the British Stage* (1724)

year. In spite of the notorious topical exploitation, their pantomime failed, closing after seven performances.[29] Hogarth here contributes to the lively discussion excited by the rivalry between drama and pantomime that accelerated in the early 1720s when playwrights denounced the spectacles, and dramatic satirists 'ridiculed the follies of the stage', often attacking theatre managers.[30] Paulson observes that one barb of Hogarth's *Just View* is the managers' attempt to outdo Rich in folly, and that the artist comically contrasts 'their high-flown pretensions' with their own 'real pandering' (*HGW*, 55). But I think Hogarth's target may be broader, extending to the palace walls, an idea that close scrutiny of his own playbill suggests. To see this at work, we need to look closely at the Hogarth's substantial bill of fare, which includes his own favourite dance, the hay. Here is the text of his playbill in full:

This Print Represents the Rehearsing a new Farce that will Include y^e two famous Entertainments D^r. *Faustus* & *Harlequin Shepherd* to w^ch will be added *Scaramouch Jack Hall* the Chimney-Sweeper's Escape from Newgate through y^e Privy, with y^e Comical Humours of *Ben Johnsons Ghost*. Concluding w^th the Hay-Dance Perform'd in y^e Air by y^e Figures A, B, C, Assisted by Ropes from y^e Muses. Note, there are no Conjurors concern'd in it as y^e ignorant imagine. The Bricks, Rubbish &c. will be real, but the Excrements upon *Jack Hall* will be made of Chew'd Gingerbread to prevent Offence. Vivat Rex. Price six pence. (*HGW*, 55)

This mock playbill may be a piece of Hogarth's subtlest politico-cultural satire. 'Vivat Rex' was customary for playbills at Theatres Royal ('Rex and Regina' for double monarchs), but on this occasion, the phrase implies that the taste derives not only from the diverse views of the *hoi polloi*, or even management, but from royalty itself. And it did. Both George I and George II commanded and were present at many pantomimes, equilibrist shows, and freak acts, as the *London Stage* calendar enumerates.

Hogarth manipulates stage format and content here, creating a conglomerate form that simultaneously documents taste in the period and hawks a new production. There are elements in the scene Hogarth does not mention in the inscription, such as the flying dragon and fiddler playing 'Music for y^e What Entertainment', a likely reference to John Gay's *The What D'Ye Call It*, a dramatic satire (also in rehearsal form) with assorted ghosts. Crudely nailed on the headless proscenium statues, doubtless representing the demise of comedy and tragedy, are the titles 'Harlequin D. Faustus'

(left) and 'Harlequin Shepherd' (right). He thus attacks the stress on machines, extravagant transformation, risings and sinkings of characters and objects, engineered to hold the eyes only.

Puppet shows are one wooden amusement Hogarth targets as he depicts each manager with a puppet in hand. Everything, indeed, is now mechanical, including inspiration. The caption in Cibber's mouth, 'Assist ye Sacred Nine', acknowledges ironically the traditional invocation to the muses who are dimly outlined in a mural above the managers' heads. But the hanging ropes suggest that the theatremen need to be pulled up to the muses, and that they themselves are puppets.[31] Hogarth's main point, of course, is that the Drury Lane managers must look to increasingly gross props instead of ideas for inspiration, and their abundance on the stage underscores this point.

Hogarth here aligns himself with stage and page critics of the day. A similar protest appears in an anonymous farce of 1724, *The British Stage: or, The Exploits of Harlequin*, an 'After-Entertainment for the Audiences of HARLEQUIN Doctor Faustus, and the NECRO-MANCER'.[32] A set of verses on the title page lists the same paraphernalia Hogarth criticises in *Just View* and *Masquerades and Operas*:

> Here you've a Dragon, Windmill, and a Devil,
> A Doctor, Conjurer, all wond'rous civil;
> A Harlequin, and Puppets, Ghosts, and Friends,
> And Raree-Show to gain some Actors Ends:
> So perfectly polite is grown this Town,
> No play, without a Windmill, will go down.

The author explains in his preface that he had not expected to see puppets, dragons or windmills, but found them meeting with 'far greater Applause than the most elegant Play that ever appear'd upon the British Theatre' (p. vi). Like Hogarth, the critic writes his own 'Dramatick Piece' to expose the senselessness of public approval of risings and sinkings of windmills, dragons, and the like. The stage characters and critical dialogues correspond remarkably to Hogarth's visual satire in matter and manner. At one point, 'Windmill' says to 'Dragon': 'Then the Harlequin Conjurer jump'd over the Moon, without breaking his Shins – We had Shades that could sing, and Ghosts which could dance; Puppets that were Men, and Men who were Puppets' (p. 3).

Regardless of contemporary dramatic and stage parallels that can be drawn, Hogarth creates a new work. His *Just View*, which

simultaneously puffs and presents his own stage satire, comes much closer to the text of John Thurmond's *Faustus* pantomime[33] than to Rich's version (the *Necromancer*) at Lincoln's Inn Fields. The Rich entertainment relies less on mechanics and harlequinade, but contains more dialogue. The other pantomime mentioned by Hogarth on his playbill – Thurmond's *Harlequin Shepherd* – lacks textual parallels, though a frontispiece to the first edition shows a privy, a barred window and a broken wall.[34] Moreover, Hogarth's theatrical satire is much closer in words and picture to the anonymous *British Stage* of the same year than to those shows more often associated with it.

The artist manipulates traditional and novel props on his boards: statuary, trap doors, curtains and drops. He shows how they are being pressed to grotesquerie as one manager lowers a puppet of Jack Hall into the 'Privy'. The strategic ploy of a stage setting (either imagined or real) was applied again and again by Hogarth. In the 1740s, he devises a crowded stage to attack the popularity of continental dancers.

CHARMERS OF THE AGE (1741/2)

A number of years later he thus lashes at another 'reigning folly' – London's vogue for imported dancers – in his sketch of the Frenchman Desnoyer and the Italian Signora Barberini, dancers he calls *Charmers of the Age* (1741/2, see figure 4). Stylistic strategies of satire in this work show continued use of a stage setting (more generic in this case), and examples of his own aesthetic theory of linear humorous effects. In expounding this theory, and in his lively commentary on the art of dancing in the *Analysis*, Hogarth refers frequently to London stage dancers.[35]

English criticism of continental performers goes back at least to Jeremy Collier, but was kept alive into the early decades of the century. For one, *The Occasional Paper* in 1719 discusses Collier's views, with the observation that many 'Musicians and Players of late' have 'found their way hither from foreign Parts'.[36]

Theatrical dance was the London craze by the early 1740s, to the extent that the houses required resident ballet-masters. M. G. Desnoyer worked at Drury Lane from 1735 to 1740 (*LS*, 3, clxxix). He has been identified as the ballet master Hogarth caricatures here, along with Barberini, whom Desnoyer had introduced to audiences at Covent Garden in October 1740 (*LS*, 3, II, 857 and *HGW*, 111).

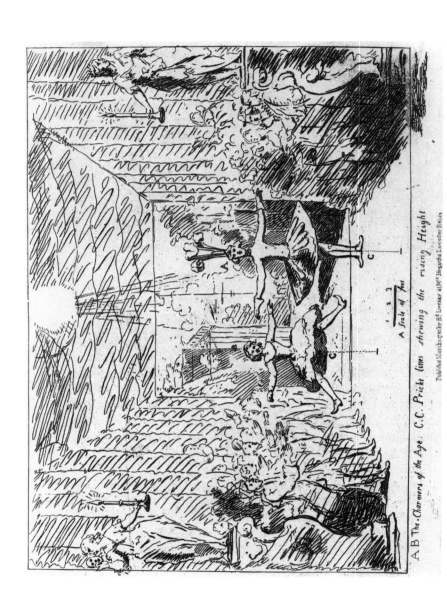

A.B The Charmers of the Age. C.C. Prickt lines shewing the rising Height

A Scale of Feet

Publisht March 19 1741 by R.t Livesay & M.rs Hogarth Leicester Fields

Figure 4 William Hogarth, *Charmers of the Age* (1741/2)

Linear angular effects produced by the body were by Hogarth's own theory comic, not aesthetically pleasing. Specifically, he claims that when the body's form is divested of serpentine lines, it becomes 'ridiculous as a human figure' (*Analysis*, 158). Hogarth draws Barberini leaping off the stage in an exaggerated manner, her legs spread out horizontally, the linear effects of which he considers 'ridiculous'. The male dancer, possibly performing a 'Pirouette', drawn to emphasise the perpendiculars of legs and arms, creates an effect of straight lines, similarly 'ridiculous'.

Whether or not Hogarth intended an obscene pun in this drawing, his allegiance is to the serpentine line and its related pictorial theory of humour outlined in the *Analysis*.[37] The more that serpentine lines are excluded in a dance, he claims, the more 'low, grotesque and comical' it becomes (*Analysis*, 158). Thus, ironically called 'Charmers', his inelegantly exaggerated figures become grotesque caricatures.

Hogarth strategically creates, moreover, a stage space large enough only for two, a visual sign that the overriding popularity of continental dancers was literally crowding English drama off the stage. In the 1730s and 1740s dancing was so popular that formal ballets were included in pantomimes and offered separately between acts. By mid-century, each patent theatre employed a 'ballet master', a 'premiere danseuse, and a company of from ten to twenty dancers' (*LS*, 4, cxxv).

Barberini's initial success may be judged by an increase in house receipts that more than tripled (*LS*, 3, II, 857). The Covent Garden playbill for her English debut indicates that the managers expected large audiences at this command performance: 'Tis humbly hop'd no Person will take it ill their being refused Admittance to the Music Room; the Dances depending greatly on the same being kept entirely clear' (*LS*, 3, II, 857). Five nights later, on 30 October 1740, at another command performance, management was even more specific about ensuring room for Barbarini and Desnoyer: 'The Performance of the . . . Entertainment depending greatly on the Orchestra and the Stage being kept entirely clear'. No spectators were to be admitted behind the stage scenes (*LS*, 3, II, 859).

It is entirely possible that Hogarth had these popular premiere performances in mind when he depicted the applauding spectators onstage, standing very close to the dancers, clearly behind the scenes. The irony increases with knowledge of the managers' requests to clear the stages for these dancers.

* * *

In each of the theatrical satires, Hogarth becomes the imaginative critic of a multi-faceted theatrical world. His style in these works utilises the eighteenth-century theatre and its values as he attacks contemporary taste in entertainment. He specifically uses its forms and milieu as stylistic signs.

Masquerade Ticket underlines the lecherous motivation of masquerades. But operas and masquerades are pernicious in their effect on stage production, driving serious plays off the boards and into wheelbarrows for waste paper or toilets in *Masquerades and Operas*. And though Hogarth praises dancing from the minuet to the country 'hay' in the *Analysis*, he indicts the dancing of French ballet masters and dancers as awkward and absurd, along with public taste, shown as an overcrowded stage audience applauding dancers' acrobatic feats in *Charmers of the Age*.

In *A Just View*, Hogarth 'draws the scene', opening for us a stage darkened with bad taste, the only light coming from a feeble ghost. Everything depends on false appearances, or 'gingerbread'. For one thing, the men rehearsing are managers, not actors. Hogarth engineers stage and green room conventions, along with thematic elements such as the rehearsal and masquerades. Thus he attacks the empty sensationalism prevalent on the London stages that he felt was driving legitimate drama into waste-paper bins. This trend his patrons would readily acknowledge; whether or not they would alter their 'reigning folly' is less easy to know.

This approach to Hogarth's satiric strategies is not meant to ignore the graphic conventions he employs as well, but rather focuses on the theatrical values in form and content he so explicitly enumerated in his own writings about his art. He was always alert to the nature of theatre and the causes of its effects.

In explicit efforts to alter cultural focus and restore what he calls 'the fruitfull Theatre of old' in these four works, Hogarth creates visual statements of satiric intent, dressed in fictions familiar to his audiences from their evenings at operas, masquerades, pantomime performances, and other entertainments. Without this common and settled base, his satire would lack potency.

In his 'lashing' of contemporary taste, Hogarth takes his place among the Augustan satirists of his day, employing with originality the traditions of theatre and literature as stylistic strategies of satire in a pictorial form. To this he adds his own linear theory of humour. For optimal effect, he relies upon a shared body of

cultural tastes, and sharp awareness in his viewers of theatre and drama conventions. By exaggeration, he points out the failings of a culture falling into the quicksand of mindless and escapist spectacle, blindly following the lead of profit-oriented managers who lure them to ambiguous pleasures. Thus he attempts to disturb (and hence correct) the age's self-images in dramatic art and theatrical taste.

Hogarth's extensive use of theatre in the visual domain demonstrates that these stylistic strategies are more rather than less common to modes of expression in general. The use of theatre as a subject, the satirical fiction of its foibles, and specific stage conventions, all elements in Hogarth's style, appear in contemporary literature and criticism as well. The four works examined reveal Hogarth's heightened use of shared structures in the arts for rhetorical and persuasive purposes. His theatrical satires in particular illuminate this, since he employs the form of theatre in an attempt to alter its content.

NOTES

1 *The Elements of Life: Biography and Portrait Painting in Stuart and Georgian England* (Oxford: Clarendon Press, 1990), pp. 4 and 179.

2 Princeton University Press, 1983. Citations in my text are drawn from this edition.

3 See Klinger Lindberg, 'William Hogarth's Theatrical Writings: The Interplay Between Theatre, His Theories, and His Art', *Theatre Notebook* 47:1 (1993), pp. 29–41.

4 This is not to ignore other aspects of Hogarth's style, such as his infusing standards such as history painting with vitality by creating new subjects for art, depicting occurrences of everyday life, employing art to illustrate his own theories of beauty and humour, and focusing on social topics and themes depicted in ways that support his own views of society.

5 For links between the London stage and Hogarth, see Mary Klinger, 'William Hogarth and London Theatrical Life', *Studies in Eighteenth Century Culture*, 24 vols. (Madison: University of Wisconsin Press, 1975), vol. V, pp. 11–27, and 'Dramatic Analogues in William Hogarth's *Marriage à la Mode*', in Joachim Möller, ed., *Hogarth in Context: Ten Essays and a Bibliography* (Berlin: forthcoming).

6 'Hogarth and the Traditions of Satire', *Humanities Association Review* 31 (1980), pp. 67–85.

7 See Blair's 'Hogarth's Comic History-Paintings and the Satiric Spectrum', *Genre* 9 (1976), p. 10. Ronald Paulson, *Breaking and Remaking: Aesthetic Practice in England, 1700–1820* (New Brunswick and London:

Rutgers University Press, 1989), notes 'idolatry is quite literally the theme of Hogarth's satires', p. 167.

8 'Theatrical Satire: A Protest from the Stage Against Poor Taste in Theatrical Entertainment', in Peter Hughes and David Williams, eds., *The Varied Pattern: Studies in the 18th Century*, I. Publications of the McMaster University Association for 18th-Century Studies (Toronto: A. M. Hakkert, Ltd., 1971), p. 121.

9 Robert Hume considers *Eurydice Hissed* a 'topical satire', and *The Author's Farce* between 'Burlesque and Topical Satire', *Henry Fielding and The London Theatre 1728–1737* (Oxford: Clarendon Press, 1988), p. 257.

10 I use Paulson's dates for these works in his 'Catalog', *Hogarth's Graphic Works* (London: The Print Room, 1989). Future references in my text are abbreviated as *HGW* followed by page number.

11 Blair, 'Hogarth's Comic History-Paintings', p. 10.

12 Peter Lewis, *Fielding's Burlesque Drama: Its Place in the Tradition*, University of Durham Series (Edinburgh University Press, 1987), p. 206.

13 'Theatre, Related Arts, and the Profit Motive', *British Theatre and the Other Arts, 1660–1800* (Cranbury, N.J.: Associated University Presses, Inc., 1984), pp. 33–6 and *passim*.

14 *Autobiographical Notes*, in Joseph T. A. Burke, ed., *The Analysis of Beauty with the Rejected Passages from the Manuscript Drafts and Autobiographical Notes* (Oxford: Clarendon Press, 1955), p. 205.

15 'Shakespeare in the Periodicals', *Shakespeare Quarterly* 3:4 (October 1952), p. 315.

16 Fielding attributes to 'Curiosity' that which 'sends the British fair':

> To see Italians dance in air,
> This crowds alike the repr'sentation
> Of Lun's and Bullen's coronation.
> By this embolden'd, tim'rous maids
> Adventure to the masquerades.

See *The Grub Street Opera . . . To which is added, THE MASQUERADE, A POEM Printed in MDCCXXVIII*. LONDON, Printed, and sold by J. Roberts, MDCCXXXI. Also see Terry Castle, 'Eros and Liberty at the English Masquerade, 1710–90', *ECS* 17:2 (1983/4), pp. 156–176, and *Masquerade and Civilization* (Stanford University Press, 1986), *passim*.

17 'Dancing and Pantomime on the English Stage, 1700–1737', *Studies in Philology* 31 (1934), pp. 451–2.

18 *Hogarth to Cruikshank: Social Change in Graphic Satire* (New York: Walter, 1967), p. 21.

19 Also see Ronald Paulson, *Hogarth: 'The Modern Moral Subject' 1697–1732*, 3 vols. (New Brunswick and London: Rutgers University Press, 1991), vol. I, pp. 168–9. References are abbreviated *Hogarth* followed by volume and page.

20 Frederick Antal, *Hogarth and His Place in European Art* (New York: Basic Books, Inc., 1962), p. 74, comments that the 'playful Lion and Unicorn placed over the clock are a further reminder of the future King's

predilection for masquerades'. Fielding observed of Heidegger in 'The Masquerade' (lines 155–8): 'So, for his ugliness more fell, / Was H – d – g – r toss'd out of hell, / And, in return, by Satan made / First minister of's masquerade [*sic*]' (see note 16 above, *The Grub Street Opera*).

21 H. B. Wheatley, *Hogarth's London* (London: Constable & Co., Ltd., 1909), p. 354.
22 'The Man of Taste', ed. F. P. Lock (Los Angeles: William A. Clark Memorial Library, Augustan Reprint Society Publication No. 171 (1975), p. 13.
23 Wheatley, *Hogarth's London*, p. 352.
24 Anonymous, *The Masquerade* (London: Printed for J. Roberts, 1724). Stanzas 20–4 describe the adventures of 'A loving Pair, that long were wed, / But seldom lay in the same Bed' (lines 9–10).
25 London, Printed for Bernard Lintot, 1719, act III, scene i.
26 Wheatley, *Hogarth's London*, p. 353.
27 'SCENE', act II (London: Printed for J. Sackfield, 1717), p. 22. Castle also comments on this play in 'Eros and Liberty', p. 156.
28 Paulson notes this print was announced as published on 10 December 1724 in the *Daily Post* (*HGW*, 55).
29 *The London Stage, 1660–1800*, parts 1–4 (Carbondale: Southern Illinois University Press, 1962–8), 2, II, 797. References to the calendar are cited in my text as *LS* followed by part, volume, and page number.
30 'The Defense and Criticism of the Pantomimic Entertainment in the Early Eighteenth Century', *English Literary History*, 5 (1938), p. 127.
31 Sean Shesgreen also makes this point in *Engravings by Hogarth* (New York: Dover Publications, Inc., 1973), pl. 4.
32 London, printed for T. Warner, 1724. References in my text are drawn from this edition.
33 The title of Thurmond's piece is *Harlequin Doctor Faustus: With the Masque of the Deities* (London: Printed for W. Chetwood, 1724). Rich's *Faustus* is entitled *A Dramatick Entertainment call'd the Necromancer: or, Harlequin Doctor Faustus*. For a comparison of the two pantomimes which emphasises Rich's use of music and dance, see John McVeagh, ' "The Subject of Almost All Companies": A New Look at the Necromancer', *Theatre Notebook* 45:2 (1991), pp. 55–70.
34 See *Harlequin Sheppard. A Night Scene in Grotesque Characters . . .* (London: 1724) [Huntington K-D 196]. The frontispiece is supposed to depict a cell in Newgate; it shows a barred window, cracked brick wall, and a privy. *Harlequin Sheppard* failed, giving only three performances at Drury Lane in November 1724.
35 See Klinger Lindberg, ' "A Delightful Play upon the Eye": William Hogarth and Theatrical Dance', *Dance Chronicle* 4:1 (1981), pp. 19–45. Also see above, note 14, *The Analysis* and the *Rejected Passages*.
36 'Of Plays and Masquerades' (London: printed for E. Matthews, 1719), act III, p. 15.
37 Obscenity may also be an effect of the intensified angularity to make the performers ludicrous. See *HGW*, 111.

Style in architecture: the historical origins of the dilemma

J. MORDAUNT CROOK

Architecture is two things: it is service and it is art. It has to work and it has to be seen to work. It is building and an image of building; structure and an image of structure. An architect is thus both a builder and an image-maker, and style in architecture is just a way of building codified in imagistic form. In simply organised societies – communities with unitary cultures – there is no radical choice of image. Style is still a vernacular medium, not a product of aesthetic preference. But between the disintegration of the classical tradition in the second half of the eighteenth century, and the rise of the Modern Movement in the first half of the twentieth century, architects were faced with a choice – in many cases a multiple choice – between alternative images, alternative codes, alternative systems of design, alternative styles. That choice I have called *The Dilemma of Style*.[1] This chapter is a summary of my findings as regards its historical origins.

In brief the stylistic dilemma was a product first of the Renaissance (which gave us the idea of individual style), and then of Romanticism (which gave us the idea of a multiplicity of styles). The dilemma strikes first – historically speaking – in England, where Romantic taste found particular expression in the formulation of the Picturesque aesthetic. That was the historical phenomenon which lay at the root of the dilemma of style.

The word 'picturesque' derives from the Italian *pittoresco*, meaning 'in the manner of painters'. The work of a group of seventeenth-century French and Italian masters, chiefly Claude Lorrain, Salvator Rosa, and Gaspard and Nicolas Poussin, made such an impression on early eighteenth-century Grand Tourists that it conditioned the Englishman's way of seeing for more than one hundred years. Historians, however, have tended to speed up the

pace of this conceptual change. By using a teleological telescope, they turn 'picturesque' (an early eighteenth-century term: 'as in a picture') into 'the picturesque' (a latter eighteenth-century label involving the aesthetics of untamed scenery). Still, both sets of mind overlap and coalesce; operating together in the writings of William Gilpin. By the second half of the century, through the polemics of Uvedale Price, Richard Payne Knight, and Humphry Repton, the Picturesque had become established as a set of visual criteria based on pictorial values. Hence the aesthetics of the landscape garden. What links the early phase and the later – the emblematic and the expressive garden, William Kent and Capability Brown – is a continuous feeling for the garden as theatre, the reciprocity of setting and spectator, the aesthetic dynamic of landscape in action. In all this, architecture plays a secondary, scenographic role. And therein lies the origin of the dilemma: style had become not an expression of structure but simply a pictorial allusion.

It was in the area of romantic landscape that the idea of appropriate form, that is a style appropriate to a particular context, first came to fruition. Of course the idea had a long history. Vitruvius endowed the different classical orders with distinct characters – masculine Doric, matronly Ionic, and so on – establishing a classical tradition of decorum, or manner, and thus variation and stylistic differentiation; ideas which in turn were developed in eighteenth-century France. J.-F. Blondel explained the appropriate use of style as a kind of 'colouration', 'the poetry of architecture'. 'In a word', he suggests, 'style . . . enables the architect to create a sacred genre, a heroic one, a pastoral one'. Ledoux took such ideas of stylistic expression a good deal further, designing buildings such as his notorious phallic-shaped brothel, or his barrel-shaped house for a cooper or barrel-maker, which are themselves three-dimensional metaphors. Architecture thus becomes a symbolic language. In eighteenth-century England, where Neo-Palladianism was, by definition, a conscious stylistic choice, stylistic symbolism never developed in such a literal way. Nevertheless the range of stylistic reference widened considerably as part of the furniture of the landscape garden. At Stourhead, Wiltshire (1744 onwards), for example, architectural features included a Turkish tent, a Chinese Alcove and Umbrello, a Rustic Cottage (see figure 5), a Roman Pantheon, a 'Convent in the Wood', a Tuscan Temple of Flora, a Temple of the Sun modelled on the original at Baalbeck, as well as medieval fragments salvaged from nearby Bristol.

Figure 5 John Carter, *Rustic Cottage*, Stourhead, Wiltshire (1806)

In effect, the Rococo, or Poetic, or Emblematic garden of the early eighteenth century revived in Augustan England the apparatus of the ancient Roman garden, via surviving Renaissance examples. This apparatus was then turned into pictorial form and naturalised by absorption into a different climate and a different agricultural context. The romantic garden emerged not just as a paratactic art – that is a sequence of stage sets designed for peripatetic spectators – but as a kinetic art in four dimensions. The mobile spectator not only experienced the three-dimensionality of landscape, he was also carried back through time on a magic carpet of associations. Through the multiplication of *fabriques* – garden structures designed as triggers to the imagination – these landscapes of romance became four-dimensional memory-banks. Surrounded by temple, ruin, hermitage, or grotto, the receptive spectator was wafted through time and space by means of his manipulated imagination. As at Duncombe Park, Yorkshire, where a sinuous walk between classical temples overlooks the ruins of Rievaulx Abbey: 'space-time', by association.

William Kent's landscape buildings – the Praeneste Monument (1739) at Rousham, for instance – are chiefly informational, or emblematic: their allusions require explanation. Capability Brown's landscape buildings, by contrast, are chiefly affective and expressive; as at Stowe, where he smoothed down the work of Bridgeman and Kent: the landscape forms are naturalistic, and the temples less obtrusively allusive. One contemporary, Thomas Whateley, described Brown's landscapes as having 'the force of a metaphor, free from the details of an allegory'. Repton's garden buildings – the Camellia House at Woburn, Bedfordshire (*c.* 1806), for instance – are different again: they do furnish a landscape but they also make concessions to utility, or at least amenity.

But despite their differences, the landscape buildings of Kent, Brown, and Repton all convey messages. Hence their emphasis on style. Stylistic choices act as triggers to the imagination: to conjure up a memory, to reinforce a mood, to express a specific purpose or ownership, or simply to focus a landscape and create a sense of place. In this way, the notion of appropriate character in architecture – the idea of a style for each mood, and a mood for each style – eventually emerged full-blown as the theory of architectural association.

The philosophy of association can be traced back at least to the seventeenth century, to Thomas Hobbes' *Human Nature* (1640), and more especially, to John Locke's explanation of mental processes in

his *Essay Concerning Human Understanding* (1690: 4th edn. 1700). Locke's theories were popularised by Joseph Addison in *The Spectator* of 1712, and refined in David Hartley's *Observations* (1749). But it was the Scottish school – Hume and Hutcheson, Gerard, Kames, Dugald Stewart, and Archibald Alison – who built on Locke's psychology and developed a consistent theory of associationist aesthetics. 'All beauty' noted Hutcheson in 1726, 'is relative to the sense of some mind perceiving it'. 'Beauty', Hume concluded in 1757, 'is no quality in things themselves; it exists merely in the mind which contemplates them . . . Each mind perceives a different beauty'. That – despite equivocation – was the basis of Burke's view.

Archibald Alison is often given the credit for the propagation of these ideas. But he was not well known South of the Border until noticed by Francis Jeffrey in the *Edinburgh Review* of 1811. 'There is no such thing as absolute or intrinsic beauty', Jeffrey concludes, 'it depends altogether on . . . associations . . . All tastes [if not all men of taste, are therefore] equally just and correct'. Universal standards of taste, therefore, had no foundation except in 'universal associations'.

This rejection of the idea of objective standards of beauty, or absolute values, had the significant effect of displacing Classicism as the universal style. Classical harmonies were no longer the eternal verities of architectural taste: architecture was no longer synonymous with classical architecture. In a kind of aesthetic Reformation, private judgement – in this case stylistic multiplicity – triumphed over prescriptive authority. So much so, that the mysteries of classical proportion came popularly to be regarded as a forgotten secret. 'A rule of proportion there certainly is', lamented William Gilpin in 1792, 'but we must inquire after it in vain. The secret is lost. The Ancients had it. They knew well the principles of beauty; and had that unerring rule, which in all things adjusted their taste . . . If we could only discover their principles of proportion . . . ' In fact, even by 1792, the Vitruvio-Palladian system of proportional harmony was not quite lost. Architectural skill was still thought to consist in the manipulation of standardised components. But there had been a distinct shift in aesthetic attitudes: from objective to subjective, from the pursuit of harmony to the cult of sensibility, from absolute standards to relative values, from unitary style to plurality of choice, from mimetic to expressive, from classic to eclectic. This shift of taste has been called Romanticism.

Although Alison's personal taste was basically Neo-Classical, his associationist theories opened the way to stylistic agnosticism, and thus to a veritable Pandora's box of stylistic choice.

It was Payne Knight who produced the definitive statement of associationist thinking:

As all the pleasures of intellect arise from the association of ideas, the more the materials of association are multiplied, the more will the sphere of those pleasures be enlarged. To a mind richly stored, almost every object of nature or art, that presents itself to the senses, either excites fresh trains and combinations of ideas, or vivifies and strengthens those which existed before: so that recollection enhances enjoyment, and enjoyment heightens recollection . . . [For example] a person conversant with the writings of Theocritus and Vergil will relish pastoral scenery more than one unacquainted with such poetry. [And a] spectator [whose] mind [is] enriched with the embellishments of the painter and poet . . . [feels] beauties which are not felt by the organic sense of vision, but by the intellect and imagination through that sense.

Hence C. R. Cockerell's compounded delight on seeing William Wilkins' recreation of a Grecian temple in a Reptonian landscape at Grange Park, Hampshire (1805–9, see figure 6): 'Nothing can be finer, more classical or like the finest Poussins . . . There is nothing like it on this side of Arcadia.'

That viewpoint had been nicely summed up some years before, in 1769, by William Gilpin, in a letter to William Mason. 'I have had a dispute lately', writes Gilpin – with Mr Lock of Norbury Park – 'on an absurd vulgar opinion, which he holds – that we see with our eyes: whereas I assert, that our eyes are only mere glass windows; and we see with our imagination'. Not a bad explanation of the physiological process by which the brain makes sense of the images transmitted to it by the eye.

Ruins were the most obvious stimuli. These 'towers and battlements', noted Sir Joshua Reynolds in 1786, these 'Castles of Barons of ancient Chivalry', bring 'to our remembrance ancient costume and manners', and 'give . . . delight . . . by means of association of ideas'. 'Real ruins', explained Whateley in 1790, produce the best 'effects . . . but [effects] are [also] produced in a certain degree by [ruins] which are fictitious; the impressions are not so strong, but they are exactly similar'. One of the first of these mock-ruins was King Alfred's Hall, Cirencester Park, Gloucestershire (1721, see figure 7).

Figure 6 William Wilkins, *Grange Park*, Hampshire (1805–9)

I. Taylor sculp

Figure 7 *King Alfred's Hall*, Cirencester Park, Gloucestershire (1721 onwards)

In 1772 Sir William Chambers noted that the Chinese had thought of the same thing long before:

They are fond of introducing [into their gardens] statues, busts, bas-reliefs . . . [for] they are not only ornamental but . . . by commemorating past events, and celebrated personages, they awaken the mind to pleasing contemplation, hurrying our reflections up into the remotest ages of antiquity . . . their aim is to excite a great variety of passion in the mind of the spectator.

For Chambers, such excitements – what Gilpin and Knight called 'the chain of ideas' – formed the basis of architectural aesthetics, and Kew Gardens became an advertisement for his theories. Besides his famous Chinese Pagoda (1761–2), there was a ruined Roman Arch (1759–60), Ionic temples of Victory (1759) and Peace (1763), Tuscan temples of Aeolus (*c.* 1760; 1845) and Bellona (1760), a Mosque and an Alhambra – all by Chambers – as well as a Gothic Cathedral (1753–9) and Moorish Alhambra (1750; 1758) by J. H. Muntz; a Palladian bridge, and a House of Confucius (designed *c.* 1750 by Goupy or Chambers with furniture by Kent). Queen Charlotte's Cottage (1770; 1805) adds a final touch of vernacular rusticity.

So all styles were grist to the associationist mill. But were they all equally appropriate? As early as the 1730s and 1740s, at Stowe, Gothic and Grecian styles had been used symbolically. Antique ideals were expressed in classical symbols: Ancient Virtue took the shape of a classical temple (Kent, 1734); while ancient English liberties took on Gothic forms, as in Gibbs' Temple of Liberty (*c.* 1740–4), with its ceilings emblematic of the Saxon Heptarchy.

Lord Kames, whose *Elements of Criticism* (1762) developed Hume's 'Association of Ideas', distinguished – rather speciously – between the impact of Greek and Gothic ruins. 'Should a ruin', he asked, 'be in the Gothic or Grecian form? In the former, I think; because [a Gothic ruin] exhibits the triumph of time over strength; a melancholy but not unpleasant thought: a Grecian [or Roman] ruin suggests rather the triumph of barbarity over taste; a gloomy and discouraging thought'. But Kames did concede that beauty in architecture was twofold: relative and intrinsic – intrinsic beauty consisting in proportion and harmony; relative (or extrinsic) beauty consisting in a building's fitness for purpose or contextual relevance. For example, he thought Inverary Castle (1745 onwards) appropriately Gothic because of 'the profuse variety of wild and great objects'

in the vicinity. Dr Johnson was more forthright: 'What I admire here', he boomed, 'is the total defiance of expense'. In fact, Kames and Johnson were both right: Inverary is a symbol of wealth and power – a trigger of neo-feudal emotions – but it is also a symptom of habitual stylistic preference, in other words, taste.

But it was Humphry Repton who made stylistic differentiation popular. Repton was less concerned with symbols than with pictorial impact; he was concerned to maximise – partly through architecture – the picturesqueness of a given site: to bring out the genius of the place. He showed first how Grecian, Gothic, or Castellated trimming could change the nature of otherwise identical buildings, and then how Grecian and Gothic compositions suited different settings. Grecian suited a site which was pastoral or Arcadian; Gothic maximised the pictorial impact of a setting which was already Picturesque, and could, in turn, be divided into 'castle Gothic' and 'abbey Gothic'; 'castle Gothic' for a rocky eminence, 'abbey Gothic' for a fertile valley. In his *Sketches and Hints on Landscape Gardening* (1795), Repton had already pointed out that irregular Gothic houses looked best surrounded by deciduous trees; classical buildings looked best surrounded by 'spiry-topped' or coniferous trees. Partly that was due to contrast: the horizontal lines of Greek architecture contrasted well with vertical pines and cypresses. Partly, however, he admits the effect is due to association: 'the ideas of Italian paintings [or paintings on Italian themes], where we often see Grecian edifices blended with [pines], firs and cypresses'.

In Repton's writings, the choice of style in landscape or garden building is dictated as much by considerations of status, situation or use as by historical associations. He recommended a rustic hut for a primeval forest; an irregular Gothic house for an irregular landscape, as at Luscombe, Devon (1800–4); a cottage orné, as at Endsleigh, Devon (1800–11), for a small-scale, variegated landscape; or a seat in the manorial style – Haddon Hall being the ideal – for the sort of place where 'the Lord of the Soil resides among his tenants'.

Repton was certainly an eclectic. But he was an eclectic in taste rather than an eclectic in style: he never developed the idea of synthesis. 'To add Grecian to Gothic, or Gothic to Grecian', he wrote, 'is equally absurd'. The result would be a mere 'pasticcio, or confusion of discordant parts'. He preferred to think of himself as a stylistic utilitarian. At Plas-Newyd, for instance, he used the idea of a cathedral chapter-house to produce a charming green-house-cum-prospect-pavilion – especially delicious by moonlight – on the basis

that conservatories particularly suited the 'flat Gothic arch of Henry VIII', an arch which admitted more light.

Repton's ideas can be traced through a whole series of publications on Picturesque design, by Plaw, Malton, Elsam, Lugar, Gandy, Papworth, Goodwin, and others, but particularly in the writings of J. C. Loudon. Now Loudon was enough of a radical – in social and aesthetic matters – to talk wistfully of the fading away of style: traditional taste, he believed, would eventually go the way of traditional social attitudes. However, this withering away of the empire of style never actually happens: Loudon's *Encyclopedia* – with all its multitude of styles – remains a monument to bourgeois taste.

It was Richard Payne Knight who developed the idea of stylistic eclecticism. 'In the pictures of Claude and Gaspar', he notes, 'we perpetually see a mixture of Grecian and Gothic architecture employed with the happiest effect in the same building, and no critic has yet objected to the incongruity of it'. Such a 'miscellaneous', or 'mixed style', Knight recommends as 'the best style for irregular and picturesque houses'. He designed his own house, Downton Castle, Herefordshire (1771–8), to be 'Gothic . . . without, and Grecian . . . within'. In consciously propagating synthesis rather than accumulation, Knight was well ahead of his contemporaries, and his synthesis set out to be consciously modern. 'The design of almost every age and country', he wrote, 'has a peculiar character . . . [every house] should . . . maintain the character of a house of the age and country in which it is erected'. That Proto-Hegelian notion – what Summerson once called 'the Mischievous Analogy' – had a long life ahead of it.

In the early eighteenth century – the cultural watershed when nature replaced religion as the motive force for creative artists – the cult of styles had become rooted in the soil of the Romantic landscape. But it was not until the early nineteenth century that choice developed into conflict. The first uses of revived Gothic – that is Gothic as a post-vernacular image – had been determined by environmental considerations. Sir Christopher Wren's Tom Tower, at Christ Church, Oxford (1681–2), for example, was built in the Gothic mode to avoid 'a disagreeable mixture'. Hawksmoor, however, at All Souls College, Oxford (1715–40), took a major step forward in the direction of stylistic autonomy; and William Kent, at Esher, Surrey (1729–32), went one stage further, with a tentative synthesis of Gothic and Classic, indicating a shift from environ-

mental to associational design. In the work of Batty Langley, Sanderson Miller and their circle, this evolution from environmental to associational thinking is complete. Their Rococo rejoiced in severing the link between form and structure, and treated Gothic ornament simply as a species of communication – a kind of visual Morse code, tapping out the message 'medieval' – as in Henry Keene's Gothic chapel at Hartlebury Castle, Worcestershire (*c.* 1750). By comparison, the Picturesque placed less emphasis on ornament and more on pictorial impact: architectural design became basically a scenic device. Buildings were now pictorially conceived as memories in three dimensions, as at Miller's Tower on Edge Hill, Warwickshire (1747–50): there are echoes here of Guy's Tower at Warwick; but it was also designed to enshrine a statue of the Saxon hero Caractacus on the spot where Charles I raised his standard against the Roundheads, and it was ceremonially opened on the anniversary of Cromwell's death.

The habit of regarding buildings as scenery – as aggregates of separate visual units – encouraged not only irregular skylines and asymmetrical plans, but triangular, hexagonal, and octagonal features, eyecatchers and all manner of follies – John Carter's Midford Castle, Bath (1775, see figure 8), for example. Picturesque thinking was certainly an encouragement to drawing-board architecture: designing a house from the outside inwards, rather than from the inside outwards – a process of design ideal for landscape features. Carter's triangular fort is reciprocally picturesque: a building designed to be looked at as well as looked from; an example of scenographic design, based on the multiplication of points of vision.

This was a clever but dangerous game, which, in conjunction with the multiplication of stylistic choice, came near to disintegrating architectural design altogether. In the Menagerie at Woburn, Bedfordshire (1806, see figure 9), Repton suggested different styles for opposite faces of the same structure – classical for the formal approach, Gothic for the informal. Castle Ward, Co. Down (*c.* 1762), has separate Palladian and Gothic facades; Castle Goring, Sussex (*c.* 1790) is another stylistically schizophrenic house – Neo-Classical and Castellated – designed by Biaggio Rebecca for the eccentric Shelley family. Eccentric or calculated, this pursuit of optical effect lay at the root of Picturesque thinking, and threatened the disintegration of architectural composition into a mosaic of Picturesque devices.

Figure 8 John Carter, *Midford Castle*, Bath (1775)

One man whose career encompassed all styles was John Foulston of Plymouth, the leading Regency architect of the West of England. He was a Greek Revivalist who could rival Smirke, a Gothic Revivalist who could rival Wilkins. He was a town planner who could rival Nash; and he was a Neo-Classicist who could, occasionally, rival Soane. But Foulston will always be remembered for something else. He appears in every textbook as the architect of the extraordinary group of buildings at Kerr Street, Devonport, Ply-

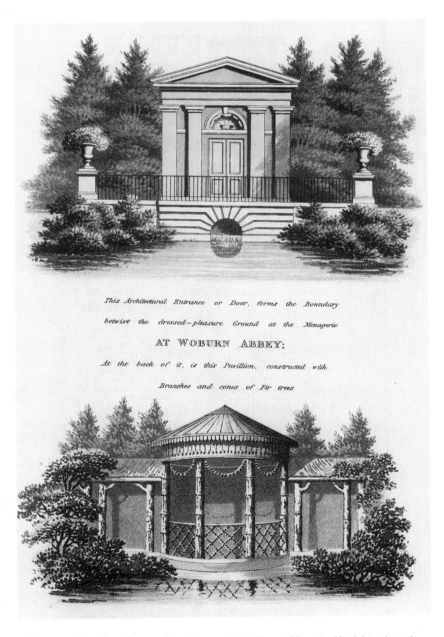

This Architectural Entrance or Door, forms the Boundary

betwixt the dressed—pleasure Ground at the Menagerie

AT WOBURN ABBEY;

At the back of it, is this Pavillion, constructed with

Branches and cones of Fir trees

Figure 9 Humphry Repton, *The Menagerie*, Woburn Abbey, Bedfordshire (1806)

THE TOWN-HALL, COLUMN, & LIBRARY, DEVONPORT.

Figure 10 John Foulston, *Town Hall, Column, Chapel* and *Library*, Kerr Street, Devonport, Plymouth (1821–4)

mouth (1821–4, see figure 10), where no fewer than five styles are simultaneously represented: a range of terraced houses in Roman Corinthian; a Greek Doric town hall and Naval Column; an 'Oriental' or 'Islamic' or 'Mohammedan' Mount Zion Chapel (now demolished); a pair of Greek Ionic houses (now also demolished); and an Egyptian Library (later, appropriately, an Oddfellows Hall).

Architecture was starting to flex its muscles for the Battle of Styles. There is a choice, but Pugin had yet to give the dilemma a moral dimension. Indeed, by the Regency period, the comparability of styles had become something of an article of faith. As Thomas Hopper put it in 1830: 'it is the business of an architect to understand all styles, and to be prejudiced in favour of none'.

Foulston's successor, George Wightwick, clearly found this urge to experiment irresistible. In 1840 he published an architectural romance entitled *The Palace of Architecture* – the first architectural coffee-table book – in which he portrays just the sort of stylistic fantasy Foulston was dreaming of, a veritable 'epitome of the architectural world'. His book, Wightwick explains, 'aspires to that station in regard to Architecture which the Novels of Scott occupy in relation to History'. The palace itself was Neo-Classical, but its gardens were the *reductio ad absurdum* of Picturesque theory; an anthology of all styles known to man: Indian, Chinese, Egyptian, Greek, Roman, Constantinal (i.e. Lombardic Romanesque), Norman, Decorated Gothic, Old English or Manorial, Tudor Gothic, Turkish, Protestant Baroque, Soanean, Anglo-Greek, and Anglo-Italian. But it was reserved for the entrance gateway to combine all these modes, in a fantastic portal compounded of fragments of all styles. 'This gateway', Wightwick explained, 'symbolises MUSEUM . . . A masonic riddle, teeming with multiplied significancy'.

Wightwick made no attempt to explain the choice of any particular style, he merely rejoiced in the fact that choice existed. But in the following year, 1841, a book appeared which did attempt such an explanation: Richard Brown's compendious volume, *Domestic Architecture*. Here every conceivable historic style is set out: cottage orné, Tudor, Stuart, Florentine, Flemish, Pompeian, Venetian, Swiss, French Chateau, Egyptian, Grecian, Roman, Anglo-Grecian (which is actually Soanic), Anglo-Italian, Persian, Chinese, Burmese, Oriental, Morisco-Gothic, Norman, Lancastrian, Plantagenet, Palladian. To assist the budding architect or patron, 'Prof.' Brown suggests that the choice of each style should be determined by purpose and situation. He illustrates in one view (see figure 11),

Figure 11 Richard Brown, 'Norman, Tudor, Grecian and Roman Residences: their appropriate situation and scenery' (1841)

appropriate landscape settings for at least four styles: a Norman castle in rugged mountains, a Tudor seat among bosky plantations, a Grecian villa in rolling woodlands – with hints of Arcadia – and a Roman (i.e. Palladian) mansion in verdant pasture – with suitable echoes of the campagna. But for the more bizarre styles, there could be no such explanation. Their choice was determined by romance rather than utility. Henry Holland's Dairy at Woburn (1792) is Chinese; Cockerell's Dairy at Sezincote (1827) is Moorish: English architects during the Regency were simply indulging their imaginations. Sezincote, Gloucestershire (c.1805), was indeed a nabob's retreat, but its 'Indian' style had no contextual relevance to the Cotswolds. 'In the midst of all this', noted John Weale in 1844, 'there was but one man, the late Sir John Soane, who dared to be positively original. All others were mad in some particular foreign fashion; but he alone was mad in his own way . . . there was a method in the old knight's madness.' Indeed there was. But half the impact of Soane's genius stems from the genius of J. M. Gandy, whose illustrations to Soane's Royal Academy lectures provide historians with their most eloquent commentary on the roots of Regency taste.

Gandy himself adopted an eclectic viewpoint. Imitation he denounced as 'unworthy of modern genius'; 'a comprehensive mind', he explains, 'will select from all sources'. Classical architects had limited themselves to 'one particular style'; we 'moderns [must] prepare a system selected from all tastes . . . [culled from] the beauties of every climate and every age'. In the whole spectrum of historic styles, Gandy believed, there must be some unifying bond; some explanation of that elusive link between style and culture. Without it there could be no hope of finding that architectural philosopher's stone: a new style for a new age. Hence his diagrammatic fantasy, *Comparative Architecture* (1836), an attempt to decode the mnemonic power of style by a codification of all styles. Here, in effect, Gandy was attempting to find a future in the past; to trace the mystic symbolism of architectural form back to its organic roots, back to its *Natural Model* (1838). Out of what he calls the primeval 'protocol of architecture', that new style would one day emerge, 'a symbolic system . . . perfect, durable, and universal.' Alas, it did not emerge in Gandy's own architecture. Some of his villa designs do indeed possess a prophetic simplicity, and as such they appealed powerfully to the Modernists of the 1930s. But in his executed work, Gandy – just as much as any of his generation – was locked into the Picturesque system.

By 1844, one commentator, John Weale, was able to identify the problem: Neo-Classicism had fallen victim to the Picturesque. In its abstract geometry, Neo-Classicism had suggested – negatively speaking – a way out of the historicist jungle. 'A feeling for what was termed "classic simplicity" pervaded every art', writes Weale, 'even our tea caddies became mere cubes of wood'. But, with the graphic revolution, 'The introduction of our richly illustrated ANNUALS administered more and more to that taste for picture which had already existed; and . . . what may be termed the romance of architecture obtained a considerable influence on the public [Salvin's stables and laundry at Mamhead, Devon, 1828–33, are an extreme example] . . . architects were now induced to leave the academical formalities of their Greek and Latin Grammars, and to cultivate . . . picturesque effects'. Hence 'the triumph of picture over geometry – the conquest of poetry over mathematics'. He meant the victory of imagination over reason; the victory of atectonic criteria over structural harmonies; the triumph of the eye over the mind: the triumph of the Picturesque.

The legacy of the Picturesque aesthetic was a stylistic jungle, in which Victorian architects wrestled with the dilemma of style. The Modernists hoped to resolve that dilemma once and for all, by hacking down the jungle of historic form. But our instinct for familiar images of the structural process, for ornament, for semiotic codes, for essential inessentials, was not so easily abolished. As we enter the Post-Functional age, the dilemma has surely returned.

NOTE

1 J. Mordaunt Crook, *The Dilemma of Style: Architectural Ideas from the Picturesque to the Post-Modern* (London: John Murray (publishers) Ltd, 1987; paperback edn. 1989), from which all quotations in this chapter are derived.

Par le style on atteint au sublime: the meaning of the term 'style' in French architectural theory of the late eighteenth century

CAROLINE A. VAN ECK

I

Style has been a somewhat vexed topic in architecture since the classical style, based on the treatises of Vitruvius, Alberti, and Palladio, lost its monopoly at the end of the eighteenth century. 'In which style should we build?' was the way the German architect Heinrich Hübsch formulated the problem in 1828, and even now his question has lost nothing of its force.[1] When we read Hübsch's pamphlet, we are confronted with a phenomenon that occurs time and again in nineteenth-century architecture: the demand for a new style, which for Hübsch should be the result of climate, available building materials and the state of technology, and which ought to possess the same eternal and universal validity as the classical style, is not fulfilled. Instead, we receive the dusty answer of a revival of Romanesque architecture.

How did this situation arise? What had happened since the time when the choice was not so much between several styles of building, but rather between architecture and non-architecture, because the paradigm of the classical tradition reigned supreme?[2] Studies of the dilemma of style in the nineteenth century usually explain the erosion of the classical tradition and the subsequent rise of stylistic pluralism by drawing attention to the consequences of Renaissance individualism and of the Picturesque movement in British aesthetics at the end of the eighteenth century.[3] Also, Wittkower has drawn attention to the importance of the rise of Empiricism with its stress on the subjective, sensational character of beauty for the loss of understanding of the philosophical background of Renaissance aesthetics.[4]

However, another way of understanding the erosion of the classical tradition as the only architectural paradigm and the rise of architectural pluralism, which I wish to explore here, is to take a closer look at the way the notion of style itself developed in the years from 1750 to 1800. This is a new way approach: usually, in studies of the role of style in nineteenth-century architecture, the meaning of that central concept is not questioned. It is used in the usual art–historical way of designating period styles on the basis of formal characteristics. Here, rather than starting from generally received notions about style as they were formulated at the end of the nineteenth century, I will concentrate on eighteenth-century sources. In doing so, I will concentrate on the theoretical writings of Germain Boffrand, Jacques-François Blondel, and Antoine-Chrysostome Quatremère de Quincy, whose work has received comparatively little critical attention. What did these late eighteenth-century architects and architectural theorists themselves understand by the term 'style'?

When we try to give an answer to this question, it turns out that style was understood not primarily in visual or constructional terms, or in the sense of historical style, but in poetical or rhetorical terms.[5] Thus, Boffrand stresses the close parallel between poetry and architecture, which enables him to use Horace's *Ars Poetica* as a precept for architecture. And Blondel's use of the word 'style' in his *Cours d'architecture* of 1771 shows a striking resemblance to that of the article in the *Encyclopédie* of Diderot and d'Alembert, which offers a rhetorical elucidation of style.[6]

Therefore, I will defend the following two theses: in the first place, the awareness of the rhetorical content of the term 'style' suggests a new approach to the downfall of Vitruvianism. I will argue (in section II) that the rhetorisation of architecture, as it manifests itself in the meaning attached to the term 'style' may very well have been an important, but until now neglected, factor in the gradual erosion of the classical doctrine. Wittkower for instance in his seminal work on the architectural principles of the Renaissance completely ignores the role of rhetoric, both in the formation of these principles and in their subsequent erosion. For example, although he mentions that Daniele Barbaro, who published an important edition of Vitruvius, was very well versed in Aristotelian rhetoric, he completely ignores the role of rhetoric in Barbaro's commentary, although he does discuss the Aristotelian and Platonic elements in it.[7]

My second thesis is that we can observe a fundamental change in

the meaning of the term 'style' in the last quarter of the eighteenth century: from the rhetorical meaning we find in Boffrand and Blondel to a view of style as character in the writings of Quatremère de Quincy, expressing circumstances such as climate or period that determine a building. Style thereby becomes the key notion or guide in the interpretation of architecture (section III). In the last section of my essay, I will try to show how these two theses are related to each other. Thus, by looking at the way in which 'style' was introduced in architectural theory, we are able to gain new insights into its meaning, and into the reasons why it became so important in the nineteenth century.

<div align="center">II</div>

Filarete used the interrelated terms 'stile' and 'maniera' already around 1460, when he spoke of style as a means to recognise an artist.[8] The term was applied to painting and sculpture from the time of Poussin onwards.[9] The very first mention of the term in an architectural context probably occurred in 1578, in documents related to the completion of San Petronio in Bologna.[10] A century later, Guarino Guarini uses the term 'ordine' ('*ordine gotico*' for instance) in his discussions of Gothic architecture, when he talks about architecture alone, but 'style' when he places architecture in the context of the other arts.[11] The term started to be employed frequently in architecture probably as late as 1714 in the United Kingdom, and in France from 1750 onwards. An instance of the British use can be found in the writings of Sir Christopher Wren, who used terms like 'style' and 'manner' in his proposal for the completion of Westminster Abbey: for instance, when speaking of Gothic building:

This we now call the *Gothic* Manner of Architecture (so the Italians called what was not after the *Roman* Style) tho' the *Goths* were rather Destroyers than Builders; I think it should with more Reason be called the *Saracen* Style.

And:

I have made a Design, which will not be very expensive but light and still in the *Gothic* Form, and of a Style with the rest of the Structure, which I would strictly adhere to, throughout the whole Intention: to deviate from the old Form, would be to run into a disagreeable Mixture, which no person of a good Taste could relish.[12]

Well into the eighteenth century, different types of architecture were described in terms of the architectural 'order' rather than in terms of style. In France, Cordemoy's *Nouveau traité de toute l'architecture* (1714) does not contain an entry on 'style' in the glossary attached to it. Instead, terms like 'goût', 'manière' or 'genre' were used. And Montesquieu spoke in the same vein in his work on Gothic architecture of the 'goût' or 'ordre gothique'.[13]

It is not before Germain Boffrand's *Livre d'architecture* (1745) that we find the term if not applied to, at least closely associated with architecture:

> The arts and sciences are so closely connected, that the principles of one group are the principles of the other; Architecture, although it seems that its object is the use of matter only, is capable of different genres that make the parts (so to speak) animated by the characters it makes perceptible. A building expresses by its composition as if on a stage, that the scene is pastoral or tragic . . . These various buildings must announce their destination to the spectator by their structure, by the way they are decorated; if they do not do this, they sin against expression and are not what they should be.
>
> It is the same with Poetry: there are various genres, *and the style of one genre is not convenient for another genre.*[14]

Boffrand, who was a nephew of Quinault and wrote plays in his youth, compares architecture with theatre sets. Thereby it becomes *parlante*, and part of a literary genre. He even speaks of the orders as if they were literary genres:[15] 'The Orders of Architecture used in the works of the Greeks and the Romans are for the various categories of buildings, what the various poetical genres are in the various subjects of poetry.'[16]

It then seems a small and logical step to apply to architecture the same rules as to poetry or drama: the precepts of rhetoric. An example is the stress on the appropriate use of ornament, in accordance with the genre of *caractère* of the building. This is comparable to the rhetorical attention, guided by the notion of *decor* (that which is fitting or appropriate),[17] to the correspondence of the styles of speaking (the *genera dicendi*) with the occasion, purpose, and audience of the speech.[18]

This should not be confused with what Peter Collins calls 'the linguistic analogy' in his *Changing Ideals in Modern Architecture*. Collins is concerned with the notion that the parts of a building can be compared to the parts of speech, or that architectural styles can be compared to languages since they both possess a syntax and a

vocabulary. But my concern here is not with interdisciplinary analogies, but with the (consequences of) the application of the terminological apparatus of rhetoric to architecture, and especially with the consequences for Virtuvian theory of the importation of the rhetorical significance of the term 'style'. Also, in my opinion Collins exaggerates when he says that Boffrand 'extracted a whole theory of architecture from Horace's *Ars Poetica'*. *Boffrand's theory is firmly based on the Vitruvian theory of the orders (see his Introduction)*; he uses Horace only to make his precepts of design explicit.[19]

Boffrand is part of a tradition that goes back to Alberti when he stresses the theatrical character of architecture. We find the same view of architecture as a stage setting for public life in Alberti's use of the triumphal arch for the facade of S. Andrea in Mantua.[20]

Because Boffrand is convinced of the similarity between poetry and architecture, he applies the precepts of Horace's *Ars Poetica* to the latter.[21] He tacitly translates linguistic terms such as 'words' (*verba*) and 'syllables' (*syllaba*) with architectural terms such as 'parts' (*parties*) and 'profiles' (*profils*). Also, he compares the decorative parts of a building (profiles, mouldings – *profils, moulûres*) with the words of language. In this as well, he follows a practice that can be traced back to Alberti, who transposes the terminology of literary composition to the field of painting. For instance, he defines composition, originally a rhetorical term, as 'that procedure in painting whereby the parts are composed together in a picture. The great work of the painter is the "historia"; parts of the "historia" are the bodies, part of the body is the member, and part of the member is a surface.'[22]

Also, he quotes with approval Horace's famous tag *si vis me flere* to stress that every building should be designed in accordance with its nature and function. Music rooms should be smiling by their layout, lighting, and decoration; but mausoleums should be treated in a serious and solemn manner; because 'nature has made our heart sensitive to these various impressions, and it is always moved by harmony'.[23]

A clear example of what this means in practice is Bofffand's most famous work, the Rococo decorations for the apartments of the Princesse de Soubise in the Hôtel de Soubise (now Archives Nationales) in Paris dating from 1735 to 1736.[24] These can be considered as an exponent of the movement away from the formalities of the Court of Versailles to the greater informality of the

hôtels particuliers which was one of the contributing factors of the rise of the Rococo style (of which Boffrand was one of the creators). They are an example of the new 'style pittoresque' in which the first concern was not for correct proportions, but for the effect of the decorations on the visitor, and on the expression of the informal, private character of the apartments.

The first direct application in French architectural theory of the term 'style' to architecture occurs in Blondel's *Cours d'architecture* of 1771, and here we can see very clearly that style is understood in rhetorical terms:

> By *Style* in Architecture is meant the true genre which one must choose, with respect to the motive which led to the construction of the building. The style in the *ordonnance* of the façade, and in the decoration of the apartments, is properly speaking the poetry of architecture, which alone contributes in making all the compositions of an Architect interesting; it is the style, proper to every kind of building that brings with it that infinite variety in buildings of the same kind, and of different kinds. The style can equally well paint the sacred genre, the heroic and the pastoral genre; style can express in particular the character: regular or irregular, simple or composed, symmetrical or varied; and finally by the style one arrives at the sublime.[25]

For Blondel 'style' seems to have a rather 'interdisciplinary' meaning. It is the poetry of architecture, but it can also paint the genre and character of the building. In calling style the poetry of architecture, Blondel perhaps echoes similar remarks Trévoux had made on the function and the 'poetry of style'. Style, according to Trévoux, is the 'soul of the discourse', through which the writer attracts the attention of the mind. In the same way, for Blondel the style attracts the eye and the mind of the beholder.[26]

Style plays a guiding and unifying role: once the architect has decided upon the style of the building – in relation to the purpose or reason of the building – all the further decisions on the articulation of the facade and the choice of ornament have to be determined in harmony with this style.[27] But the style not only determines choices in formal design; it also regulates the impression the building makes on the beholder, in painting the genre – sacred, heroic, or pastoral – and in giving expression to the character.[28]

Now let us pause for a moment to consider the implications of Boffrand's and Blondel's view of style. It is striking to see how both Boffrand and Blondel take a literary and rhetorical view of style. Boffrand closely associates poetry and architecture. Both have

different genres: poetry can be tragic, comic, or bucolic, and architecture can be pastoral or sacred; in architecture, these different genres are expressed by the orders. Of course Boffrand is not the first one to make this association: Alsted for instance says in his *Encyclopedia* of 1630 that 'columns are to the architect, what the modes are to the musician and the genres (*carminum genera*) to the poet'.[29]

All this is perfectly in line with the rhetorical division of the creative process in *inventio, dispositio,* and *elocutio* (architecture of course is not concerned with *memoria* and *actio*), and with the central place that rhetoric gives to considerations of the character, goal, and audience of a speech. The material and the means of expression must be ordered by reference to *decor,* the overall notion of what is appropriate to the situation, the public and the matter at hand. When this rhetorical apparatus is transposed to architecture it means that the design of the building, and especially the selection of ornament, is regulated by considerations of *decor.* Boffrand continues a line of thought that had originated with Vitruvius and Alberti, who both applied the terminological apparatus of rhetoric to the theory of architecture.[30] But Boffrand introduces a new element because he gives a new interpretation of the proportions, different from the significance they were given in the Renaissance, as a reflection of the proportions of the universe. Instead, Boffrand allows them to be determined by 'their character and *by the impression they have to make*' (italics added).[31]

Blondel adds to the literary vision of architecture we find in Boffrand a decidedly rhetorical interpretion: style, or genre, determines in architecture all the decisions in design; style gives colour and expression to the character of the building. This recalls one of the basic assumptions of rhetoric, the distinction of the *ratio verborum* and the *ratio rerum,* between thought and its formulation.[32] But it also recalls Buffon's famous discourse on style of 1750, in which he stresses that the choice of style should be determined by a previously made plan of the work.

Both for Boffrand and for Blondel – and here we reach the heart of the matter – style is a regulative and unifying notion by which the design of a building is guided in such a way that we can recognise its function, genre, and character. The decision on the style of a building entails a system of possible choices of the *ordonnance* of the facade, the use of ornament and the disposition of the parts of the building. Thereby, style becomes the general concept, so to speak, by

which the spectator is enabled to interpret or 'read' the building correctly. The notion of 'style' seems to perform the same regulative and unifying function in the late eighteenth century as the concept of *decor* or *aptum* did in Antiquity and the Renaissance.[33] By now, the emphasis is entirely on the effect of the building on the spectator. In this context a short remark of Blondel on the role of the orders is very revealing: 'by keeping of those orders simply their expression, which would bring on the stage now a grave and sublime style, now a masculine and terrible genre'.[34]

The rhetorical view of style of Boffrand and Blondel implies a strong emphasis on the emotional effects of architecture. For them, style is the poetry of architecture, which alone can make a building literally 'interesting': that is, which can establish an affective bond between the spectator and the building.

This corresponds with the tendency (which started with Cicero) to consider *movere*, exciting emotions, as the most important of the three *officia oratoris* (the other two being *docere*, to instruct, and *delectare*, to entertain or to delight). But by borrowing from rhetoric this concentration on the emotional effects of the building on the spectator, one part of Renaissance aesthetics, namely the notion that beauty is based on mathematical proportions, is being overruled by the other part, namely the rhetorical concentration on the emotional impact of the work of art on its public.[35] Whereas these two parts existed together harmoniously in the Renaissance, the emotional impact of a building is now preferred at the cost of its mathematical proportions.

The dominance of the emphasis on expression is in sharp contrast to the Classical and Renaissance attitude to architectural composition in general and to the use of the orders in particular. According to Vitruvius, the form and structure of a building should be based on its proportions. These are based on geometrical relations which are everywhere present in the universe. This idea is symbolised in the *homo quadratus*.[36] For Alberti, the author of the first treatise on architecture of the Renaissance, which was extremely influential, beauty in architecture is the result of *concinnitas*. This is a rhetorical term, whose original meaning could be rendered as 'elegant or skilful joining of several things', and by transposition as 'beauty of style, resulting from a skilful connection of words and clauses'. Alberti used it in *De re aedificatoria* to refer to an inherent quality of a building, consisting in the purposive unity of the parts with each other and the whole, based on the 'first and absolute law of nature.'[37]

Architecture should be designed in accordance with the purposive unity that is the mark of Divine creation in the universe.[38] But architectural beauty is also based on *ornamentum*, in Alberti's words 'a form of auxiliary light and complement to beauty . . . it has the character of something attached or additional'.[39] Beauty is intellectual; ornament appeals to the senses. Now what happens in the eighteenth century is that with the increasing concentration on *movere*, beauty based on ornament gained the upper hand at the cost of the notion of mathematical, inherent, intellectual beauty.

Therefore, the emphasis Blondel gives to the expressive role of style in architecture enables us to approach the downfall of Vitruvianism from the new angle. Usually, this process is explained by pointing to the crucial role in it of the representationalist epistemology of British Empiricism. When beauty, according to Empiricist philosophy, evidently belongs to the category of secondary qualities (which are not present as such in the object, but only as dispositions), it can no longer be maintained that beauty is an inherent property of buildings, based on mathematical proportions.[40] Burke for instance remarks that 'if proportion be one of the constituents of beauty, it must derive that power either from some natural properties inherent in certain measures, which operate mechanically; from the operation of custom; or from the fitness which some measures have to answer some particular ends of conveniency'[41] and then proceeds to refute all these possibilities. And Hogarth considers the cause of beauty to lie in the mind: 'The active mind is ever bent to be employ'd. Pursuing is the business of our lives . . . The eye hath this sort of enjoyment in winding walks, and serpentine rivers . . . that lead the eye a wanton kind of chace, and from the pleasure that it gives the mind, intitles it to the name of beautiful.'[42]

In this context, it is revealing to note that Blondel was greatly influenced by British models in his own theoretical work, and that he had an equal veneration for the works of Newton, Wren, and Locke.[43] But as we have seen, the increasing concentration on the emotional impact of architecture, as it manifests itself in the meaning attached to the term 'style', has probably been an equally important factor in the gradual erosion of the classical doctrine.

III

The rhetorical significance of the term 'style' which we discussed in the last section did not stay unchanged for long. We can observe a

further, logical development of its significance in this period in the work of Antoine-Chrysostome Quatremère de Quincy. He devoted an article to style in the volumes on architecture of the *Encyclopédie méthodique* of 1788–1825. The meaning of style changed from the rhetorical meaning we have found in the work of Boffrand and Blondel to a view of style as character, expressing the circumstances such a climate or period that determine a building. Quatremère is important in this context because he is probably the only French author in this period to write so explicitly about style and its diverse meanings in the context of both art history and theory. Also, in view of the close relationships between his work and that of pioneers of art history and archaeology such as Winckelmann and Caylus, his writings on style are crucial to understand the development that led to the birth of art history as a science at the end of the eighteenth century.[44]

According to Quatremère, the notion of style was taken from the *arts du discours*, where it has two meanings. In the first place, style is the form a writer gives to his thoughts according to the nature of the subject, the effect he wants to produce, and the harmony between the goal he has set himself and the means to reach it. This is traditionally the domain of rhetoric, and Quatremère refers the reader to reference books on rhetoric for more details.

In the second place, style is the expression of individuality of a work of art, of its *caractère*:

According to the second point of view, the word 'style' signifies, in a much more generally accepted sense, that typical and characteristic form, which very general causes impress on products of the mind . . . Style, as we say, becomes synonymous with *character*, or with the individual manner (*la manière propre*) of the distinctive physionomy which belongs to each work of art, to each author, each genre, each school, each country, each period.[45]

Style thus becomes for Quatremère the *language* to express *character*. It is perfectly natural that the visual arts have taken over this rhetorical or literary notion of style, because the visual arts have to be considered as a language or a way of writing anyway: they are always trying to give a material, tangible form to ideas, to intellectual relations, moral affections or to the products of the imagination. Therefore, by a process of metonymia, the idea of the mechanical activity of a writing instrument is transferred to an activity of the mind, namely the 'art of expressing one's ideas in the signs of writing'.[46] Thus, style refers to the most mechanical as well as to the most spiritual of human activities: on the one hand, it signifies the

instrument that gives tangible form and colour to our thoughts by means of graphic signs, but on the other it signifies the conception of ideas and the art of putting them into words.

Although architecture at first sight seems to have very little in common with the art of writing, the rhetorical meaning of the term style, concerned with the formal choices the artist makes to give material form to his or her ideas, is nevertheless very apposite, because architecture is so much concerned with giving material form to ideas.[47]

Herein resides the new element of Quatremère's view of style: on the one hand he still adheres to the traditional, rhetorical notion of the form of the content, the material clothing of thought, but on the other hand, he identifies it with character, which for Quatremère is the expression of the circumstances that are attached to every work of art. But style is the language or vocabulary of forms with which character can be expressed. It is therefore no longer the guiding and unifying notion, operative in the design process, that it was for Boffrand and Blondel, but it acquires a new function: that of the chief instrument of historical classification. In the rising science of art history, works of art began to be studied with the aim of classifying them chronologically and geographically on the basis of characteristics that are the result or the expression of the circumstances, such as climate or the availability of certain materials that contributed to their creation. Now these characteristics are identified by Quatremère with the style of a work of art.[48]

In my view, Quatremère occupies a very central and somewhat Janus-faced position in the development of the pluralism of architectural styles which started after 1800. On the one hand, in his rhetorical interpretation of style as a codification of the ways of giving a tangible form to ideas he looks back to the rhetorical tradition; but on the other hand, by his identification of style with character, he makes possible the art–historical use of style as an instrument of historical classification. And, perhaps the most far-reaching consequence of this identification, he has shown that style in architecture can no longer be the same, eternal, unchanging Vitruvian aesthetics of proportion: it has to be the individual expression of the age, the country and even the climate. Thereby he completes a development that began with the use by Alberti of rhetoric in the theory of the visual arts, which led in the eighteenth century to an increasing stress on the emotional, and therefore subjective and contingent, impact of architecture at the

cost of an eternal, universally valid beauty based on mathematical proportions.

IV

And so we have reached the point at which we started: Hübsch's concept of style as a contemporary expression of the country, the climate and the indigenous materials, which would lead after 1800 to the unfulfilled need for a style that would be an adequate and *zeitgemäß* alternative to Vitruvianism. To conclude, I will try to shed some light on the relations between my two theses. The first one concerned the rhetorical significance of 'style' in the work of Boffrand and Blondel and its role in the downfall of Vitruvianism; the second one was about the change of meaning of the term 'style' in the work of Quatremère. At first sight, they may seem to contradict each other. The rhetorical significance of style can be seen as a contribution to the erosion of the classical tradition, which regards architectural beauty as timeless and unchanging. By the increasing stress on the subjective character of beauty, architectural beauty becomes contingent, changeable, and subject to history and taste.

The increasing stress on the subjective character of beauty can be explained by drawing attention to the influence of British Empiricism on aesthetics, but also, as I have shown, by taking into account the role of rhetoric in the theory of architecture with its stress on the emotional impact of a building at the cost of the importance given to mathematical proportions as the cause of beauty. This may seem to make architectural beauty a matter of individual taste, irreducible to the general concepts and categories of art history. But it can also be regarded as the connection with the art–historical use of style by Quatremère as the major instrument of the historian of art. Since style no longer seems to be a part of the classical theory of art that regards beauty as based on timeless, universal, and eternal principles, but as the contingent expression of time, place, and other circumstances that determine the work of art, style can acquire a heuristic function for the historian of art as an instrument of classification. Thus we see in Quatremère that his notion of style is that of an instrument of historical classification. By its style, a building expresses the circumstances that led to its construction. But at the same time, the imperative for architecture to have a style also

condemns it to acknowledge the contingent character of that style, subject to the changes of time and taste.

Therefore, the nineteenth-century quest for a style of its own, for which the foundation was laid at the end of the eighteenth century, was a quest for the impossible, because the two notions of style that were underlying it are irreconcilable. It is impossible to develop a style which is both immutable, universal, and eternal, like the classical style, and at the same time a historical, and therefore changeable expression of the age in which it is developed.[49]

NOTES

1 H. Hübsch, *In welchem Style sollen wir bauen? Beantwortet von Heinrich Hübsch* (Karlsruhe: Chr. Fr. Müller Hofbuchhandlung und Hofbuchdruckerei, 1828). See also W. Herrmann ed., *'In what style should we build?' The German Debate on Architectural Style* (Santa Monica: The Getty Center for the History of Art and the Humanities, 1992), *Introduction*.

2 Compare E. S. De Beer, 'Gothic: Origin and Diffusion of the Term', *Journal of the Warburg and Courtauld Institutes* 11 (1948), p. 156: 'For the silence of the architectural authors [on stylistic terms] there is a fairly obvious reason. They were writing for practical ends. The only style in use was the classical (or revival classicism); anything else could scarcely rank as architecture. Gothic was not an alternative, even if it had occasionally to be employed. The antithesis is not so much Roman and Gothic as architecture and non-architecture.

The only admissible explanation of the absence of stylistic terms in these writers [viz. educated travellers in the seventeenth and eighteenth centuries] appears to be that they had not met with the idea of architectural styles.'

But there could be another possible explanation: We do find mention of the term 'style' as early as 1460 in the work of Filarete, applied to poetry or painting. (Compare G. Germann, *Gothic Revival in Europe and Britain: Sources, Influences and Ideas* (London: Lund Humphries, 1972), pp. 11–12) Could it be the case during the Renaissance that people simply thought architecture not to be a discipline to which terms like style (or maniera) could be applied?

3 J. M. Crook, *The Dilemma of Style. Architectural Ideas from the Picturesque to the Post-Modern* (London: John Murray 1989 (1987)), ch. 1, 'The Consequences of the Picturesque', and especially pp. 30–1.

4 R. Wittkower, *Architectural Principles in the Age of Humanism* (New York/London: Academy Editions/St. Martin's Press 1971 (1949)), pp. 150–3.

5 See for example the conclusions of W. Szambien's *Symétrie goût*

caractère (Paris: Picard, 1977): style in the sense of 'historical' style occurs for the first time in France in Chateaubriand's *Génie du Christianisme* (III. 8).

6 The rhetorisation of architectural theory – *ut poesis architectura*, so to speak – has received very scant critical attention. An exception is H. Mühlmann's *Aesthetische Theorie der Renaissance. Leon Battista Alberti* (Bonn: Halbelt Verlag, 1981), who studies the rhetorical elements of Alberti's *De re aedificatoria*. The analogies between architecture and poetry, especially in English literary criticism of the seventeenth and eighteenth century, have been studied by A. Fowler in his 'Periodization and Interart Analogies', *New Literary History* 3, pp. 487–511, by P. Palme in his 'Ut architectura poesis' in *Idea and Form. Studies in the History of Art* (*Acta Universitatis Upsaliensis*, N.S. 1, 1959), pp. 95–108, and in B. Nugel's *The Just Design. Studien zur architektonischen Vorstellungs-weisen in der neoklassischen Literaturtheorie am Beispiel Englands* (Berlin/New York: Walter de Gruyter, 1980). But studies on the relations between architecture and rhetoric, comparable to the chapters in B. Vickers' *In Defence of Rhetoric* (Oxford University Press, 1990 (1988)) devoted to the function of rhetoric in the development of a terminolo-gical apparatus for painting and music are extremely rare. A synthesis of much of the work that has been done in this field, together with many new perspectives is C. Smith's *Architecture in the Culture of Early Humanism. Ethics, Aesthetics, and Eloquence 1400–1470* (New York/ Oxford: Oxford University Press, 1992).

7 See Wittkower, *Architectural Principles*, pp. 66 ff.

8 'E cosi d'ogni facultà si conosce lo stile di ciascheduno'. See Germann, *Gothic Revival*, pp. 11–12. The quotation can be found in *Filarete's Treatise on Architecture, Being the Treatise by Antonio di Piero Averlino, Known as Filarete*, translated with an introduction and notes by J. R. Spencer, 2 vols. (New Haven and London: Yale University Press, 1968), vol. I. p. 12, corresponding to book I, fol. 5v. Compare also J. Onians, *Bearers of Meaning. The Classical Orders in Antiquity, the Middle Ages and the Renaissance* (Cambridge University Press, 1988), p. 163.

9 E. Panofsky, *Idea. Ein Beitrag zur Begriffsgeschichte der älteren Kunsttheorie* (Berlin: Wissenschaftsverlag Volker Spies, 1960 (1924)), pp. 115 n. 224.

10 Germann, *Gothic Revival*, pp. 12–13.

11 *Ibid.*, pp. 16.

12 *Ibid.*, p. 24.

13 See J.-L. Cordemoy, *Nouveau traité de toute l'architecture ou l'art de bastir* (Paris: n.p., 1714 [1706]) and Szambien, *Symétrie goût caractère*, p. 200 n. 4 (= Montesquieu, *De la manière gothique* in *Œuvres complètes*, 4 vols., vol. I, p. 966, Paris: Bibliothèque de la Pléiade, 1951).

14 Boffrand, *Livre d'architecture* (Paris: G. Cavelier père, 1745), p. 16: 'Les sciences & les Arts ont un si grand rapport, que les principes des uns sont

les principes des autres; l'Architecture, quoi qu'il semble que son objet ne soit que l'emploi de ce qui est materiel, est susceptible de differens genres qui rendent les parties, pour ainsi dire, animées par les différents caracteres qu'elle fait sentir. Un Edifice pas sa composition exprime comme sur un Théatre, que la scène est Pastorale ou Tragique . . . Ces différents Edifices par leur disposition, par leur structure, par la maniere dont ils sont décorés, doivent annoncer au spectateur leur destination: et s'ils ne le font pas, ils pechent contre l'expression, et ne sont pas ce qu'ils doivent être.

Il en est de même de la Poësie: il y en a de différents genres, et le stile de l'un ne convient pas à l'autre'. (As with all other eighteenth-century quotations in this chapter, I have left Boffrand's somewhat inconsistent spelling unchanged.

On Boffrand see L. Hautecoueur, *Histoire de l'architecture classique en France, T. III (Première moitié du xviiie siècle. Le style Louis XV)* (Paris: Auguste Picard, éditeur, 1950), pp. 124–40 and M. Gallet and J. Garms eds., *Germain Boffrand (1667–1754). L'Aventure d'un architecte indépendant* (Paris: Herscher, 1986). See also a passage in J.-F. Blondel's *Cours d'architecture, ou traité de la décoration, distribution et construction des bâtiments*, 7 vols. (Paris: Desaint, 1771–7), vol. II, p. 231; 'en ne retenant de ces ordres que leur simple expression, qui ameneroit sur scène, tantôt un style grave et sublime, tantôt un genre mâle ou terrible'. Notice how he uses the terms of the rhetorical *genera dicendi* (*gravis, sublimis, tenuis*) to define styles.

15 Boffrand does not compare the Doric, Ionic, and Corinthian orders with the three rhetorical *genera dicendi* (*gravis, tenuis,* and *sublimis*) or styles as some authors do, such as K. Borinski in his *Die Antike in Poetik und Kunsttheorie* (Leipzig: Dieterich, 1914), pp. 143 ff. As Mühlmann has pointed out in his *Ästhetische Theorie* (p. 86, n. 101), this is impossible because the distinction between the lowly (*tenuis*) level of style and the sublime or elevated level cannot be made when speaking of the orders of architecture. By their use a building is *ipso facto* transposed into the sphere of the *genus sublime*. On the analogy between building types and literary genres see Fowler, 'Periodization and Interart Analogies', pp. 502 ff.

16 Boffrand, *Livre d'architecture*, p. 24: 'Les Ordres d'Architecture employés dans les ouvrages des Grecs et des Romains, sont pour les differens genres d'édifices, ce que les différents genres de Poësie sont dans les différents sujets qu'elle veut traiter'.

17 See for instance Aristotle, *Rhetoric*, 3.7.1–5 (1408a).

18 The juxtaposition in this passage by Boffrand of genre, which here recalls the rhetorical meaning of *genus dicendi*, in Greek: χᾰρᾰκτήρ, and *caractère* might shed some new light on the interpretation of the last term: might it be the case that the origins of its use in architecture do not lie exclusively in psychology, or physiognomy (such as Lavater's theories), as is suggested by Szambien, *Symétrie goût caractère*, p. 178, or in the

attention to character in biology at that time, but in rhetoric? In order to answer that question, we would have to determine the relation between the Greek term χᾱρακτήρ and the Latin *genus*, and we would have to determine whether writers on architecture from the Renaissance onwards were familiar with this Greek equivalent for *genus dicendi*. Another fact however that points in the direction of a rhetorical origin of *caractère* is that the original meaning of the Greek equivalent of the Latin *decor/decorum*, το πρέπον, based on the Greek verb πρέπω, is something like 'to be seen clearly, to be conspicuous', and hence came to refer to what is characteristic in a thing. See J. J. Pollitt, *The Ancient View of Greek Art: Criticism, History and Terminology* (New Haven and London: Yale University Press, 1974), pp. 341–7. However, to go into this would far exceed the bounds of the problem here at hand.

19 P. Collins, *Changing Ideals in Modern Architecture* (London: Faber and Faber, 1965), pp. 173–82. The passage on Boffrand occurs on p. 174.

20 Mühlmann, *Ästhetische Theorie*, pp. 106–7 and 138. The same concentration on the theatrical or stage-setting aspects of architecture can be found in N. Le Camus de Mézières' *Le Génie de l'architecture ou l'analogie de cet art avec nos sensations* (Paris: chez l'auteur, 1780), pp. 4 ff. See also R. Sasselin, 'Architecture and Language: The Sensationalism of Le Camus de Mézières', *British Journal of Aesthetics* 15 (1975), pp. 239–53.

21 Boffrand, *Livre d'architecture*, p. 17: 'quoiqu'il n'ait jamais pensé à l'Architecture, il m'a paru qu'ils y avoient tant de rapport, que j'ai crû qu'on pouvoit les y joindre, et en faire une très-juste application à ceux qui nous ont été donnés pour l'Architecture par les Anciens et les Modernes, & qu'ils pourroient encore les enrichir d'un caractère plus sublime'.

22 See L. B. Alberti, *On Painting and Sculpture. The Latin Texts of De Pictura and De Statua*, edited with a translation and notes by C. Grayson (London: Phaidon Press, 1972), p. 72 and Vickers, *In Defence of Rhetoric*, p. 342.

23 Boffrand, *Livre d'architecture*, p. 27: 'la nature forme notre cœur susceptible de ces différentes impressions, & il est toujours remué par l'unison'. In this he seems to be very close to the ideas of Le Camus de Mézières, who used the motto 'Non satis est placuisse oculis, nisi pectora tanges / C'est peu de plaire aux yeux, il faut émouvoir l'âme' for his *Le Génie de l'architecture*.

24 See Gallet and Garms, *Germain Boffrand*, pp. 46–7, 108–9 and 221–35.

25 Blondel, *Cours d'architecture*, vol. I, p. 401: 'Par *Style* en Architecture, on entend le véritable genre dont on doit faire choix, rélativement au motif qui fait éléver l'édifice. Le style dans l'ordonnance des façades, et dans la décoration des appartements, est proprement la poésie de l'Architecture, qui seul contribue à rendre toutes les compositions d'un Architecte véritablement intéressantes: c'est le style propre à chaque espèce de bâtiment qui amène cette variété infinie dans les édifices du

même genre, et de genres différents; le style peut peindre également le genre sacré, heroïque et pastoral, exprimer en particulier le caractère régulier ou irrégulier, simple ou composé, simétrique ou varié; enfin par le style on atteint au sublime, on parvient à la convenance, à l'expression; en un mot à ce degré de perfection du ressort de toutes les productions d'un Architecte. See also vol. I, pp. 183 and 391–2. On Blondel see R. Middleton, 'Jacques-François Blondel and the *Cours d'architecture*', *Journal of the Society of Architectural Historians* 18 (1959), pp. 140–8.

26 See the *Dictionnaire de Trévoux* (Paris, 1771), quoted in P.-E. Knabe, *Schlüsselbegriffe des kunsttheoretischen Denkens in Frankreich von der Spätklassik bis zum Ende der Aufklärung* (Düsseldorf: Schwann, 1972), s.v. Style.: 'Le style . . . est en quelque sorte l'âme du discours, l'attrait et le charme qui soutient l'attention de l'esprit.'

27 According to Vickers, *In Defence of Rhetoric*, p. 366, decorum performed a comparable unifying function in music.

28 This passage is one of the longest and most explicit on style in French architectural theory of this period. Brief mention of style is also made by Blondel in a passage in which he juxtaposes style and character: 'Nous allons donner l'idée précise que doivent produire à l'imagination des spectateurs tous les divers membres de l'Architecture . . . C'est par le secours de ces nuances imperceptibles qu'on parvient à mettre une distinction réelle dans les projets des deux bâtiments du même genre mais qui néanmoins doivent s'annoncer différemment, en préferant dans l'un un style sublime . . . dans l'autre un caractère naïf, simple, vrai (vol. I, p. 373).

29 Quoted by U. Schütte, ' "Als wenn eine ganze Ordnung da stünde . . . " ' Anmerkungen zum System der Säulenordnungen und seiner Auflösung im späten 18. Jahrhundert', *Zeitschrift für Kunstgeschichte* 44 (1981), p. 32, n. 89. See also G. Pochat, *Geschichte der Ästhetik und Kunsttheorie. Von der Antike bis zum 19. Jahrhundert* (Köln: Dumont Verlag, 1986), p. 311.

30 See on the role of decor for instance Vitruvius, *De architectura libri decem*, VI.5. 1–3 and Alberti, *De re aedificatoria*, IX, 157v–159v and 170v–172. The application of rhetoric to the theory of architecture by Vitruvius is based on the conviction, which he shared with Cicero, that the sciences and arts, including architecture, share the same roots. See Vitruvius I.i.12 and Cicero, *De oratore* III.vi.21. and *Pro Archia* I.2. We find the same conviction in the Renaissance: Daniele Barbaro for instance in his edition of Vitruvius gives a detailed analysis of the key notions of Vitruvian theory to show that they are really identical to those of rhetoric: p. 23 of the Latin edition (Venice: *apud Franciscum Francis- cium Senensem, & Ioan. Crugher Germanum*, 1567). Barbaro also published, with a commentary, the Latin translation by his uncle Ermolao Barbaro of Aristotle's *Rhetoric* in 1544. See A. Horn-Oncken, *Über das Schickliche. Studien zur Geschichte der Architekturtheorie I*

(Göttingen: Vandenhoeck & Ruprecht, 1967), pp. 100 and 110 ff., and Wittkower, *Architectural Principles*, p. 66.

31 Boffrand, *Livre d'architecture*, p. 25: 'Ces ordres d'Architecture . . . ont des proportions relatives à leur caractère & à l'impression qu'elles doivent faire'.

32 See for instance Cicero, *De oratore* III.55–73.

33 See for example the way the notion of *decor* functions in Horace's *Ars Poetica*, 100–6, 115, 156 ff.

34 See note 14.

35 See Vickers, *In Defence of Rhetoric*, pp. 346–51 and 362.

36 Compare for instance Vitruvius, *De architectura*, III.i.3–9.

37 *De re aedificatoria* IX.5 and VII.5 quoted from J. Rykwert, N. Leach and R. Tavernor trans., *Leon Battista Alberti. On the Art of Building in Ten Books* (Cambridge, Mass/London: The MIT Press, 1991), pp. 302 and 199.

38 In proposing purposive unity rather than the use of modular proportion as the defining characteristic of *concinnitas*, I differ considerably from generally accepted interpretations – such as Wittkower's or Orlandi's and Portoghesi's – of that central term in Alberti's philosophy of architecture. See van Eck, *Organicism in Nineteenth-Century Architecture. An Inquiry into its Theoretical and Philosophical Background* (Amsterdam: Architectura & Natura Press, 1994), pp. 43–57 for an extended defence of my interpretation.

39 Alberti, *De re aedificatoria* VI.2, quoted from the translation by Rykwert *et al.*, p. 156.

40 See for a development that is comparable to the influence of Empiricism on British aesthetics Szambien, *Symétrie goût caractère*, p. 177: 'M. Briseux est le premier qui a cru que le beau essentiel de l'architecture consiste dans ses sensations'. Up to then, 'essential beauty' (the structure of the building) was thought of as belonging to the domain of primary qualities. See Cl. Perrault, *Ordonnance des cinq espèces de colonnes selon la methode des anciens* (Paris: J. B. Coignard, 1683), pp. vi–vii: '[la beauté positive est] fondée sur des raisons convaincantes . . . [les beautés arbitraires] dépendent de la volonté qu'on a eu de donner une certaine proportion, uniforme et une figure certaine . . . et qui ne sont point rendues agréables par les raisons dont tout le monde est capable, mais seulement par l'accoutumance et par une liaison que l'esprit fait de deux choses de différente nature: car par cette liaison, il arrive que l'action dont l'esprit est prevenu pour les unes dont il connait la valeur, insinue une estime pour les autres dont la valeur est inconnu.'

41 E. Burke, *A Philosophical Enquiry into the Origin of our Ideas of the Sublime and the Beautiful*, edited with an introduction by J. T. Boulton (London: Routledge and Kegan Paul, 1987 (1757)), p. 93.

42 W. Hogarth, *The Analysis of Beauty, with the Rejected Passages from the Manuscript Drafts and Autobiographical Notes*, edited with an introduction by J. Burke (Oxford University Press 1955 (1757)), pp. 41–2.

43 See Pochat, *Geschichte der Ästhetik*, p. 398, and Blondel, *Cours d'architecture*, vol. III, p. 423.
44 On Quatremère de Quincy see A. Vidler, *The Writings of the Walls. Architectural Theory in the French Enlightenment* (London: Butterworth Architecture, 1987), 'From the Hut to the Temple: Quatremère de Quincy and the Idea of Type', especially p. 220, notes 22 and 26; and T. Rowlands, *Quatremère de Quincy: The Formative Years 1785–1795* (Ph. D. thesis (unpublished) of the University of Evanston, Ill.).
45 A. Chr. Quartremère de Quincy, *Encyclopédie méthodique*, 3 vols. (Paris: Pancoucke, 1788–1825), vol. III, p. 411: 'style . . . devient synomyme de caractère, ou de la manière propre de la physionomie distinctive qui appartient à chaque ouvrage, à chaque auteur, à chaque genre, à chaque école, à chaque pays, à chaque siècle'.
 Compare Hübsch, *In welchem Style sollen wir bauen?*, p. 6: 'Die Gestaltungsmomente [des Styles] sind im Allgemeinen Clima und Baumaterial'; and p. 23: '[der Styl] muß nicht aus früheren, sondern aus der gegenwärtigen Beschaffenheit der natürlichen Bildungsmomente hervorgehen'.
46 Quatremère de Quincy, *Encyclopédie méthodique*, vol. III, p. 410: 'On appliqua par métonymie à l'opération de l'esprit, dans l'art d'exprimer ses pensées avec les signes de l'écriture, l'idée de l'opération mécanique de la main, ou de l'instrument qui trace ces signes.'
47 *Ibid.*, pp. 412–13. 'Et pourquoi cette métaphore ne lui seroit-il pas aussi justement applicable, s'il est vrai que, selon l'esprit qui constitue le genre de son imitation, cet art, par tel ou tel choix de formes et de proportions, sait rendre intelligibles aux yeux, telles ou telles conceptions abstraites, telles ou telles combinaisons de l'intelligence; s'il est vrai que par un emploi diversement modifié de parties, de membres et d'ornemens, il sait, comme à l'aide des signes de l'écriture, faire naître en nous des idées déterminées.'
48 See Vidler, *The Writing on the Walls*, p. 129 for a discussion of the character of the then nascent science of art history in relation to architecture.
49 Wolfgang Herrmann's recent collection of nineteenth-century German writings on the question of style in architecture, including Hübsch's essay, contains much interesting material bearing directly on the topics discussed here. Rudolf Wiegmann's 'Bemerkungen über die Schrift: *In welchem Styl sollen wir bauen?* von H. Hübsch' of 1829 clearly documents the persistence of rhetorically informed concepts of style in the nineteenth century (see Herrmann, *In What Style should we build?*, pp. 104–12, and especially pp. 105–6). For its continued relevance in the work of Semper and Viollet-le-Duc see van Eck, *Organicism in Nineteenth-Century Architecture*, pp. 228–9 and 239.

Aesthetic forms of philosophising

LAMBERT WIESING

The philosophical endeavours of the present day are characterised by resignation: the hope that one might some day arrive at a single true and complete description of the world, as expressed by the metaphysical tradition, appears increasingly to be unrealisable and is as a consequence no longer unanimously shared. Scepticism and critique have brought to ruin those attempts that were designed to grasp the essence of the world. It has become questionable whether truth can, through philosophical methods, be given a compelling and substantial grounding in reality at all. The very conception of a 'unit' of being has lost its persuasive power. The 'real' reality, to which truth was thought to refer, cannot be found in the numerous, ontologically equivalent worlds of interpretation, each of which has its own specific way of world-making. With the growing realisation that the world consists as much of appearances as of being – if not more so – a crisis in our understanding of reality has ensued such that our confidence in a traditional concept of truth, referring to a *single* reality, has diminished.

As a result of this situation the concept of style has become central to postmetaphysical philosophy. Style – it is hoped – will be able to offset as much as possible the loss of reality; style is thought to be capable of occupying the place vacated by the concept of truth. A preference for 'style' as opposed to 'truth' also constitutes the distinctive feature of the 'Stil statt Wahrheit' programme, which arose in philosophy and art alike in the first half of the twentieth century and which allows one to establish a systematic link between the works of the artist Kurt Schwitters and those of the philosopher Ludwig Wittgenstein despite the apparently unrelated nature of their concerns.

My chapter is divided into three parts: firstly, I shall show how the

artist Kurt Schwitters constructed, in the form of an artworld, a utopia in which style serves as a substitute for the concept of truth. Secondly, I shall show how in the works of the philosopher Ludwig Wittgenstein the human being comes to be regarded as a being of style. My contribution deals with two theories, each of which proceeds from a different starting-point but which converge at a common centre. Schwitters starts with art and extends the concept of style so as to include that of truth. Wittgenstein starts with philosophy and analyses the concept of truth in terms of the concept of style. In the third part I shall explain why the concept of style common to both Schwitters and Wittgenstein must at the same time lead to a very similar conception of philosophy.[1]

SCHWITTERS AND THE CONCEPT OF STYLE

Schwitters coined the neologism *merz* in order to designate his conception of an aesthetic form of life. *Merz* represents a departure from the traditional conception of a work of art in that it attempts to communicate the whole of life into art. The theoretical reflections accompanying Schwitters' efforts to conceive of life as art can be made fruitful for contemporary philosophy in so far as they develop a perspective which affirms the loss of absolute truth described at the beginning of my paper. Unlike the leading intellectual figures of an earlier generation, Schwitters no longer regards the loss of absolute truth as a loss. Indeed it is worth remarking that the sceptical attitude of Schwitters toward all forms of validity-claims, though everywhere present in his work, at no point assumes an accusatory or critical character. In this respect he is fundamentally at odds with nineteenth-century philosophy and with many of his artistic contemporaries, for example the dadaists, for one of whom Schwitters is often (mistakenly) taken. Here Schwitters succeeds in dissociating himself from a then widespread intellectual malady, which has in fact dominated our culture up to the present day – the anguish caused by a lack of orientation. This lack of orientation, itself brought on by the absence of definite values, has been described as 'a suffering from decadence'. The dadaists are the forerunners of this modern attitude, which has been strongly influenced by Nietzsche. Through their artistic campaigns they pilloried the decline of values, which they saw manifested in the wholesale slaughter of the First World War. The sceptical world-

view, which they displayed in deliberate attempts at provocation, was for the dadaists a diagnosis of fear.

The basic attitude that we find expressed in Schwitters' works is entirely different. He converts what was formerly an assertion of loss into an assertion of gain. Thus Schwitters is able to claim that 'the happiest day of my life was when I discovered that everything is really indifferent.'[2] This sentence from the year 1929 may be regarded as an early document of postmodern thinking in so far as it expresses a new perspective – new, at least when compared with the dadaists and the general attitude of the nineteenth century. As the postmodern theorist Wolfgang Welsch has recently argued, it is precisely in such a shift of attitude that the change of an epoch must be seen: 'As long as the dissolution of totality continues to be experienced as a loss, we still remain situated in modernity. Only when a different perception of this "taking leave" of totality – i.e., a positive one – has arisen, can we make the transition to postmodernity.'[3] Such a conversion can, in fact, already be found in the works of Schwitters, for example, in the course of a letter where he writes: 'Not only are all things true but their opposites as well. Therefore I agree with everyone so as to preclude in advance the possibility of discussion.'[4]

This is the crucial point: if everything or nothing is true, then it no longer makes sense to erect a worldview on the basis of discussion or, more abstractly expressed, to construct a discursive philosophy. The loss of truth opens for Schwitters the way to an aesthetical form of philosophising, which from a purely discursive point of view would have seemed nonsense. This alteration in viewpoint is what Welsch is alluding to when he writes: 'Postmodernity is precisely that epoch, in which the positive side of what could previously be experienced and practiced only as decadence is grasped and understood.'[5] Gottfried Benn's famous aphorism, 'Nihilism is a feeling of joy', attests to a transformation which already taking place within Schwitters' generation.[6] The new attitude towards life may be expressed as follows: 'It depends on what one is prepared to make out of one's nihilism.'[7]

The concept of style contributes decisively to a positive revaluation of the traditionally lamented loss of truth. Schwitters is only able to accept the inscrutable nature of truth because he has made style the fundamental principle of orientation in life. 'No more eternal truths!' he writes. 'There is only a truth of our age just as there were truths of other ages.'[8] The 'truth of an age' is for

Schwitters its style. For anyone who believes in a unique and abiding truth, the relativisation of truth to the 'truth of an age,' i.e., to a phenomenon of a particular space and time, is totally unacceptable. But for all those who regard the search for truth as having failed to arrive at its object, the concept of style opens up the possibility of a new concept of truth: for Schwitters, truth does not represent the correspondence of idea and thing but only the self-manifestation of a form, the form's showing of itself. Style becomes a concept of truth with the possibility of being pluralised: whereas singularity and universality are peculiar to truth, plurality and particularity are characteristic of style.

Thus style, which unlike truth does not lie hidden behind a veil of Maya, enjoys the favour of those who had been disappointed in their search for a traditional concept of truth. Owing to its ability to combine surface with sense (or meaning), the concept of style could be developed into a fully fledged programme by artists and philosophers – and not only by Schwitters. In this context it is only appropriate to mention the 'De Stijl' movement with whose members Schwitters co-operated intensively. Many artists looked upon style as a principle which could provide them with a means of orientation without at the same time laying claim to the status of a discovered truth. Benn expresses the point quite succinctly: 'Style is superior to truth; it carries within it the proof of its own existence.'[9] This substitution of style for truth is the clear expression of an intellectual attitude which regarded as banal and idle the attempt to combat scepticism with the hypothesis that there is a reality which has only to be discovered. Confronted with a surfeit of uncashable validity-claims, one turned away from the profound and, as Benn describes the situation, 'dedicated oneself to the elimination of truth and the foundation of style'.[10]

To put it briefly the programme became one of 'style instead of truth'. In this way the concept of style comes to signify a utopia for a generation which had come to terms with the impossibility of achieving eternal truth in life. As Schwitters emphasises, 'The word "style" is worn out but still it signifies better than anything else the type of artistic striving that is characteristic of our age.'[11] In other words, the goal of art is no longer to be considered truth but rather style, for style at least appears to be attainable. As a result Ernst Jünger and others come to see in style the primary task of man: 'We believe that in the cultivation of a new style is concealed the only sublime possibility of making life bearable' (*Strahlungen*, preface).

This, in turn, corresponds to Schwitters' own conception of the 'Stil statt Wahrheit' programme: 'We hope that in the foreseeable future our efforts to make known the enormous lack of style within our culture will give birth to a mighty will and a great yearning for style. Then we will turn against dada and campaign only for style.'[12]

Without doubt Schwitters must be counted among those artists who were largely responsible for having pursued the 'style instead of truth' programme to its logical conclusion. Through *merz* he is able to design a utopia in the form of a style-world. In order further to characterise this utopia, Schwitters once again introduces a new concept – that of 'deformalising' (*entformeln*). With the word 'deformalise' he designates a method which he hopes will enable the artist to found a world of style. 'Deformalising' is nothing other than the organising principle of a collage. A collage depends for its success on the 'deformalising' of all materials employed in its composition. This process consists in liberating these materials from the sense or meaning with which they are normally endowed in everyday life and reducing them to pure elements of form. Schwitters understands the artistic process *expressis verbis* as a destruction of life-world connotations. This thesis implies that the context of sense is disrupted by the artistic composition of two mutually extraneous things in such a way that the individual components appear to human beings as pure impressionistic elements of form. With respect to a pear and an elephant which had been pasted together, and their relations to one another rearranged, so as to form a work of art he says, 'Of the elephant only colour remains and of the pear only colour as well; colours can only enter into relationships with other colours.'[13]

This method is for Schwitters the basis of every artform. Schwitters' poetry is pure 'sound painting' (*Lautmalerei*), by which is meant that meaningful words are converted through the process of artistic composition into meaningless material. Such works of art are to have no sense or meaning but only surface. For Schwitters this is equivalent to the claim that they consist purely of style. It seems almost as if he had hoped to fulfil with such a concept of style the well-known desire of Gustave Flaubert, who wrote in a letter to Louise Colet dated 16 January 1852: 'What I mean by beautiful, what I myself would like to create, is a book about nothing, a book lacking all manner of support apart from itself, a book which through the sheer inner force of its style maintains stability, just as the earth hangs in the air without support, a book that would be practically

devoid of theme or in which at least the theme would remain invisible.'

Yet Schwitters' artform *merz* cannot be said to be *almost* lacking in thematic content: it is absolute in its renunciation of every form of content. In this way Schwitters radicalises Flaubert's original intent: rather than satisfying himself simply with creating themeless works of art, be they novels or collages, he strives to design a themeless life. The goal of Schwitters' art is to create a world which would remain true to Flaubert's novel. *Merz* is the utopia of a life conceived as pure style. Schwitters' main pronouncements are '*merz* is form' and 'I am *merz*', which apply the claims of art to his own person.

Guided by this conception of 'deformalising' (*entformeln*) Schwitters envisions in a type of utopian excess the task of making *merz* out of the whole world. In other words he would like to deliver the world from values and the accompanying possibility of the tragic. This is the reason why Schwitters is so captivated by the vision of a world of style without values. Since every claim of truth or value is for him synonymous with the possibility of introducing tragedy and chaos into life, he rejects them in their entirety and raises the maxim 'no values, no tragedy' to the status of a postulate. If all values and every meaning (or sense) is destroyed in *merz* art, then life can no longer be suffused with, or be a harbinger of, the horrible, for it is only with respect to values that one is able to experience something as terrible. In this way Schwitters initiates the aforementioned postmodern revaluation, which he describes in terms of his discovery that the happiest moment of his life was when he noticed that everything is really indifferent. A similar worldview underlies Benn's exclamation as well: 'Nihilism is a feeling of joy.'

But unlike Benn and many postmodern theorists, Schwitters recognises that only art is capable of bringing about such a refuge of senseless tranquility. That is why he broadened the scope of his concept of art. For Schwitters it is not the reshaping of traditional works of art that is here at stake but rather the reshaping of life itself: '*Merz* is capable of transforming sometime in the not too distant future the entire world into a giant work of art . . . in the meantime *merz* produces sketches for a collective reorganization of the world, for a universal style. These sketches are the *merz*-pictures.'[14] '*Merz* means establishing connections, preferably among all things in the world.'[15] The things of the world 'are torn from their old context, deformalised [*entformeln*], and placed into a new, artistic context; they become fragments of form . . . and nothing more'.[16]

With the words '. . . and nothing more' we come at last to the gist of the matter. The world is nothing more than, as Schwitters says, a universal style. Without doubt *merz* is an artificial and historically outdated position. But nevertheless we find here the roots of a problem and a thesis, both of which have in our day acquired a new actuality. *Merz* is the idea of an aesthetic utopia brought to its logical culmination, and the well-known expression of Jean Baudrillard, 'the agony of the real', applies to it in the full range of its meaning. At this point it becomes clear why Wolfgang Welsch feels compelled to assert – rightly, I believe – that 'our lifeworld can be understood as the exoteric cash-value of the once esoteric modernity of the twentieth century'.[17] This thesis can be confirmed by pointing out the similarity between Schwitters and Baudrillard. The work that Schwitters viewed as remaining to be done if the world was to be 'deformalised' appears to Baudrillard to have already been to a large extent achieved: 'there is no truth, no reference, and no objective ground but only a single era of similitude brought on by the liquidation of all referents'.[18] What for Baudrillard is reality is for Schwitters a dream.

Schwitters would doubtless have regarded such an epoch as having its origins not in something called 'postmodernity' but in *merz*. Nevertheless he himself would not have recognised this epoch as having already begun, since for him it is only possible to realise such a utopian and meaningless world in a work of art. In a properly constructed *merz*-world it should be possible, according to Schwitters, to stage the collision of two locomotives without the catastrophe amounting to more than a play of light. But obviously we are not yet living – nor will we ever live – in such a fictitious world. In this respect style represents for Schwitters, as Albert Camus expresses it in one of his reflections on style, 'an impossible demand given expression and form'.[19]

WITTGENSTEIN AND THE CONCEPT OF STYLE

At this point we may turn to Wittgenstein and the second part of my chapter. Wittgenstein's approach to the phenomenon of style is different from that of Schwitters. He does not want to translate the style of collages into that of life but to analyse life, as it presents itself to us. Still he comes to conclusions that are remarkably similar to those of Schwitters. Wittgenstein and Schwitters agree in their positive valuation of the formal. Both refuse to recognise a sense, an

essence, or a reality behind the appearance. In certain respects Wittgenstein's thesis regarding style is simply an amplification of this anti-essentialist position. The manner in which Wittgenstein comments on the famous dictum of Buffon shows that for him the human being need not live in an artistic utopia in order to realise his being as style. On the contrary, in assessing the relative merits of two alternative formulations of the maxim usually ascribed to Buffon, Wittgenstein indicates that a man is always already defined in terms of his style: '"Le style c'est l'homme," "le style c'est l'homme même". The first sentence has a cheap, epigrammatic tersity. The second and more correct sentence yields a wholly different perspective. It says that 'style is the image [*Bild*] of man'.[20]

According to this interpretation style is not simply a matter of rules of convention which would merely be supervenient on, or remain external to, a person's way of behaving, but style is indistinguishable from the person himself. As Karl Kraus (for whom incidentally, Wittgenstein had great respect) has pointed out, 'style is man himself' implies that 'style is not the expression of what one means but rather the formation of what one is' (*Die Fackel*, 1921; 65). With respect to Wittgenstein this must be understood to mean that style is the formation of man's image of himself. If we are to follow this train of thought, we must have recourse to a reflection from the year 1938 in which Wittgenstein explains the relation between picture or image (*Bild*) and expression:

If, for example, one were to set up for a given group of people certain pictorial (*bildhafte*) propositions as dogmas of thought which would fully determine not their opinions as such but the form of expression they receive, this would have a curious effect. The people would live under an unconditional and palpable tyranny, without however being able to say that they are not free. I believe that the Catholic Church operates in a somehow similar fashion. For a dogma is as much a form of expression as an assertion, and there's nothing that can be done to undermine it, and so every practical opinion can be made out to accord with it, naturally some more easily than others.[21]

This reflection explains why Wittgenstein has chosen to elaborate upon Buffon in such a manner that style for him becomes the image (*Bild*) of man. A picture (*Bild*) can govern, or determine, the behaviour of man in more subtle, but also more radical ways, than a dogma: pictures do not lay down concrete prohibitions but are responsible for selecting among various 'possibilities of expression'. Pictures are for Wittgenstein forms of expression or, in other words,

possibilities of representation. The expression is the visible and external being, the pure behaviour, of a person; the appearance of a person is thus to be contrasted with his inner state of mind, of which it is only the representation. To phrase the same point in the classical terminology of philosophy: the opinion yields the content and the expression the form. Similarly, aestheticism was defined by Gottfried Benn, one of its main adherents, as 'the giving of meaning to all content solely through form'[22] – which, of course, represents an inversion of the traditional point of view. Wittgenstein accepts the consequences of this aesthetical inversion in all their radicality: the content of a dogma is always such as to leave ample room for interpretation. In the above passage, which is manifestly related to the famous rule-following passage (§201) of the *Philosophical Investigations*, Wittgenstein is claiming that practically every opinion can be made out to accord with a dogma as long as the latter is understood only with respect to its content, for the content of a doctrine alone does not suffice to determine univocally the behaviour of a person. Here the question of content has already been reduced to relative insignificance when compared with the multiplicity of its forms of expression, but it is still possible to ascribe to the opinion a content which exists beyond, and resists assimilation to, its outward form.

In the case of pictorial forms of expression, however, the type of control to which the person is subject is even more extreme. These are capable of exerting, as Wittgenstein notes, an 'unconditional tyranny'. Pictures are able to govern the behaviour of a person, regardless of his state of mind. As a result the dualism between content and expression vanishes completely: content ceases to have any function at all in the expression of a person's style. Wittgenstein's thesis amounts to the claim that the external and not the internal conditions, or governs, life. His anthropological and aesthetic reflections are characterised by the same form of thinking as the analytical philosophy of language of his later period. Thus what Wittgenstein has to say about language applies with equal validity to human beings, 'for nothing is concealed . . . For nothing is hidden'.[23] 'Since everything lies open to view there is nothing to explain. For what is hidden, for example, is of no interest to us.'[24] These are sentences which could just as easily stand, without need of further supplementation, in the pages of any *merz* manifesto.

More importantly, however, these passages point to certain structural affinities which link Wittgenstein's own reflections on the

relation between content and expression to those of the art historian and philosopher of art, Heinrich Wölfflin. In a lecture entitled 'The Problem of Style in the Graphic Arts' held in 1912 Wölfflin had reacted with great animosity to attempts 'to interpret style primarily in terms of expression'.[25] By 'expression', however, Wölfflin understands, somewhat misleadingly in the context of the present discussion, what has been described above as the *content*, and not the various possibilities of representing this content. For him the most important aspect of style by far is that which can be discovered 'as soon as one abstracts from the matter, i.e., the material, of style and concentrates only on the method of composition, the way in which the seen is given form . . . Here one encounters a more primitive layer of concept-formation . . . These are concepts which bear no direct relation to those of "temperament", "disposition", and the like but are exclusively related to a certain mode of representation . . . Every expression is tied to an optical possibility which is different for every epoch. The same content could not at different times have been represented in the same manner, not because the emotive temperature had changed but rather because the eyes had changed.'[26]

These reflections of Wölfflin led at the beginning of this century to a new valuation of the phenomenon of style. Style acquires a supra-individualistic and epochal validity. Once the level of representation (or form) was distinguished from the level of expression (or content) what was originally a psychological phenomenon became a logical problem. The new task for Wölfflin's theory of style is to develop for the forms of representation a logic whose laws would explain, independently of the content of representation, the formal constraints (*Zwänge*) to which each human being is subject. Indeed Wölfflin's well-known *Basic Concepts of Art History* pursues no other objective than to develop just such a logic. This new point of view amounts to a change of paradigm within the investigation of style, and it exerted a correspondingly great influence on the ways of thinking about style that ensued. 'If one does not treat the value of expression as the criterion of style', wrote Hans Freyer in 1928, 'then style must be understood in terms of a system of mutually extraneous elements and contexts of form and thus as bound to opinion . . . all possible manner of contents can be clothed in such a language of form, as in a garment, and the unity of our entire culture consists in nothing other than in their being so clothed.'[27]

Here we see prefigured Wittgenstein's later reflections on style.

There are 'forms of representation'[28] which fix, as Wittgenstein has said in the passage cited, the expression of an opinion irrespective of its content. These forms of expression are for Wittgenstein the 'pictorial sentences' (*bildhafte Sätze*) which constitute a person. This is why he asserts in the course of his commentary on Buffon's sentence that style is the image or picture (*Bild*) of man. The identity of a person is grounded in these pictures in so far as they determine the style of that person, and this, in turn, is only possible because a picture (or image) is a form of expression. For Wittgenstein the unity of a person is a phenomenon of style – just like the unity of an epoch for Wölfflin or that of a culture for Freyer. In defining the identity of a person in terms of style, Wittgenstein applies to anthropology a concept of style which was first developed in the field of art history and which sees the distinctive characteristic of that history in a supra-individualistic logic of representational forms. The constraints (*Zwänge*) of representation determine human being; the 'human being', formerly conceived as a rational animal, is now regarded as a being of fantasy. Style makes the man, or to express the same idea in terms of my opening statement, style instead of truth is constitutive of human beings.

Wittgenstein goes so far in his reflections as to extend his account of the phenomenon of style not only to personal behaviour but also to thought itself. Even the question of the validity of individual propositions is converted to a question of form or style. Wittgenstein writes, 'For the physicist causality stands for a style of thinking. One might compare it to the assumption of a creator in religion . . . The same applies to Creation as well: God is one style; the nebula the other. A particular style may give us satisfaction but one style is not more rational than another.'[29] If one takes Wittgenstein seriously here, then a critic of religion can at most assert what Gottfried Benn was indeed later to say, namely, that 'God is a poor principle of style.'[30] For Wittgenstein, to argue that a proposition be regarded as 'true' is equivalent to the claim that the proposition can be subsumed stylistically in a system. A proposition is 'true' when it can be made to fit into a language-game. In order, however, for the proposition to fit into a language-game, the style of the language-game itself must be preserved. As a result it only makes sense to talk of truth within certain 'systems'. Nevertheless for the individual participants in a given language-game style remains an invisible norm. Thus the aesthetic character of truth is not present to them *qua* aesthetic.

THE SELF-REFLECTIVE TURN TO STYLE IN THE WORKS OF SCHWITTERS AND WITTGENSTEIN

With this explanation – although there is still much more that could be said – I come to the third and last point of this chapter. As we have seen, the predominant characteristic of Schwitters' as well as of Wittgenstein's mode of thinking may be expressed in terms of a preference for 'style rather than truth'. Divergent as their respective starting points may be, the conclusions that they reach involve similar conceptions of philosophy. This much at least can be said to be unproblematic: if philosophy has traditionally been regarded as a discipline which is concerned with the truth-claims of propositions, then our conception of this discipline can hardly remain unaffected once the concept of truth has been subjected to such radical change. The views of both Schwitters and Wittgenstein are, in fact, marked by this conviction.

Both attempt to dissolve in their work the opposition of art and philosophy, Schwitters transforming the artistic task into a philoso-phical one, whereas Wittgenstein converts the philosophical task into an artistic one. In both cases this transformation leads to a postmetaphysical conception of philosophy, which is, in the manner of its expression, as aesthetic as it is theoretical. Clearly Schwitters' *merz* texts cannot be regarded as examples of discursive argumenta-tion. This is the reason why his contribution to philosophy has not been appreciated sufficiently in the corresponding academic circles, although he himself was aware of the great importance his work has for philosophy. He thought that *merz* itself would suffice to bring about 'a renewal of philosophical thinking'.[31] The guiding principle of this philosophy is to 'show', or illustrate, one's statements. Thus Schwitters not only asserts that '*merz* is form' but also gives an example of this assertion by showing through a mixture of nonsense, banalities, and extravagant typography that the phenomenon in question is of an aesthetic, and not a theoretical, nature. A *merz* text is about *merz* and is at the same time *merz*. Schwitters sees in the style of his texts the appropriate medium for presenting his programme. A discursive form of argumentation would not have allowed him to outline his programme, since such an argument would presuppose a claim to truth. But it is precisely this pretension to truth against which Schwitters inveighs and which he hopes to substitute with the concept of style.

The same self-reflective turn to style as a medium of philosophy

can be found in Wittgenstein, most obviously in the *Tractatus Logico-Philosophicus*, which in its motivation is thoroughly aesthetic. Wittgenstein writes of the book in the preface: 'Its whole meaning could be summed up as follows: What can be said at all can be said clearly; and whereof one cannot speak, thereof one must be silent.'[32] The central problem of the book is to draw a boundary. The realm of what can be meaningfully said must be marked off from that of the unsayable. But if this problem is to be resolved, then it is necessary that both areas be accessible to our thought, 'for in order to draw a limit to thinking we should have to be able to think both sides of this limit (we should therefore have to be able to think what cannot be thought)'.[33]

As a result Wittgenstein finds himself confronted with the task of discovering an alternative medium to discursivity. His solution to the problem is based on a recognition of the fact that what cannot be said can nevertheless be shown. For, as Manfred Frank has pointed out, there is indeed 'a phenomenon on the boundary between the sayable and the unsayable, and this third thing is style'.[34] Style can be a medium for the unsayable in so far as style illustrates and 'shows' (or reveals) its sense: 'There is indeed the inexpressible. This *shows* itself', writes Wittgenstein.[35] The logical consistency of Wittgenstein's thought is reflected in the fact that in his own attempt to draw a boundary to the unsayable he has recourse to this medium of self-showing or self-manifestation. This is why he says: 'I believe I was summing up my own attitude toward philosophy when I said: Philosophy should in fact only be composed.'[36]

These two aspects of Wittgenstein's work – the stylistic and the discursive – are not for him of equal significance. He is clearly more interested in the medium of the unsayable: 'What I meant to write then, was this: My work consists of two parts: the one presented here plus all that I have *not* written. And it is precisely this second part which is the important one.'[37] This is an unequivocal evaluation of the *Tractatus*, which can also be found in the *Tractatus* itself: the content of the written is to be considered secondary because it is in the first instance meaningless. Wittgenstein writes not for the sake of the sentences themselves but in order to reveal something through what is said: 'My propositions are elucidatory in this way: he who understands me finally recognises them as senseless.'[38] This is the form of thinking which underlies the entire *Tractatus* and for which Schwitters coined the expression *merz*. Sentences which divulge their real meaning only to the extent that they are recognised to be

nonsense are not therefore senseless, since in the words of Schwitters 'there is a sense in nonsense'.[39] This sense in nonsense manifests itself not discursively but in the form which the content takes. In the words of Wittgenstein, 'the unsayable is contained unsayably in the said'.[40] The style becomes the bearer of meaning (sense) for the unsayable in so far as style in its role as bearer of sense is able to show (or reveal) the sense without itself having to embody it.

I hope it has become clear in the course of this chapter that the image of humanity (*Menschenbild*) which Wittgenstein and Schwitters share is embedded in a philosophy which both regarded as a kind of aesthetic work. The thesis that style is to be identified with man himself leads in the thinking of both to an aesthetic form of philosophy, which cannot help but appear nonsense from a discursive point of view. The descriptions which Wittgenstein and Schwitters give of this form of philosophy may easily be substituted for one another without giving rise to confusion. 'Indeed don't be afraid to speak nonsense! Only you must be prepared to pay heed to your nonsense.'[41] This according to the 'artist' Wittgenstein. The 'philosopher' Schwitters says, 'Because you do not see the logic in art you are disturbed by the absence of what is understandable.'[42] For both Schwitters and Wittgenstein, philosophy must abandon its self-imposed claim to discursivity in favour of an exercise in style. If style is to be seen as an alternative to unprofitable claims to truth, then style can no longer be for philosophy a mere decoration or superficial trapping but must instead be recognised as the original task of philosophy. Philosophy becomes an advertisement for style. This is the consequence which is implied in the 'style instead of truth' programme and which we find realised in the works of Schwitters and Wittgenstein: 'I am in a sense' – said Wittgenstein – 'making propaganda for one style of thinking as opposed to another . . . How much of what I do involves changing a style of thinking and how much of what I do involves persuading people to change their style of thinking!'[43]

NOTES

This chapter was translated by Roger Wasserman.
1 The themes touched upon in this chapter are further elaborated on in my book, *Stil statt Wahrheit. Kurt Schwitters und Ludwig Wittgenstein über*

ästhetische Lebensformen (München: Wilhelm Fink-Verlag, 1991). For this reason I have omitted all reference to the secondary literature on this topic.

2 Kurt Schwitters, *Wir spielen, bis uns der Tod abholt. Briefe aus fünf Jahrzehnten*, ed. E. Nündel (Frankfurt a. M.: Ullstein, 1984), p. 322.

3 *Unsere postmoderne Moderne* (Weinheim: VCH, Acta Humaniora, 1988), p. 175.

4 *Wir spielen*, p. 159.

5 *Unsere postmoderne Moderne*, p. 181.

6 *Gesammelte Werke*, ed. D. Wellershoff, 4 vols. (Wiesbaden: Limes, 1965), vol. I, p. 410.

7 *Ibid.*, vol. IV, p. 159.

8 *Das literarische Werk*, ed. F. Lach, 5 vols. (Köln: Du Mont Schauberg, 1973–81), vol. V, p. 168.

9 *Gesammelte Werke*, vol. IV, p. 159.

10 *Ibid.*, vol. I, p. 493.

11 *Das literarische Werk*, vol. V, p. 168.

12 *Ibid.*, p. 132.

13 *Wir spielen*, p. 87.

14 *Das literarische Werk*, vol. V, p. 187.

15 *Ibid.*

16 *Ibid.*, p. 134.

17 *Unsere postmoderne Moderne*, p. 6.

18 Jean Baudrillard, *Agonie des Realen* (Berlin: Merve, 1978), 11 and 9.

19 Albert Camus, *The Rebel: An Essay on Man in Revolt* (New York: Random House, 1954), p. 271.

20 *Vermischte Bemerkungen* in *Werke* (Frankfurt a. M.: Suhrkamp, 1984), vol. VIII, p. 561.

21 *Ibid.*, p. 489

22 *Gesammelte Werke*, vol. I, p. 217.

23 *Philosophical Investigation*, ed. G. E. M. Anscombe (New York: Macmillan, 1958), §435.

24 *Ibid.*, §126.

25 'Das Problem des Stils in der bildenden Kunst', *Sitzungsberichte der Königlich Preussischen Akademie der Wissenschaften* (1912), p. 572.

26 *Ibid.*, pp. 572 f.

27 *Theorie des objektiven Geistes. Eine Einleitung in die Kulturphilosophie* (Berlin: Teubner, 1928), p. 192.

28 Wölfflin, 'Das Problem des Stils', p. 573.

29 *Vorlesungen*, 1930–5 (Frankfurt a. M.: Suhrkamp, 1989), p. 123.

30 *Gesammelte Werke*, vol. IV, p. 160.

31 *Wir spielen*, p. 126.

32 *Tractatus Logico-Philosophicus*, ed. C. K. Ogden (London: Routledge and Kegan Paul, 1958), p. 27.

33 *Ibid.*

34 'Wittgensteins Gang in die Dichtung', *Wittgenstein. Literat und Philo-*

soph, eds. Manfred Frank and Gianfranco Soldati (Pfullingen: Neske, 1989), p. 28.

35 *Tractatus*, 6.522.
36 *Vermischte Bemerkungen*, p. 483.
37 *Letters from Ludwig Wittgenstein with a Memoir*, ed. B. F. McGuinness, trans. L. Furtmüller (Oxford: Basil Blackwell, 1967), pp. 143ff.
38 *Tractatus*, 6.54.
39 *Wir spielen*, p. 211.
40 Quoted by Frank, 'Wittgensteins Gang in die Dichtung', p. 33.
41 *Vermischte Bemerkungen*, p. 530.
42 *Das literarische Werk*, vol. V, p. 99.
43 *Vorlesungen und Gespräche über Ästhetik, Psychologie und Religion* (Göttingen: Vanderhoeck and Ruprecht, 1971), p. 55.

Style and community

SALIM KEMAL

We feel a justifiable repugnance towards mere style. It is without substance – perhaps the last refuge of an isolated and ineffective personality. In an age of total administration and the penetration of market forces into every aspect of our lives, style allows us to reinvent ourselves every morning in determinate spaces as wearers of Armani suits, consumers of L. L. Bean hunting shoes, or as readers of Penguin Paperbacks. It is a superficial gloss which, rootless in itself, breeds relativism, subjectivism, and solipsism.[1]

One philosopher at least would respond to these criticisms by conceding them, yet without denying seriousness to the matter of style. In my chapter I shall explore his use of style, arguing that Nietzsche redeems the concept by relating it to issues of interpretation. He proposes to choose between interpretations on the grounds of their fullness and strength, without depending on a commitment to absolute and eternal values; and his arguments show that the pursuit of style engenders a radical and healthy community of creators.

STYLE AND GENEALOGY

Nietzsche rejects 'substance' and 'being', subverting their ponderousness by remembering that their power over us comes from our forgetting that we created them.[2] By this genealogical construal, values are not universal, absolute or objective. They are all, including the items we valorise as knowledge, interpretations[3] – an order of preferences constructed by us from some position in an underlying structure of power and domination.[4]

To explain this constructive nature of values as interpretations, Nietzsche talks of the style and creativity of values,[5] of philosophers

becoming 'poets of our lives',[6] and of associated notions including 'taste', 'seeing', 'the artists' victorious energy', and 'satisfaction'. Taste is an activity of organising elements.[7] Because they have taste, agents have an economy in which they can give significance and order to different elements. To have taste of a particular kind, to construct an economy of a particular kind, is to have a particular style.[8] Actors without style lack taste and therefore have no sense of economy. Since they are without any sense of order, they cannot have aims or plans, cannot distinguish means from ends, and only pursue their most immediately pressing impulses. Yet satisfaction of the latter fails to ameliorate their needs because their desires lack all limit or order. Only style introduces the possibility of satisfaction because it generates preferences. It allows for the distinction between plans and means, and requires reflection on the order of pursuits. Thereby it allows actions to be free rather than random, and for Nietzsche 'one thing is needful: that a human being should gain satisfaction with himself, whether it be by means of this or that poetry or art; only then is a human being tolerable to behold'.[9]

Style and aesthetic redemption

Nietzsche's use of aesthetic concepts like style to explain the construction of values may seem significant in the following way. In *Birth of Tragedy*, for example, he argues that life and order are justified only as aesthetic phenomena.[10] Perhaps his use of style to describe values is meant to reinforce the aesthetic redemption of values. That is often the justification given of style: that the kind of order we give – our style – is serious and significant because there we make ourselves, display our personalities, our mode of living, our sensitivity to the requirements of a good life, and give as beautiful an order as possible to the material of our lives.

In other words, our style 'itself evaluates through us *when* we establish values.'[11] For example, a system of values that opposes humanity to a God-given goodliness and value is committed to a 'declining, debilitated, weary, condemned life'.[12] That spiritualised morality enacts a conception of humanity whose specific imperatives assume that humanity is inferior because it lacks the attributes of divinity. By contrast, a human morality would have a different style because it enacts values that conceive of us as actors capable of living with our mortal existence.[13] Style here is an economy of preferences which constitutes actors. In accepting a style, actors

value an hierarchy of preferences, and so commit themselves to a particular conception of mankind and life. And so far as Nietzsche seeks an aesthetic redemption, in adopting particular styles we become artists of ourselves, and our styles are better the more beautiful they are.

However, Nietzsche's further analysis of aesthetic value denies this last claim. The more thoroughly he develops criteria for grasping values as construction or art, the more clearly he allows us to analyse aesthetic values as constructs. Just as we see moral or cognitive order as interpretations,[14] similarly we can examine aesthetic value to identify its origin in the needs it serves. That is, Nietzsche can now 'envisage the aesthetic problem [itself] from the point of view of the artist (the creator)' and his or her production of value rather than of the spectator who responds to experiences of beauty.[15] Since beauty itself needs to be explained in terms of the aesthetic need it satisfies, Nietzsche will reject any attempt to give refuge to style in its traditional harbour of aesthetic justification. Yet, if style cannot claim this aesthetic redemption, it is not clear what other justification it can have recourse to, to make its use in genealogical analyses viable.

We may find a clue to answer this issue by looking at the positive thesis underlying Nietzsche's genealogical analyses.

STYLE, VALUE, AND CREATIVITY

The positive thesis underlying Nietzsche's analysis of moral and other values may be expressed by saying that genealogy rests on a creativity that is redeemed by its style.[16] In his writings he seems to think of creativity as the activity of producing original works rather than merely following rules, where the works have only the status of interpretations precisely because they are created, where the results of the activity do not serve as rules for others but are at best models for the activity of other genealogists. Although there is no occasion where Nietzsche explicitly states and defends this conception of creativity, it seems intrinsic to the nature of genealogy.

Nietzsche's stress on creativity is already apparent in the explanation of genealogical analysis. Genealogy does not operate by following given rules but by producing order. In each case that we diagnose the style of a value and identify its basis, we produce an interpretation of that value. Genealogy not only supposes that the construction of value is a creative act but, where it subverts falsely

idolised values, it is also the construction of a value – moreover of a value conscious of its own basis. And because it brings about this new value – that is for creating this new value – genealogy is itself a creative act.

Such values cannot be made to serve as universal rules that legislate over other actors and their actions. As interpretations the values have no more reality than other interpretations. Instead, interpretations serve as examples, as particular instances displaying what can be done from one point of view. Others may adopt that viewpoint and, by grasping that example, give scope and practice to their own desire to create. But to create they have to produce their own interpretations, at most using the examples as models rather than as repositories of rules to be followed. Genealogical analyses sustain the creative activity of others, in that others can understand the product only by approaching it as an interpretation, having a certain style and constructed out of a viewpoint. Only another genealogist, aware of its nature and origin, can engage with it, not by following it but by reconstructing it so as to develop his or her own creation of values.

This activity of interpretation embodies the creating will, which for Nietzsche is inescapable. As he says at the end, 'Man would rather will nothingness than not will.'[17] So long as we strive to bring order by generating universal rules and moral values, and suppress the fact of their style of construction, we will continue to find every value inadequate and thereby be forced into nihilism. Only when we live in full cognisance of the creation of values do we escape the force of nihilism.

A PROBLEM FOR STYLE: CAN WILLING BE A VALUE?

It may seem now that a preference for this willing – the possibility of generating change – is itself a value we need, but which Nietzsche cannot defend because he has precluded appeal to any deeper foundation for justifying the choices of the will generally. I want to suggest that in an important sense willing is not value-laden; but again, in another sense, it is, although that need not be a problem. Willing is not a choice we have but the basis for any intentional action or the realisation of a choice. Values result from the exercise of our will. Nietzsche's diagnosis of values reminds us how the ability to will has been realised but subverted because those values have suppressed the will, leading us to nihilism as an alternative to

'giving up' the ability to will. Against this background, to say we value willing is to say we create values.[18] Consequently, willing is value-laden in the sense that it enacts values. And if this claim incurs the reminder that genealogists therefore have some value-commitment, then everyone has that commitment to the exercise of the will – including the nihilists who, when they question why we should act, exercise this ability in even raising the question. The genealogist's stance is inescapable if we are to raise the issue of values at all. Even those who propose a universal viewpoint or value must accept the presence of the will at work in any value. For although they do not often articulate its presence, and while they may pretend that it does not lie in the active power at the basis of the universal values they espouse, nevertheless, without that even their promises will remain unfulfilled and ineffective. Given the need for this willing, arguably our identifying it as a normative claim is not a criticism. It says only that we are dealing with the domain of normativeness, in which willing is crucial.

The preference for interpretations

This explanation also suggests why Nietzsche's account of willing, styles, and values is not self-defeating and why this understanding of will gives us reason to prefer some interpretations over others. Styles and interpretations embody the power of the will, carving out an area where individuals' choices become available and meaningful – where they create and re-create values.

Nietzsche proposes that some styles allow for the exercise of the will, and are more successful for that empowering. He uses the vocabulary of 'health', 'nature', and 'strong will-power'[19] to identify the style of interpretation that makes possible a will that does not thwart itself but allows for other perspectives and wills.

A style and interpretation that allows for willing also empowers other styles. It works to form a substantive community of mutually compatible creators whose activity opens up room in their present context for future exploration. His vocabulary of healthy willing distinguishes the style and empowerment homologous with the continued production of values from conceptions that find diverse and disguised ways of constraining and subverting the will. The latter will always prove self-defeating because they serve only to prevent development. By contrast, the more acceptable interpretations will promote further discovery and a relation between creators

that is inclusive because it is not limited by the inadequacy or dogmatism of its members. The latter signifies that subjects have willed an inefficacious order.

Problems with 'inclusiveness'

This stress on inclusiveness means neither that we cannot have any rules or style nor that the positive rules will never prove inadequate. If we think of efficacity in terms of inclusiveness, it may seem that the most inclusive willing is also the least useful. Every style requires order and restriction, with some economy of significations, by which some events are peripheral and others central. Here, as a standard for efficacy, inclusiveness threatens us with meaninglessness since it must reject every order, including that which generates meaning, because it is restrictive in some way. Only the least well-defined order will be compatible with every other potential order. And that is no increase in refinement.

For Nietzsche that inclusiveness is not simply a matter of generality or universality. Willing always has an object, and its efficacity can never be a matter of holding off from acting and creating values in the hope of arriving at some more inclusive formulation. Further, genealogical analysis does not use universality as a criterion. A 'white supremist', for example, restricts his own ability to develop by disallowing other conceptions of himself. He fails to 'become', in the sense Nietzsche contrasts with 'being', by restricting himself to whatever the style of 'white supremist' may imply. Commensurately genealogy will diagnose the possibilities in that distribution, thereby showing how the given conception is inefficacious.

Moreover, genealogical analysis will have more purchase against restrictive formations than against those formations which are compatible with others. The latter are more efficacious because their values will not exclude agents from other styles and modes of willing. The subject who generates these values is able to will other compatible values and is not constrained by the needs of the restrictive formations. As a corollary, the open production of values will be inclusive because of the particular formations it is comfortable with rather than because it satisfies some overarching or universal viewpoint or generality.

Of course, eventually, these styles too may be found less than inclusive, so they do not claim any permanence. Their failure will be

specific, and will be the more interesting because it cuts into a greater range of styles which were formerly thought compatible. Nietzsche talks of this, in one sense, as the grand style, which embodies 'the artists' victorious energy'[20] over arbitrariness. In a greater freedom stronger resistances have been overcome, in which it costs more effort 'to stay aloft'.[21] In another case, while criticising modernity, he characterises the failure of styles in terms of establishing a tradition. 'Having lost all the instincts out of which institutions grow . . . we are no longer fit for them . . . ' For institutions to exist there must exist 'a will to tradition, to authority, to centuries long responsibility, to solidarity between succeeding generations backwards and forwards in infinitum'. Where we lose this instinct, we lose the impulse 'out of which the future grows'.[22] The great failure of this style is commensurate with its depth – the tradition or compact between generations and individuals it portended. The institutions we produce, the traditions we establish, are fully capable of change, but that development is no mean effort.

Without constraining others in the future they will create, Nietzsche clarifies that the most interesting work remains that of willing new styles of value, whose greatness shows itself in the willing they allow. The greatness of these styles should redeem creativity and interpretation from sheer solipsism by making possible a community of creators. If we accept that individuals create and act by their own lights and, even if they relate to other creators, do so only to produce their own work rather than follow a rule, then the distance between them seems great. Genealogists seem never to compare their understanding of another form with the self-understanding of that form, by which they might claim superiority for their own conclusions, because they never have access to that other form independently of their own stance. Particular analyses can only serve as instances which other genealogists go beyond in their own creative acts. Only those unable to create will treat the genealogists' analyses as a rule for themselves and so escape solipsism. But they are not genealogists. Little objectivity results from such independent behaviour, and the membership of common practices and interactive forms of life, that are usually invoked in talk of community, seem non-existent – so much so that a community of creators seems empty of content. We have no guarantee that our interpretations and constructs will coincide with or enter into others' constructions, and we lack any basis for demanding such an interaction.

Despite these difficulties, I shall suggest that we generate a community of creators, making available a relation between interpretants that will sustain the validity of some styles. The claim may seem counter-intuitive in the face of Nietzsche's references to creators ravishing the herd and nature.[23] But he also uses the vocabulary of health, strength of interpretations, and fullness of style. These concepts promote a community of creators, providing a positive reading of objects and actions without bringing in any metaphysics. The politics of this community, I suggest, must be radical.

Through this analysis, we shall see that a rejection of 'being' and of a single shared system of symbols anchored in some eternal values need not lead to chaos. Every crisis produces its own cockroaches who think themselves prophets and appeal for a return to those atavistic values. Nietzsche's concept of style shows that this regressive step is not our only choice. Even without 'being', we can still construct a healthy, progressive, and creative community of stylists.

THE POLITICS OF PRODUCTION

By recasting the story in terms of our active construction of values, Nietzsche raises also an issue of the kind of community that is subtended by genealogy. We must draw out the implications of the kind of relentless creation of values that Nietzsche has suggested, considering the relation between subjects which becomes possible – we must examine the politics of this kind of production.

To characterise the community of genealogy Nietzsche proposes an equality of creators for whose future actions no present universalisable imperative can be binding. Genealogy makes clear that every imperative has a standpoint, and Nietzsche does not expect his present preferences to circumscribe the future that agents shall produce. Both these issues about the character of community and its normative force are deeply political. Together with his stress on the subject, these commitments are part of a more rational and free political order that genealogy promotes.[24]

We can develop this conception by proposing two claims: firstly, genealogy cannot be politically conservative; secondly, it uses a distinctive and coherent political vocabulary to constitute its community of actors.[25] Genealogy is a politics of subjects who are agents. We saw that value was always only a means for preserving a

131

particular kind of subject. Genealogy reveals the conception of the subject at work in any value to allow us to substitute another understanding of the subject as active agent. In other words, genealogy recognises that ' "the subject" is . . . a created entity, a "thing" like all others.'[26] We misconstrue the 'subject' as 'something given', for it is 'something added and invented and projected behind what there is'.[27] His suggestion is that we construct the subject in our construal of values, and some styles of value generate a subject who is open to development while other forms only calcify the power to act. Genealogy, then, lays bare the style and economy by which a work constructs its subject, thus opening a false 'being' into a 'becoming'. We saw also that we had reason for preferring the styles and values that facilitate the exercise of the will, empowering other styles and values.

Such genealogy cannot be conservative. If we understand conservatism as the desire to preserve the results of our natural judgement, then genealogy will corrode conservatism's basis.[28] In other words, firstly, genealogy plays a critical role by maintaining the following: where conservatives insist that natural judgement or our natural sense of beauty provides a standard for values, so that what satisfies nature is good and what is bad is unnatural, genealogy questions the origin and nature of this conception of nature. It proposes that this conception itself enacts values; and by displaying the origins of the values involved in that conception, it dissolves their justification.

Secondly, we can take as examples, Hume, who introduces an experimental method of reasoning into value to discover what causes give rise to values as effects,[29] and Burke, who argues that aesthetic and social values result from countless adjustments too complex to understand, control, or tamper with.[30] By contrast, Nietzsche maintains that by providing a genetic account of values these philosophers show the sources of value, and even identify the values being enacted but, in doing so, also open up, without answering, issues of justifying those enacted values.[31] As Hume and Burke do not have the resources for raising issues of the origin of values in enacted forms of life, style, economy, etc., they cannot even begin to examine the political implications of their own positions and genetic justification. Instead, the genealogical approach shows that their genetic explanations are inadequate because they do not consider their own bases. So far as conservatism is a politics of human judgement or nature that seeks to preserve what is

'best' about a 'natural' order, genealogy is progressive because it identifies the latter as a value-laden assumption and, pointing out its style and basis, dissolves its justification. No conservative claims to legitimacy will escape this kind of questioning, and any progressive theory that depends on similar accounts of human nature will also fail.[32]

Similarly, a politics based on subjects reasoning out the morality of their actions and projects, which they justify by bringing their actions under rational and universalisable rules, will not receive succour from genealogy. Such imperatives seem inadequately grounded. These values depend on an implausible conception of humans as rational beings and therefore reduce value to an etiolated sphere separate from any engagement with reality. They suppose that all moral or beautiful things share some common feature, regardless of the historical or political position of works, their construction, and reception, and maintain that we can cut through these latter contingencies to grasp value, in its universal language, addressed to a universal subject, who underlies all the 'contingent' historical and political forms of individual existence. Morality and beauty thus become a matter of subjects' distinctive responses to only particular features of objects and events; and the construction of value, the notion of a subject which it subtends, the style and economy implicated in this conception of beauty, all become lost to analysis. In this context, genealogy is progressive first by reminding us of the basis of values and secondly in dissolving that value by presenting its sources – by showing the incomplete notion of the subject that this conception of values implies.

A radical right fares little better. If we understand a radical right as the attempt to maintain a group or policy in power for the sake of that power, without any attendant claims to legitimacy, then genealogy rejects its claims. It denies that power any legitimacy, just as it denied legitimacy to conservatism; and where power does not seek legitimacy, genealogy condemns the unhealthy form of life that its style portends. For this form of life, even if it holds on to power without apology, must still will an order, and that willing is the object of Nietzsche's analysis. By his account, we may argue, values that serve only to keep a few in power lose their richness and complexity. Value becomes necessary only to legitimate a concep-tion of a subject and power; yet because a radical right does not seek to justify itself, it has no need for values, and so impoverishes our ability to will.[33] But the radical right cannot do without willing as

such, and where it wants to reserve power for a few, it must either suppress others' ability to will or must control it. But if it suppresses others' wills, it makes its own power ineffective. It now no longer dominates other agents because there are no longer any agents possessing wills: by suppressing their wills, this naked power only thwarts itself. On the other hand, if it only seeks control of other wills, then it fails ever to gain a grand style, with the attendant sense of balancing strength and weakness that we saw, earlier, was essential to the exercise of strength in willing. Its interpretation and basis in power thus become impoverished.

Now, the last rejection of power may seem futile because genealogy's condemnation of the radical right does not bring about its abolition. But that is a general condemnation of any methodology because, in the face of an irrational or unapologetic pursuit of power for its own sake, no rationalisation can succeed. Yet at least genealogy is effective in bringing out the limitations of that brutal power, for this radical right grasp of power must establish and perpetuate itself in some way at least among those who exercise it. Against such a grab for power, a theorist of democracy who does not grasp the genealogy of democratic forms in domination and power will have recourse only to the democratic forms of opposition. But these, because they do not thematise the undemocratic mechanisms that can bring about democracy, can oppose a shameless exercise of power only with mere moral incantations. By contrast, Nietzsche's genealogy defends a 'community of creators' because it depends on the very willing which underlies every exercise of power. Nietzsche can suggest where the defence begins to develop, for his exploration of irrationalism allows him to recognise that a community of creators must be prepared to counter violence and barbarity. That is, the community of creators may form as a counter to a despotism that limits willing. And because we recognise the sources of rational forms, we can thematise that countering by developing an account of the community of creators.

The community of creators

To defend this claim for Nietzsche, we must look more carefully at the 'community of creators'. Given Nietzsche's descriptions of their ravishing the herd and nature,[34] it is not clear that these creators can form a community. This difficulty arises also because Nietzsche's stress on creativity, given the differences in our abilities to create,

seems to preclude the kind of balance between parts involved in talk of a community. But Nietzsche also uses the vocabulary of richness, health, strength of interpretation, etc., that provides a positive reading of objects and actions without bringing in any metaphysics. This leads us to recognise that even if Nietzsche does not provide an analysis of political structures, he does give insight into the politics of values.

The community of creators is not an impossibility. It only seems so from the point of view of a resentment that seeks control of every action by clamping it under already given rules. By contrast with some agents, who use categorical imperatives as a mechanism for controlling moral creativity and our exploration of the complexities of new moral situations, Nietzsche stresses the latter, showing we generate new rules in our actions. Rather than consider the fact of judging or responding to actions, he examines the matter of acting. His is a community of actors rather than a community of responders, where the former community develops out of a relation of actors to acts and not of responders to acts. A work or action provides an example that other actors can take up not as a rule to be followed but as an example they use to produce their own work. The community, then, is an interaction of producers and their objects, of rules generating new rules, of interpretations giving rise to new interpretations, and not a matter of including only those events that satisfy a universalisable rule. In other words, we may still talk of a community even though it is a group of creators who respond to each others' works and actions by creating their own, or create their own independently.

Individual and community

Nietzsche sees no contradiction between such creative individuality and community. For example, he proposes that the 'host of conventions' which lie at the basis of mature art give substance to the community that shares this language and set of conventions. Nor does such convention offend against creativity. Nietzsche sees convention as a condition for our activity, 'not an obstacle'.[35] We do not condemn those who produce values as uncreative because they use linguistic and social conventions to construct a work. Conventions are means for making ourselves and our creative products understood, and they no more interfere with creativity than the rules of logic prevent us from uttering truths.[36]

Only the community that seeks to overpower the individual in the name of some social rule also opposes the creative individual. That oppressive community Nietzsche is happy to condemn; yet this does not deny all community, and Nietzsche also pleads the need for a creative and social individual. And such creative and social individualism, we may expect, will likely rebel against extraneous formal rules and such conservative values as either seek control or oppose the individual to all forms of community.

An objection and a reply

While this sense of a community based on actions can stand further detailing, even at this general level we can raise an objection that typifies others. A community of creators, a critic may argue, is impossible. A community suggests a balance in which every individual is necessary to the whole and, so, equally important. But different subjects are creative to different degrees, and surely some individuals will stand out over others. Their greater importance to the community will cause inequality, and make the community of creators politically questionable. Genealogy then still only results in another arbitrary grouping of unequal actors. Yet progressive thought must surely liberate us from hierarchies, making possible a free and equitable relation between agents,[37] and showing how any present imbalances in such things as wealth and creativity do not preclude equity in worth. Yet creativity does not sustain such liberation.

The reply to this kind of objection is straightforward. Possession of the ability to will and create is not a source of inequality: the democratic community no more institutionalises individuals in hierarchies by reference to variations in their intelligence than a community of creators need exclude agents by reason of variations in their ability to create. More importantly, the criticism uses an evaluative conception of creativity, treating it as an ability to produce values that only some specially gifted agents possess. That is not Nietzsche's conception – the herd does not lack creativity, it merely fears to exercise it or prefers to control it.[38]

Of course, Nietzsche does not provide any analysis of the political structures and institutions that will sustain creative activity. His sense of politics is wider than such an institutional analysis, and it implicates a progressive political relation between creators. This community of creators does not exclude any subject from its politics.

And though he does not give us an analysis of political institutions as such, Nietzsche suggests that we have a tool for excluding those who would introduce conservativism. He talks of the richness of interpretations,[39] of their health,[40] and of the strength in styles, as we saw earlier, that provide a criterion for politics through a notion of inclusiveness. We can exclude interpretations that impose limitations and exclude possible actions and actors.[41] People who promote, say, a community of only white males have a poorer ability to act, impoverishing themselves by insisting on the validity and incorrigibility of certain rules and having to suppress others because they can find no reason to oppose them. Yet the very insistence that white male society constitutes the only legitimate community already makes him redundant in the light of the richer experience, interpretations, and forms of life available from another perspective.

Without exhausting all possible viewpoints within the compass of a single moral fable or eschatology, Nietzsche moved that the richer interpretation is better because it empowers us better to act and construct healthy, future-seeking forms of life. For genealogists it is important to keep open the future, seeing every interpretation and its form of life as a willing. And for sustaining the ability to act, for empowering us in a form of life, we value that creativity. Its contrast is with a form of life that imposes redundant boundaries of class, race, sex, position, and so on, on our will and style. We prefer the style of life that promotes our willing.[42] And so far as genealogy makes this possible, it is a politics of production and creativity.

NOTES

1. In 'Some Problems of Genealogy', *Nietzsche Studien*, 1990, I defend Nietzsche against charges of relativism, solipsism, and normativeness. See also 'Nietzsche, Creativity, and the Redundancy of Literary Value', *Nietzsche Studien*, 1992, and 'Nietzsche's Genealogy', *Journal of the British Society for Phenomenology* (1990) for some developments of issues considered in this chapter.

2. He wants us to grasp values in terms of their becoming. 'Becoming does not aim at a *final state*, does not flow into "being" ' Section 708 *The Will to Power*, trans. Walter Kaufmann (New York: Vintage, 1981). Values do not have some objective being or immutable nature but are the products of certain perspectives or relations of power.

3. See sections 353–80, F. Nietzsche, *The Gay Science*, translated with a commentary by Walter Kaufman (New York: Vintage 1974) and *Will to*

Power, sections 68, 69, *et al.* Nietzsche's references to science and interpretation are numerous.

4. See *The Last Philosopher* or *Reflections on the Struggle Between Art and Knowledge, Will to Power*, in *Philosophy and Truth*, edited and translated by Daniel Breazedale (New Jersey: Humanities Press International, 1979); sections 795, 1048, and 816, and *Gay Science*, section 299.

5. See for example *The Genealogy of Morals*, essay III, trans. Walter Kaufmann and R. J. Hollingdale (New York: Vintage, 1967), where he understands the ascetic in terms of style, or pp. 78–81, *Twilight of the Idols*, translated and edited by R. J. Hollingdale (New York: Penguin Books, 1968), where he considers the relation of style to valuation. In *Gay Science*, section 299, he again discusses creativity, style, and valuations.

6. *Gay Science*, section 299.

7. *Ibid.*, section 290.

8. 'Actors survey all the strengths and weaknesses of their nature and then fit them into an artistic plan until every one of them appears as art and reason and even weaknesses delight the eye' (*ibid.*).

9. *Ibid.*

10. *The Birth of Tragedy*, sections 5 and 24.

11. *Birth of Tragedy*, section 4.

12. *Twilight of the Idols*, p. 45.

13. *Ibid.*, pp. 47–54.

14. They appear as modes of becoming rather than being.

15. *Genealogy of Morals*, essay III, p. 6, italics added.

16. *Ibid.*, section 24.

17. *Ibid.*, essay III, section 28.

18. When we allow the values to stand over us, and think them justified independently of our willing, we merely forget or disguise the fact of our creation.

19. *Twilight of the Idols*, pp. 72, 45–7, 65.

20. *Beyond Good and Evil*, section 223.

21. *Twilight of the Idols*, p. 92.

22. *Ibid.*, pp. 93–4.

23. See *Beyond Good and Evil* and *Genealogy of Morals*.

24. I have in mind Habermas and the Frankfurt School as a contrast to Nietzsche on this point.

25. Both these claims would hold of genealogy even though they may well prove false of Nietzsche himself.

26. *Will to Power*, p. 556.

27. *Ibid.*, p. 481.

28. The example I have in mind is Hume's reliance on a conception of human nature by which natural judgements are the basis for our claims to knowledge and value. See book III *Treatise of Human Nature*, ed. L. A. Selby-Bigge, 2nd edn. by P. H. Nidditch (Oxford: Clarendon Press, 1977).

29. *Ibid.*, book II, section VII and book III, part II, section II, on vice and virtue and on the origin of justice and property.
30. See Edmund Burke, *Reflections on the Revolution in France*, trans. and ed. L. G. Mitchell (Oxford University Press, 1993) and *A Philosophical Enquiry on the Origins of our Ideas of the Sublime and Beautiful*, ed. J. T. Boulton (Oxford: Blackwell Press, 1987).
31. See for example *Gay Science*, section 345, where he says that even if morality has grown out of an error, the realisation of this fact would not determine the issues of its value.
32. See for example, Sebastian Timpanaro, *On Materialism*, (London: NLB, 1972), who relies on a notion of human nature derived from biology to propose that universal values are available to Marxism.
33. See Nietzsche's criticisms of 'cultural philistines' and his account of aesthetic necessity cited earlier.
34. See note 22 above.
35. *Will to Power*, p. 809.
36. In *Thus Spake Zarathustra*, in 'Thousand and One Goals', Nietzsche maintains that people are creators first and individuals second, suggesting both that an opposition between individual and community is a result of creativity and not something that suppresses individuality, and that individuality depends on conventions because creativity does so. That is, far from the individual creator and community being opposed, they are interdependent: creators use language and its conventions to produce their work and so enhance and develop the community.
37. Even if there is an actual inequality – from each according to their abilities and to each according to their need – these imbalances remain unimportant because the worth of agents is not decided by their wealth.
38. Nietzsche says that priests are the strongest among the weak. See *Genealogy of Morals*, essay III, on the particular creativity exercised by the ascetic. Nietzsche explains that the 'slave revolt in morality begins when ressentiment becomes creative and gives rise to values' (*ibid.*, p. 10). That is, rather than deny that the herd is creative, he diagnoses that its self-understanding subverts the herd's creativity, leading it to produce destructive values.
39. See, for example *Genealogy of Morals*, where Nietzsche points out the role of interpretations. *Will to Power* contains numerous instances of this stress.
40. See *Twilight of the Idols* for more on Nietzsche's idea of health.
41. This is not entirely true since Nietzsche says we must narrow our perspective to produce new values (See *Genealogy of Morals*, Essay III, p. 12, where he talks of the narrowing of perspective). However, his whole thrust here too is to make progress in producing new works, and where a narrowing frustrates this production, we shall jettison it.
42. The human *will* does not afford a metaphysics in Nietzsche's work. Clearly, it is central to his account, but it is not a metaphysical entity. The will shows itself fully and only in our actions. It does not have any

substance-like residue that allows it to unify its diverse appearances as accidents under some single rubric. The will and its exercise gain meaning from their context. Of course, Nietzsche has a more complicated notion of the will than many others do – for instance, he allows that it hides its search for power under different guises – but it still shows itself only in the way it hides its aims. And by pointing to these guises of the will Nietzsche is pointing out that when people have taken to metaphysics it is precisely a result of their ignorance of the operations of the will. Were they to recognise those claims as constructions from a viewpoint, they would not credit them with the authority that engenders a metaphysics.

Metaphor and paradox in Tocqueville's analysis of democracy[1]

FRANK ANKERSMIT

INTRODUCTION

No theorist of democracy has received more praise than Tocqueville. But although Tocqueville's views have been so very influential, it is surprisingly difficult to summarise his theory of democracy. This is all the more surprising since the major textbooks appear to have little difficulty in identifying convincingly a few central theses in Tocqueville's political philosophy. One can think here of Tocqueville's insight into the strained relation between freedom and equality, his thesis about the continuity between the Old Regime and the Revolution or about democracy's inclination to develop into a 'tutelary despotism'. Yet the more detailed one's analysis of Tocqueville's work becomes, the less happy one will be with these and similar summaries. Summarising Tocqueville seems inevitably to result in some stale and relatively uninteresting truths and to reduce the intellectual depth of his thought to the level of trivial conversation. It is, in one word, as if the essence of his œuvre is that it does *not* have an essence; as if we could not better summarise his work than by saying that it can*not* be summarised.

One might infer from this state of affairs that, despite appearances, Tocqueville has no 'theory of democracy' in the proper sense of the word to offer to his readers; it may seem that his work is not an attempt to lay bare the hitherto hidden essence or nature of democracy. Or, to put the same idea in a more positive, possibly truer and certainly more interesting way, it might be that we ought to interpret Tocqueville's œuvre as saying that, in fact, no 'theory of democracy' is possible and that precisely our effort to 'theorise' about democracy will prevent us from seeing what is really new and interesting about democracy.

It will be my main purpose in this chapter to demonstrate the plausibility of such an 'anti-theoretical' interpretation of Tocqueville's texts.

I hope to make clear in this chapter that it is only by focusing on Tocqueville's style – or, rather, on the *styles* adopted by Tocqueville – that we can grasp both the nature and the significance of the Tocquevillian insight that of democracy no theory is possible. Tocqueville adopts a style enabling him to develop an analysis of democracy that could never be expressed in a prose drawing its principle of organisation exclusively from the purported organisation of the subject-matter represented by it. Style and content are not merely closely interrelated in his writings – as surely is the case in any great achievement in historical writing or in social and political theory. Style here even dominates content in order to discourage any attempt to 'compress' or to epitomise content within the narrow confines of a merely theoretical account of democracy. In Tocqueville's œuvre we see how and why the category of style thus has precedence over both theory and content. Hence, to the extent that we allow ourselves to be convinced, or even only intrigued by Tocqueville's analysis, Tocqueville's texts embody an implicit suggestion about which style or form we should adopt if we wish to say anything revealing about democracy. In a curiously oblique way Tocqueville's texts show that its anti-theoretical, anti-metaphorical, and paradoxical style is our only key to the secrets of democracy – that best-known but least understood political system. In contrast to relatively crude political systems like feudalism, aristocracy, or absolutism, the political and social web woven by democracy is so subtle and intricate that we will tear it apart if we approach it with an unsuitable stylistic apparatus. Thus, before starting to think or write about democracy, we will have to make up our mind about the style to adopt for doing so; reversing that order will inevitably make us blind to its most interesting features.

METAPHOR

Metaphor is the trope that comes naturally to both historiography and political theory.

Historical discourse presents us with a text which – when taken as a whole – does not refer or correspond to reality in the way this can be said of the constative statement. One cannot compare a historical representation of the past as given in the text as a whole to a

historical reality as we can do with the statement. Instead, we should conceive of this historical text as a substitute, present for us here and now, for an absent past. Instead of an objective and publicly accessible and perceivable historical reality that is given to historians when they speak about and discuss the past, we have the historical representations historians have proposed as its substitutes. This may explain the essentially metaphorical character of historical representation. For just as the historical representation is used for speaking about the absent historical reality that is represented, so metaphor proposes the metaphorically used expression (and the semantic field that is commonly associated with it) for speaking about the subject of the metaphorical utterance. And there is an additional reason for the historian's reliance on metaphor. For what makes metaphor especially valuable in historical discourse is its capacity to organise knowledge. A simple metaphor like 'the earth is a spaceship' effects an organisation and hierarchisation of hitherto not or insufficiently integrated knowledge we have about the earth, the pollution of the ecosystem, about the biosphere being a closed system etc. A good metaphor may be so successful at organising knowledge that it even suggests a certain course of action – the metaphor given just now is a good example. Metaphor achieves such an organisation of knowledge because it proposes a point of view or perspective on (historical or political) reality. As is suggested by the notion of perspective or point of view, metaphor effects a distancing from the reality metaphorised and thanks to the distance thus created a hierarchisation of knowledge, of what is important or unimportant, can take place. Similarly, because of its metaphorical character, the historical text will show its reader what is of central and what is of merely peripheral significance for understanding the nature of a particular part of the past. Depth, distance, relief, a textual *clair obscur*, a contrast between foreground and background, hierarchisation of the important and the unimportant, a differentiation between centre and periphery, and above all, narrative organisation are all achieved if the historian makes use in his text of the resources of metaphor.[2] Moreover, at the same time we discover here the political uses of metaphor. For all political action requires a point of application, so to speak, from where social or political reality is changed or influenced. And metaphor offers both the political theorist and the politician such a point of application. Obviously, the point of view proposed by the historical text or a political analysis is closely related, if not

identical to, the point where political thought and action are applied to reality.

Against this background we would not be astonished by the metaphoricity of Tocqueville's analysis of democracy and of its historical origins. And indeed, we do find metaphors in his work. To be more exact, we can discern in Tocqueville's work both an acceptance of metaphor as a formal principle for organising the text *and* the proposal of a quite specific and crucial metaphor. I shall start with Tocqueville's use of metaphor as a formal principle. Nowhere is metaphor as a formal and organising principle more freely embraced by Tocqueville than at the end of the first volume of *Democracy in America*.[3] He offers there a characteristic of his enterprise with the following words:

> I am approaching the close of my inquiry . . . my present object is to embrace the whole from one point of view . . . I shall perceive each object less distinctly, but I shall describe the principle facts with more certainty. A traveller who has just left a vast city climbs the neighbouring hill; as he goes farther off, he loses sight of the men whom he has just quitted; their dwellings are confused in a dense mass; he can no longer distinguish the public squares and can scarcely trace out the great thoroughfares; but his eye has less difficulty in following the boundaries of the city, and for the first time he sees the shape of the whole. (*Dem. I*, 447)

A similar acceptance of metaphor and of the organising capacities of metaphor is found in Tocqueville's other great book, *The Old Regime*, where Tocqueville argues that at the time the work was written, humanity found itself at that precise point in the course of the evolution of western history and society from which one can best perceive and pass judgement on the French Revolution (*AR*, 61). For it was at that time, some sixty years after the outbreak of the Revolution, that the Revolution stood out clearer than ever before or after against the encompassing background of French and European history.

In both these cases Tocqueville appears to allot to metaphor the task metaphor ordinarily performs in historical and social scientific writing. However, if we take a closer and more careful look at the text, we shall discover that Tocqueville's use of metaphor is curiously self-contradictory or paradoxical. A first indication of Tocqueville's paradoxical use of metaphor, a use of metaphor in which metaphor annuls itself, can be found in *The Old Regime and the Revolution*. As has been pointed out by several theorists of historical writing, notably Louis O. Mink,[4] the metaphorical point of view is ordinarily used by historians for organising and expressing

historical change. The narrative account of historical change and evolution requires the metaphorical point of view from which such narrative accounts are organised. However, in his book on the Revolution Tocqueville succeeds in adopting a metaphorical point of view that by contrast destroys narrative and obliterates historical change. Metaphor is turned against itself. Thus, in a brilliant analysis of *The Old Regime and the Revolution* Linda Orr has argued that the Old Regime and the Revolution are so intimately tied together in it, that they can be so little dissociated from each other, that the Old Regime becomes a duplication of the Revolution and vice versa.[5] And the result is that narrative and temporal order are destroyed. It was the notion of centralisation that enabled Tocqueville to pull the Old Regime and the Revolution so close together that any distinction between them becomes a mere historical and misleading pedantry. Misleading, because the attempt to see differences invites us to see differences where it is essential that we do *not* see them. From the point of view of centralisation there is no difference between the Old Regime and the Revolution. As Ms Orr succinctly puts it, the book would have been better entitled *L'Ancien Régime est la Révolution* than *L'Ancien Régime et la Révolution*.[6] Thus centralisation was indeed used by Tocqueville as his metaphorical point of view, but, in sharp opposition to how metaphor is ordinarily employed by historians, the metaphorical point of view paradoxically serves the purpose here of eliminating temporal and narrative organisation.

Democracy in America presents us with a roughly similar picture. At the beginning of this book it looks as if Tocqueville intends to write a narrative history of how democracy developed in America. Thus Tocqueville declares at the outset that American freedom and American democracy can only be understood if seen as the result of a complex historical evolution, and he assures his readers that he is going to tell them that history. Nations will always bear 'the marks of their origin' (*Dem. I*, 28) and a narrative account of American history will contain 'the germ of all that is to follow and the key to almost the whole work' (*Dem. I*, 29). But, having said this, Tocqueville immediately abandons the narrativist programme. For apart from a few incidental remarks about Puritanism and the tradition of municipal government, historical references are virtually absent in the two volumes of *Democracy in America*. Thus a pseudo-narrativist opening merely serves as a Tocquevillian ploy for entering into the non-narrative analysis developed in the rest of the

book. And if the book does not have a beginning in the proper sense of the word, neither does it have an acceptable ending. It is even somewhat comical to see how the book ends several times, only to be taken further again each time. The book already ends twice in the first volume. Then the book ends for a third time with the anacoluthon of the third book of the second volume. Lastly, as if he had himself become impatient with his inability to find a suitable closure, the book ends for a fourth time with the resounding kettledrum beat of the short fourth book. So, just as was the case in *The Old Regime* a narrative, metaphorical organisation of the subject-matter is turned here against itself. In both cases the metaphorical style is paradoxically pitted against itself.

I shall now turn from these formalist considerations to a material one and discuss the central metaphor proposed by Tocqueville in his analysis of democracy. And once again we will encounter here the paradoxical use Tocqueville tends to make of metaphor. The metaphor in question is that of the democratic state as the 'guardian' ('tuteur') of the democratic citizen. Although it was already used by Tocqueville at the end of the first volume, the metaphor only makes its real appearance in the fourth book of the second volume, but from there it casts its long and sinister shadow over the whole of the text preceding it. The metaphor is introduced by Tocqueville in the following way: 'when I consider the petty passions of our contemporaries, the mildness of their manners, the extent of their education, the gentleness of their morality, their regular and industrious habits, and the restraint which they almost all observe in their vices no less than in their virtues, I have no fear that they will meet with tyranny in their rulers, but rather with guardians' (*Dem. II*, 336).

There are two aspects to this metaphor which require our attention. Firstly, it should be observed that this metaphor does not correspond to democracy itself, but rather to a degenerate form of democracy, that is, to a democracy that has changed into a benevolent and over-centralised form of despotism. Above the democratic multitude, writes Tocqueville, 'stands an immense and tutelary power, which takes upon itself alone to secure their gratifications and to watch over their fate. That power is absolute, minute, regular and mild' (*Dem. II*, 336). Metaphor truly realises here its political potential: metaphor's capacity to organise and to unify a chaotic manifold has become here a political reality. Yet, the important thing to note is, that if metaphor here does realise itself

politically, the result is *not* democracy itself, *not* democracy in its true form, but the bastardisation of democracy in the form of some new and unheard-of kind of despotism. Once again, Tocqueville's text denies to metaphor *in practice* the task it *theoretically* ought to perform by giving us a grasp of democracy.

Nor is this all. We must note that it is generally the task of the guardian to identify with the interests and the point of view of the persons entrusted to his guardianship. More specifically, the guardian ought not to pursue his own interests if these are hostile or detrimental to those of his wards. Since the relationship between the state and the citizen is constructed by Tocqueville in such a way that a conflict of interests between the state and the citizen is far from imaginary, this puts the state in a highly ambiguous and even paradoxical position. So the metaphor of the state as guardian is what one might refer to as a most paradoxical metaphor – paradoxical in the sense that it requires the state to reconcile the incompatible interests of itself with those of the citizen. Even in Tocqueville's characterisation of degenerate democracy, therefore, metaphor has to yield to paradox. And, of course, what is the notion of a 'benevolent despotism' other than a powerful political paradox?

Let us sum up our findings about the role of metaphor in Tocqueville's political thought. Metaphor is present in both a formal and material sense in Tocqueville's work. In this respect Tocqueville's analysis of democracy does not differ stylistically from more traditional accounts of democracy and of its historical origins. Yet it must strike us that metaphor in Tocqueville's text is nowhere allowed to occupy the central place so naturally assigned to it in historical and social scientific texts. Metaphor only makes its appearance so that it can be marginalised again.

PARADOX

Few texts in the history of western political thought have so much 'personality', are so immediately recognisable and possess such extraordinary rhetorical vigour as Tocqueville's books on American democracy and on the nature of the French Revolution. So if it is *not* metaphor with its affinity with unity, hierarchical organisation, the dominance of the centre over the periphery, with its reliance upon narrative and chronology and causal relation, then *what* did Tocqueville choose as his stylistic code? It will be my thesis that Tocqueville's break with the historiographical traditions of his (and

our own) time mainly consists in his abandonment of metaphor in favour of paradox. And surely we may expect a 'penchant' for paradox in an author who, like Tocqueville, presents to his readers the French Revolution as being, in fact, no revolution at all or who describes democracy as being, in fact, a despotism of the multitude and as a political system that is essentially conservative (the last paradox undoubtedly being the most amazing of the three to Tocqueville's contemporaries). In each of these three examples it is Tocqueville's strategy to present a historical or political thesis by means of its opposition to an accepted truth; the rhetorical strength of his argument is derived from this opposition, which is carefully upheld in the text.

And, indeed, we find paradoxes on nearly every page of Tocqueville's books; every time he reaches a conclusion that pleases or interests him it is moulded in the form of paradox. Since much of my argument in this essay rests on this replacement of metaphor by paradox, I may be expected to be generous with examples. To begin with, Tocqueville, considering himself, notes the paradoxes of the human heart: 'I need not traverse earth and sky to discover a wondrous object woven of contrasts; of infinite greatness and littleness, of intense gloom and amazing brightness, capable at once of exciting pity, admiration, terror, contempt. I have only to look at myself' (*Dem. II*, 80). Next, in the years before 1848 notions of right and wrong, good and bad seem to have become confused in the paradoxical turmoil of his mind. In desperation he cries out: 'where was truth? Where was falsehood? On which side were the evil ones? And on which side the well-intentioned?' (*Rec.*, 84). The character of nations and of peoples is no less paradoxical: thus the Americans are 'at one constrained and without constraint' (*Dem. II*, 229); America is the country 'where the precepts of Descartes are least studied and best applied' (*Dem. II*, 4); and in spite of all their Cartesianism and their confidence in their own resources, Americans are more gullible than any other people (*Dem. II*, 11). Even more paradoxical is the French national character: the French care about property but not about their lives; they are 'equally bent on reasoning and on being unreasonable' (*Rec.*, 114). And a two-page list of the paradoxes of the French national character is drawn up as a kind of afterword to *The Old Regime* (*AR*, 320, 321).

But what most catches the eye and contains, moreover, a good deal of the essence of Tocqueville's argument are the sociological and political paradoxes he uses when discussing democracy. It is

true that the pre-revolutionary period is not completely free of paradoxes – thus in aristocracy 'some actions have been held to be at the same time virtuous and dishonourable; a refusal to fight a duel is an instance' (*Dem. II*, 242) – but the number of paradoxes increases quickly when Tocqueville starts to discuss democracy, so much so that it seems impossible for Tocqueville to describe democracy without an appeal to paradox. Thus with the rise of democratic equality landowners remain unaware of social levelling because rents tend to rise in this phase of history (*Dem. I*, 198). Equality fosters a kind of 'virtuous materialism' (certainly an oxymoron in Tocqueville's eyes) and, what is more important, 'the democratic nations that have introduced freedom into their political constitution at the same time when they were augmenting the despotism of their administrative constitution [a condition typical of democracy F.A.] have been led into strange paradoxes. To manage those minor affairs in which good sense is all that is wanted, the people are held unequal to the task; but when the government of the country is at stake, the people are invested with immense powers; they are alternately made the plaything of their rulers, and his masters, more than kings and less than men' (*Dem. II*, 339). Furthermore, American democracy offers the paradoxical spectacle of possessing freedom of the press 'without independence of mind and real freedom of discussion' (*Dem. I*, 273) and political power will both 'be more extensive and more mild' in a democracy than in other political systems (*Dem. II*, 335). Nothing is more common in democracy than to 'recognize superior wisdom in the person of one's oppressor' (*Dem. II*, 12). But in contrast to this paradox Tocqueville elsewhere presents the paradox that in democracy power increases when authority diminishes and vice versa. But of all the characteristics of democracy that are 'most formidable but least foreseen' (*Dem. II*, 348) surely democracy's most surprising feat is to have created a society in which everything changes and yet everything remains the same (*Dem. II*, 239).

If we wish to understand the meaning of Tocqueville's exchange of metaphor for paradox, it will be necessary to devote some attention to the similarities and dissimilarities of the two tropes. In both cases, in metaphor no less than in paradox, we have to do with semantic deviance, with an apparent conflict at the semantic level. Both metaphor and paradox interrupt the easy flow of literal language. But the way in which semantic conflict is solved is different in each case. As we have seen at the beginning of this chapter, metaphor solves semantic conflict by the identification and

fixation of a semantic point where the conflict disappears and significant meaning originates. In the case of historiography this semantic point is the point of view from which we are invited to see the past.[7] It must be noted, next, that such points of view are outside and independent of historical reality itself, and this is no coincidence. For metaphorical historiography requires of the historian a movement of estrangement from historical reality (a movement often associated by historians with the pursuit of the state of objectivity); it is a movement that results in the opposition of, on the one hand, a now 'objective' or even 'objectively given' historical reality and, on the other hand, a metaphorical point of view whose preferably maximum distance from that objective reality guarantees that an objective survey or account can be given of it. One must realise, then, that in metaphorical historiography historical truth comes into being only thanks to this movement of withdrawal from what is to *become* historical reality. Historical truth is achieved when the distance between the past and the point of view is infinite (and yet all the details are respected and still clearly visible), so that all perspectivism thus seems to have been eliminated.

Paradox favours a movement that is precisely the *opposite* of that of metaphor. Take for instance Tocqueville's paradox of the governments that have succeeded that of the great Revolution: 'the governments it [i.e. the Revolution] set up were less stable ("plus fragiles") than any of those it overthrew; yet, paradoxically, they were infinitely more powerful ("plus puissants")' (*OR*, 9). Semantic conflict exists, as in metaphor, in the paradoxical notion of a government that is both more fragile and more powerful than the government that preceded it; language resists this conjunction of concepts. Yet, and this is essential, paradox does not invite us (as metaphor does) to resolve the conflict at a linguistic level, but requires us to look at historical reality itself in order to find that *both* halves of the paradoxical assertion are true. Postrevolutionary governments *are* both more fragile and more powerful than those of the Old Regime and we are misguided by language in presuming a conflict here. What paradox lays bare, therefore, is the betrayal of language (if I may put it in this slightly paranoic way); paradox teaches us that language erroneously makes us see oppositions or incompatibilities where, in reality itself, they do *not* exist. Metaphor trusts language unconditionally; all the possibilities of linguistic friction, of linguistic double play that language offers, are even used confidently for the cognitive purposes of the historian and the

politician. Paradox, by contrast, firmly turns away from language and redirects our attention to reality itself. It is deeply aware of the shortcomings of language and of the blind alleys language may lead us into. As we saw a moment ago, metaphor effects a movement of redoubling in which (metaphorical) language and reality are set opposite to each other, but in such a way that the former determines the nature of the latter; paradox, on the other hand, effects a rehabilitation of reality in its relation to language. Paradox shows us that reality is stranger than language suggests.

At first sight paradox and irony do not seem to lie too far apart. What is known as 'Weltironie', 'cosmic irony' or the 'irony of events'[8] expresses the insight that there is often a paradoxical relation between what we intend to do and what is actually the result of our actions. Political thinkers such as Mandeville, Adam Smith, Hegel, and indeed, Tocqueville himself, have pointed out the paradoxical workings of cosmic irony. It is therefore not surprising that Hayden White should see Tocqueville's œuvre as dominated primarily by the trope of irony.[9] But there are two differences between irony and paradox that we cannot afford to ignore. Firstly, when being ironical we say one thing but mean the contrary of what we say (just as in cosmic irony the effects of our actions are contrary to our intentions). We expect the hearer or reader to see our point and to exchange what we say for what we really intended to express. But here irony differs from paradox. For, as we have seen, in the case of paradox semantic opposition should *not* be obliterated – as irony expects us to do – but has to be respected. At most one could say that paradox and so-called 'romantic irony' come quite close to each other. For theorists of romantic irony such as Friedrich von Schlegel (romantic) irony is a precarious and momentary equilibrium between two opposites and the secret of romantic irony, like that of paradox, lies in the requirement that neither of the two opposites should yield to the other.[10] The second and perhaps more important difference between irony and paradox is that an understanding of the former always depends upon additional knowledge (knowledge that is not provided by the ironical assertion itself). One must have at least some acquaintance with Viscount Bolingbroke's most dubious political career in order to appreciate (or even recognise) the irony of Samuel Johnson's remark that 'he was a holy man'. The irony is, in fact, an interplay of the ironic utterance itself with the associations we already possess with the subject of the utterance. Hence, like metaphor, irony tends to keep on the level of language and thought,

on the level of associations and knowledge we already have. Paradox, on the other hand, is the trope that inexorably sends us back to reality after the holidays we have spent at the linguistic level in the company of metaphor and irony. It demonstrates the shortcomings of our knowledge and our system of associations. Metaphor and irony are a celebration of language and are given to idealistic patterns of thought, paradox is a celebration of reality – in its insistence on redirecting our attention to reality and in its effectiveness in doing so, it is even more persistent than the literal statement.[11]

But, more importantly, it is perhaps the supreme paradox of all of Tocqueville's paradoxes that he has the courage to posit the sublimity of democracy, of that apparently so homely, so petty and so utterly lustreless political system. Surely Shiner is right when he writes that for Tocqueville the advent of democracy meant the final triumph of pettiness over 'grandeur',[12] but the exactness of this assertion might make us forget that, according to Tocqueville, precisely democracy's love of well-being, of petty pleasures and of petty details, has unleashed a political force that makes those of aristocracy and of the Old Regime dwindle into mere insignificance. More than any other previous political system, democracy is not what it seems. It mobilises every potential source of political strength and action in society – nothing will be allowed to remain as it was before the advent of democracy. Democracy has given us a 'providential, and creative power' (*Dem. II*, 309) of the same sublimity as the raging seas or the distant stars that so deeply impressed Kant.

This is how we ought to interpret Tocqueville's famous characterisation of the birth of democracy as 'a providential fact' (*Dem. I*, 6), as a historical event that must fill our minds with a kind of 'religious awe' (*Dem. I*, 7). Tocqueville could be so sensitive to the sublimity of democracy itself and of the historical process to which it owed its birth because he looked at democracy with precisely the peculiar and paradoxical mixture of feelings that the sublime awakens in us. Consider the confession found among Tocqueville's papers after his death: 'j'ai pour les institutions démocratiques un goût de tête, mais je suis aristocrate par instinct; c'est à dire que je méprise et crains la foule. J'aime avec passion la liberté, la légalité, le respect des droits, mais non la démocratie. Voilà le fond de l'âme'.[13] Tocqueville hated, or better, feared democracy, but at the same time he was prepared to recognise that democracy will realise the equality which 'the Creator and Preserver of man has set as man's highest historical goal' (*Dem.*

II, 351). When Schiller describes the sublime as 'dieses einzige Schreckliche *was er* [i.e. man F.A.] *nur musz und nicht will'* (Schiller's emphasis)[14] and which evokes in us the contradictory feeling of both 'Wehsein' and 'Frohsein',[15] this captures exactly Tocqueville's paradoxical attitude towards democracy and towards its entrance on the scene of world history.

CONCLUSION

In a penetrating and intelligent commentary Jon Elster has written of Tocqueville: 'il faut le dire très clairement: il n'y a pas de grand penseur qui se contredise aussi nettement, aussi souvent, sur des questions aussi centrales'.[16] Confronted with the contradictions and paradoxes in Tocqueville's work, Elster develops a number of 'principes de décodage' that will enable him to straighten out these contradictions. It is his expectation that these 'décodages' will give us both a Tocqueville more true to his own manifest intentions and a better and more responsible theory of democracy. It would certainly be quixotic to go to war with this interpretative strategy. Elster's own study not only demonstrates that this strategy results in new and interesting sociological insights, but, even more so, that the Tocquevillian text certainly contains a number of inconsistencies it can do without. Yet, for all his assiduity, even Elster has to concede that 'ces opérations de sauvetage ne réussissent pas toujours, et d'ailleurs elles ne réussissent jamais entièrement'.[17] I agree with Elster, but would rather reverse the emphasis in his approach to Tocqueville's writings: what is really interesting in Tocqueville, in my opinion, is not what lends itself to a reduction to consistency, coherence and logical argument, but rather the paradoxes and inconsistencies that resist such a reduction.

Tocqueville's inconsistencies and paradoxes are not merely a regrettable defect in his argument (if only because Tocqueville, not being quite the most obtuse of political philosophers, would undoubtedly have been capable of avoiding them if he had thought that their presence might interfere with the nature of his enterprise). I therefore propose to see these inconsistencies and paradoxes rather as marks or signs of the brakes provided by the text itself to resist any Elsterian attempt to force it willy-nilly into a coherent and consistent 'theory' of democracy or social action. Moreover, if it is recognised that the major and real purpose of these inconsistencies and paradoxes is to discourage the construction of a 'theory' of

democracy, the question by what textual means this purpose actually is achieved in individual cases becomes uninteresting. Hence it would be mere pedantry to distinguish between contradictions (on the linguistic level), inconsistencies that might arise between two statements against the background of Tocqueville's acceptance of a third statement that is compatible with only one of the two, paradoxes in the proper sense of the word etc. For the precise logical nature of these problematic conjunctions is largely irrelevant: what counts is that they all point in one direction – avoidance of 'theory' and a recognition of the sublime character of the democratic system. The text does not offer a 'theory' or if one would prefer to put it that way, it is at most a 'theory' saying that *no* theory of democracy is possible. For as soon as one starts to theorise about democracy, this ever so elusive political system will make us see only the reflection of the theorist behind which it will carefully hide itself.

The tradition of western epistemological thought generally upholds the distinction between form and content, between what we say and the reality we talk about. The idea that language and thought should somehow mimic their content is rejected within this tradition. In our undergraduate years we have all been taught the naivety of the idea that the description of something round should be round itself. Yet here we are confronted with an example that is in conflict with this common epistemological wisdom. We should not describe democracy, nor develop 'theories' about it, but democracy must be represented or 'depicted'; and as the depiction of a tree always ought to share some structural features (for example, of form and colour) with the tree itself, so there should be some resemblances between democracy and the text about democracy. More specifically, if Tocqueville is correct in saying that democracy has no centre, that it has neither essence nor nature of its own, this requires us to adopt a style that bestows on the text exactly the *same* characteristics. For if we opt for metaphorical analysis, as almost all contemporary historical, sociological, and political writing does, democracy will remain invisible forever. As the last chapters of *Democracy* prove, metaphor will provide us with a theoretical model that is no longer a model of democracy itself; it will inevitably present us a political system possessing a centre. Metaphor always and inevitably generates centres. It is only the trope of paradox therefore that will give us access to sublimity of democracy and that will respect the anti-essentialism and centrelessness of democracy.

Already in his own time Tocqueville was rightfully considered to be the greatest thinker on democracy. Now that democracy at the end of the millenary seems to be beginning its triumphal procession over our entire globe, Tocqueville is still our best guide if we wish to understand democracy. Tocqueville has an undeniable right to such praise since no other political thinker has been more deeply aware of the paradoxes and the sublimity that are forever the glory of democracy.

NOTES

1 For an elaboration of the analysis given here, see my essay 'Tocqueville on the Sublimity of Democracy. Part I', *The Tocqueville Review* 14, no. 2 (1993), pp. 173–201. The second part of this essay will be published in the first issue of 1994 of this journal.

2 F. R. Ankersmit, 'Reply to Professor Zagorin', *History and Theory* 29 (1990), pp. 175–97, and also 'Twee vormen van narrativisme', *De navel van de geschiedenis* (Groningen: Historische Uitgeverij Groningen, 1990), pp. 44–78.

3 References to Tocqueville's own work are mostly, though not always, taken up in the text. The notation system adopted is as follows: *Dem. I* refers to A. de Tocqueville, *Democracy in America. The Henry Reeve Text as Revised by Francis Bowen, Vol. I* (New York: Vintage Books, 1945); *Dem. II* refers to A. de Tocqueville, *Democracy in America. The Henry Reeve Text as Revised by Francis Bowen, Vol. II* (New York: Vintage Books, 1945); *AR* refers to A. de Tocqueville, *L'Ancien Régime et la Révolution* (Paris: Gallimard, 1967); *OR* refers to A. de Tocqueville, *The Old Regime and the Revolution. New Translation by Stuart Gilbert* (New York: Doubleday Anchor Books, 1955); *Rec.* refers to A. de Tocqueville, *Recollections: The French Revolution of 1848. Edited by J. Mayer and A. P. Kerr* (New Brunswick: Transaction Books, 1987).

4 L. O. Mink, 'History and Fiction as Modes of Comprehension', *Historical understanding* (Ithaca: Cornell University Press, 1987), pp. 56–7.

5 L. Orr, 'Tocqueville et l'histoire incompréhensible: l'Ancien Régime et la Révolution', *Poétique 49* (1982). See also *Headless History: Nineteenth-Century French Historiography of the Revolution* (Ithaca: Cornell University Press, 1990).

6 Orr, 'L'Histoire incompréhensible', p. 58.

7 F. R. Ankersmit, *Narrative Logic* (The Hague, Martinus Nijhoff Publishers, 1983), pp. 209–20.

8 D. C. Muecke, *Irony and the Ironic* (London: Methuen, 1982), p. 11.

9 H. White, *Metahistory. The Historical Imagination in Nineteenth-Century Europe* (Baltimore: Johns Hopkins University Press, 1973), pp. 191–230. Similarly Gossman speaks of Tocqueville's 'ironic vision'; see

L. Gossman, 'Michelet's Gospel of Revolution', *Between History and Literature* (Cambridge, Mass.: Harvard University Press, 1990), p. 207.

10 F. R. Ankersmit, 'Ironie en politiek', *De navel van de geschiedenis* (Groningen: Historische Uitgeverij Groningen, 1990), pp. 309–13.

11 Tocqueville's respect for the sublimity of historical reality, a reality that permits no aesthetic embellishment, is evident from the heated discussion he had with his friend Jean Jacques Ampère on the revolution of 1848: see *Rec.* 67, 68.

12 L. E. Shiner, *The Secret Mirror. Literary Form and History in Tocqueville's Recollections* (Ithaca: Cornell University Press, 1988), p. 21.

13 A. de Tocqueville, *Œuvres complètes. Tome III. Ecrits et discours politiques* (Paris: Flammarion, 1985), p. 87.

14 F. von Schiller, 'Ueber das Erhabene', *Sämtliche Werke. Band XII* (Stuttgart s.a.), p. 191.

15 *Ibid.*, p. 194.

16 J. Elster, *Psychologie politique (Veyne, Zinoviev, Tocqueville)* (Paris: Les Editions de Minuit, 1990), p. 111.

17 *Ibid.*, p. 118.

The formation of styles: science and the applied arts

JAMES W. MCALLISTER

STYLE AND REVOLUTION IN SCIENCE

On traditional models of scientific practice, whenever there arise two or more incompatible theories purporting to explain the same domain of phenomena, scientists choose one from amongst them by applying criteria of empirical adequacy. These criteria attribute value to empirical virtues of theories, such as their predictive accuracy and scope, their ability to generate novel predictions, and the degree of their simplicity.

Certainly, this model of theory-choice is still capable of accounting for very many notable episodes in the history of the sciences. However, the realisation has grown that, in order to achieve even better agreement with the historical record, the belief that scientists decide choices among theories by examining their empirical qualities needs to be supplemented by reference to extra-empirical, and particularly to aesthetic, criteria which scientists use. There is now little doubt that scientific communities choose among available theories not only for their empirical performance, but in part also on the application of aesthetic criteria of assessment.[1] It appears that these evaluations are guided by what may be considered 'stylistic canons', often holding across an entire scientific community, in which given aesthetic features of theories are attributed positive values. Examples of such features are the form of a theory's simplicity (such as 'ontological parsimony', or 'arithmetical simplicity'), its symmetry properties, and its susceptibility to particular analogical interpretations (such as by mechanistic analogies).[2]

The following is a model of the mechanism by which these aesthetic or stylistic canons are constructed and revised.[3] On this

model, the mechanism is inductive. A community constructs its stylistic canon at a certain date from among the aesthetic features of all past theories by attributing to each feature a weighting proportional to the degree of empirical success scored up to that date by the theories which have embodied that feature. (The degree of empirical success scored by theories is, of course, judged by the application of the community's empirical criteria of theory-evaluation.) The collection of aesthetic features and weightings thus assembled forms the community's stylistic canon.

For an illustration of this mechanism, imagine the following scenario. A scientific community looks back over the recent history of a particular branch of its physical science. It perceives that several of its past theories, which have been empirically very successful, exhibited ontological parsimony to notable degree; and that certain other past theories which it had entertained, which supported mechanistic analogies, scored on the contrary little empirical success. Both 'ontological parsimony' and 'tractability by mechanistic analogies' are, on this model, aesthetic qualities of theories. In consequence of the empirical success of the ontologically parsimonious theories, ontological parsimony will obtain an increased weighting in the aesthetic canon of theory-evaluation which the community will hereafter apply in the relevant science. On the other hand, the property of being tractable by mechanistic analogies will receive a lowered weighting in the canon, in virtue of the scarce empirical success of recent theories which displayed this property.

Of several implications of this inductive mechanism, two are worthy of note here.

Firstly, the mechanism ensures that stylistic canons in science are conservative: they will tend to attribute greater value to, and to recommend for adoption, theories which are stylistically similar to past theories, in duplicating the aesthetic features embodied by the empirically more successful theories of the recent past. This phenomenon can be described by saying that scientific activity traverses periods in which a certain style is dominant.[4] For instance, successive theories in the principal physical sciences from the end of the seventeenth century onwards showed a unifying 'Newtonian style': they exhibited (among other aesthetic features) the form of simplicity embodied in Newton's theory of gravitation, in seeking to resolve all problems into the effect of radial forces.[5]

Secondly, while the inductive process is of itself continuous, in the sense that under its operation any change in the composition of a

stylistic canon is achieved continuously or gradually, it is easy to envisage situations which might prompt the discontinuous substitution of one stylistic canon by another in the community. Consider the following two cases.

Continuous development of a stylistic canon will be obtained while the canon's rate of evolution roughly maintains pace with the evolution of the aesthetic features exhibited by the sequence of theories which come to be embraced by the community. This is the situation in which theories embodying new features appear infrequently enough, or demonstrate their empirical power gradually enough, that the stylistic canon is able to reshape itself so as to come to value highly the particular aesthetic features which the theories exhibit. In this situation, in other words, the stylistic canon is able to renew itself as fast as the style of successive empirically successful theories changes.

If, on the other hand, the aesthetic features of the theories progressively adopted by the community evolve too fast, the community's aesthetic evaluative canon will no longer be able to renew itself sufficiently quickly to reflect those changes. The canon will lag behind developments, continuing to attach the greatest weight to aesthetic features which were exhibited by the community's former best theories, but which are not shown by the current best theories. In these circumstances, in order to remove conflict in theory-choice, some members of the community will see no alternative but to suspend their allegiance to the established aesthetic canon, and to conduct theory-choice on empirical criteria alone.

An illustration both of the inherent conservatism of aesthetic canons, and of a decision by the progressive members of a community to suspend allegiance to aesthetic commitments, is offered by the early history of quantum physics. The decision to formulate non-deterministic theories of atomic phenomena was taken by several scientists in the early decades of the twentieth century in order to solve empirical problems which were defeating the resources of classical physical theory. However, conservative scientists like M. Planck and A. Einstein soon came to oppose the new quantum mechanics, on grounds which are most accurately described as aesthetic and metaphysical: Einstein opposed the theory not because of any empirical deficiency of it, but because he felt it depicted a universe lacking harmony and beauty. More progressive colleagues of his, most notably N. Bohr, chose on the

contrary to abandon the commitments they may have had to aesthetic preferences entrenched by exposure to classical physics, and embraced quantum mechanics in virtue of its empirical successes.

By this route one reaches an interpretation of the notion of 'scientific revolution', as a suspension of a community's aesthetic evaluative canon (after which a fresh aesthetic canon is of course formed by the postrevolutionary community, through the renewed operation of the inductive mechanism already described). There are several well-known transitions in the history of science which on this model are interpreted as revolutions. For example, the preference for interpreting the planets' path as circular was deeply entrenched in Ptolemaic and Copernican astronomical theory up to the seventeenth century. It prompted initial resistance to J. Kepler's theory, which attributed to the planets elliptical rather than circular orbits. However, Kepler's theory gradually demonstrated its predictive superiority, contributing to the overthrow of the previously long-held aesthetic and metaphysical commitments, and leading to the formation of a new canon of theory-assessment in planetary astronomy. Because of the discontinuous change in the community's aesthetic evaluative canon which this episode witnessed, it counts on the present scheme as a revolution.[6]

While this model of theory-assessment enjoys good accord with data on several episodes in the history of science, the suggestion that the canons of theory-assessment constructed by the inductive mechanism are indeed aesthetic canons, rather than canons of some other sort, has attracted some scepticism. In response, this chapter seeks to support the idea that aesthetic evaluative canons may be constructed in scientific practice by roughly the mechanism described above. This aim will be pursued by pointing out that aesthetic or stylistic canons are in some of the applied arts constructed by a similar sort of mechanism. It will be argued that the similarities between the manner of formation of styles in science and of styles in the applied arts are sufficiently striking for us to conclude that the same processes underlie both phenomena, and hence that the evaluative canons in science discussed above are as 'aesthetic' as those in art.

The following treatment of some episodes of the history of architecture and other applied arts draws on the idea that, roughly speaking, a certain new material or technique of construction can foster the establishment of a new aesthetic or stylistic canon, once

resistance grounded on pre-existing stylistic canons has been overcome. (For present purposes, a known material used for the first time in a new activity or context counts as 'a new material'.)

THE ARCHITECTURAL USE OF CAST IRON

Before 1750, cast iron had been used very little in construction in Britain, chiefly in railings, fire-backs, and other decorative and domestic fittings, rather than in structural roles. The greatest familiarity with the material had been gained not by architects schooled in aesthetics, but by engineers trained in the technical aspects of foundry. Because of this, the first structural uses of cast iron in building were prompted primarily by non-architects, and motivated by practical rather than aesthetic concerns.[7]

One of the building sectors in which practical concerns were most prominent was the construction of bridges. Masonry was still the customary material for bridges towards the end of the eighteenth century, but ironmasters and engineers began then to suggest that cast iron be used, partly in the effort to obtain long spans. The ironmaster J. Wilkinson recommended the use of iron when plans were drawn up to bridge the River Severn at Coalbrookdale in Shropshire, the county at the centre of pioneering work in iron casting: his efforts resulted in 1779 in the world's first cast-iron bridge, by the ironmaster A. Darby.[8] The civil engineer T. Telford, who was county surveyor to Shropshire, built no fewer than five iron bridges in the county. The first of these, over the River Severn at Buildwas (1796), was of particular importance, since it contained notable improvements over the design of the Coalbrookdale bridge, thanks to which it achieved greater economy in its use of iron. Another engineer, J. Rennie, erected several iron bridges, including one over the River Witham at Boston, Lincolnshire (1803), and the Southwark Bridge over the Thames in London (1819). The tradition whereby the design and construction of bridges in cast iron fell to civil engineers rather than architects was carried forth by I. K. Brunel, among others. By his time, iron bridge-building was firmly established in France as well as in Britain.

Another practical concern which prompted the recourse to iron in building was fireproofing. Fire was a great concern in the eighteenth century wherever people assembled in large numbers either for work, as in factories and warehouses, or for entertainment, as in theatres. Textile mills in both Britain and France traditionally had

internal structures of heavy timber beams and columns. Since they were lit by naked flames, and the machinery which they housed used inflammable lubricants, they were very vulnerable to fire. In the last years of the eighteenth century, several mills burned down with great losses, and it became imperative for mill owners to find ways of making their buildings incombustible. Cast-iron-framed mills were developed largely in response to this need. Their designers were primarily not architects but, as were the designers of the early iron bridges, engineers: often the same engineers who were simultaneously using cast iron in developing jennies and looms of new designs and the steam engines which would power them. The engineer W. Strutt and R. Arkwright, the inventor of the spinning jenny, erected a six-storey cotton mill at Derby in 1792–3 which had iron columns (though still retained timber beams, protected by plaster sheathing) and was described as fireproof. The engineers who perfected rotary-motion steam-engines, M. Boulton and J. Watt, constructed a much-imitated seven-storey cotton mill in Salford in 1801 which employed not only cast-iron columns but also I-section cast-iron girders to carry the floors.[9]

These applications of iron by engineers allowed the new material to demonstrate its potential in solving structural problems in building, and encouraged architects to contemplate exploiting it. However, the early uses of iron by architects reveal misgivings about the material's aesthetic acceptability which the engineers had not felt.

Where engineers used iron to solve what they regarded primarily as engineering problems, they tended to be unconscious of or to ignore architectural styles or mannerisms evolved for use with previous materials: it was this insulation which helped them to produce the remarkable examples of original design embodied for instance in the early iron bridges. However, largely because of professional demarcations, the designs of bridges and industrial buildings produced by engineers were not considered to enter the scope of architectural-aesthetic concerns. It is not of course that these structures had no style, merely that their style went unrecognised as such. By contrast, the work of members of the architectural profession fell – virtually by definition – within the scope of aesthetic canons. Because of this, the architects who first came to use iron in structural roles often felt the need to be 'architectural'. In their eyes, this meant continuing to apply prevailing aesthetic guidelines, despite the fact that these had been evolved before the

arrival onto the architectural scene of iron structures and drew their justification from the aesthetic potentialities of pre-existing and familiar materials, such as masonry. Architects could not prevent engineers from designing whatever structures they chose outside the architectural domain, but intended that within their domain the established canons should be retained.

The architects' established styles frequently led them to conceal any iron structures which they or engineers had designed behind claddings and trimmings in some traditional material, and shaped in some traditional style. Among the earliest architect-designed buildings which incorporate cast iron in structural roles is H. Labrouste's Bibliothèque Ste-Geneviève in Paris (1843–50).[10] The graceful vaulting of the library's reading-room could have been achieved only through the use of slender iron columns and arches: to this extent, the form of the building is determined by the new material. The iron-frame structure is visible within the reading-room; however, the library has a facade of masonry in a generally conventional Neo-Renaissance design, which completely hides the internal iron frame from public view.

The same lack of aesthetic conviction is apparent in several mid-eighteenth-century railway stations in Britain. The design of stations was often the outcome of collaboration between architects and engineers, and sometimes the resulting edifices reflect an uneasy compromise between the professions. For instance, in St Pancras Station in London (1864), the engineer W. H. Barlow erected a cast-iron train-shed of which the elegant pointed arch had the widest span ever achieved; but this was entirely concealed from the approach to the station by the massive Gothic head-building in traditional masonry designed by Sir George Gilbert Scott.[11] The aesthetic ambivalence of this kind of marriage has been illuminated by J. Gloag's remark that in the mid-nineteenth century in Britain engineers saw themselves as 'putters-up of structures', while architects were 'putters-on of styles'.[12]

Clearly by this time it had not yet been accepted by many architects that iron, for all its technical advantages, was worthy of aesthetic acceptance as a material for public display. Some still tried to confine the use of iron to 'utilitarian', 'non-architectural' buildings. As late as 1863, the influential German architect G. Semper was declaring that while iron was a suitable material for railway stations, in view of their impermanent nature, stone was the only true material for monumental art, including libraries.[13]

Gradually, however, some critics began to call for the open and visible use of iron in buildings of all categories. In the 1860s, E. E. Viollet-le-Duc retraced the failings of many current architectural projects to a lack of authenticity, deriving from the fact that the forms actually imposed on buildings were not those most appropriate to the materials or techniques of construction employed:

> We construct public buildings which lack style, because we attempt to ally forms bequeathed by certain traditions to requirements which no longer bear relation to those traditions. Naval architects and mechanical engineers do not, when building a steamship or a locomotive, seek to recall the forms of sailing-ships of the time of Louis XIV or of harnessed stage-coaches. They obey unquestioningly the new principles which are given them and produce works which have their own character and their proper style.[14]

Viollet-le-Duc demands two things: that any materials of construction used in a building should appear openly, not hidden by cladding, and that structures should follow the stylistic principles most suited to their materials, rather than mimic forms appropriate to other ages. If cast iron is used in the frame of a building, for example, firstly it ought to remain visible from the exterior, and not clothed in masonry or stucco, and secondly the style impressed on the entire building should be the one which permits the fullest exploitation of the technical capabilities of iron.

By the end of the nineteenth century, Viollet-le-Duc's call for authenticity was answered within his profession, and architects felt able to use cast iron openly in public buildings. A particularly influential demonstration of the uses of iron was given in two buildings erected for the Paris Universal Exhibition of 1889.[15]

In the Galerie des Machines, by the engineer V. Contamin and the architect F. Dutert, which was an exhibition pavilion boasting a span of over one hundred metres (demolished in 1910), iron and the forms appropriate to its use were not so much displayed as flaunted. The building's gross structure was constituted by a number of trusses or arches, each made up of two symmetric halves, which touched at a point along the centre-line of the roof. Each truss thinned noticeably towards the ground, unlike stone or masonry columns, which generally taper upwards. This building's design embodied distinctive architectural-aesthetic principles, permitted by the characteristics of iron, and not seen in buildings designed with earlier materials in mind: for instance, the separation between beam and column had vanished, so that it was no longer possible to

distinguish between load and support. The effect of the gallery was described by C. Schädlich:

All the aesthetic ideas associated with stone buildings have been turned on their head in one instant. With the point-like bearing surfaces for the great masses, the seemingly floating vaulting, and the transparency of the whole construction, in similar fashion to the related station halls, new aesthetic laws are postulated which, understandably, not all observers readily accept as a legitimate architectural medium. The architecture lives by its own laws of completely integrated and visibly composed iron design.[16]

In this building, in short, no style had been applied to the structure, other than the one which arose naturally from the structure's material.

The second notable building erected for the 1889 exhibition was, of course, the three-hundred metre iron tower by G. Eiffel. At first, this was commonly considered a hideous monster. Even before its completion, the Artists' Protest of 1887, instigated by C. Garnier, the architect of the Paris Opera House, and signed by the writers G. de Maupassant and E. Zola among others, requested that the tower not be retained beyond the close of the exhibition, on the grounds of its ugliness.

In the face of this criticism, the commonplace early defence of the tower was to enumerate its utilitarian justifications, such as the benefits it offered for communications and scientific research (in physics and meteorology, for instance). This manner of justifying iron structures, hinging entirely on their utilitarian advantages, virtually concedes the aesthetic ground to the conservatives, as if it were too much to argue that a structure like the Eiffel Tower could ever be considered beautiful. Soon, however, iron buildings began to acquire also an aesthetic defence, in virtue of the fact that the architectural aesthetic had begun to be remoulded by the forms characteristic of the new material. Thanks to this evolution of aesthetic canons, the Eiffel Tower outgrew its perception as a monster, acquiring in time the status of modern icon.[17]

By the end of the nineteenth century, cast iron (and later its structurally similar replacement, steel) was admitted into the vernacular of civic architecture. This evolution threw into the shadow some of the materials which had earlier dominated architectural style. According to J. K. Huysmans, for instance, the contrast with iron made stone appear 'played out, exhausted by its repeated use' in the buildings erected for the 1889 Paris exhibition.

'It could only produce better disguised or more skilfully linked borrowings from old forms.'[18]

The design innovations prompted by cast iron made their appearance at different times in different countries. For instance, Vienna came to know the iron structures pioneered in such centres as London and Paris only late in the nineteenth century and in a tamer form. Designing the stations of the Vienna city railway system in 1894–1901, O. Wagner allowed iron beams and arches to emerge to the exterior, but he remained under the spell of the traditional impulse to architectural beautification, which led him to incorporate such features into quasi-Baroque stone facades.[19]

In the gradual introduction and acceptance into architecture of cast iron, three partially overlapping phases may be discerned. In the first, iron was still foreign to architectural work. Engineers progressively demonstrated its utilitarian advantages by employing it in structures outside the commonly accepted scope of the architectural aesthetic, such as bridges and industrial buildings. In the second phase, architects began to exploit iron for its utilitarian attributes; however, the pre-existing stylistic canons in architecture – centred upon the use of masonry – still forbade the new material a place in aesthetic constructions, and architects felt the continuing need to conform to these canons by concealing iron structures behind more conventional claddings.

In the third phase, towards the end of the nineteenth century, misgivings at the lack of authenticity involved in this masking prompted more open uses of iron; gradually, the material began to reshape architects' stylistic canons. The opinion grew in strength that architectural canons ought no longer to hinder the exploitation of iron: whereas in the earlier stages the manner of using iron would have bowed to the requirements of architectural canons, it was increasingly felt that from then on the architectural canons ought to reflect the usefulness of iron. As the German critic A. Gurlitt wrote in 1899: 'The question ... is not how to mould iron to make it conform to our taste, but the much more important one, how to mould our taste to make it conform with iron?'[20] It was in consequence of this appreciation that iron structures began to be regarded as susceptible of holding aesthetic value. When this stage became established, architects working in iron were no longer imposing alien styles onto iron structures, but allowing the structures to find the styles most appropriate to them.

THE INTRODUCTION OF REINFORCED CONCRETE IN ARCHITECTURE

The stages through which cast iron gradually established itself in architecture as a material with not only utilitarian benefits but also aesthetic dignity were traversed also, with a lag of a few decades, by reinforced concrete.[21]

During the twentieth century, concrete came to be appreciated as a material offering the possibility of architectural forms self-evidently different from those of brick, stone, or iron. Its plasticity allows it to assume any curve or other shape in which moulds can be constructed, and its monolithicity permits traditional separations between different building elements, such as wall and roof, to be superseded. But the earliest types of concrete were seen merely as synthetic stone, apt to mimic at lower cost the effects typical of the long-established techniques of masonry construction. Stuccoed rubble, treated to simulate masonry, was used in France as early as the reign of Louis XVI by architects attempting to recreate the splendour of mansions of former times for fashionable but impoverished clients. As long as concrete was used in no other guise, the architectural principles which governed the practice of construction in masonry could easily be applied to it.

Concrete grew better appreciated in Britain in the 1870s, when it became habitual to cite to its advantage two qualities, alongside its low cost: that it was 'sanitary' (or hygienic) and 'fireproof'. The first quality was valued especially in workers' dwellings, and the second – once again – in public and industrial buildings. In France, following some destructive fires in the textile district around Roubaix and Tourcoing in the 1890s, the great pioneer F. Hennebique built a number of concrete spinning mills. The possibility of filling structural concrete frames with nothing but sheets of glass permitted the fulfilment of a further requirement, the provision of adequate light in multi-storey factory blocks. In short, the qualities of concrete were found to meet some utilitarian needs of the new industrial society.

Initially, discussions among architects and engineers about the use of concrete were confined to its technical aspects, as if the problem of finding pleasing and appropriate forms did not arise for such a utilitarian material; but as its use grew more widespread, it became apparent that the chief remaining obstacle to its full acceptance as an architectural medium lay in the difficulties of giving it an appro-

priate appearance. The usual tendency, reminiscent of the habit of cladding cast-iron structures which was then gradually being discontinued, was to follow tradition in imposing upon any visible concrete surfaces either a cladding in some other material, or a finish which mimicked stone.

The ambivalence of architects torn between the exploitation of concrete for its utilitarian advantages and the concealment of the material for its aesthetic unacceptability is illustrated by one of the landmark buildings in concrete in California. The Leland Stanford Junior Museum of Stanford University was designed by E. L. Ransome in 1889–91 to have the entire wall and floor in concrete. On the one hand, this is probably the earliest building in which concrete is left exposed, rather than being regarded as a cheap infilling or backing to which a fair surface had subsequently to be applied. On the other hand, the concrete surface is deliberately tooled to imitate masonry, to complement the building's traditional design and classical colonnade.

The approach of concrete towards full architectural acceptance was promoted by architects and critics who, much like Viollet-le-Duc on behalf of cast iron, urged acknowledgment that the characteristics of a new material ought to be allowed to dictate the manner of its own ornament and presentation, rather than being constricted into the idiom of some other material. The concern for authenticity surfaced for instance in 1901 in the comments of the critic P. Forthuny on a concrete building, designed by E. Arnaud and incorporating both offices and apartments, which had been erected in Paris three years earlier. Arnaud had feared public disapproval of a bare concrete facade, and had therefore faced his building with cement rendering of conventional form. Forthuny regrets this act as missing an opportunity to help develop an aesthetic appropriate to concrete:

Reinforced concrete is a new material, and has no links with the systems of construction which preceded it; it must thus necessarily draw from within itself its exterior aspects, which must be clearly differentiated from familiar modellings in wood, marble or stone. How can one innovate lines and surface modellings in domestic architecture which are in some way the consequence of the use of reinforced concrete? . . . M. Arnaud has doubtless not dared to risk such an undertaking . . . How much more edifying his façade would have been had he just made the effort to adorn it in its own way, extracting from the study of his material the elements of an entirely personal decoration of his own design.[22]

Once again, the stage of development of a new material had been reached in which authenticity was perceived to demand its open use, and the exploration of the aesthetic implications of such use.

Reinforced concrete achieved its aesthetic maturity perhaps in the work of the French architect A. Perret, whose career shows an increasingly undisguised use of concrete.[23] One of his earlier works is the well-known apartment block at 25b, Rue Franklin, in Paris (1903). The skeleton of this building is entirely in concrete, and consists of columns, beams, and slabs, which have the advantage of removing from the plan of the apartments any load-bearing walls. But the facade appears as yet unwilling to acknowledge the material which dictates the building's form, and is clad in ceramic tiles. Before long, however, Perret came to reject such ornamental veneers, and displayed the concrete frames of his buildings undisguised. He did this first in buildings such as the Admiralty Research Laboratories, on Boulevard Victor, in Paris (1928): these are simple rectangular buildings with blank walls in which the structural elements were displayed openly. While architectural innovations might be dismissed as lacking aesthetic implications in buildings of such utilitarian functions as laboratories for technical research, Perret soon extended the use of bare concrete to buildings with greater aesthetic pretensions. The deepest architectural acceptance of a new material is perhaps signalled when it comes to be used visibly in religious buildings: Perret's Notre Dame du Raincy (1922) exhibited columns and vaulted slabs of concrete framing large expanses of glazed non-load-bearing walls.

Even at this advanced date, many architectural critics objected to Perret's design, maintaining that, in a church, concrete ought to be confined to vaulting and be covered by a decorative veneer, since its appearance was insufficiently noble for the building's liturgical functions. None the less, concrete had by that moment generally attained architectural acceptance in virtue of its aesthetic potentialities as well as of its utilitarian advantages. From then, one could begin to speak literally of the aesthetic of reinforced concrete, meaning by that expression the aesthetic canon which sprang in this way from the architectural use of the material.[24]

The stages outlined for cast iron and reinforced concrete could be retraced for many other materials, such as aluminium and plate glass, as well as for many construction techniques. Almost every building material and technique has undergone a kind of aesthetic apprenticeship, moving from the fringes of architectural activity to

its centre, initially on the strength of its utilitarian applicability, until it had reshaped architectural taste and expectations so as to carve out a place for itself in the prevailing aesthetic canons.[25]

MATERIALS AND FORMS IN INDUSTRIAL DESIGN

The aesthetic apprenticeship served by materials in architecture is perceptible also in other applied arts, such as industrial design.[26] There too, new materials are first used to mimic styles established by their more familiar predecessors. This mimicry is often essential in the manufacture of consumer goods, which would fail to appeal to aesthetically conservative householders if clothed in styles considered too futuristic or iconoclastic. Only gradually do manufacturers allow their designers to communicate to their products those new forms permitted by the new material; and then only gradually do some of these forms win acceptance among consumers. Eventually, of course, the consumers may come to expect such objects to have no appearance other than the one made familiar by the new material.

An example of this cycle is provided by the bent steel which became available for household goods in the second half of the nineteenth century. Early designs for furniture using this material tended to imitate traditional wood-inspired styles, and few designers took steel as a prompt to develop new forms. It was only with the advent of tubular-steel structures in the 1920s that furniture design began to respond to the new aesthetic possibilities offered by the material.[27] Similarly, plastics, which began to appear in consumer goods after the First World War, were initially seen only as an economical substitute material to be used in such articles as buttons, buckles, and combs; these objects in plastic tended to mimic the forms and appearance of their predecessors in the traditional and more expensive wood, horn, or ivory. Only in the 1930s did the aesthetic possibilities of moulded plastics begin to be explored, in such objects as portable radios, after which the new visual images offered by plastics grew to command their own aesthetic credit.

When manufacturers give a new material, in its early phases, traditional forms, neglecting to pursue its distinguishing aesthetic possibilities, they reassure the aesthetically conservative public, but often horrify progressive designers and critics, who may see in this a kind of duplicity bordering on betrayal. One such is N. Pevsner, who lists some of his dislikes:

In a cardboard travelling-case made to imitate alligator skin, in a bakelite hair-brush made to imitate enamel – there is something dishonest. A pressed-glass bowl trying to look like crystal, a machine-made coal-scuttle trying to look hand-beaten, machine-made mouldings on furniture, a tricky device to make an electric fire look like a flickering coke fire, a metal bedstead masquerading as wood – all that is immoral.[28]

The forms imposed on each of these articles seemingly deny its new materials or techniques of manufacture, and mimic those most apt for a past material or technique.

THE INDUCTION TO STYLES

The above accounts of the emergence of styles appropriate to new materials in architecture and in industrial design echo the model of the formation of aesthetic canons in science that I outlined at the beginning of this chapter. These echoes can be made sharper, by choosing similar language in which to describe developments in the two domains. This is attempted in the following couple of paragraphs.

The model of theory-evaluation that I outlined at the beginning of this chapter pays regard to the evolution of three factors affecting the community's judgement: the empirical power of each theory within the sequence of theories embraced by the community, the aesthetic features displayed by those theories, and the community's aesthetic evaluative canon. The empirical power of a theory adds weight to that theory's particular aesthetic features within the community's aesthetic evaluative canon; in turn, this canon is used to pass aesthetic judgements on future theories. An entrenched aesthetic canon will cause the community to produce and esteem aesthetically orthodox theories. Sometimes a theory emerges which, perhaps in consequence of pursuing new approaches or techniques, shows unprecedented aesthetic features. Such a theory is likely at first to be resisted within the community, in virtue of the community's established aesthetic canon. When and only when this theory, or others similar to it, has shown sufficient empirical success (especially if its success cannot seem to be emulated by theories of more orthodox aesthetic form), its own aesthetic features gain weight within the evaluative canon. This allows the new theory to win aesthetic as well as empirical acceptance. The revision of the evaluative canon ensures that credit will more likely be extended to

future theories which embody the new aesthetic features, enabling the community to pursue further the approach or technique which gave rise to the new style.

Similarly, the above accounts of the origin of aesthetic canons in architecture refer to the evolution of the following three factors: the perceived utilitarian worth of past buildings, their architectural-aesthetic features, and a community's architectural or stylistic canon. The utilitarian worth of a past building adds to the weight attributed in the community's stylistic canon to the stylistic elements which that building exhibits; in turn, the canon is used both to guide and to assess the design of future buildings. A well-entrenched aesthetic canon will cause the community to design and esteem aesthetically orthodox buildings. This orthodoxy of design will be maintained even in the early stages of the exploitation of a new architectural material. When a building showing aesthetic features made possible by and appropriate to the new material is erected, it is at first resisted within the community in virtue of the established aesthetic canon. When and only when this building, or others stylistically similar to it, shows sufficient utilitarian worth (especially if its practical applications cannot apparently be matched by buildings of more orthodox aesthetic form), do its own aesthetic features gain weight within the evaluative canon, allowing buildings in the new style to win acceptance on aesthetic as well as utilitarian grounds. The revision of the evaluative canon ensures that credit will more likely be extended to future buildings which embody the new stylistic features, enabling architects to exploit further the material or technique which gave rise to the new style.

In both domains, then, the demonstrated empirical or utilitarian worth of a work (the predictive power of a theory in science, the utilitarian applicability of a building in architecture) is capable of reshaping the stylistic canons by which new creations (further theories in science, further buildings in architecture) are evaluated and by which the line of progress of the discipline is partly determined.

In this light, the same stages of innovation and conservatism can be identified in the two domains. Copernicus' theory has within early-modern planetary astronomy the position occupied by a masonry building within mid-nineteenth-century architecture, before the exploitation of concrete had begun: both creations fully accord with the well-established, if soon-to-decline, stylistic canons

in their field. The early versions of quantum mechanics, which still won the approval of Planck and Einstein, occupy within the twentieth-century revolution in physics a position analogous to that of Labrouste's Bibliothèque Ste-Geneviève in the rise of cast-iron architecture: both works contain elements of profound innovation, but retain enough of the appearance of a long-established style to appeal to the conservative critics who would soon part company with the new trends.

These interpretations of the rise of stylistic or aesthetic canons in science and in the applied arts prompt a couple of closing reflections.

Firstly, the fact that certain evaluative canons used by scientists originate in procedures isomorphic to those of the formation of stylistic canons in the applied arts supports the idea that those scientific canons are indeed aesthetic, rather than being evaluative canons of some other nature. Here is therefore some evidence that scientific communities subject their creations to an aesthetic judgement, alongside the logico-empirical evaluations whose operation is almost universally recognised.

Secondly, some further light is shed on the relationship between at least some of the sciences and some of the arts. The contention of this chapter is that the procedures in which certain aesthetic or stylistic canons arise in sciences and in arts are identical, in that they are both inductive. There is therefore scope here for genuine generalisation over the two domains, perhaps via the hypotheses that these procedures are the manifestation of the same psychological tendency to value forms which have become associated with utilitarian worth, or of the same mechanisms of stylistic habituation in creative communities.

NOTES

1 For some historical support of this claim, see H. Osborne, 'Mathematical Beauty and Physical Science', *British Journal of Aesthetics* 24 (1984), pp. 291–300; G. Engler, 'Aesthetics in Science and in Art', *British Journal of Aesthetics* 30 (1990), pp. 24–34; and J. W. McAllister, 'Dirac and the Aesthetic Evaluation of Theories', *Methodology and Science* 23 (1990), pp. 87–102.
2 For a discussion of the special problems posed by the evaluative criteria of simplicity, see J. W. McAllister, 'The Simplicity of Theories: Its Degree

and Form', *Journal for General Philosophy of Science* 22 (1991), pp. 1–14.

3 For details and further illustrations of this inductive model, see J. W. McAllister, 'Truth and Beauty in Scientific Reason', *Synthese* 78 (1989), pp. 25–51, especially pp. 36–41.

4 These styles are reminiscent of, but not identical to, the 'paradigms' discussed by T. S. Kuhn, *The Structure of Scientific Revolutions* (University of Chicago Press, 1962; 2nd edn., 1970), pp. 43–51. A survey of some issues involved in speaking about styles in science is A. Wessely, 'Transposing "Style" from the History of Art to the History of Science', *Science in Context* 4 (1991), pp. 265–78.

5 On the 'Newtonian style', see I. B. Cohen, *The Newtonian Revolution, with Illustrations of the Transformation of Scientific Ideas* (Cambridge University Press, 1980), pp. 52–154. Elements of several other styles of scientific work are identified in A. C. Crombie, 'Designed in the Mind: Western Visions of Science, Nature and Humankind', *History of Science* 26 (1988), pp. 1–12, and in Crombie, *Styles of Scientific Thinking in the European Tradition*, 3 vols. (London: Duckworth, 1994).

6 Fuller discussion of this interpretation of scientific revolutions is given in McAllister, 'Truth and Beauty in Scientific Reason', pp. 41–7.

7 On cast iron in architecture, see S. Giedion, *Space, Time and Architecture: The Growth of a New Tradition* (Cambridge, Mass.: Harvard University Press, 1941; 5th edn., 1967), pp. 163–290; J. Gloag and D. Bridgwater, *A History of Cast Iron in Architecture* (London: Allen and Unwin, 1948), pp. 53–236; N. Pevsner, *Pioneers of Modern Design: From William Morris to Walter Gropius* (Harmondsworth: Penguin Books, 1960; rev. edn., 1974), pp. 118–40; and Pevsner, *The Sources of Modern Architecture and Design* (London: Thames and Hudson, 1968), pp. 9–20, 147–9. In general on the influence of materials and techniques on architectural canons, see *The Macmillan Encyclopedia of Architecture and Technological Change*, ed. P. Guedes (London: Macmillan, 1979); R. Mark and D. P. Billington, 'Structural Imperative and the Origin of New Form', *Technology and Culture* 30 (1989), pp. 300–29; and M. Pawley, *Theory and Design in the Second Machine Age* (Oxford: Blackwell, 1990), especially pp. 69–94, 140–61.

8 On the Coalbrookdale bridge, see R. Maguire and P. Matthews, 'The Ironbridge at Coalbrookdale: A Reassessment', *Architectural Association Journal* 74 (1958), pp. 30–45, especially pp. 35–7.

9 On the early iron-framed textile mills, see A. W. Skempton and H. R. Johnson, 'The First Iron Frames', *The Architectural Review* 131 (1962), pp. 175–86.

10 On the Bibliothèque Ste-Geneviève, see N. Levine, 'The Romantic Idea of Architectural Legibility: Henri Labrouste and the Néo-Grec', in *The Architecture of the Ecole des Beaux-Arts*, ed. A. Drexler (London: Secker and Warburg, 1977), pp. 325–416, especially pp. 325–57; and Levine, 'The Book and the Building: Hugo's Theory of Architecture and

Labrouste's Bibliothèque Ste-Geneviève', in *The Beaux-Arts and Nine-teenth-Century French Architecture*, ed. R. Middleton (London: Thames and Hudson, 1982), pp. 139–73, especially pp. 154–64.

11 On the critical reception of St Pancras Station, see J. Simmons, *St Pancras Station* (London: Allen and Unwin, 1968), pp. 91–108.

12 J. Gloag, *Victorian Taste: Some Social Aspects of Architecture and Industrial Design from 1820–1900* (London: A. and C. Black, 1962), p. 3.

13 W. Herrmann, *Gottfried Semper: In Search of Architecture* (Cambridge, Mass.: MIT Press, 1984), p. 179.

14 E. E. Viollet-le-Duc, *Entretiens sur l'architecture*, 2 vols. (Paris: Morel, 1863–72; facsimile edn., Paris: Pierre Mardaga, 1977), vol. I, p. 186; my translation.

15 On the buildings of the 1889 Universal Exhibition, see W. Friebe, *Buildings of the World Exhibitions*, trans. J. Vowles and P. Roper (Leipzig: Edition Leipzig, 1985; original publication, 1983), pp. 88–108.

16 Quoted from Friebe, *Buildings of the World Exhibitions*, p. 94. For more information on the Galerie des Machines, see M.-L. Crosnier-Leconte, 'La Galerie des Machines', in *1889: La Tour Eiffel et l'Exposition Universelle*, edited by the Musée d'Orsay (Paris: Editions de la Réunion des Musées Nationaux, 1989), pp. 164–95, where an account is given also of its reception, and J. W. Stamper, 'The Galerie des Machines of the 1889 Paris World's Fair', *Technology and Culture* 30 (1989), pp. 330–53.

17 On the early critical reception of the Eiffel Tower, see H. Loyrette, *Gustave Eiffel*, trans. R. and S. Gomme (New York: Rizzoli, 1985), pp. 169–89, and Loyrette, 'Images de la Tour Eiffel (1884–1914)', in *1889: La Tour Eiffel*, pp. 196–219; for testimony to the extent to which the Tower has become an icon, see R. Barthes and A. Martin, *La Tour Eiffel* (Paris: Delpire, 1964).

18 Quoted from Loyrette, *Gustave Eiffel*, p. 177.

19 C. E. Schorske, *Fin-de-Siècle Vienna: Politics and Culture* (New York: Knopf, 1980), pp. 79–81.

20 Quoted from E. H. Gombrich, 'The Logic of Vanity Fair: Alternatives to Historicism in the Study of Fashions, Style and Taste', in *The Philosophy of Karl Popper*, ed. P. A. Schilpp, 2 vols. (La Salle, Ill.: Open Court, 1974), vol. II, pp. 925–57, on p. 945. Gombrich remarks on the plasticity of taste revealed by the increasing acceptance of iron in architecture *ibid.*, pp. 945–6.

21 On the introduction of reinforced concrete in architecture, see P. Collins, *Concrete: The Vision of a New Architecture* (London: Faber and Faber, 1959); Pevsner, *Pioneers of Modern Design*, pp. 179–84; and Pevsner, *The Sources of Modern Architecture and Design*, pp. 150–5.

22 Quoted from Collins, *Concrete*, p. 70.

23 On Perret, see Collins, *Concrete*, pp. 153–287, and R. Banham, *Theory and Design in the First Machine Age* (London: Butterworth Architecture, 1960; 2nd edn., 1962), pp. 38–43.

24 A discussion of some aesthetic principles underlying the use of

reinforced concrete in architecture is P. A. Michelis, *Esthétique de l'architecture du béton armé* (Paris: Dunod, 1963).

25 On some of the personal architectural styles stimulated by new materials and techniques in the 1970s and 1980s, see C. Davis, *High Tech Architecture* (New York: Rizzoli, 1988).

26 On materials and form in industrial design, see J. Heskett, *Industrial Design* (London: Thames and Hudson, 1980), and P. Sparke, *An Introduction to Design and Culture in the Twentieth Century* (London: Allen and Unwin, 1986), especially pp. 37–55, 124–39.

27 On furniture design in the machine age, see P. Sparke, *Furniture* (London: Bell and Hyman, 1986), pp. 26–51.

28 N. Pevsner, *An Enquiry into Industrial Art in England* (Cambridge University Press, 1937), p. 11.

Beyond the mannered: the question of style in philosophy or questionable styles of philosophy

NICHOLAS DAVEY

INTRODUCTION: ON THE FATALITY OF A SPELLING MISTAKE[1]

If, as Wittgenstein suggested, 'language can go on holiday', then like all travellers it too runs the risk of taking the wrong connection. No doubt anticipating the increasing preference amongst English tourists for Greece rather than Spain, the English spelling of the word 'style' has immortalised an error. The spelling with a 'y' stems from the erroneous notion that the word reflects the Greek *stulos* meaning column. Etymology, however, identifies the Latin *stilus*, spelt with an 'i' meaning writing or a writing instrument, as the appropriate root. But what would have happened if Englishmen had decided to spell properly? 'Style' (manner, mode or fashion of expression) would be indistinguishable from 'stile', meaning a barrier to climb through or over. Thereby hangs a philosophical tale. Plato and Gadamer are not the only philosophers who view the problems posed by *stilus* (writing) as something stilelike (*steigen*) to be surmounted. The questions raised by the issue of style in philosophy pose formidable obstacles in the path of philosophy remaining a meaningful enterprise.

Tchaikovsky penned in his diary, 'Nothing is true except what is unsaid.' Re-formulated, the remark succinctly captures the deconstructive view that 'Nothing could be true, nothing could have a meaning, except the unsaid.' The notion of a limitless potential for variant meanings within language, the assertion of no meaning-in-itself, has prompted the re-emergence of the question of style in philosophy. Though there is nothing substantive to be said anymore, there remain ways of saying, rhetorics and stylistic conceits. Without doubt, the emergence of the question of style in philosophy has

several clear advantages. It is not without reason that Rorty comments that nothing is so valuable for an hermeneutic inquirer than the discovery of an epistemology in a given text.[2] Once what the author is 'about' can be ascertained, it can be asked whether the expressive idiom used is appropriate to the ideas conveyed (as in the instance of Schopenhauer placing an existential insight in the formal dress of Kantian transcendentalism) or whether the stylistic mode injects nuances into the content which do not belong there (consider the difficulties facing any formulation of flux in subject-predicate based languages). There is, however, a significant dimension to the question of style in philosophy which is negatively nihilistic and threatens to incapacitate philosophy's faith in the meaningfulness of its insights. Far from seeking a transcendental basis for a consideration of style, it is the quasi-transcendental ground, the detachment from the experience of meaningfulness which as this chapter will argue, is the root cause of attempts to reduce philosophy to issues of style. Ironically, deconstructive thought embodies such a disinterested detachment. It looks at propositions and statements not as catalysts for an experience of meaningfulness, as invitations to think about potentialities for enhancing our existence, but as constructs and formulations valuable only as examples of literary feigning and stylistic decisions. Whilst acknowledging what the analysis of style can achieve for philosophy, the primary aims of this chapter are to identify the threat posed by the stylistic analytics of deconstruction and to diminish it by exposing the faulty reasoning which sustains it.

We shall now turn to the thinking which animates deconstruction's attempt to reduce all philosophical statements to a body of rhetorical idioms or stylistic stratagems.

HOW TO BUILD A STILE

When Willem de Kooning commented that 'Nothing is positive about art except that it is a word' and that 'right from there to here all art became literary',[3] he anticipated postmodern literary criticism which has sought to dissolve the alleged fixed meaning of words into a limitless horizon of semantic possibilities. Steiner remarks that as 'language knows no conceptual, no projective finality, *anything* can be said and, in consequence, written about *anything*'.[4] Judgements about what a word means are ultimately relative: 'they can be falsified neither on formal logical grounds nor in existential substance . . . there are no rational or falsifiable decision procedures

... between ... differing interpretations'.[5] Analogous reasonings enable Derrida to effect an extraordinary historical reversal of philosophical orientation. Just as Heidegger inverted Platonic metaphysics by declaring appearance (disclosure) to be the medium of Being, just as Gadamer overturned Plato's conviction concerning art's twofold removal from actuality by suggesting that it is precisely art's unreality that allows it to structure and realise indeterminate aspects of actuality, so Derrida, tracing out the shadowier linguistic side of such logics, reveals that philosophy – the very enterprise which Plato believed could disarm the pernicious manoeuverings of the rhetorician – is exposed as rhetorical through and through.

Derrida's thought brings to fruition the negative import of Nietzsche's amputation of the metaphysical. The latter's denial of Being, his repudiation of meaning-in-itself and his resultant perspectivism, left hermeneuticians wondering whether all philosophical interpretation has collapsed into the random subjectivities of differing rhetorics, that is into different manifestations of the will to power. If the meaning of a word or text is in Derrida's words 'undecideable' ('n'avoir aucun sens decidable'),[6] the ascription of sense, 'the preference of one possible reading over another . . . is no more than the playful, unstable, undemonstrable option or fiction of a subjective scanner who constructs and deconstructs purely semiotic marks as his own momentary pleasures, political, psychic needs or self-deceptions bid him to'.[7]

Regarding the question of style in philosophy such comments have a double edge: 'Le Roi est mort, Vive le Roi!'. On the one hand, Derrida demolishes the formal distinction between style (form) and its appropriacy to content for if the 'question of style must be measured against the question of interpretation itself'[8] and if, in the words of Christopher Norris, 'meaning can never coincide with its object in a pure unimpeded union',[9] that is, if there is no hermeneutic terminus, the problem of style is abolished. The absence of substantive meaning suggests that 'there never has been *the* style, nor *the* simulacrum capable of insinuating it'.[10] And yet, on the other hand, if philosophy stripped of its universal pretences is exposed as 'conceptual poetry' at best or a naked 'conceptual will to power which aspires to theory'[11] at worst, the phoenixlike question of style re-emerges in two respects. (A) If 'deconstruction bids fair to overthrow the age old prejudice that elevates philosophic truth and reason at the expense of literary feigning', philosophy becomes susceptible to rhetorical demystification: its apparent

'what' can be shown to emanate from its 'how'.[12] The purported differences between idealism, realism, and empiricism emerge no less and no more than fictions produced by differing styles of discourse. The premise of this position is a disbelief in 'philosophical discourse being able to refer to anything beyond itself' for without that assumption, content could once again take precedence over form. (B) By exploding the myth of a singular foundation for philosophy, deconstruction opens the door to a pluralism of thought maintained by varying styles or rhetorics. Its plausibility can only be 'shown' through the operational adoption of a polysemic variety of *Welt-Perspektiven*, never by its being stated propositionally (which would lead to self-contradiction).[13] Derrida implies similarly in *Spurs* that pluralistic philosophy can only insinuate never state or propose itself: 'if the simulacrum is ever going to occur, its writing must be in the interval between several styles'.[14]

Despite efforts to daub Derrida with the brush of a philosophical *terroriste* threatening western culture with deconstructive semtex, the renewed emphasis he gives to the primacy of writing in philosophy has consolidated and extended the views of both past and contemporary thinkers. Nietzsche not only shares Derrida's view that 'writing is the better part of thinking'[15] but also the conviction that writing is a form of alienated speech which sets meaning at a distance and variance from that originally intended by the author: 'What are you after all, my written . . . thoughts'. Nietzsche laments, but 'always only what is on the verge of withering and losing its fragrance!'[16] Gadamer, a principled opponent of both Nietzsche and Derrida is haunted by the same problem. In *Truth and Method*, 'all writing', he suggests, 'is a kind of alienated speech . . . Writing involves self-alienation' for 'in writing [the] meaning of what is spoken exists purely for itself, completely detached from all emotional elements of expression and communication'.[17] Yet Gadamer exhibits what is for Derrida the phonocentric prejudice of European philosophy: rather than delighting in the endless play of interpreting the written word, Gadamer nostalgically pursues the original intimacy of the inwardly spoken word which writing disrupts. 'Because the [spoken] meaning has undergone a kind of self-alienation through being written down, this transformation back [into speech and meaning] is the real hermeneutical task.'[18] Recognising the importance of Derrida for the contemporary re-tracing of the Platonic feud between poetry and philosophy, Berel Lang in his recent book *The Anatomy of*

Philosophical Style adopts a less reductive position than Derrida or de Man. When Lang states 'we need . . . a theory and practice of literary philosophy for the same reason that we need philosophy', he grants that because of philosophy's status as writing, any interpretation of philosophical texts must unavoidably 'take a position with respect to the literary or stylistic character of those works'. Yet, by considering the manner in which the stylistic 'how' of a philosophy allows its 'what' to put in an appearance, he argues that the 'what' is not reducible to rhetorical dissimulation alone.[19] But here we come to the crux: what might this 'what' be? Is there a 'zero degree style' (Lyotard) of philosophy?

The 'zero degree style' – what Lang terms the 'neutralist view' – asserts 'a single and common ground of philosophical discourse: propositions which tie predicates to subjects and which ascribe or deny existence to the variety of objects . . . that comprise the reference of philosophical discourse'.[20] This Lang denies, counter-asserting that there is no disembodied philosophical text that can be approached irrespective of considerations of its style. Though he does not suggest that philosophy in its entirety should be deconstructed, what that irreducible residue of philosophy is Lang declines to inform us. Furthermore, Lang's distinctions place him in a double bind. Despite opposing the zero-degree style notion of philosophy he is plainly desirous of enforcing a demarcation between philosophy's literary and conceptual aspects. Yet whatever this 'other' dimension is, it will in the act of its conveyance necessarily have a rhetorical or stylistic character in which case the attempted differentiation collapses. Perhaps Lang's difficulty is that like deconstructive linguistic philosophers, he tends to inadvertently conceive of philosophy exclusively in terms of propositions and assertions. In so far as any differentiation between philosophy and rhetorics will have to be spoken or written, that differentiation unavoidably becomes susceptible to the hermeneutics of suspicion in a deconstructive idiom. Is it possible to break out of this circle, to climb over the stile?

The argument to be presented will suggest that an escape is possible. One reading of Nietzsche's warning that 'when fighting dragons one should be careful not to become one oneself' might be that since dragons can only fight dragons, an effective way of preventing a dragon from being able to engage is to become other than dragon oneself. Combatting deconstructive philosophy in its own terms is futile. Any counter-proposition would by virtue of its

use of words be itself deconstructible. Indeed, we accept the plausibility of the deconstructive stance that there is no meaning-in-itself and yet, despite this, refuse to accept that philosophy's content is reducible merely to a set of fictive conceits. What is necessary is to slip outside that ring of words in which statement and counter-statement are locked and move from that dominant model of philosophy as writing alone be it propositional or narrative. The attempt is a precarious one for the core of what we wish to suggest is that there indeed is a dimension of philosophical awareness that cannot be put into words and, furthermore, it is precisely an acquaintance with this awareness that prevents philosophy's collapse into the purely rhetorical and endlessly interpretable. This might invoke the response that 'What we cannot speak about, we must pass over in silence'.[21] Yet, as with aesthetic experience, what language cannot state propositionally, it can at least point to. It is just such a 'pointing to' that this chapter wishes to attempt. That to be pointed out is the revelatory experience of 'meaningfulness' which when understood shows why philosophical experience cannot universally be reduced to the rhetorical and why deconstruction's emphasis upon the analytics of style is so dangerous.

ON 'REVELATION', THE 'MOMENT' OF UNDERSTANDING
or
PASSING THROUGH THE TURNSTILES

To dare to speak of revelation, of the profundity of an experience of meaningfulness, is unquestionably provocative in the present intellectual climate which places all between the devil and the deep blue sea. The climate is formed by a meeting of two violently opposed intellectual systems which share an animate hostility to any talk of revelation. The positivistic inheritance with its refusal to admit to the sense of any postulate which cannot submit to verification and deconstruction which repudiates any claim to the disclosure of meaning have both conspired to deny the 'revealed' sense or legitimacy. However, neither has revelation been refuted nor de-legitimised but merely, to borrow Foucault's terms, 'displaced by dominant discourses'. What then is the experience of revelation taken to be?

Firstly, we take revelation to be an experience, often unexpected, of unquestionable meaningfulness. The phenomenological imme-diacy of that experience cannot be verbally transcribed into proposi-

tional language for it is something that one *undergoes*, that happens to one. It is 'the penny dropping', suddenly coming to the realisation of what someone is 'getting at', arriving at that point where one will say '*now* I understand what is going on' or 'my God, that's it!' or even that sudden premonition of what is about to befall the *dramatis personae* of a play or novel.

Secondly, and this is of paramount importance to our case, the experience of meaningfulness overwhelms or renders secondary any consideration of style or rhetoric. It is solely occupied with the 'what' of the revealed and not with its 'how'. In his unworthily neglected *Aesthetic Theory*, Adorno alludes to this point when he speaks of that artistic truth which when experienced as 'truth' cancels the artwork with its illusion.[22] When that artwork 'speaks' to us, when its truthfulness becomes apparent, we experience being addressed. We are focused on *what* is being told us. That it is an artwork of a certain medium, that certain fictions might be employed, is irrelevant for in the moment of being addressed it is the experience of having something disclosed to one that matters. To be sure, the revealed will by the fact of its communication will have a stylistic mode, but as Gadamer insists, in a successful artwork, the style facilitates the unhindered absorption of the subject-matter disclosed. Paradoxically, style realises itself in its abnegation.[23] In *Truth and Method*, he remarks on the concept of style 'the fundamental purpose of which is not to exist for itself but for something else, in order to fashion a place for it within the unity of a life context'.[24]

The third feature of the experience of a meaningfulness is its involuntariness, that it 'happens' to one and does not emerge as the 'bottom line' of an analytical procedure. Nietzsche noted how thoughts come to us not when we will, but when they will. In any discourse one can suddenly 'see something' irrespective of any desire of illumination. What is more, what is 'revealed' can be painfully surprising, contrary to one's expectancies. Gadamer is accordingly prompted to attribute a certain objectivity to hermeneutical insight in the specifically Kantian sense of it occurring despite and 'beyond our willing and doing'.[25]

To recapitulate: the experience of being immersed in a meaningfulness embraces (A) an immediate awareness of something being 'shown' one, (B) it overwhelms any deliberation about style for who, if spoken to by a God, would quibble about accents?, and (C) it occurs 'beyond one's willing and doing'. Having outlined what the experience of revelation is, two qualifications are necessary. The first

concerns the determinacy of meaning in revelation and the second, the rhetoric of revelation itself.

(A) *On the determinacy of meaning in revelation*: In the experience of illumination something is, as German etymology has it, 'bared', laid open (*Offenbarung*). One has the phenomenological experience of being offered a determinate meaning, that the novel or sonata is saying this and not that. Now let us not fall into the Cartesian trap of claiming that the inner certainty of what is revealed to us is adequate ground for the claim that our experience of a determinate meaning *is* the meaning of the work itself. The deconstructivist would be perfectly right to insist here that what *is* experienced as a determinate meaning could, objectively speaking, always have countless other possible readings. Such a move is taken to be deconstruction's decisive blow against the 'revealed' but it is so only if either those who experience meaningfulness lay claim to *the* meaning of the work or if deconstruction supposes the experience of revelation to be synonymous with such a claim. Neither necessarily follows. The phenomenological fact of my experience of mean-ingfulness does not entitle me to claim that the meaningfulness experienced is *the* meaning of what I have experienced though *lacking that entitlement has no bearing upon the meaningfulness of what I have experienced*. The experience of meaningfulness remains, untouched by the deconstructivist's quite proper insistence that outside of my phenomenological framework, the object of my experience has any number of meanings. Is this an instance of 'having one's cake and eating it'? Undoubtedly so for we are wishing to maintain both the unquestionable experience of meaningfulness and deconstruction's rightful attack on meaning-in-itself. The experience of meaningfulness has a certain duality. On the one hand, the experience is an *experience* of meaningfulness and, on the other, the manifested *meaning* is (apart from my experiencing of it) always susceptible to countless interpretations.

It has been necessary to clarify this dual dimension of revelation in order to show that a real danger posed by deconstruction is rhetorical. It seeks to persuade us that because of the universal absence of intrinsic meaning, our particular experiences of mean-ingfulness are meaningless. The oblique *theologica negativa* in the deconstructivist's position is clear. Its assertion of the absence of meaning inadvertently declares that meaningfulness would be meaningful only if meaning in itself were present. We will be persuaded of this only if by default we accept the claim that in order

for our experience of meaningfulness to be meaningful there must be meaning-in-itself. But, as is being contended, the experience of meaningfulness does not depend on that presence and nor is it weakened by its absence. What then does that experience rest on? Here we turn to our second qualification of our understanding of revelation.

(B) *The contextual nature of revelation*: A common understanding of revelation entails the idea of a sudden inspirational insight, a view perpetuated by Nietzsche. In *Ecce Homo*, he writes of revelation:

> The involuntariness of image and metaphor is strangest of all; one no longer has any notion of what is an image or a metaphor; everything offers itself as the nearest, most obvious, simplest expression . . . [It seems as if] the words and wordshrines of all being open before you here all being wishes to become word.[26]

Though this passage supports the suggestion that the apprehension of meaningfulness immediately transcends considerations of style, it presents a misleadingly incomplete view of revelation. Whilst the phenomenological occurrence of revelation might be abrupt, breaking the ordinary or expected flow of experience, there is nothing arbitrary let alone *ex nihilo* in the revealed. The experience may be of 'a bolt coming out of the blue' but the *content* of that experience is rarely if at all isolated. In this context Andrew Louth has argued,

> There cannot be pure truth of revelation: for to apprehend a truth which is received is to relate it to what we already know, to make it one's own . . . Truth of revelation remains inert till it has been appropriated by a human working recognition which is hard to distinguish from that [truth] of discovery.[27]

Louth points to a central tenet of hermeneutics; the dependence of the disclosed upon a *Vor-Verständnis*. Whilst Gadamer articulates how immersion in the unspoken but 'known' dimensions of a cultural horizon is the pre-condition of any formulation of its nature, Polyani stresses how what is explicitly understood within a field of communicative endeavour rests upon a tacit acquaintance with its norms and practices.[28] Returning to Nietzsche's description of those revelatory moments in which Zarathustra first appeared to him '6000 feet beyond man and time', though the force of those moments may have 'thrown him down', what the experience crystallised was a new formation of many of the philosophical and existential proble-

matics which had haunted him since the writing of his first book. The revelation disclosed something he was already deeply acquainted with but presented it in a new light, not so much of a sudden fracture but a sensing of the terrain around him to have radically changed and yet remaining not unfamiliar. Such revelations evoke, as Gadamer suggests, the Platonic notion of recognition but with the qualification that we are not talking of regaining an insight into a fixed truth dusty with the cobwebs of forgetfulness.[29] The problematics Nietzsche was dealing with prior to the writing of *Also Sprach Zarathustra* constituted an horizon of undecided and unrealised positions amongst which was one capable of transforming his understanding of those questions. And yet, though logically entailed within his horizon, prior to the revelation it remained phenomenologically hidden from him. The experience of meaningfulness entails the dawning awareness that what is experienced as complete and fulfilled was already tacitly known but unrecognised. Revelation is thus not so much the disclosure of the fixed but the *well forming* of what was but now no longer is undecided and unresolved. This conception of illumination has a Platonic ring about it because it reminds us that revelation is always 'placed' within an already established interpretive quest, within a project whose very life is to be 'underway'. These enabling conditions of revelation permit us to put in place that remaining piece of our argument and thereby allow us to return to the question of style.

THREADS OF SENSE

In 1885/6 Nietzsche remarked that 'Since Copernicus mankind has been rolling from the centre towards "x." '[30] What Copernicus did for humanity's sense of ontological security, Derrida has done for semantic stability. Derrida's achievement has been to reveal how language in its transference from the spoken to the written opens realms of possible meaning unimaginable and certainly unattainable within the purely spoken. The question that presses itself upon us is whether the always-imminent-logical-possibility that what a word now means can dissolve into any number of other meanings is of any existential import? The absence of universal meaning is a perfectly plausible notion. Why do we not fall into the abyss? An Ancient Sanskrit poem offers a spectacular image of the human predicament, being suspended over a darkened snake pit by a single silken thread.

It is likely that we do (logically) *exist* in a world where all meaning is undecidable but neither do we *perceive* nor live in the world that way but find ourselves curiously enveiled within a web of perspectival interpretive threads. Habermas' reworking of Husserl's notion of cognitive interests is pertinent. In *The Philosophical Discourse of Modernity* he speaks of 'the innovative potential of art and literature for our life-world and life-history, worlds which assume and rely on a whole complex of functions and structures that perpetuate and extend our life-world',[31] a 'life-world' which with its horizon of meaning serves as the basis of the cognitive interest we take in our environment. Its interests are those umbilical threads of sense which weave us into the constitutive projects of our histories and traditions, projects which enable self-understanding on the one hand and, on the other, prevent us from falling into the abyss. Where the possibilities for meaning are inexhaustible, our cognitive frameworks select interpretive options open to us and will not even acknowledge others as possibilities. It is always within these fields that our individual and collective cultural understandings are nurtured. The answer to the question of whether deconstruction's dissolution of meaning has any existential import, can now be seen to be 'no' for the following three reasons.

1. If the deconstructionist is correct and there is no meaning-in-itself, then there never has been such a meaning-in-itself. Consequently, all the particular insights gained by different cultural traditions into the human predicament remain as they are. All the denial of meaning-in-itself does is to change our evaluation of the status of those insights, i.e. whether we view them as different interpretations of a predicament or the true account of that predicament. If there is no ultimate account, the individual insight remains. Its legitimacy will depend upon the cultural horizon it belongs to, not upon the existence or not of meaning-in-itself.

2. Von Neurath likened our knowledge of the world to being on board a ship, the hull of which could never be inspected let alone overhauled.[32] Similarly, our self and cultural understandings are achieved *after* embarcation. There is no possibility of determining whether our individual and collective cultural odysseys are properly caulked let alone well founded. Logically speaking, such frameworks can always be other than they are but, contingently speaking, from the fact of our existential *Geworfenheit*, they cannot be other than they have been. We are not free to alter the heritages that we are born into. We are already at sea and whether deconstructive

soundings establish a bottom to that sea or not, does not matter. We still have to navigate ourselves down the channels that our *Vor-Verständnisse* have guided us into.

3. If all meaning is relational, the deconstructivist pre-occupation with the absence of meaning-in-itself is misguided. Searle's remark about classical metaphysicians is in this context extremely telling: 'The real mistake of the classical metaphysicians was not the belief that there are metaphysical foundations, but rather the belief that somehow or other such foundations were necessary . . . that unless there were such foundations something is lost or threatened or undermined or put in question.'[33] *Mutatis, mutandis*, deconstruction turns out to be an apologetics for precisely that which it denies. For to assert the absence of meaning is to lay down the criteria of what it would be for something to be meaningful and, furthermore, the absence of meaning-in-itself is threatening if and only if meaning is supposed to depend upon a foundation but who except rationalist metaphysicians and the deconstructivists say that it ever did? It can be argued therefore that the absence of meaning-in-itself and the forever imminent logical possibility that one meaning can be dissolved into another ought not really be of any existential import.

What is of considerable existential and cultural import, however, is that in the face of logically undecidable interpretations and despite all the possibilities, we nevertheless opt for this reading rather than that. Why? Our opting for a specific meaning is guided by the field of hermeneutic assumptions that form our horizon but within what we are guided towards as plausible options, we choose this rather than that option (or should I say it chooses us) because of a particular fullness of meaning. What is grasped as meaningful is so not because it is the meaning-in-itself but because it suddenly illuminates a nexus of meanings which have shaped our individual and cultural projects. Meaningfulness as making sense of something has nothing to do with the presence or absence of foundations. The revelation is legitimated, i.e. is experienced as being as authoritative as our own inner voice, precisely by the extent to which it 'wires up' a set of interpretive possibilities latent within our horizons in such a way as to transform our understanding of what we might be about existentially or philosophically. That such experiences reveal, and by revealing tie us more tightly to the webs of meaning that constitute the unquestionable contingencies of our given cultural traditions, explains why, despite the logical openness of all meaning and interpretation, we will nevertheless choose this rather than that view of things.

Overlooking the relational nature of meaningfulness leads both Foucault and Derrida into a needlessly ineffectual form of foundational nihilism. In *The Birth of the Clinic*, Foucault dismisses claims to both the transparency and originality of meaning. The latter 'dooms us to an endless task . . . [as it] . . . rests on the postulate that speech is an act of "translation" and exegesis, which listens . . . to the Word of God, ever secret, ever beyond itself . . . For centuries we have waited in vain for the decision of the word.'[34] But this is very tellingly to miss the point. If meaningfulness is taken to reside solely in words and statements, no wonder we wait in vain for, as Derrida so competently shows, the rhetorical surplus in all words entails meaning remaining 'ever secret', ever 'beyond itself'. Yet this is to slip into the disastrous proposition that if something is to have a meaning, it must be statemental or propositional meaning: words would be meaningful if they attach analytically fixed predications to a given subject. However, what we have been at pains to suggest is that meaningfulness in philosophy and other humanities is not the disclosure of a fixed 'presence', not the tying of the appropriate predicate to the chosen subject, but the extent to which within a moment of understanding, a nexus of possible meanings is lit up and is seen to give sense to a given field of pre-occupation. In the posthumously published notes *Zettel*, Wittgenstein alludes to what we are here describing as the relational nature of meaningfulness.

Curiously anticipating deconstruction, Wittgenstein concedes that there is no hermeneutical terminus to the meaning of a word or artwork. The quest for a final interpretation, he remarks, is the pursuit not for a further sign or picture 'but for something else – the thing that cannot be further interpreted'.[35] But for him as well as for deconstruction there is no thing which cannot be further interpreted, no final terminus for interpretation. There is, however, a psychological terminus. Wittgenstein explains, 'What happens [next] is not that this symbol cannot be further interpreted but that I do no [more] interpreting. I do not interpret because I feel at home in the present picture.'[36] Aside of this quite remarkable reinvocation of the Hegelian concept of *Einhausung*,[37] Wittgenstein's point is twofold: (A) that the meaning we 'feel' at home in is not logically exclusive of other meanings, and (B) the interpretation I accept by 'walking into it', I accept not because of its inherent statemental properties but because it links up with and extends the 'form of life' from which I and my interests have developed. In other words, the decisive factor as to why I adopt this rather than that meaning, as to where I stop

interpreting, is precisely that point where 'sense', where that moment of meaningfulness is achieved. Gadamer too speaks of this as interpretation becoming 'self-cancelling'.[38] Though what I experience as meaningful could always be otherwise logically, the meaningfulness of what I experience is unconnected with the issue of foundations or of meaning in itself but thoroughly bound up with the extent to which the revealed meaning illuminates the projects, the narratives, questions and problematics which shape and place us culturally – for let us make no mistake about this, the threads of sense of which we are talking are those upon which our self-awareness, cultural understanding and spiritual growth rest. It is precisely because the deconstructive analytics of style threatens to tear the threads of sense which mysteriously and quite contingently prevent us from tumbling into the abyss of absence that makes the question of style in philosophy so important.

STILETTOS AND STYLITES

Whilst the experience of meaningfulness entails a phenomenological involvement with the revealed, consideration of the manner or mode of the revealed entails a stepping back, a reflective distantiation from what is being said. 'Content' is suspended in favour of reflection upon the mode through which it appears. The relation between phenomenological involvement with what is said and a reflective distanciation from the 'what' to a consideration of the 'how' has obvious advantages. It questions whether the substance of the communication is enhanced or distorted by the adopted style. Secondly, it can ask whether, in the instances of such thinkers as Nietzsche, the styles (media) are the message. Thirdly, the ability to step out of what is revealed within an experience of meaningfulness and reflect upon the implications of what one has understood ensures that one does not remain hermeneutically sealed within the confines of one's own experience. In each of these instances, the questions of style can be mediated, shaped and directed by a sense, albeit changeable, of what a work or argument is about. Furthermore, considering the issue of style is to hope for yet further illumination concerning meaning. The danger posed by an extreme deconstructive reduction of philosophy to its literary modes is that the mutually nourishing ebb and flow between questions of content and questions of style is severed, a stiletto thrust which effectively can

sever the arteries of sense upon which the dynamic of inner education rests.

Deconstruction's reduction of philosophy to a mode of literary feigning is based upon what is epistemologically speaking an equivalent to a *theologica negativa*: the assertion of the absence of meaning-in-itself which allegedly legitimates the conclusion that there is nothing to be said in philosophy, only different styles of pretence. Yet the conclusion is invalid since the meaningfulness of different hermeneutic horizons is unaffected by the absence of meaning-in-itself. The danger posed by deconstruction is thus not its logic but its rhetoric for its reductive analytics of style rests upon the universal claim that *all fields of local meaning are meaningful if and only if there is meaning-in-itself and that without such a foundation all particular horizons are meaningless*. Only on such reasoning can philosophy be reduced to an analytics of style. The insidiousness of this rhetoric is not just that it deprives us of potentialities of being by reducing all philosophical expression to literary feigning but its deep persuasiveness. It adopts an idiom of argument that too many philosophers are still deeply in love with; purely abstract universal judgements. With all the seductiveness of a theoretical form, how could we dare contend it without the risk of being accused of being either purely subjective (insisting upon our own insights) or being found out as a reactionary sentimentalist secretly longing for a metaphysics of presence! The rhetoric usurps and perverts repressed rationalist longings in philosophy. If denying the deconstructivist stance with an assertion of the plurality of different meaning horizons means denying universal reasoning, better deny the plurality of meaning and uphold universal reasoning! The cunning of deconstructive rhetoric is to masquerade as a universal stance but here deconstruction is doubly telling. We have seen how deconstruction is a *theologica negativa*: by asserting meaninglessness it ipso facto asserts what it takes to be the criterion of meaning. However, as meaningfulness does not depend upon universal foundations, deconstruction only need worry us if we too – like deconstructivists – are would-be foundationalists hankering after the certainty of a universal foundation or guarantee for our particular meanings rather than accepting their obvious contingency. In other words, it inadvertently tries to persuade us that meaningfulness ought only ever reside in what the imperious rationalist would wish: the self-transparent statement in which meaning is clearly predicational. Deconstruction does not deny predicational meaning, merely the

fixity of predicational meaning and thus to deny what deconstruction denies appears perversely to deny what those with rationalist tendencies will never deny, i.e. that meaning is predicational. The power of deconstructive rhetoric is not that it marks the end of metaphysics but rather that it re-awakens and is parasitic upon longing for a universal metaphysics.

The deconstructivist nihilist believes that the repudiation of meaning-in-itself refutes all local meaning. As this does not follow from the denial of substantive meaning, the belief that it does can only reflect a desire that it ought to. Like some medieval stylite, the nihilist sits astride the pole of universal reasoning refusing the challenge to be changed, to be opened to the possibilities for being within localised spheres of meaning, in effect, purposely deceiving himself that he does not have to take their regional claims seriously because he asks of them what they cannot possibly give: namely, a universal foundation. Deconstructive rhetoric therefore seeks to persuade us that because there is no fixed meaning to words, no logical finality to interpretation, the only interest it is possible to entertain in philosophical writing is to view it as a set of stylistic or rhetorical manoeuvres. The crucial entailment within the deconstructive emphasis upon style alone is the propogation of the view that given universal meaninglessness, *it is necessary to disengage from any involvement with, interest or belief in any substantive discourse.* The cultural disaster looming in the deconstructive reduction of philosophy to an analytics of style is that it lends rhetorical force to a quite unwarranted devaluation of those regional spheres of meaning upon which cultural, individual insight, revelation and wisdom depend. That analytics is wedded to a nihilist logic of '*ressentiment*' which perhaps because it cannot have what it would wish – the fixity of meaning – unwarrantably dismisses all regional horizons of meaningfulness. How might deconstruction avoid the charge that it is the last throw of an inverted rationalist metaphysics which, as with collapsing decadent empires of old, threatens to take all else with it?

Were that to happen, the fault would be ours. We all experience moments of revelation when a book, painting, or symphony suddenly lights up a sense of ourselves. The phenomenological intensity of such moments is unquestioned. But why do we not trust these revelations and insights? Why cannot we accord them the same degree of phenomenological certainty that Descartes accorded his overwhelming sense of being? Is it because we have become so

enamoured with that monopolistic view of philosophy as an 'objective' science, dealing only with that which can be rendered in propositions and statemental assertions, that we are no longer prepared to trust our inner intuitions of sense? Deconstruction is a truly telling opponent, finding us out within our secret longings. If we trusted our intimations of meaningfulness and resided in them, deconstruction could not perturb us since we would accept that the meaningfulness of our revelations stands apart from the issue of the foundational. Deconstruction need only worry us if we have sought to dress up our insights as universal truths rather than the truths which appertain to a tradition but why should we have done that? Either because our faith in our insights is weak and we seek to bolster them by dressing them up as theoretical truths or because we have imperialist tendencies and wish to vaunt our insights over others by disguising them as universal truths. In either case, deconstruction would rightly undo us. Yet if we were prepared to accept that philosophy is not reducible to a pseudo-science of statement and counter-statement and that it can embrace revelatory experiences of meaningfulness which can have a claim upon us irrespective of the question of foundations, deconstruction would be disarmed. But it would be defeated only if we are prepared to renounce the universalising if not imperialising tendencies of our philosophical heritage and learn to trust once more what deconstruction's rhetoric of stylistics so threatens in its insensitive blanket denial of all modes of meaning, namely, the regional spheres of meaningfulness upon which both our awareness of intelligible sense and the sense of our being rests. If we re-learn such trust and hermeneutically de-colonise ourselves from a singular reason the question of style might indeed be meaningfully resurrected. In listening to our intuitive voices we will individualise, make 'subjective', as Kierkegaard might have put it, the general truths of those regional spheres of meaning that have shaped us and in so doing will find our own 'style' and climb over the stile of being merely mannered.

CONCLUSION
or
'REVEALING STYLE'

Let us now clarify the specific claims and implications of this chapter. Commenting on Richard Rorty's essay 'Philosophy as a

Kind of Writing',[39] Norris remarks that 'the central issue . . . is that of philosophical style' for any choice of style will involve commitment 'to certain operative metaphors and modes of representation'.[40] Conventional philosophy 'proceeds by subjugating language to thought, rhetoric to logic and style to the notion of plenitude of meaning' whilst 'abnormal philosophy rejects the protocols of orthodox linguistic philosophy in favour of a conscious, even artful play with stylistic possibilities . . . a constant dealing in paradox and a will to problematise the relation between language and thought'.[41] Deconstruction affirms stylistic pluralities and 'rejects the appeal of absolute knowledge' seeking to demonstrate by its analytics of style 'the delusions of systematic method'.[42] Against the backdrop of Norris' remarks the following should become clear.

Firstly, the purpose of this chapter has *not* been to defend 'normal' from 'abnormal' philosophy. To the contrary, the argument presented accepts both the plausibility of deconstruction's repudiation of meaning-in-itself and that no philosophical-cum-literary articulation can be immune from further analysis and interpretation. It has indeed been contended that there is a dual aspect to any formulation of that which is revealed as meaningful. When and wherever I cease interpretation and take something to mean this rather than that, it remains the case that what I have 'closed off' as a determinate meaning necessarily remains open to other readings. Whereas deconstruction is correctly insistent on no logical or final hermeneutic terminus to the question of meaning, this chapter nevertheless insists that revelatory experiences of meaning suggest what Wittgenstein terms a 'psychological terminus' or interpretation,[43] a point where despite the logical openness of all interpretation we choose this rather than that option, because it lights up and makes sense of the projects and concerns that define us both individually and culturally.

Secondly, in making a case for revelatory experiences of meaningfulness we are not either implying that those experiences are immune to deconstruction or that they are in some way privileged. Not only will the content of such experiences be endlessly interpretable but their form too. As Steiner bids us remember, 'Structure is itself interpretation.'[44] Nor is there any necessary fixity to the forms of life within which intuitions of meaning occur. In all these respects deconstruction represents a consistent and plausible extension of Nietzsche's repudiation of essentialist epistemologies.

Thirdly, the argument of this chapter does take issue with

deconstruction over the questions of (A) the actuality of meaningful experience, and (B) the supposition that the absence of meaning-in-itself renders regional spheres of meaning meaningless. Regarding (A) we have argued that the meaningfulness of an insight depends upon the extent to which it illuminates the projects and commitments we are individually concerned with. Arguing for this does not imply a wish to return to normal philosophy for, as suggested, deconstruction as well as conventional philosophy emphasises predicational meaning. Conventional, 'analytic' and rationalistic philosophy to a degree all pursue precise relations between a subject and its predicates. Because it seeks to show the unlimited predicative relations that can be attributed to a subject, deconstruction too exhibits a loyalty to predicational meaning. The 'meaningfulness' we allude to, however, is *not* predicational for that which illuminates such experiences lies outside them, i.e. those perspectival meanings which shape our experiences and yet can never be exhaustively given in them. Without such non-predicational meaning, the sense of our being and its possibilities would be stifled. It might further be suggested that deconstructive criticism is itself reliant upon such an experience of meaningfulness. The proposal that an open pluralistic philosophy can only ever be inferred not only suggests a meaningful insight which is not propositional (it could only ever be 'shown')[45] but also that an understanding has been reached concerning the limitations of traditional categories of meaning. Concerning (B) the supposition that all local horizons of meaning are meaninglessness, we have argued that the particular danger inherent within deconstruction is that it encourages us to stop listening to, to disengage from and to cease to believe in the culturally contingent frameworks of meaning upon which all past and future revelation of the potentialities for our being depend. As Nietzsche would have energetically insisted, the absence of meaning-in-itself is no cause for despair (passive nihilism) since it has no bearing upon, indeed, liberates us for a confrontation with what is meaningful-for-us.[46]

Fourthly, in arguing for the experience of meaningfulness which eludes propositional capture it must be stressed that neither are we advocating a mystical position nor a devaluation of theoretical reflection. Mysteriously spontaneous in their emergence though they may be, there is nothing mystical about these experiences. They are a phenomenological fact of our being. Although theoretical reflection entails a distantiation from the content of such experiences, reflection ensures that we do not remain sealed within the frame-

work of our experience. The relationship between analytic reflection and intuitive insight is of such complexity that any discussion of it is impossible here. It suffices to say, however, that any reflective examination of the revealed can expose nuances and implications within the intuition which might not have been apparent in the thralls of the experience itself. Reflective analysis is thus capable of extending and substantiating what is revealed. What these comments imply is that reflective analysis does not commence its operations *ex nihilo* but is asked to examine or confirm that revealed as meaningful. In one of his earliest philosophical essays, Nietzsche points out that reason only ever follows the 'wingbeats' of the imagination[47] or, in our terms, the experience of meaningfulness. Furthermore, analysis of revelatory experience encourages openness to yet further experience. Gadamer comments that the fulfilment of experience does not consist in comprehensive knowledge but 'in the openness to new experience'.[48] It is precisely the openness to new experience which the nihilistic (universal) denial of the meaningfulness of local horizons threatens. If the very experience of meaningfulness which gives direction to any analytical deepening of experienced meaning is denied (why should one carry the analysis out?), the critical stimulus which pushes one towards the possibility of new insight, the patience with which one listens for yet further illumination is shunned and with it the possibility of any cultural or spiritual growth.

Fifthly, the threat of such a calamity exists only if deconstruction remains wedded to the fallacious conviction that the absence of meaning-in-itself nullifies the meaningfulness of local regions of meaning. If deconstruction is constrained to operating only as an analytical or critical tool, it might positively extend the potentialities for alternative readings of a given experience of meaningfulness. As soon as it adopts a universalistic stance which declares all horizons of meaning meaningless, deconstruction threatens to destroy not only the possibility of further experience but also to wither all the roots of meaningfulness through which regional meaning and hence individual and cultural identities feed.

Sixthly, we come to the point where the aforementioned clarifications of our argument can transform our previous discussion of the question of style in philosophy. It has been argued that the phenomenological immediacy of the experience of meaningfulness renders the question of style secondary. In that experience apprehension is immediate and unequivocal: the question of 'how' the

'what' of that which we apprehend puts in its appearance does not arise. Only reflection upon that experience will lead us to consider such refinements for in the experience itself both the 'how' and the 'what' will be fused. Once distinguished, however, two possibilities arise. (A) If we can differentiate between the 'how' and the 'what' of an experience, we can distinguish between its meaning and its expression or, in Gadamer's terms, between the thing-itself (*Sache selbst*) *and* its particular modes of disclosure.[49] (B) If we can make such distinctions we can recognise that we have experienced a subject-matter this way rather than that way. Reflection upon this will show the irreplaceable singularity of our instantiations of a given field of meaning or concern. Our experiences of meaning attest to an incorporation or reception of a general framework of meaningfulness, which in the experience is concretised in a particular instantiation. The combination of placedness within a horizon of meaning and the latter's particularisation in individual exemplars of meaningfulness is worthy of deep reflection which sadly cannot be carried out here. What can be said, however, is that unwittingly and with a spontaneity that is without guile and manner, *the highly personal process of translating generally apprehended concerns and pre-occupations of meaning into the revealed exemplars of particular experiential meaningfulness reveals the style which constitutes our individuality.* Thus, in reply to Rorty and Norris, we maintain that as soon as it does become a 'matter of style' in philosophy – a question of what mode of writing to adopt – then the fundamental question of style as disclosure of individuality[50] has been lost. It will remain unretrievable until we both perceive that an adherence to the absence of meaning-in-itself does not nullify the significance of local lifelines of meaning and learn to trust once more those experiences of meaningfulness which we all know and have been shaken by but can never (to art and philosophy's advantage) fully articulate.

NOTES

1 This chapter was written for the University of Amsterdam's Philosophy Department Conference. 'Style in Philosophy and the Arts', 3–5 April 1991. It was first presented in the Philosophy Department seminar of the University of Cardiff 9 March 1991) and then subsequently in Holland during the aforementioned Conference.

2 'Nothing is so valuable for the hermeneutical inquirer into an exotic

culture as the discovery of an epistemology written within that culture.'
Richard Rorty, *Philosophy and the Mirror of Nature* (London: Basil
Blackwell, 1980), p. 346.

3 Willem De Kooning, 'What Abstract Arts Means to Me' (1951), edited
abstracts of which appear in H. B. Chipp's, *Theories of Modern Art*
(California University Press, 1968), p. 556.

4 George Steiner, *Real Presences* (London: Faber, 1989), p. 53.

5 George Steiner, 'Viewpoint: A New Meaning of Meaning' in the *Times
Literary Supplement*, 8 November 1985, p. 1262. The full text of the
article appears in Peter Abbs ed., *The Symbolic Order* (Brighton: Falmer
Press, 1990), pp. 271–84.

6 Jacques Derrida, *Spurs: Nietzsche Styles* trans. B. Harlow (University of
Chicago Press, 1979), pp. 131–2.

7 George Steiner, 'Viewpoint', p. 1275.

8 Derrida, *Spurs*, p. 73.

9 Christopher Norris, *The Deconstructive Turn; Essays in the Rhetoric of
Philosophy* (London: Methuen, 1983), p. 102.

10 Derrida, *Spurs*, p. 139.

11 Norris, *Deconstructive Turn*, p. 164.

12 *Ibid.*, p. 172.

13 This point is argued by Alexander Nehamas: 'Nietzsche's stylistic
pluralism . . . is his solution to the problem involved in presenting
positive views that do not, simply by virtue of being positive, fall back
into dogmatism . . . They (the views) show his perspectivism without
saying anything about it, and to that extent they prevent his view that
there are only interpretations from undermining itself.' See his
Nietzsche: Life as Literature (Cambridge, Mass.: Harvard University
Press, 1985), p. 40.

14 Derrida, *Spurs*, p. 139.

15 See Nehemas, *Nietzsche*, p. 41.

16 Friedrich Nietzsche, *Beyond Good and Evil* trans. Kaufman (New York:
Vintage, 1966), section 296.

17 Hans G. Gadamer, *Truth and Method* (London: Sheed and Ward, 1979),
p. 354.

18 Gadamer, *Truth and Method*, p. 355.

19 Berel Lang, *The Anatomy of Philosophical Styles* (London: Blackwell,
1990), p. 23.

20 Lang, *Anatomy of Philosophical Styles*, p. 13.

21 Ludwig Wittgenstein, *Tractatus Logico-Philosophicus* trans. Pears and
McGuinness (London: Routledge & Kegan Paul, 1967), paragraph 7,
p. 151.

22 Theodor Adorno: 'Every art work vanishes *qua* artefact in its truth
content. Especially the truly great works are rendered irrelevant *qua*
works by their truth content . . . The mark of authenticity of works of art
is the fact that their illusion shines forth in such a way that it cannot
possibly be prevaricated, and yet discursive judgement is unable to spell

out its truth. Truth cancels the art work along with its illusion.' *Aesthetic Theory* trans. Leuhardt (London: Routledge, 1984), p. 191.

23 Gadamer, *Truth and Method*, p. 451.

24 *Ibid.*

25 *Ibid.*, introduction to first edition.

26 F. Nietzsche, *Ecce Homo* trans. Kaufman (New York: Vintage, 1969), p. 300.

27 Andrew Louth, *Discerning the Mystery* (London: Clarendon, 1989), p. 55/6. In this passage Louth acknowledges that he is citing F. J. A. Hort's *The Way, The Truth, The Life* (London: 1897).

28 Michael Polyani, *Knowing and Being* (London: 1969), pp. 144–8.

29 Gadamer, *Truth and Method*, p. 102f.

30 F. Nietzsche, *The Will to Power* trans. Kaufman (London: Weidenfeld & Nicolson, 1968), section 1(5).

31 J. Habermas, *The Philosophical Discourse of Modernity* (London: Polity, 1987), p. 208.

32 Von Neurath: 'Wie Schiffer sind wir, die Ihr Schiff auf offener see umbauen müssen ohne es jemals in einem Dock zerlegen und aus besten Bestandteilen neu errichten zu können', quoted by W. V. O. Quine, *Word and Object* (Cambridge, Mass.: Harvard University Press, 1964), Flyleaf.

33 John Searle, 'The World Turned Upside Down', *New York Review of Books*, 30, pp. 74–9 cited in Susan Hekman's *Hermeneutics and the Sociology of Knowledge* (London: Polity, 1986), p. 194.

34 Michel Foucault, *The Birth of the Clinic: An Archaeology of Medical Perception* trans. A. M. Sheridan Smith (New York: Vintage, 1975), pp. xvi–xvii.

35 L. Wittgenstein, *Zettel* (London: Blackwell, 1967), section 231.

36 *Ibid.*, section 234.

37 H. G. Gadamer, *The Relevance of the Beautiful* (Cambridge University Press, 1986). See the essay 'On the Contribution of Poetry to the Search for Truth' for a discussion of Hegel's concept of *Einhausung*, pp. 114–15.

38 Gadamer, *Truth and Method*, p. 422.

39 Richard Rorty's 'Philosophy as a Kind of Writing' appears in his collection of essays, *Consequences of Pragmatism* (Brighton: Harvester Press, 1982), pp. 90–109.

40 Norris, *Deconstructive Turn*, p. 17.

41 *Ibid.*

42 *Ibid.*

43 The invocation of Wittgenstein's term 'psychological terminus' (*Psychologische Ende*) carries with it unfortunate overtones of the randomly subjective. For the purpose of this chapter, however, although it is clearly acknowledged that a terminus to interpretation is achieved in the subject's mind, that terminus occurs, as we have tried to argue, *to* the subject as an event and is to a degree beyond the subject's 'willing and doing'.

44 Steiner, *Real Presences* (London: Faber, 1989), p. 21.

45 See above, note 13.

46 Nietzsche describes 'passive nihilism' as a 'decline and recession of power' (WP 22). He also remarks that 'the philosophical nihilist is convinced that all that happens is meaningless and in vain; and that there ought not to be anything meaningless and in vain. But whence this: there ought not to be?' (WP 36). 'Active nihilism' (WP 22), however, is that which recognises that the question of meaninglessness is insoluble (WP 36) and that the question is 'to what extent we can admit to ourselves, without perishing' that meaning has an 'origin which lies in us'. (WP 15) To that extent 'nihilism as the denial of a truthful world . . . might be a divine way of thinking' (WP 15). Nietzsche: *The Will to Power*.

47 See Nietzsche, *Kritische Gesammte Werke* (Berlin: De Gruyter), vol. III 4.31f.

48 Gadamer cited in Hans Waldenfels, *Absolute Nothingness* (Paulist Press, 1980), p. 124.

49 See Gadamer, *Truth and Method*, pp. 405–7.

50 Manfred Frank develops a related insight in his reading of Sartre's approach to poetic meaning. See 'The Interpretation of a Text' in *Transforming the Hermeneutic Context, From Nietzsche to Nancy*, ed. Schrift and Ormiston (New York: SUNY, 1990), pp. 145–76.

Personal style as articulate intentionality

CHARLES ALTIERI

Wittgenstein might begin an inquiry into our understanding of style by asking us to imagine cases in which we were blind to style: what aspects of our lives would no longer make sense, and what powers of agency would we feel we had lost? We need not stretch our imaginations very much to perform this test, since our culture's best example may well be analytic philosophy's efforts to develop rigorous concepts and methods precisely to afford the seductions of style. The consequent blindness has made it very difficult for philosophy to talk about first-person or agent-relative states. And methodologically that blindness forces on us distinctions like that between saying and showing, with showing quickly reduced to the enacting of attitudes or the dialogical play of conversation. But if we take style seriously as a question for philosophy we may be able to show why there is considerable speculative value in attending to what can only be shown as the exemplary mark of subjective agency. Moreover we then take the contribution of art to philosophy beyond the realm of moral analysis to which art is usually confined: we make art central to the full register of expressive activities, which in turn we can show must be central to any philosophy responsive to first-person concerns.

Clearly style's resistance to description makes it impossible to offer firm definitions. But simply to indicate what I take the stakes to be I shall propose a tentative definition of personal style, then try to show how the terms I use for that definition help make style a significant concept for larger ethical concerns. Personal style is a dimension of purposiveness that we attribute to what I shall describe as dynamic intentionality. Attributions of dynamic intentionality need not presuppose self-consciousness on the part of the agent, but the concept of style has its greatest resonance when we come to

appreciate the rendering of intentionality as a deliberate communicative act. Thus personal style becomes a distinctive aesthetic and moral phenomenon when we imagine an agent treating how he or she self-reflexively carries out some task as part of what constitutes the action. And these self-reflexive features of style become crucial general concerns for philosophy because they call our attention to powers of subjective agency too fluid and too resistant to concepts to be easily handled by traditional models of desire and judgement, or to be easily demystified into the equation of subjectivity with subjection now dominating literary criticism.[1]

Three basic steps should make it possible to elaborate some of these powers. First I will concentrate on how attention to style affects what we say about intentionality by making clear the limitations of the cognitive, transcendental model of intentional agency developed by Husserl and by demonstrating the need for another more process-oriented version of intentionality deriving ultimately from Spinoza's *conatus*. Then I will use Nietzsche and Wittgenstein to show how aspects of purposiveness and will can be attributed to this dynamic intentionality, thereby enabling us to talk about style without subordinating the will to style to what Nietzsche excoriated as the will to truth trapping us in those cognitive versions of intentionality. Finally, I will dramatise my claims by focusing on C. K. Williams' metaphoric use of a long line as a vehicle for combatting specular models of personal identity and for establishing a different access to what had been considered the deep interiority of the subject.

We need an alternative to Husserlian intentionality because that version of agency shares with analytic philosophy a demand to cast mental life in fundamentally third-person terms that then can be imagined as available for any subject. For Husserl intentionality offers a transparent relationship between noetic structures and noematic contents, and thus locates possibilities for objective knowledge at the very core of subjective life. But Derrida makes painfully clear how this transcendental mode is purchased only by ignoring temporality and usurping the contingent features fundamental to there being singular first-person states. That demonstration then sanctions Derrida's own efforts to open an alternative path for conceiving that singular agency and its modes of taking responsibility. However Derrida's deconstructive commitments force this new path back into the old roadway because much of his account is tied to reversing Husserlian versions of plenitude, so that the non-

transcendental features of subjective agency get located primarily in processes of differing and deferring which remain parasitical on third-person models of knowledge. Derrida wants to locate expressive singularity primarily in a working signature made visible by its resistance to any single representation. Instead responsibility lies in how responsiveness is deployed. But, as I have argued in my *Canons and Consequences* (chapter 7), this leaves him without adequate accounts of what can be expressed and how one takes responsibility for the paths of responsiveness one sanctions. So we must try to preserve what is important in Derrida's account by developing a model of intentionality within which the first-person becomes a positive dynamic force.[2]

Here I can only sketch the necessary case by calling attention to the assumptions underlying the following passage from 'Afterword: Toward an Ethic of Discussion', where Derrida is at his least evasive:

Whether it is a question of prediscursive experience or of speech acts, plenitude is at once what *orients and endangers* the intentional movement, whether it is conscious or not. There can be no intention that does not tend toward it, but also no intention that attains it without disappearing with it.[3]

By stressing the dream of plenitude basic to Husserlian intentionality, Derrida simultaneously defines and resists two fundamental problems in our received models of subjective agency. First, Husserl helps him dramatise the gulf between what we might call the knowing subject, satisfied by adapting to third-person criteria that orient intentions, and the willing subject, which can only be recognised in terms of a negative force establishing singular agency against third-person expectations. In so far as an intentional agent can realise the plenitude of an intention, and thus can name what it has desired, it can no longer be in that regard an active singular desire. A fulfilled intention is merely a piece of public data – desire satisfied no longer engages a will but exists for any person, and hence only for third-person aspects of agency. Second, the need to distinguish between the knowing and the willing subject threatens to divide the structure of the subject into a component that seeks peace in knowledge and an 'other' prodigal but perhaps more 'authentic' locus of agency not so controlled. How else can we map the apparently inescapable gulf between knowing what is intended and feeling forces that seem to drive intentions but that also seem to resist any representation to which we can attribute plenitude?

How then do we keep intentionality as a first-person force?

Derrida locates that force in processes that undermine or over-determine what can be fixed as plenitude. Subjective agency, the power of saying 'yes', gets located in the activity of an 'uncondi-tionality' that refuses to submit its legislative capacities to any determinate context, since such determinacy subsumes the subjec-tivity of the subject under what can be known in third-person terms. In order for the working of the subject not to be subjected it must be able to announce itself as such only in 'the opening of context': 'Not that it is simply present (existent) elsewhere, outside of all context; rather, it intervenes in the determination of a context from its very inception, and from an injunction, a law, a responsibility that transcends this or that determination of a given context' (*LI*, 152). Even though agents define specific situations by invoking contexts – 'this is the moment of strategies, of rhetorics of ethics, and of politics', the acts of definition only carry subjective agency to the degree that they remain indeterminate. There must be a border or limit or margin where the choice of context itself 'entails a clause of nonclosure' (*LI*, 152–3).

But why should we accept the strict binary between determinacy and indeterminacy on which Derrida's model of singularity's 'yes' depends? Indeterminacy relative to concepts need not entail indeterminacy in relation to practices or modes of perception allowing us to locate continuities and responsibilities precisely in how contexts are opened and controlled. Because Derrida cannot make such distinctions, cannot allow a mode of expression that is articulate despite, or because of, how it resists concepts, he can only produce quite thin versions of the senses of duration and of responsibility that seem necessary for any account of subjective agency. His version of subjective agency can define itself as singular only to the degree that it refuses determinate plenitude and locates its investments in the disseminating mobility that attends upon self-division. Similarly, for him the richest way to respond to others as singularities is not to honour their intentions but to keep on them a pressure that helps them remain at a tangent to the specular selves intentionality projects. Thus the individual will not be subsumed under some fixed idea that either the agent or an audience has of that person, and the way is opened for the self to have the only continuity a singularity can have within time, one that depends on the constant adaptability of what none the less carries a signature.

The price Derrida pays is most evident when he tries to derive ideals of responsibility from the conditions of readerly responsive-

ness that deconstruction exemplifies. There is simply no way to avoid having an ideal of unconditionality reduce ethics to a domain of radical choice where claims about responsibility cannot be tied to any specific obligations – either to oneself or to others. What is there to be responsible to if one's singularity depends on refusing to subsume desire under any specular image or determining idea? One might here suggest, as Charles Taylor does, that there are conditions of expressivity that allow us to shape identities over time, so that we are responsible at least for relating our present to our past. But Derrida's ideal of unconditionality has to deny the authority of contexts derived from previous expressions: the only ideal must be one that locates mobility in a continual swerve away from what understanding might seize, thereby reducing all promises, commitments, and obligations to a single plane of advisory conditions, from which singularities establish particular paths.

But how do we escape such oppositions? If we cannot locate subjectivity within the parameters of third-person knowledge, how do we not locate it in what can remain singular by refusing those categories? I think we need to see that many other partial oppositions can enter our picture, so that we must negotiate different levels of investment and modes of articulation and understanding. And through these we begin also to recast what a full theory of intentionality must provide. Consider first the way that Derrida seems trapped into treating responsibility as if it occupied the same structure of concerns that we apply to basic intentional states. It seems as if agency too had to be understood as something we must be able to locate within the moment, so that in principle we could perceive it and surround it in the same way that we do an image of a tree or a chair. Then to preserve a first person for responsibility this agency would have to be distinguished sharply from categorical understandings which subsume singular agency. In so far as we had reasons for responsibility we would surrender agency to the authority of those reasons. But I doubt that responsibility can be conceived as something so intimately tied to specific intentional moments. Responsiveness is something we can stop and observe as it takes place, so it does occur within psychological processes. But responsibility is not something we attribute to such processes. Rather it consists in how we frame such processes and draw conclusions from them. Responsibility depends not on how we respond but on how we represent actions so as to involve consequences in our relations to future selves and to other persons.

Thus I take responsibility for these words not because I can recuperate who I was in choosing them but because I am willing to be judged by them before a particular community, no matter how they emerged in my processes of writing. And whatever identity I establish by such willingness cannot be a matter of intending an image or plenitude, nor of a worked indeterminacy. Instead the level of identity achieved consists in the relation one can draw between how an act is performed and how that performance can be fitted into certain frames and projections. We move from intentionality to committed interpretations of what intentionality displays.

To be responsible one must be responsible for something as well as to something. If we take this something as our discrete actions, we can rely on traditional models of judgement. But if we imagine responsibility as connected to truthfulness or to ongoing relationships to ourselves and to others, we need a mode of self-articulation that can be roughly determinate even though it does not submit to the categories of understanding. We need, in other words, a model of dynamic intentionality, whose basic features emerge by contrast with Derrida's use of Husserl. Derrida's deconstructions require his opposing the negational force of singularity to an intentionality that can be located in discrete and definable events, each oriented towards a specific plenitude. But this opposition clearly does not account for the fact that we continue to take pleasure in and a sense of articulate singularity from intentional states even when they do not achieve a plenitude or presence. The trying is often enough; in fact the trying is often preferable to the attaining.

We might explain this satisfaction by suggesting that our subjective investment in intentions has less to do with the specific ends gained than with the sense of ongoing power that stems from the feeling of being able to direct a life, even when intentions are not fully realised. Moreover intentions are rarely discrete states which stay stable enough to allow the drama of plenitude and its vicissitudes. As Wittgenstein saw, our awareness of ourselves as intentional agents must be located primarily in simple practices of paying attention to what we are doing. Such intentional focus rarely takes the explicit form in which it is plausible to think about plenitude and deferral. Intentionality seems fulfilled or blocked largely in terms of whether its projections manage to work linkages from one state to another without the feeling that one has lost control of one's actions. If we are to speak of plenitude, we must locate it less in the achieving of specific goals than in the sense that we

continue to feel we control our participation in a network of desires, plans, and ongoing interpersonal relations or structured practices. Intentions are satisfied primarily by generating other intentions. This is why selves can value mobility without having to base that mobility primarily on negations, and this is why, despite Derrida's cogent argument on realised intentions, we do not feel the accomplishment of any one desire as a loss. The openness to loss is more than compensated for by a sense of the transitions made possible to other desires. Finally, this line of thinking suggests that it is reductive to imagine the entire subject's singularity at stake in any given intention. No particular binary opposition between identity and non-identity in any given intentional event could possibly create that overall sense of agency, since there is never only one context (or sense of self) in which we make those choices. We develop the feelings of singular agency that pervade intentional behaviour from histories of intentional acts and the interpretations which we come to accept for those acts. So while images of ourselves as agents are both unavoidable and useful, it also proves possible to locate the most dynamic features of that agency in an ongoing purposiveness that cannot be represented in concepts or images, yet which we must grant both links and disseminates intentional states.

To test this hypothesis consider how we attribute singularity to those we know well. We do not (usually) try to summarise them in images, or to imagine them as having to secure non-identity by resisting the pressure of our gaze. We know them as characters who manifest orientations and traits that assume many modes, all of which become manifest through intentional powers that have very little to do with plenitude, unless some situation requires taking full responsibility for the various facets of those activities. Most of the time when we attribute responsibility to them we still do not equate our sense of them with any one concept. We attribute responsibility to accounts of behaviour that allow people to earn certain identifications, certain respects for purposiveness by virtue of how they connect a past to a future. Just as we cannot feel deep grief for a moment (Wittgenstein), we cannot take responsibility for momentary states without referring them to larger patterns of identification.

Nietzsche offers us probably the richest philosophical appreciation of this dynamic intentionality, since his claims for the will to power depend on a version of being for itself which the *conatus* provides.

And he clearly has a great deal to say about style. But for my purposes these specific remarks on style are less important than the underlying model of intentionality. For Nietzsche's actual positioning of how we will seems to me less problematic than his explicit theorising on the topic. This embodiment of willing exemplifies a means of developing a singular agency not subordinated to the will to truth, and hence not hollowing out that agency from within in order to establish its submission to third-person categories. This model then affords us a recasting of Kantian purposiveness without purpose that applies to all expressive manifestations of dynamic intentionality and that thus enables singular agency to establish articulate responsibilities.

The model of a purposiveness not dependent on the will to truth derives from Nietzsche's realisation that combatting Christianity required a great deal more than efforts to refute its dogmas. One must understand how that religion actually possessed souls by seducing people into internalising its values, and one must define the forces by which such deep emotional structures pervade cultural life even when the dogmas lose their hold on us.[4] For Nietzsche that force resided primarily in the way Christianity led us to define will in accord with an ideal of truth. Then who I take myself to be at my most powerful becomes inseparable from how I imagine myself being judged according to certain ideal truths: so the inwardness of self gets defined as fealty to some third-person principle within the agent that others might grasp better than the individual can. Here then is western culture's first demonic account of subjectivity as subjection, most striking in its capacity to define what remains problematic in those Enlightenment philosophers who set reason against those superstitious Christian dogmas. As examples we might consider the ideals of subjective autonomy developed by Kant and by Mill (as well as the need within Romantic poetry to temper its individualism by the justificatory use of idealising allegorical structures). Both philosophers conceive realising personal autonomy as inseparable from adapting the self to an idealised model of rationality – either in Kant's deontological identification of true identity with universalising legislative powers or in Mill's emphasis on justified practical reasoning. In both cases the dream of getting free from the authority of priests in fact threatens only to restore a version of that authority in more virulent form because we internalise it as a condition for our own wills to power. Thus our priestly heritage contaminates any direct assertion of expressive

will, forcing us instead to locate authenticity in obedience or collective sympathy. As these locales for value became increasingly dreary, the will was faced with the difficult alternatives of turning to a nihilism where no willing is possible (and subjects become only objects) or of securing some activity of will by learning to will the very suffering or torment that characterised agents' experiences. So we understand the general outline shaping how modern philosophy idealises its own resistance to idealisation: modern philosophy is born as an ascetic effort to imitate science, in the process reducing science's capacities for creation to principles that have only critical force, without their own ability to create values. In order to overcome superstition the Enlightenment ultimately devalued all expressive energies, projecting personal liberation only as an extension of those critical principles. The highest states of self become those moments where the first-person is conquered by the third, for only then could the self fully experience a voluptuousness of willing that at the same time could feel itself justified. Our deepest cultural experience of will then consists in its struggling against the very demand for individuality, since its only site for subjective intensity had become a set of disciplinary practices occupying the hollowed core within our dreams of deep identity.

One could go on with great voluptuousness to catalogue the effects of this will to truth – Nietzsche does precisely that. But that is not all he does, or that we must do. Nietzsche's analysis of the subjection imposed by wills to truth does not trap us into taking all relations to the symbolic order as equally displaced and subjected, so one can imagine the analysis making concrete social differences. Where Lacan and Althusser each propose permanent structures of the psyche or of social life to account for that subjection of expressive will, Nietzsche roots the problems in a specific (albeit very general) historical formation. Thus it becomes possible to imagine alternative dispositions, since we can begin to resist the will to truth by dwelling on the following four non-idealist features of a fully immanent expressive agency. Through these features dynamic intentionality finds articulate expression and opens grounds by which to carry self-reflexive investments in its own activity.

1. We must realise that the very idea of 'will' is an abstraction and idealisation created by the will to truth so that the various desiring features of subjective agency can be put under the control of another idealised force – that of judgement or reason. But willing actually involves a complicated set of forces:

Willing seems to me above all something *complicated*, something that is a unit only as a word . . . [Therefore] let us say that in all willing there is first a plurality of sensations, namely the sensation of the state '*away from which*', the sensation of the state '*towards which*', the sensations of this '*from*' and '*towards*' themselves, and then also an accompanying muscular sensation, which, even without our putting into motion 'arms and legs' begins its action by force of habit as soon as we 'will' anything.

Therefore just as sensations (and indeed many kinds of sensations) are to be recognised as ingredients of will, so, secondly, should thinking also: in every act of the will there is a ruling thought – let us not imagine it is possible to sever this thought from the 'willing', as if any will would then remain over.

Third, the will is not only a complex of sensation and thinking, but it is above all an *affect*, and specifically the affect of the command. That which is termed 'freedom of the will' is essentially the affect of superiority in relation to him who must obey: 'I am free, "he" must obey.'[5]

2. Given this complexity, we need alternatives to our idealised rationality to describe how these various factors become articulate within, or better, *as* will, and hence as the agency within acts of valuing. This I think is the basic reason why style becomes so important for Nietzsche, and correlatively why aesthetics becomes so central as a model for ethics. Aesthetic analogues for human activity make it more difficult to separate subject from object, because they emphasise the degree to which our interests pervade the worlds we see beyond the ego. Aesthetic analogues in effect allow us to speak of a purposiveness that is not only without purpose but within our purposes, yet still not reducible to the concepts governing the overall orientation. Therefore Nietzsche can use aesthetic analogues to show how expressive agency extends beyond psychological concerns: expressive agency literally establishes values by transforming dominant social structures and not subordinating its energies to the regime of 'truth'. For when the artist acts to compose form, he 'obeys thousand-fold laws, laws that . . . precisely on account of their hardness and determination defy all formulation through concepts (even the firmest concept is compared with them, not free of fluctuation, multiplicity and ambiguity' (*BGE*, sec. 188).

3. To the degree that we can submit such values to public discussion we must find means of judgement that can emphasise concerns for 'truthfulness' rather than for 'truth'. For, as we have seen, any reliance on determinate categories necessary for assessing truth statements is likely to ignore precisely what it is that carries the singular force of willing, namely its interest in altering or reshuffling the very terms relied on by typical descriptions of actions. Then

Nietzsche proposes as his specific model for such valuation a concern for how that truthfulness manages a struggle between the pathos of victimage (i.e. Nietzsche's own fears and obsessions) and various means for opening paths and processes that enable transformations of that pathos. Such transformations can either restore a sense of organicist coherence for the will by sponsoring actions that 'grow out of us with the necessity with which a tree bears fruit' (*GM* preface, sec. 2), or they can make it possible to extend the self's struggles so that they become exemplary for how other agents engage similar problems.

4. The ultimate value of truthfulness consists in the capacity it has to bond the singular and the social along lines very different from those fostered by the will to truth. For Nietzsche the social bond involves a model of self-legislation very different from Kant's: rather than reconciling the subject to the law, Nietzsche envisions legislation in the form of promises that bind the subject to its own expressive gestures. Here is Nietzsche's promising about promises at its most idealised:

> If we place ourselves at the end of the tremendous process where the tree at last brings forth fruit, where society and the morality of custom at last reveal *what* they have simply been the means to: then we discover that the ripest fruit is the *sovereign individual*, like only to himself, liberated again from the morality of custom, autonomous and supermoral (for 'autonomous' and 'moral' are mutually exclusive), in short, the man who has his own independent, protracted will and the *right to make promises* – and in him a proud consciousness, quivering in every muscle, of what has at length been achieved and made flesh in him, a consciousness of his own power and freedom.
> (*GM* II, sec. 2)

Such promises can be made explicitly, or, as style, they can take the form of offering others a process of exploring the resources that one's own expressive energies allow so that one builds responsibility into the self-consciousness governing the processes of articulation.

All of Nietzsche's brilliance, however, will not save his rendering of expressive will from the pathos that forces him to an *Ecce Homo*, his tormentingly complicated effort at once to celebrate and to ironise the need for images of his own personal power. That is why we also need Wittgenstein if we are to develop a model of style subject neither to the will to truth nor to the desperate efforts to make the expressive self replace all third-person states. Where Nietzsche's perspectivism collapses the knowing subject who takes responsibility for propositions into the willing subject constructing

the world in accord with specific values, Wittgenstein takes the opposite tack. He proposes a sharp distinction between the willing and the knowing subject. For the subject of cognitive activity the solipsist ego becomes an extensionless point, its agency subsumed under the task of description (or, in *Philosophical Investigations*, subsumed under the grammar of language games). Thus for Wittgenstein the eye that sees is placed within a visual field that it does not control, so the 'I' becomes an aspect of the field that can be described in third-person terms. But if we concentrate on the willing subject, we shift to a mode of activity that cannot be so enclosed: how the eye feels about what is sees and how it gives significance or projections to that field does not appear within the scene. Rather such feelings and affects constitute boundary conditions establishing qualities for the scene as a whole. Boundary conditions are precisely what we cannot hope to encompass in any form of description because they define the parameters for the description. Thus willing cannot be represented in any specular projection. What we can say about it depends not on who agents imagine themselves to be but on how they dispose themselves in relation to those fields within which truth statements are possible. Will then is less a matter of how selves master worlds than of the specific modalities persons bring to specific engagements within a shared world.

It is not easy to grasp a sense of the agent as at once attentive to the objective and irreducibly a locus of subjective will. But we get considerable help from the figure of boundary conditions that Wittgenstein uses to connect ethics and aesthetics to the transcendental nature of logical form. In each of these domains we must allow sharp distinctions between what can be said and what must be shown. What can be said presupposes certain lines of connection between language and the world. But we cannot speak about those containing frames because any claim we made about them would have to presuppose exactly what it purported to describe. Logic provides the most striking example of the two conditions. Logic gives the form of propositions, which means there cannot be meaningful propositions about logic itself; there can only be displays of what logical form does in its establishing boundary conditions for what can count as truths. Ethics and aesthetics rely on analogous distinctions, but there the nature of individual wills takes the place of the boundary force of logical form. In aesthetics the framing condition requires treating the object as 'seen *sub specie aeternitatis* from outside' rather than from within the midst of other objects, so

that one perceives it together with space and time rather than in space and time. In ethics on the other hand the boundary condition becomes the state of the subject as the force which composes values for its specific moment in space and time:

Things acquire 'significance' only through their relation to my will.

As my idea is the world, in the same way my will is the world-will.

The will is an attitude of the subject to the world.

6.43 If good or bad acts of the will do alter the world, it can only be the limits of the world that they alter, not the facts, not what can be expressed by means of language.

In short their effect must be that it becomes an altogether different world. It must, so to speak, wax and wane as a whole.

The world of the happy man is a different one from that of the unhappy man.[6]

Ethics becomes a matter of how agents establish investments in and as the dynamic intentionality that gives particular casts to events and that projects connections to other features of the agent's life. Then, near the end of his life, Wittgenstein managed to make this vision concrete by envisioning the process of framing as simply the particularising work of the 'now' and the 'this', as if purposiveness resided in the very activity of identifying with what occupies consciousness.

Style is for me the making visible of the conditions allowing us our investments in the 'now' and the 'this', whether we imagine those conditions as fundamentally matters of how we engage the world or how we dispose ourselves towards other agents in those engagements. Style maps a will onto a world. But since such activity is so various, and so resistant to concepts and to images, the force of that willing must be developed through the kind of examples that art affords, that is examples where the intensity of investment is fundamental to the engagement with the world. So I will turn to a recent volume of poetry, C. K. Williams' *Flesh and Blood* in which experiments with a long, highly self-conscious line provide a dramatic analogue for this Wittgensteinian model of subjective agency. Here we find a version of Spinoza's *conatus* which cannot be made the object of an image or of imaginary projections, but which none the less makes continually present the contours of an expressive will inseparable from yet not reducible to a knowing subject bound entirely to the facts of a shareable world. At heart Williams is a Cartesian. He dreams of introspectively capturing consciousness at the very originating source of its deepest proprio-

ceptive energies. But that very desire demands that he turn to a vehicle like the line which can survive the collapse of the images it generates in its Cartesian quest, and thus which can define a will able to reject the demand for thematisable self-images in favour of satisfying itself simply in the purposive process of framing and dynamising that it can bring to bear.

Had we the space we could develop the fundamental oppositions haunting Williams' Cartesian quest – at one pole a fierce 'lust of self toward self', and at the other a sense of insubstantiality so encompassing that he imagines his lyric activity as

this infected voice that infects itself with its despair, this voice that won't stop,
that lays the trap of doubt, this pit of doubt, this voiceless throat swallows us in doubt.[7]

But for now the most I can do is track a single poem's effort to negotiate these oppositions by letting the line at once de-interiorise subjectivity and celebrate its force as a mode of command embodied simply in how the will becomes articulate in and as its control of relational movements. This is 'Conscience', a poem whose title positions it beautifully between Descartes and Nietzsche:

That moment when the high-wire walker suddenly begins to falter, wobble, sway, arms flailing
that breathtakingly rapid back-and-forth aligning-realigning of the displaced center of gravity,
weight thrown this way, no too far; that way, no, too far again, until the movements themselves
of compensation have their rhythms so that there is no way possibly to stop now . . .
that very moment, wheeling back and forth, back and forth, appeal, repeal, negation,
just before he lets it go and falls to deftly catch himself going by the wire somersaulting up,
except for us it never ceases, testing moments of the mind-weight this way, back and back and forth
no re-establishing of balance, no place to start again, just this, this force, this gravity and fear. (*Flesh and Blood* p. 67)

We begin with 'that moment' because Williams wants to have voice emerge in the kind of situation where it is most threatened, where unpredictable events challenge conscience and drive it to its full intensity. That intensity requires an analogy in order to find expression at all, so the specific comparison to the high-wire walker's beginning to falter must do double labour. The analogy

establishes a dramatic focus for reflection, and it calls attention to the mind's need for that analogical mode in order to suture the gap that the sudden eruption of events opens up. Yet the sense of time's pressure will not relent. Notice the repeated 'that's, which display a mind seeking to fix itself by setting stable reference points as its boundary conditions. However each 'that' phrase soon collapses because of the weight it must bear, both within the analogy and in relation to the demand for analogy. None the less by facing this risk of falling, the poem ultimately discovers its own way of 'somer-saulting up', since it manages to shift from those 'thats' to a sense of rhythm within the balancing that gives conscience its access to a constantly shifting 'now'. This sense of 'now' then requires surren-dering any hope for specific stopping points (which I take to be figures for the ego's desires for specific images of itself), so that one can reconcile oneself to the irreducible and inescapable demands of conscience. Even the analogy must collapse, destroyed by that painful 'except us' marking the mind's difference from any satisfying allegorical representations of itself. Instead self-reflection finds itself forced back on the pun in 'gravity' as the ironic price exacted by the effort to take oneself seriously. Personal identity founded on demands like these cannot be separated from a constant sense of fear, a sense left beautifully indeterminate at and as the poem's conclusion: 'no reestablishing of balance, no place to start again, just this, this force, this gravity and fear.'

Yet this naming of fear also provides a means of gravity for handling the otherness of events. As images fail, the structure of dynamic intentionality becomes visible, and we realise that the 'this' may suffice to take responsibility for, and within, what the line brings together. This repetition of 'this', grounded in an intricate syntactic balance and emerging from repeated negations, locates in simple assertion a responsiveness to the motions of mind and shifts in its contents far more supple than any analogy. First the repeated negations insist on the return of doubt's voiceless throat as the analogy collapses. Dreaming of gravity seems inseparable from a constant fear of falling. For taking identity as a serious issue and allowing conscience its nagging voices submits all ideas about the self to judgements about truth that lack any possible means of determining a will. Not only does gravity then elicit direct fear, it also opens the possibility that conscience makes fools of us all by producing the ironic suspicion that the fears we feel are themselves only stage props in a circus act we create in order to claim that

conscience had some determining power in our struggles.[8] But there remains the real and the metaphoric force of the line's ability to contour itself even to such gravities because it does not impose specular images upon them. Instead the line proposes its own activity as its figure for a 'this' that engages the destructive forces, establishing at least an intimacy and directness sharply opposed to the mind's efforts earlier in the poem to make repeated 'that's sustain a distanced balance. Thus there may be no need for a place elsewhere from which one might start again. While the effort to negotiate the mind's desires for gravity and the fears which this generates may strip away all projected stabilities, there remains available a Cartesian response to the poem's version of Cartesian doubt: the poem cannot doubt its own passionate investment in the process of defining those doubts. That is its gravity. Yet Williams need not follow Descartes' way of locating the 'I am' purely in some inner process. Here the cogito finds a home within the activity of language, in the justness of how that concluding string of deictics defines the mind's desperation. In that definition Williams moves from analogies for the mind's actions to a literal process of interpretive attention, to the actual force of the mind's activities within, and as, the poem. There need be no place from which to begin because the tracking of beginnings takes us beyond abstract possibilities to a place continually in the making. Where Williams' namesake had called for no ideas about the thing but the thing itself, this Williams locates the necessary alternative to ideas in the mind's coming to feel the force of the gravity it constantly produces.

Not all of the later Williams is as grim as this, or as Cartesian. But we best prepare the context for his more positive assertions by beginning with those poems that in effect win the right to locate investments within the movement of the line as at once metaphor and enactment of an underlying *conatus*. Unfortunately I have been so consumed by the preparation that I have very little time for the feast. All I can do is indicate some of the basic investments that become available if we grant Williams' line the metaphoric capacity to struggle against the Cartesianism that calls it into being. Line becomes the linguistic bearer of an intentional will locating values and a sense of identity not in concepts nor in images but only in the qualities of engagement it can sustain and the long-term relational work it manages to accomplish. Line in Williams then is style become conscious of itself, and thus freed to a Nietzschean war

against the dependencies that attend to the will when it is subordinated to criteria based on ideals of truth.

The test of these ideas, in turn, becomes how well they allow us to appreciate the life that Williams' poetry offers, both in itself and as a figure for what style can make available in any endeavour. First it is crucial to take into account how Williams' line becomes a means of conceiving a 'really now' constantly available to the imagination. By insisting on its own powers his line asks us to reflect on what follows from grasping intentionality as a condition of linguistic activity treated as an end in itself without a need for governing or justifying concepts. Then we are in a position to appreciate how desire can be disposed simply in how verbs heap on one another, in how complex syntactic balances develop, or in how descriptions move through supple ranges of register – all freed from the need for supplementary allegories. On this basis we can move to a second level where the discursive can return to poetry under a new regimen. Rather than imagine discursivity as a mode of abstracting from particular engagements with aspects of experience, we are free to treat discursivity as simply one of the ways that his mobile line organises its investments so that we can engage the considerable desires that we invest directly in processes of abstract reflection. Discursiveness then is as concrete as images, since both are simply aspects or what Williams calls 'vehicles' of mental life. Discursiveness then can engage the world with at least the same concreteness as images, since what matters is the ways the movement of the poetry becomes a 'vehicle' for mental life.

Finally, we must note the power of lyric affirmation that Williams manages by putting such emphasis on what binds and enables the poem's movements. On one level this affirmative power consists simply in Williams' capacity to free poetry from the pastoralism and the cult of lyric silence so common in recent years. By locating lyric force in how the line apprehends a world rather than in how poetry might transcend that world, if only into vague mysteries, he gives poetry back the full data of the world as its subject. These poems become analogous to photographs in their digestive capacity, except for the very important difference that their instrument allows direct access to the beliefs we hold, while providing a far more complex medium for capturing the various aspects of desire that the objects or thematic topics might engage.

For one instance of a power radically different from the photograph we might turn to the moment when Williams finds a simple

scene of his wife going out into the snow demanding a second poem, as if not even the long line could gather in one poem the range of feelings that she elicits in this context. For another, more elaborate version of the work of desire accomplished by the long line, let us turn to 'Dawn', Williams' signature version of both the contemporary nature lyric and of the Modernist insistence on making the work of the medium (here a single sentence) the figure for the powers of agency by which nature can still carry value for us:

> The first morning of mist after days of draining, unwavering heat along the
> shore: a *breath*:
> a plume of sea fog actually visible, coherent, intact, with all of the quieter
> mysteries
> of the sea implicit in its inconspicuous, unremarkable gathering in the weary
> branches
> of the drought-battered spruce on its lonely knoll; it thins now, sidles
> through the browning needles,
> is penetrated sharply by a sparrow swaying precipitously on a drop-glitting
> twiglet,
> then another bird, unseen, is there, a singer chattering, and another, long
> purls of warble,
> which also from out of sight insinuate themselves into that dim, fragile,
> miniature cloud,
> already now, almost with reluctance, beginning its dissipation in the over-
> powering sunlight. (*Flesh and Blood* p. 50)

As in most of Williams, every moment of pleasure or shape is on the verge of disappearance. But the long line can adapt to that sense of time and let go, with no more than a hovering hint of reluctance, because of how lovingly and extensively it can inhabit what that moment offers a sensibility content with its own modes of gravity.

NOTES

1 The best commentator on the value and limits of philosophical discussions of personal style is Berel Lang. His fullest statements are in his 'Space, Time and Philosophical Style', in Lang, ed. *Philosophical Style* (Chicago: Nelson Hall, 1980), pp. 144–72; and his *The Anatomy of Philosophical Style: Literary Philosophy and the Philosophy of Literature* (Oxford: Basil Blackwell, 1990). See also Nelson Goodman's 'The Status of Style', *Ways of Worldmaking* (Indianapolis: Hackett Publishing, 1978), ch. 2. I deal at length with Goodman in my 'Style as the Man: From Aesthetics to Speculative Philosophy', in Richard Shusterman, ed., *Analytic Aesthetics* (New York: Basil Blackwell, 1989), pp. 59–84. For other treatments of style insistent on its relation to personal identity see the last chapter in Arthur Danto, *The Transfiguration of the Common-*

place (Cambridge, Mass.: Harvard University Press, 1981), which is very good on the limits of Goodman's position; Richard Wollheim, 'Pictorial Style: Two Views', in Berel Lang, ed., *The Concept of Style* (Ithaca, New York, 1987), rev. edn., an essay that makes a powerful case for equating style in painting with psychological identity; and Jenefer Robinson, 'Style and Personality in the Literary Work', *The Philosophical Review*, 94 (1985), pp. 227–47.

2 Altieri, *Canons and Consequences* (Evanston: Northwestern University Press, 1990). I should also note that the accounts of Nietzsche, of Derrida, and of C. K. Williams in this chapter were first developed in my 'Contemporary Poetry as Philosophy: Subjective Agency in Ashbery and Williams', *Contemporary Literature*, 33 (1992), 214–42.

3 Derrida, 'Afterword: Toward an Ethic of Discussion', in Gerald Graff, ed. *Limited Inc* (Evanston: Northwestern University Press, 1988), p. 129. Future references to this essay will be in parentheses within my text, abbreviated *LI*.

4 See especially section 27 of Nietzsche's *Genealogy of Morals*, trans. Walter Kaufmann and R. J. Hollingdale (New York: Random House, 1967). (Future references to this work will be abbreviated *GM* within the text.) We should note that Nietzsche's claims here are made considerably richer by his basing the overall argument on a demand to shift from an emphasis on the audience in ethics and in aesthetics to a focus on how wills actually produce values. And I should note that my Nietzsche has significant parallels with those developed by Bernard Williams in *Ethics and the Limits of Philosophy* (Cambridge, Mass.: Harvard University Press, 1985) and Alexander Nehamas, *Nietzsche: Life as Literature* (Cambridge, Mass.: Harvard University Press, 1985), but I think I differ in trying to give a more careful rendering of the specific versions of agency that must carry the force of will. For Williams that agency is simply the individual with person-centered values; for Nehamas it is style, conceived by analogy with literary character. But both notions need fleshing out to show how there are plausible ways that style can afford models of agency. For the richest sense of agency in Nietzsche, and for the darker side of what any account of style must ultimately face see Henry Staten, *Nietzsche's Voices* (Ithaca: Cornell University Press, 1990).

5 Nietzsche, *Beyond Good and Evil*, trans. Walter Kaufman (New York: Random House, 1966), section 19. Future references to this book will be abbreviated *BGE* in the text.

6 The first quotation is from Ludwig Wittgenstein, *Notebooks: 1914–1916*, trans. G. E. M. Anscombe (Oxford: Blackwells, 1961), pp. 84–7; the second from Wittgenstein, *Tractatus Logico-Philosophicus*, trans. D. F. Pears and B. F. McGuinness (London: Routledge and Kegan Paul, 1961), p. 147.

7 C. K. Williams, *Flesh and Blood* (New York: Farrar, Strauss, and Giroux, 1987), p. 68.

8 For an explicit rendering of this kind of suspicion see 'Vehicle: Violence', in *ibid.*, p. 70.

Style and innocence – lost, regained – and lost again?

DOROTHEA FRANCK

Motto:
What's ragged should be left ragged.
(L. Wittgenstein, *Vermischte Bemerkungen*)

POSTSCRIPT AND PREFACE

This chapter is born out of a failure: the failure to turn an improvised oral monologue, presented at a conference, into a written document. The generally assumed convertability of oral and written currency did not work in my region. But just at the moment when I was ready to give up, this struggle started to appeal to me. Turning vice into virtue, the task of reconstructing past paths of reasoning could be redefined as deconstructing a writer's block symptomatic of its theme. The suspicion that my view of style could be hiding in those heaps of contradiction and confusion that were blocking my road gave me the courage to try again.

What had happened? How had I become stuck? As you will see in the fragment below, I set out to confront the 'morally dubious' notion of style with some images and concepts usually not associated with it, hoping that they might throw some light on the peculiar ambivalence of this notion. Being both the most and the least conventional and imitable, the most and the least individual and original aspect of human activities, style, as a notion, seems to record the itinerary itself of the fall from paradise: from origin and innocence to affectation, imitation, cliché and forgery. Heinrich von Kleist's essay of 1811 'Über das Marionettentheater' ('On the Theatre of Marionettes') served as major source of inspiration for my meditations, containing a wealth of images and parables for this fall as well as for its paradoxical continuation: the 'Kehre' or return, the

move forward back to paradise, to the union of natural grace and total consciousness, the dream behind every work of art. Hölderlin, Kleist's contemporary, wrote somewhere in a letter 'one can also fall upward'.

From where Kleist had left me I laid out an itinerary that should have led me in a similar, circular movement through several stations, defined by questions such as: If style at the innocent end is not conventional, is not a sign at all, how can it be interpreted? What is the relation between the concept of style and the notion of truth? And other weighty questions seemed to wait down the road, still partially in the fog. What seemed to loom up at the end of this path was a glimpse of a well-known tableau: the curse of alienation, brooding over us since we left the garden of Eden: the fissure between aims and means, the gap between style and content, form and function; the crevice between 'Sagen' and 'Zeigen' (what can be said and what shows), the abyss between subject and object and between Me and You. For me, this pointed to the conclusion that I had to end with Hölderlin, who did what others after him only have proposed or attempted: miraculously bridged the abyss 'mit leichtge-bauten Brücken' (delicate bridges). He ended and began philosophy by making philosophy and poetry coincide.

But soon, not even halfway along this path, my forces began to fail me. Not only did the Leitmotiv 'style' become lost here and there and the connections between the stations often refuse to rise out of the fog, but worse: my growing unease in constructing coherences and relevancies willfully and my remaining confined in the academic prose of 'Sagen', while the tendencies inherent in my theme were drawing me towards the utopia of 'what shows', produced in me an intellectual paralysis. I seemed to suffer from a defect in the academic immune system which keeps topic and talk safely apart. It is usually provided by a will to control trains of thought and features of style, a will which is accustomed to obedience and which presupposes feasability. Without this immu-nity, we can no longer maintain the separation between what we assert and the act of asserting it. Thus, when talking about a breakdown of communication, our own communication might break down before we are able to give it a formulation. Or when we state that a strict borderline between art and the discourse *about* art can no longer be drawn, our own discourse might become infected by this confusion, without, however, automatically becoming art. We might just end up in a limbo where the safety and discipline of

'aboutness' is gone but no other haven is yet in sight. And that is where I think I am now. However, even with no shore in reach, the need to move on, to talk, to write, has not disappeared. So, if we cannot hold out in silence until a clear vision, a new language, a new – or regained – spontaneity or innocence has become manifest, we may write postcards from Limbo. That is also a place to be explored . . .

STYLE – INNOCENCE LOST AND REGAINED

Style is a shy animal. It appears to belong to the category of things which change as soon as you take a sharp look at them, like quarks or the expression on a face. As a kind of shadow, attached to every human action or its products, style functions unproblematically as long as it stays in peripheral perception. (This is not just the usual dissolution that happens to every word once you put it under the microscope of inquisition or repetition.) But I will try to sneak up a little closer by circular motion, without, however, trying to catch it in the narrow trap of a definition.

Style not only is a shy animal, but also belongs to the class of creatures able to lose their innocence. Related to this potential of having or losing innocence is its paradoxical connection to the notion of convention and the equally questionable, fragile relation-ship to 'will', 'intention' and 'control'. The complexity of the relation between style and intentionality seems to lie, at least in part, in a strange kind of indexicality: being sensitive to first/ second/third-person perspective, to tempora and modes, as well as to degrees of self-consciousness and artisticality. (Charles Altieri also talks about the first/third-person difference in chapter 11 of this volume.)

As Berel Lang writes in chapter 1, style is (mostly) a retrospective category. Even when an artist characterises his or her work as being mainly a struggle with problems of a stylistic nature, we cannot infer from this that this artist aims at 'having a particular style'. Cézanne did not intend to paint 'in the style of Cézanne'. Most of our activities and creations are perceived as having a style while they are produced with no thought of style whatever. As soon as style-as-such is intended, we seem to enter dangerous waters, the realm of mannerism or at least its neighbourhood. Style is sensitive to the degree of self-consciousness of the person producing it, but the respects in which this sensitivity and the aesthetic effects of it show

are all but clear. Certainly, there is no strict inverse correlation between self-consciousness and quality, although Schleiermacher seems to pronounce a widely shared intuition when he states that mannerism lurks in the sphere of self-consciousness, and that mannerism is a movement 'downhill'.

Ist aber . . . etwas nicht aus der persönlichen Eigentümlichkeit hervorge-gangen, sondern angelernt und angewöhnt, oder auf den Effekt gearbeitet, so ist das Manier, und maniriert ist immer schlechter Stil.

But if . . . something does not come forth from personal individuality but is learned or made a habit, or produced aiming at a specific effect, then this is mannerism, and mannerism is always bad style.[1]

On what is this intuition, that 'good' and 'natural' are almost synonyms when applied to style, based? How to account for the deep gap between art and artifice? How can artefacts or controlled action even be called 'natural'? Unable to provide any direct answers to these questions, I will nevertheless follow the threat of this theme through a reading of Heinrich von Kleist's essay 'Über das Marionettentheater', where he connects the notions of (self-)con-sciousness, intention, innocence, and gracefulness in an unusual but elucidating way.

THE SECOND BITE

In his famous essay Kleist is concerned with the devastating effect of (self-)consciousness on the natural grace of a human being. What distinguishes humankind from animals and automatons as well as from gods is a feature of dubious value: namely the possibility of 'Ziererei', i.e. affectation and artificiality in our way of acting. A physical metaphor for this lack or loss of grace Kleist finds in the fact that our movements can issue from places other than the centre of gravity of our body, in which the soul or 'vis motrix' is located; whereas the movements of a marionette can never arise anywhere else. This accounts for the unfailing gracefulness of the latter. In terms of a single polarity, the machine, the animal and the god are all at one end of the scale of gracefulness and we human beings on the other – gods having infinite consciousness and the machine and the animal (according to Kleist) none. To err is our privilege. Kleist depicts the evolution not as a linear but as a circular or spiral movement, from the innocence of the unconscious creatures towards the infinitely conscious gracefulness of the divine. Since we have

been exiled from the garden of innocence by eating of the Tree of Knowledge, and since there is no way of sneaking back past the cherub with the flaming sword, we can only go forward, hoping, as the world is round, to end up at the garden's back entrance. Or, in other words: since we cannot 'uneat' the first bite (knowledge is irreversible), we must try to eat from the tree a second time.

Kleist's essay is written as a conversation between the narrator and an acquaintance who is a famous ballet dancer, and, to the amazement of the narrator, an amateur of marionettes. The dancer recalls the Genesis story of our exile from the garden in his attempt to justify his seemingly vulgar predilection. The narrator, feeling slightly provoked by his friend's argument, wishes to demonstrate his own understanding of the myth, by relating a concrete experience of his own: an example of the loss of innocence, a fall from grace which he himself had witnessed and, in fact, triggered in a young man of his circle of acquaintances. He had taken a bath together with this particularly graceful adolescent of about sixteen years of age, shortly after a visit to an exhibition where they had both seen the famous Greek sculpture of a boy pulling a thorn from his foot. Now, when the young lad was drying his foot, he happened to cast a glance into a mirror and was reminded of this statue by his own stance. He told this to his friend the narrator, who secretly had also noticed this similarity. But, in order to tease his young friend, or to counter those first traces of vanity that he had lately found in him, he pretended not to have seen the likeness and challenged him to repeat the gesture – a response with devastating consequences. With each attempt to repeat the original graceful act, the movements of the young man became more tense and awkward, until he gave up in embarrassment. From that moment on, the previous grace and charm of the boy left him more and more and was all gone within a year's time, never to return.

It is obvious how this story applies to the case of style. To focus on one's own style means to become self-conscious – in the negatively connotated meaning that this expression carries in English. The mirror plays a crucial role in this process: from anticipation and concern of how one is perceived by others it is a small step to affectation and distraction by mere form. (In this context, I find it interesting that primate apes, with the exception of the chimpanzee and orang-utan, fail to recognise 'themselves' in a mirror, as researchers have recently reported.)

Although we strive, in Kleist's terms, towards the infinitely great

consciousness of the gods, it is clear that more consciousness is not always better: after all, an increase in consciousness caused the fall. But why this should be so, remains mysterious. At any rate, self-reflection seems to be a double-edged sword, a mixed blessing, and not least in the realm of communication. While on the one hand we feel that there can hardly be enough empathy or 'Einfühlung' with the recipient, which means that we attempt to share the other's perspective, this concern turns sour when too much attention is paid to the anticipation of how one is perceived by the other. Where does reflection become corrupted? An answer is not (yet?) in sight. We can only state that the notion of style seems to travel along the same line as our fall from a first natural (or ignorant) innocence into awkwardness and artifice – which turn out to be two sides of the same coin. The rise from there to a consciousness of renewed innocence, the 'fall upward', we can only hope for; art and literature grant us a glimpse of it now and then. But whether our reflections on style, talking topically about it, contribute more to falling upward or downward, I cannot say. I suspect that the style in writing about style is not irrelevant in this respect; but then I become afraid that this article may end in a cul-de-sac right here. So let me try a fresh start from another angle, pretending innocence or ignorance of the signalled traps, and see whether this new path leads a little closer to some answers.

DIVINATION AND SUBJECTIVE TRUTH

Style is the natural place of difference, the irreducible residue of individuality, the objective trace of concrete subjectivity. As such it should be impossible to interpret (by for example current linguistic theory), but it isn't. On the contrary, it is seldom misunderstood. Style communicates directly. Of course it is not independent of culture and custom, but it is not communicating in the way of the discrete 'coded' codes. It is not a system, not a sign. Although it cannot escape becoming conventionalised once it is recognised and valued as such, it does not originate in convention. The interpretation of individual style, then, seems to us, so enslaved by our need of system, little less than miraculous.

Schleiermacher, one of the first and still one of the foremost theoreticians of style, calls the essential parts of the procedure by which we understand style '*divination*', in contrast to the *technique* of grammatical interpretation. 'Divination' might seem a rather

mysterious procedure, but if we consider the analogous nature of style, based on the fact that language, in spite of radical structuralists, is never totally in the grip of arbitrariness but has preserved layers of motivation under the ruins of the Tower of Babel, the notion of divination might lose some of its obscurity.

Nevertheless, the notion of divination can in our times hardly hope for popularity, especially when we talk about successful divination. It suits neither the analytic optimist nor postmodern sceptics of communication. Everyday life contains both success and failure to communicate. We all experience both satisfying and unsatisfying attempts to understand, superficial exchanges and the precious but rare instances of deep communion. The actual variety in quality and depth is accounted for neither by a shallow idea of 'total' and completely rule-governed communication, nor by radical and fundamental doubts about the mere possibility of non-haphazard understanding. Hopes and fears concerning communication become operational articles of faith in those approaches, while the variation in satisfaction remains unexplored.

At present, the analytical prospect of an 'ideal', that is to say, logical and completely intersubjective language, is vanishing, together with its own illusory foundation: a metaphysics of unequivocal, pre-linguistic reference – even though one aspect of it is materialised in technological tools, good enough 'for all practical purposes'. Related to this modern ideal was the notion of a radically style-less language, in which the last traces of subjectivity, obscuring the clear view of objects and facts, are dissolved. The postmodern counterposition of unredeemable subjectivity, on the other hand, will collapse on its own premises too. It cannot be more than a (temporarily useful) strategic subversive topos, if only because the position it claims cannot truly be inhabited by the thinker who endeavours to communicate it to others. (Likewise, the logicians could never do without our messy 'natural' language before, after, and around their formulae.) So, perhaps what we should be looking for is not another theory but another attitude towards language: one which allows the thinker – as speaker, hearer, writer, reader – to live up to his or her own declarations without immediately getting caught in the snares of his or her own paradoxes.

It might not be accidental that great philosophers are great stylists as well. In fact, the best of them realise or approximate the stylistic ideal that style and content mirror each other. This is not the same as the above-mentioned ideal of a logical style-free language, but

ultimately it comes from the same desire for a language without 'Ziererei', without detours for the sake of form or alienated and distracting traces of vanity. In fact, as Wittgenstein has shown in the *Tractatus*, logic has in a way realised this ideal of making form and content coincide, albeit at a high price: that of meaning. So let me continue with two quotations from the later Wittgenstein, who was more consequent, I think, in drawing the 'moral' conclusions from the end of the modern project of total communication than many of his later postmodern colleagues. Already in the *Tractatus* he points to the limits of the sayable. He draws these very strictly but admittedly does not keep to these limits himself, seeing the sayable obviously as a tiny island in the vast space of the unspeakable. He realised – in the double sense of the word – that a *tertium* is given: what cannot be said but what shows ('was sich zeigt'). And many things 'showed' in his own discourse. While, for example, he did not talk much *about* the fragmentation and liquidisation of our systems of thought, his own writing became fragmentary out of an inner necessity. His position could no longer be systematically identified and fixed with any single statement, but rather had to be gathered between the lines, in the movement from sentence to sentence. (In German, 'Satz', the word for sentence, also means 'leap'.) The notes printed under the title 'Vermischte Bemerkungen', in English 'Culture and Value', were perhaps not even meant to be published. Nevertheless, the following notes might be taken as valid statements, leading a step further in our discussion. The first remark refers directly to Wittgenstein's own practice of style.

Ein stilistischer Behelf mag praktisch sein, und mir doch verboten. Das Schopenhauer'sche 'als welcher' z.B. Es würde den Ausdruck manchmal bequemer, deutlicher machen, kann aber nicht von dem gebraucht werden, der es als altväterisch empfindet; und er darf sich nicht über diese Empfindung hinwegsetzen.

A stylistic device may be useful and yet I may be barred from using it. Schopenhauer's 'as which' for instance. Sometimes this would make for much more comfortable and clearer expression, but if someone feels it is archaic, he cannot use it; and he must not disregard this feeling either.[2]

For a literary writer such a remark might seem trivial (given a wish to avoid archaism), but for a philosopher in the analytic tradition it is not self-evident that an aesthetic principle should overrule values like clarity and economy of expression. But then, clarity as such is not sacrificed here. Wittgenstein aims at a higher order of clarity: the

clarity of representation is made subordinate to the authenticity of subjective expression. The stylistic intuition has equal say in the process of cognition and clarification, or, we may say: of truth.

This remark reflects the direction in which the notion of truth changed in Wittgenstein's writings – and in the course of current philosophy in general: from 'objective' truth to 'subjective' *truthfulness*. This ethical notion of truth appears again in the following note.

Man *kann* die Wahrheit nicht sagen; wenn man sich noch nicht selbst bezwungen hat. Man *kann* sie nicht sagen; aber nicht weil man noch nicht gescheit genug ist. Nur der kann sie sagen, der schon in ihr *ruht*, nicht der, der noch in der Unwahrheit ruht, und nur einmal aus der Unwahrheit heraus nach ihr langt.

No one *can* speak the truth; if he has still not mastered himself. He *cannot* speak it; but not because he is not clever enough yet. The truth can be spoken only by someone who is already *at home* in it; not by someone who still lives in falsehood and reaches out from falsehood towards truth on just one occasion.[3]

Here 'truth' appears in two different positions, which are identified under specified conditions: truth as something to be said (but, in general, that cannot be said) and truth as a place where our mind should dwell (German 'ruht in' means: rests in). This particular state of mind is the *conditio sine qua non* of truthful statements, not incidental efforts to match words and facts. 'Truthcondition' then is the condition of the speaking subject. How can we understand this being *in* truth? I hear in these words a faint echo of Hölderlin's invocation, written about one hundred and fifty years earlier, at the beginning of one of his fragmentary hymns (Dem Fürsten): 'Lass in der Wahrheit immerdar / mich bleiben' ('Let in the truth me stay always'). Can we get a glimpse of that place where truth can be spoken because the speaker lives in it? I am afraid this is asking the question too bluntly. Could the answer be one that cannot be said but must be shown? But then my own discourse catches up with me again: how can I pretend to stand in that truth in order to say or to show it? Again, I shall try another angle, making recourse to some other quotations.

HANDWRITING: STYLE AND CONTROL

Du mußt die Fehler deines eigenen Stils *hinnehmen*. Beinahe wie die Unschönheiten des eigenen Gesichts.

(You have to accept the faults in your own style. Almost like the blemishes in your face.)[4]

The impalpable whimsical notion of style is due in part to its bemused relationship with the notion of control. Here, the sensitivity to first, second, and third person in handling style comes in. I produce a style, I can work at my style, but I cannot really see my style as a whole, as 'my style'. Like our handwriting, it is so much part of ourselves, that the view from the inside differs inevitably from the one from outside, i.e. the view of someone else. Looking back at (a trace of) myself from a certain distance in time, I can do this somewhat more 'objectively', but this is just because it is no longer the same 'me'. Wittgenstein says

Man kann den eigenen Charakter so wenig von Außen betrachten, wie die *eigene Schrift*. Ich habe zu meiner Schrift eine einseitige Stellung, die mich verhindert, sie auf gleichem Fuß mit anderen Schriften zu sehen und zu vergleichen.

It is as impossible to view one's own character from outside as *one's own handwriting*. I have a one-sided relation to my handwriting which prevents me from seeing it on the same footing as others' writing and comparing it with theirs.[5]

The first-person blind spot for our own style has to do with the 'physicality' of style: it shares with the body the fact that we cannot see our own face. This similarity goes further: while the body is the only thing we immediately control, this control is limited. Most of its qualities are given – we 'find' ourselves in the world with this body and of course there are physical and other limits to what we can do and which functions of the body we can control. But again, here, as with style, the limits of control and the awareness of it differ from person to person, and from moment to moment. And here too it is not at all clear whether or when a higher degree of control is desirable. The blind spot is not necessarily a default.

Thus, the relationship between style and body seems to open a new avenue of insight, but we must not push the parallel between body and style too far. We can say for instance: 'I haven't found my style yet' or 'What I did there wasn't like me.' Here we are facing the crux of writing itself: we assume that we have a 'natural' personal style, but first we have to find it. Is this another example for Goethe's motto: 'Werde wer du bist!' ('Become who you are!')?

Unlike the modelling of the body, the search for our style is not

like plastic surgery: adopting a somewhat arbitrary change through an outside instance. It seems more like looking for a clear mirror, a mirror made of our actions or products, reflecting our selves to ourselves.

So it seems that style is, like the body, a zone where the reach of control ends somewhere in its unaccessible middle. Where exactly the borderline runs varies and cannot be seen clearly, neither from inside nor from outside. This is inherent to its nature, not because 'we are not yet clever enough'. What is even more puzzling is the fact that this limit of control which restrains the reach of intention does not prevent us from interpreting and evaluating the style of others in depth, or to respond instinctively and strongly to its subtlest features.

We can choose *a* style, we cannot choose *our* style: we have to *find* it. For everyone not content with mere routine, this remains a never-ending quest, as we remain a riddle to ourselves, no matter how far we progress on the road of the Delphic advice: 'Know thyself!' – but, if style is something 'natural', don't we just *have* a style? What about the commonplace that we 'are' our style ('Le style c'est l'homme même')? How can we search for something, if that something is intrinsic to our very nature? It would seem that this searched-for style could only be an artifice, a case of fashion or affectation. But this is not the case. Could it be then, that when we are in search of our style, we are in a way in search of our own future, the future where 'we become who we are'? And, what is even stranger: whenever we find a token of it, it seems to be something of our past, because of the anamnetic evidence, the feeling that we have always had it. (Is this perhaps a hint at the circular movement of which Kleist was talking?)

To complicate things further: How can I speak of 'a' style? Is there or should there be a common denominator to all our actions? In our times, the subject as a monolithic entity has been dissolved – it has only been a theory anyway. So style fractures in its turn. But isn't authenticity, the truthfulness, the style without artifice, linked to a singularity? Or can we be authentic in various versions, i.e. in the different personae we are embodying? This has been explored in literature. As the best example, the great Fernando Pessoa comes to my mind, for he is authentic as Pessoa and as (or rather through) each of the personae or heteronyms which he impersonates as author.

THE MIRROR

Now perhaps the metaphor of the mirror can bring us back to Kleist's version of the story of the Fall. Eating from the Tree of Knowledge for the first time is like looking into a mirror – and discovering what a mirror is. After Adam and Eve had eaten from the sweet forbidden fruit, they looked at each other and at themselves and they felt shame at their nakedness.

This means they have been looking at the other like one looks into a mirror: to see how one is seen by another. The look from the inside makes place for a look (as if) from outside, mirroring ourselves in the eyes of another consciousness. With this, the unity of our own consciousness is lost, it is splitting up into reflecting and reflected. But, as we know, one mirror is not enough to see oneself as one is: the image is reverted. We have to reflect the reflection again in order to reverse the reversal. On the physical plane, we can reach only an approximation and not a frontal view, because we are standing in between and obstructing the reflections. Can our mind reach more transparency? Kleist's version of the Genesis story suggests a continuation to the Fall, the return to the garden and an entrance to it from the other side. He calls this 'the last chapter of the story of mankind'. Since we cannot go back to pre-self-conscious innocence, we have to take the path of knowledge all the way to its end and eat from the tree again, that is to say: to reflect the reflection completely.

The first reflection produces shame or loss of grace. We compare what we think the other is seeing with what we wish them to see. We are not prepared to accept the difference. Insisting on a unity which we have already lost produces only delusion.

The second reflection does not cancel the difference, but it leads the look that went astray back to the looker. When I see that I confused myself with my image in the first mirror, that is: when I see what I projected into the view of the other, then I start to see something of my real self. In seeing the procedure of how I construct my self-image and related 'illusions', I might be able to make myself a little bit more transparent to myself, even without having the confidence of Kleist's protagonist, that this process might ever come to a completion.

In our time, we even have new kinds of mirrors. When we hear or see ourselves for the first time on audio- or video-recordings, we tend to feel embarrassed: 'This is not me!' If we could become fully

conscious of the causes of this embarrassment and integrate the inside and the outside view – would the embarrassment vanish? Could we say then, that we have seen or found our style?

THE END OF PHILOSOPHY

To close the circular itinerary of this chapter and to make some loose ends meet, I present Wittgenstein reflecting on Kleist.

Kleist schrieb einmal, es wäre dem Dichter am liebsten, er könnte die Gedanken selbst ohne Worte übertragen. (Welch seltsames Eingeständnis.)

Kleist wrote somewhere that what the poet would most of all like to be able to do would be to convey thoughts by themselves without words. (What a strange admission.)[6]

Wittgenstein is probably referring to Kleist's 'Letter from one poet to another', also published in 1811. The letter is a critical response to the well-meant compliments of another poet for the perfection of his use of poetic forms like rhythm, sound, and verse. Kleist concludes from these compliments that his friend and colleague had not understood him at all. All his efforts of form are directed towards one single goal: to direct total attention to the thought that he expressed. Form must never be an aim in itself. Good form enables the spirit to communicate directly, as if unmediated, while bad form draws attention to itself like a distorting mirror. Kleist and Wittgenstein have a similar stylistic ideal, the style 'without style': maximum transparency. So, in fact, the colleague's compliment revealed to Kleist that he had failed, at least with respect to this reader, unless the latter is to blame for an inadequate reading. Style, when noticed as such, is the painful trace of our alienation and distraction, a reminder of our exile from the place where aims and means, wording and things, acts and their meaning are one.

But can this ideal ever be realised in 'real life'? How far can we approximate the truthfulness, where saying and doing coincide? Can we get past the turning point? Here I come to a most essential remark of Wittgenstein, where he sums up his philosophy in a rather unexpected way:

Ich glaube meine Stellung in der Philosophie dadurch zusammengefaßt zu haben, indem ich sagte: Philosophie dürfte man eigentlich nur *dichten*. Daraus muß sich, scheint mir, ergeben, wie weit mein Denken der Gegenwart, Zukunft oder der Vergangenheit angehört. Denn ich habe mich

damit auch als einen bekannt, der nicht ganz kann, was er zu können wünscht.

I think I summed up my attitude to philosophy when I said: philosophy ought really to be written only as a *poetic* composition. It must, as it seems to me, be possible to gather from this how far my thinking belongs to the present, future or past. For I was thereby revealing myself as someone who cannot quite do what he would like to be able to do.[7]

By now, it should no longer sound like a contradiction, when Wittgenstein on the one hand strives towards the 'style-without-style', and on the other hand names poetry as the ultimate goal of his philosophical writing. He sees poetry as the consequent continuation of philosophy with other, that is, more apt means – a continuation that he, in his own opinion, did not fully realise. But what exactly does 'dichten' (create poetry) mean in this context? In German, 'dichten' contains the notion of density. In poetry, words have a different specific weight than in regular use. In true poetry, the truth-conditions are not outside but inside the text itself. 'Sagen' and 'zeigen' coincide. The alienation between what and how, between meaning and style, seems at least momentarily healed. Not that the gap between every me and every you has disappeared, but the most profound poetry actually seems to approach and inhabit the abyss as a dwelling place, creating every once in a while those miraculous fragile momentary bridges, where the most individual and the most universal are reconciled. Poetry is the language past the turning point.

There *is* a philosopher, rediscovered (or first really discovered in his significance) in this century, who did draw this radical conclusion. Hölderlin, the central member of the triad formed with his friends Hegel and Schelling, formulated the necessity of this step from philosophy to poetry, and in doing so, took it. Renouncing the discursive mode of speaking, the philosophy of 'aboutness', he paid a high price for his consequentiality. Official philosophy did not follow his path but stayed, with Hegel, on the side of a safe, discursive language of argumentation, that is on the side of mere 'sagen'.

It is in this sense that Wittgenstein's clear, sober, cruelly honest, and yet unmistakably personal prose did *and* did not fail, still belonging more to either past and future than to the present.

The world is round. We do go in circles. Hölderlin appears now rather as continuing than as preceding Wittgenstein. He says in 'Mnemosyne':

233

> Lang ist
> Die Zeit, es ereignet sich aber
> Das Wahre.

(Long is / the time, but what happens is / the truth.)

More than Wittgenstein's writing, of course *this* chapter fails, on stylistic grounds, to manifest the philosophy it attempts to express. But, through Wittgenstein and Hölderlin, we might be better able to accept what *shows*, independently of our intentions, through the limits we meet. It shows where I stand.

Heinrich von Kleist, 'On the theatre of marionettes' (1810)[8]

While I was spending the winter in M., I met in a public garden Mr C., who had recently been engaged as first dancer at the Opera and who was an extraordinary success with the public. I told him that I had been astonished several times to have found him in the theatre of marionettes which has been set up temporarily at the marketplace and which entertained the public with burlesque mixed with song and dance.

He assured me that he enjoys the pantomime of these puppets a great deal and he explained to me that a dancer who wants to improve himself can learn a great deal from them. Since the tone of voice in which he said this made me realise that it was more than just fancy, I sat down with him to hear more about just why he made his strange claim. He asked me if I had not found some of the puppets' movements, especially those of the smaller ones, particularly graceful.

I could not deny that this was so. A group of four peasants, dancing a rondo to a fast rhythm, could not be depicted better even by Teniers.

I asked him about the mechanism of these figures and how it was possible to control their individual limbs and extremities without having myriads of threads at one's fingertips, to move them according to what the rhythm of the movement of the dance required.

He answered that I would be wrong to suppose that each of the limbs had to be moved separately by the puppeteer at the various moments of the dance.

Each movement, he said, had a centre of gravity; it was sufficient to move this in the interior of the puppet; the limbs, which were nothing but pendulums, followed automatically, without any independent action.

He added that these movements were very simple; each time the centre of gravity was moved in a straight line, the limbs would describe a curve, and often, when shaken in an arbitrary way, the whole puppet could start moving rhythmically, as though executing a dance. This remark, so it seemed to me, helped me to understand the pleasure he claimed to find in the puppet show. Meanwhile I still could not foresee all the conclusions he would draw from it. I

asked him if he believed that the puppeteer who directed these marionettes should be a dancer himself or at least have a notion of the beauty of dance.

He replied that the fact that a certain activity was easy on its mechanical side didn't mean that it could be carried out without sensitivity.

The line which the centre of gravity describes was, in his opinion, very simple and in most cases straight. When it was curved, the law of its curve seemed no more than of the first or second degree, and even in the latter case it was only elliptic, which is the form of movement most natural for the extremities of the human body (because of the joints), and therefore not difficult for the puppeteer to produce.

On the other hand, he said, this same line was something very mysterious. Because it is no less than the path of the dancer's soul. And he doubted that the puppeteer could find it in any other way than by placing himself in the centre of gravity of the puppet; in other words: by dancing. I replied that I had imagined this activity to be something quite dull and uncreative, like turning the handle of a barrel-organ.

'Not at all', he answered, 'on the contrary: the way in which the movements of the fingers relate to the movement of the doll is quite sophisticated, roughly similar to the relation between numbers and their logarithms or between the asymptote and the hyperbola'. Moreover, he believed that even this last fragment of consciousness could be removed from the marionettes, that their dance could be transported entirely into the realm of mechanical forces and produced by turning a handle, just as I had imagined. I expressed my astonishment about all the attention he dedicated to this common variant, designed for the masses, of a fine art. He not only considered it worth further development, he even seemed personally preoccupied with it.

He smiled and said he would be prepared to state that if a craftsman were to make him a puppet following his instructions precisely, he could produce a dance with it which neither he nor any other skilful dancer of his time would be able to imitate. Since I remained silent, with my eyes cast down, he asked, 'have you ever heard of those mechanical legs which English artists make for those unfortunate people who have lost a limb?'

I said no, I had never seen anything like that.

'That is a pity', he replied, 'because if I told you that these

unfortunate people dance with them, I am afraid that you might not believe me. Did I say dance? Admittedly the range of their movements is very limited, but they produce the few movements available to them with such calm, lightness, and grace, that any intelligent being would be amazed by it. I said jokingly, that he had found the man for the job: because the artist capable of constructing such a remarkable leg should surely also be able to construct a marionette to order. Now it was his turn to avoid my gaze in embarrassment, and so I asked him what exactly were the requirements of art that such a craftsman would have to meet.

'Nothing' he replied, 'that I don't already have here: good proportions, mobility, lightness – but everything to a greater extent; and especially a more natural arrangement of the centres of gravity'.

'And what advantage would these puppets have over human dancers?'

'What advantage? First of all a negative one, my dear friend, that the puppet can never have artificial affectation. Because affectation appears, as you know, when the soul, (*vis motrix*) resides in any point other than the centre of gravity of the movement. Since the puppeteer cannot through his thread control any point other than this one, all the other limbs, quite rightly, are dead – pure pendulums, in other words, obedient only to the law of gravity – which we would fail to find in the majority of our dancers.'

'Just look at our much fêted Miss P.' he continued, 'When she is dancing the role of Daphne and – pursued by Apollo – looks round as she flees from him, her soul is seated in the vertebrae of her back, turning almost to breaking point, like a young najad of the school of Bernini. Or look at the young F., when, in the role of Paris, he is standing among the three goddesses and hands the apple to Venus: his soul is even situated, shockingly enough, in his elbow. Such mistakes' he added, interrupting himself, 'are unavoidable since we have eaten from the tree of knowledge. But paradise is locked now and the cherub is behind us; we have to travel the whole way round the world and see if perhaps we might find a back entrance open on the other side.'

I laughed. Indeed, I thought, the spirit cannot err where it doesn't exist. But I noticed that he had more to say and so I asked him to go on.

'What is more', he said, 'these puppets have the advantage that they are antigravitational. They are untouched by the inertia of matter – the force that is most opposed to dance: the force that draws

them up is greater than the one that pulls them down. What wouldn't our dear G. give to be sixty pounds lighter or to be assisted by an equivalent force in her entrechats and pirouettes? The marionettes only use the floor to touch it lightly, like elves, and give new impetus to their limbs by the momentary restraint; we, in contrast, use the floor in order to rest and to recover from the effort of dancing, a moment which by itself is not dance and with which we can do nothing better than try to reduce it to a minimum.

I said that, no matter how eloquently he stated the case for his paradoxes, he could never make me believe that a mechanical jointed doll could contain more grace than the structure of the human body.

He replied that it was simply impossible for a human dancer to reach the level of a puppet; only a god could compare himself with inanimate matter in this way, and that this was the point where the two ends of the ring round the world would join once more.

I was more and more dumbfounded and did not know what to reply to such strange remarks.

Apparently I had not read the third chapter of the first book of Moses properly, he said, taking a pinch of snuff. 'Properly speaking, it isn't possible to talk about subsequent periods of human evolution, let alone the last, with someone who doesn't know about the first.'

I said that I was quite well aware of the derangement that consciousness can cause in the natural grace of man. A young man of my acquaintance had lost his innocence – as it were in front of my eyes – through one remark and since then had never found his way back to paradise, however hard he tried. 'But what can you conclude from this?' I asked.

He wanted to know what incident I was referring to.

'About three years ago' I recalled, 'I was taking a bath together with a young man whose features radiated a marvellous grace-fulness. He might have been sixteen years old then, and he betrayed only the very first traces of vanity, encouraged by the admiration of women. By chance we had just recently seen, in Paris, the statue of the youth taking a splinter out of his foot; copies of the statue are well known and exist in most of the German collections. The glance he threw at the mirror just at the moment when he was putting his foot on a stool to dry it made him think of it. He smiled and told me what he had just noticed. Indeed, the same thing had just struck me at the same moment; but – either to put his gracefulness to the test or

to tease him a little for his vanity – I laughed and replied that he must be seeing a ghost! He blushed and lifted his foot again to show me, but his attempt, as one might have guessed, failed. He lifted it a third, a fourth, maybe even ten times in bewilderment, but in vain! He was incapable of producing the same movement again – or, rather, the movements he made looked so comical, I could hardly stop myself laughing.

From that day, or rather from that very moment, a mysterious change took place in the young man. He began to spend whole days in front of the mirror. An invisible and incomprehensible force seemed to have cast an iron net over the free play of his gestures, and after a year had gone by, there was no trace left of his former charm which used to give so much pleasure to his circle of friends. I even know someone else who could vouch for this strange and tragic incident, just as I've told it to you.'

'At this point' said Mr C. warming to his theme, 'I have to tell you another story, and you will easily understand its relevance in this context.

On a journey to Russia I stayed on the estate of Herr von G., a count from Livonia, whose sons at that time were very much involved in practising fencing. The oldest son, especially, who had just returned from the university, played the virtuoso and, one morning, when I was in his room, offered me a rapier. We fought, and it turned out that I was his superior. Almost every one of my thrusts struck home and finally his rapier flew into a corner. Half-joking and half-hurt, he remarked, while he was picking up his rapier, that he had found his master; but that everyone on earth has their master somewhere or other, and now he was going to lead me to mine. The brothers roared with laughter and shouted: "Come on, come on, let's go to the woodshed!" and with these words they took my hand and led me to a bear which Herr von G. kept on his estate. I looked at him in amazement. The bear was standing on his hind legs, leaning with his back against a pole to which he was chained, his paw lifted ready to strike, and looked into my eyes: this was his fighting position. I felt as though I was dreaming, seeing myself faced with such an adversary. "Thrust! Thrust!" said Herr von G., "and see if you can touch him!" After I had recovered a little from my astonishment, I lunged with the rapier. The bear made a very short movement with his paw and parried the blow. I tried to trick him with feints: the bear did not move. Again I made a lightning thrust – if it had been a man I would not have missed his chest this time – the

bear made a tiny movement with his paw and parried the thrust. Now I was almost in the same position as the son of Herr von G. The gravity of the bear's demeanour added to my bewilderment; thrusts and feints followed one on top of the other; I was drenched in sweat: it was all in vain! Not only did the bear parry all my thrusts as effectively as the best swordsman on earth; what is more – and here no fencer on earth could match him – he did not even respond to feints: he stood, facing me eye to eye, as if he could read my soul, his paw lifted and ready; and when my thrusts were not meant, he didn't move.

Do you believe this story?'

'Absolutely!' I said, agreeing enthusiastically. 'The story is so probable, that even if a stranger had told me it, I would have believed him - how much more if you are the one telling it!'

'Well then, my worthy friend', Mr C. said, 'you have all you need to know to understand my point. We see, that in proportion as in the animal world self-awareness becomes dark and diminishes, so gracefulness increases and becomes more radiant. But, just as two lines, starting from one point, meet again, after having passed infinity, or just as the image in a concave mirror, after vanishing completely, suddenly shows up right in front of our eyes: in the same way gracefulness reappears after consciousness, as it were, has gone through infinity; so that it appears in its purest form in the human body either when it has no consciousness at all or when it has an infinite one: that is, either in a puppet or in a god.'

'Which means', I continued, slightly bewildered, 'that we have to eat from the tree of knowledge once again in order to regain the state of innocence?'

'Precisely,' he replied. 'This is the last chapter of the history of the world.'

NOTES

For editorial advice and corrections I am indebted to J. McAllister, C. van Eck, R. van de Vall, and my friend Z'ev.

1 F. Schleiermacher, *Hermeneutik und Kritik*, Hrsg. von M. Franck (Frankfurt a.M.: Suhrkamp Verlag, 1977), p. 168; translation mine.
2 L. Wittgenstein, *Culture and Value*, ed. G. H. von Wright (University of Chicago Press / Oxford: Basil Blackwell, 1980), p. 71.
3 *Ibid.*, p. 35.
4 *Ibid.*, p. 76.

5 *Ibid.*, p. 23.
6 *Ibid.*, p. 15.
7 *Ibid.*, p. 24.
8 Translated by Dorothea Franck, helped by Donald Gardner.

Index

242

Index

Einstein, A. 159, 173
Elster, J. 153
Empiricism, British 89, 97, 100
engineering, style in 161–3

Fielding, H. 50, 53, 56
Filarete (Piero Averlino, known as) 91
Flaubert, G. 112–13
formalism 43, 44
Forthuny, P. 168
Foucault, M. 182, 189
Foulston, J. 82–3
Frank, M. 120, 200
Freyer, H. 117

Gadamer, H.-G. 177, 179, 180, 183, 185,
 186, 190, 196, 197
Gandy, J. 87
garden, landscape 71–2
Gay, J. 53, 61
genealogy 26, 31, 124–5, 126–7, 128–33,
 138
George, M. D. 56
Gerard, A. 74
Gilpin, W. 71, 74
Gloag, J. 163
Goethe, J. W. von 229
Goodman, N. 218
Griffin, B. 59
Guarini, G. 91
Gurlitt, A. 166

Habermas, J. 138, 187
Hartley, D. 74
Hawksmoor, N. 80
Hegel, G. W. F. 151, 189, 233
Heidegger, M. 25, 179
Hennebique, F. 167
historiography, style in 141–56
Hobbes, T. 73
Hogarth, W. 50–69, 97
Hölderlin, F. 221, 233
Holland, H. 87
Hopper, T. 85
Horace 90, 93
Hübsch, H. 89, 100
Hume, D. 74, 78, 132, 138
Husserl, E. 21, 187, 202–3, 206
Hutcheson, F. 74
Huysmans, J. K. 165–6

identity 202, 206, 207, 209, 215, 216
implication, stylistic 32–4
individuality 135–6, 139, 197, 209, 223,
 225
industrial design, style in 170–1

intention 19, 20, 22, 34, 203, 206, 207,
 222, 223
intentionalism 39
intentionality 15, 202, 206, 222–5, 228;
 dynamic 201–2, 203, 206, 207, 208,
 209, 213, 215
interpretation 124–5, 126–7, 128, 137,
 139, 179, 187, 188, 189, 190, 194,
 199, 206, 216
irony 151–2

James, W. 21
Jeffrey, F. 74
Johnson, C. 57
Johnson, S. 78, 151
Jünger, E. 111

Kames, H. Home, Lord 74, 78
Kant, I. 11, 13, 21, 23, 25, 28–30, 32–3,
 34, 152, 178, 183, 208, 211
Keene, H. 81
Kenny, S. Strum 54
Kent, W. 71, 73, 80
Kepler, J. 160
Kierkegaard, S. 22, 26, 193
Kleist, H. von 220, 223–5, 230–2
Knight, R. Payne 71, 75, 80

Labrouste, H. 163, 173
La Bruyère, J. de 19
Lacan, J. 209
Lang, B. 180–1, 218, 222
Langley, B. 81
La Rochefoucauld, F. de Marsillac, Duc
 de 19
Ledoux, C.-N. 71
literature, style in 26, 225, 227
Locke, J. 22, 25, 73–4, 97
Lorrain, C. 70
Loudon, J. C. 80
Louth, A. 185
Luther, M. 25
Lyotard, J.-F. 181

Macey, S. 53
Mandeville, B. 151
meaning 113, 177–200; in itself 177, 179,
 182, 184, 185, 187, 188, 190, 191,
 194, 195; propositional 189, 191–3,
 195; and style 7–11, 120–1, 227, 233
meaningfulness, experience of 177–200
Meisel, M. 52
Merleau-Ponty, M. 43
merz 109, 112, 113, 114, 116, 119, 120
metaphor 31, 71, 73, 142–7, 148, 149,
 150, 152, 154, 216